IMAGERY

Art *for* Wine

BOB NUGENT

Foreword
DONALD KUSPIT

IMAGERY
Art *for* Wine

BOB NUGENT

Foreword
DONALD KUSPIT

THE WINE APPRECIATION GUILD
SAN FRANCISCO

Imagery: Art for Wine

The Wine Appreciation Guild
360 Swift Avenue
South San Francisco, CA 94080
(650) 866-3020
www.wineappreciation.com

Library of Congress Cataloging-in-Publication Data

Nugent, Bob L.
 Imagery : art for wine / by Bob Nugent ; foreword by Donald Kuspit.
 p. cm.
 Includes bibliographical references and index.
 ISBN 1-891267-92-2
 1. Wine labels--California--Sonoma Valley. 2. Imagery Estate
Winery--Art collections. 3. Vintners--California--Sonoma Valley. I.
Wine Appreciation Guild (San Francisco, Calif.) II. Title.
 TP548.5.L32N84 2006
 741.6'92--dc22
 2005021558

ISBN 1-891267-92-2

Editors: Natalie Hardcastle, Bryan Imelli
Book Design: Diane Spencer Hume

Printed and Bound in China

To our mom Helen

who always appreciated the finer things in life.

—Joe Benziger

CONTENTS

FOREWORD

WINE AND ART:
THE BENZIGER GRAND ALLIANCE

DONALD KUSPIT

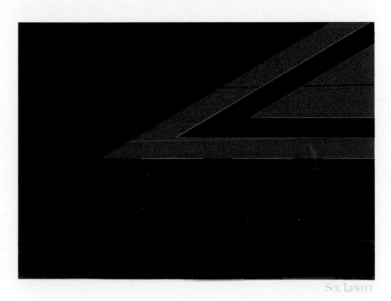

Wine has always been a powerful ally of the philosophy of nature; because it has demonstrated conclusively to the world that spirit also resides in nature.

—G.W.F. Hegel, Letter to J.W. v. Goethe, 1821

Spirit of the Earth, you are nearer to me;
already I feel my power increasing,
already I glow as if I'd drunk new wine,
I have the courage to venture into the world.

—Johann Wolfgang von Goethe, *Faust*, Part I

It's an ingenious idea: to mark their own artistry the Benzigers sponsored label art—images made to identify their most experimental wines. Not any old label art, but original art by major artists, reproduced as labels to confirm the originality of the wines with which they are associated. As Fred Tasker writes, "Imagery Series wines are like works of art themselves in that they are intense, individualistic, even eccentric, made by taking their component grapes to the ultimate expression of their inherent flavors."[1] They have, as Chris Benziger says, "a lot of personality. We're not trying to make mainstream wines." Similarly, the art the Benzigers commission has a lot of personality, and is as far as it is possible to be from the visual mainstream of America. It has nothing to do with the kitsch, mass-produced, facile imagery of the media, and everything to do with the best and most subtle America has to offer in art, just as the Benzigers represent the best and most subtle America has to offer in wine.

Thus the autonomy of the artists signals the autonomy of the winemakers. Indeed, it is independence of vision that the Benzigers value. They are not constrained by current conventions of winemaking, but rather explore new possibilities, just as avant-garde artists explore new possibilities of art.[2] Thus they have chosen artists who are equally innovative. The imagery disseminates their vision, even as their wine bottles disseminate the vision which art is.

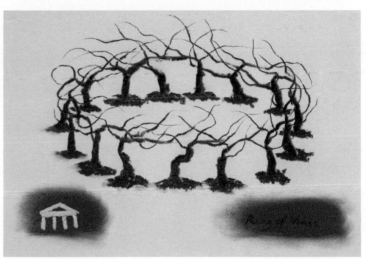

The lynchpin—spiritual center—of each image is the Parthenon-like structure that crowns the Benziger vineyards. It is the very personal symbol of Benziger enterprise, aspiration, and integrity. Each artist has the creative freedom to make whatever image he or she wishes, but each image must include the Parthenon, represented in whatever style the artist chooses. Thus, in Sol Le Witt's grand rendering, it is a sober, sacred, abstract icon, while in David Nash's image it is a witty little accompaniment to a circle of grapevines, each a kind of maenad linked in a Dionysian dance of nature. Let us recall that the original Parthenon was a temple dedicated to Athena, the goddess of wisdom and the practical arts, and that since antiquity wine

has been regarded as a sacred, potent substance, with a god—Dionysus—of its own. Can we say that the Benziger Parthenon, which presides over their wine-growing property the way the original Parthenon presided over Athens, represents the practical art of growing wine grapes, which also requires a great deal of wisdom? And there is divine wisdom—a heady mix of science and art—in wine itself, as the Latin saying "in vino veritas" tells us. In other words, wine, as the quotation from Hegel tells us, represents the spirit that resides in nature, and as such has a spiritualizing effect on those who drink it. Of course, as the classical scholar Jane Harrison reminds us, "intoxication to us now-a-days means not inspiration but excess and consequent degradation."[3] But excess is not a necessity of drinking, and as Harrison notes "serious excess in drink is rare among southern nations, and the Greeks were no exception to the general rule." Wine, in moderation, is on the side of wisdom, which makes it an attribute of Athena. In the Benziger spirit of blending incommensurables, Athena's classical Parthenon has also become the abode of romantic Dionysus.

As Goethe testifies, wine increases one's sense of power—one's feeling of being alive. It is invigorating, and distills the vigor—the capacity for growth—of the earth, as Plutarch said, noting that Dionysus represents the principle of moisture, which, together with the principle of dryness, represented by Demeter, the goddess of the earth, are the essential materials of life.[4] In a sense, the wine grape is a blend of earth and moisture, which is why wine is filled with the force of life. The life force in wine brings one close to the spirit of Mother Earth—indeed, wine is her milk, as Goethe implied—which is why it could renew Faust's life force, and with it the strength of character necessary to venture into the world, presumably to conquer it. Wine enhanced his sense of self—gave him enough conviction to have courage—rather than undermined it, sapping the courage he needed to face and endure and hold his own in the world.

Now I want to suggest that the image of the Parthenon, which is the backbone, as it were, of every Imagery picture, represents Benziger courage and·idealism—the ego strength necessary to stick to one's ideals—while the dynamic way the Parthenon is pictured by the artists conveys the life force in the wine. In other words, the Parthenon, a balanced, classical structure signifies courage and ambition and sense of purpose—virtú, as it was called in the Renaissance—while the romantic way in which the artists render the Parthenon, or the exciting esthetic environment in which they situate it, signifies the wine that fuels the Benzigers' pluck and integrity and idealism, that is, empowers their sense of possibility.

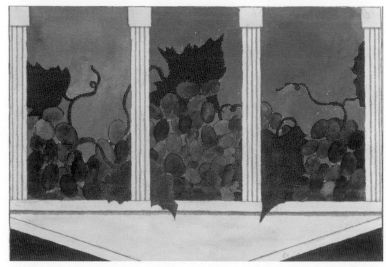

Tom Wudl wittily puts the Parthenon in a wine bottle and sets it afloat on a dark ocean, clearly suggesting that it will survive as it sails toward the bright horizon of the future. It is a perfect visual gesture, encapsulating both the grand theory and practical reality—the lordly Parthenon and the lowly bottle—of the Benziger winery. Similarly, April Gornik cleverly integrates wine grapes and Parthenon, stood on its head so that it cradles and supports the grapes. The golden sky above the lush purple grapes epitomizes the combination of idealism and vitality that go into making Imagery wines, and the "experimental" inversion of the temple their experimental character. Sam Gilliam spins the Parthenon until it falls apart, becoming an ironic shadow of itself, and sets the fragments of shadow in a collage of luminous colors, which it haunts like a ghost. The fragmentation of both temple and environment, and their idiosyncratic reassembling, suggests the infinite attention to detail involved in wine making, and the complex blending that makes for a good wine, as well as good art. Like Gilliam's

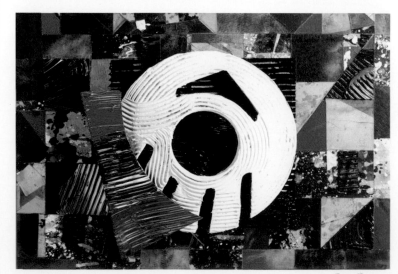

work, a good wine is a subtle collage. In all these cases the "passive" temple is artistically activated. In a sense, the life implicit in wine is breathed into it.

This life seems to have an independent existence in Gregory Amenoff's magical glass of red wine, raised like a toast into the sky. The glass dervishes like a top, its aura illuminating the whole sky. The Parthenon below all but dissolves in the light, and into light. The sacramental, mythical quality of both building and wine become all but explicit. In contrast, Jack Stuppin's equally luminous, intense temple glows like a star in the green of the vineyard landscape. The many shades of green suggest the many stages of growth as well as the nuances of taste that make the final product so pleasurable. The Parthenon becomes a kind of beacon in the complex terrain—a point of orientation in the barely tamed wilderness. Stuppin reminds us that however cultivated the land, it is raw underneath, and it is cultivated rawness that we enjoy in wine. Anne Siems's baroque picture calls attention to the religious meaning of the wine grape. It is from these grapes that the blood of Christ is pressed, as their brilliant halo suggests. One cannot help but think of the sacred still lives of Juan Sanchez Cotan, in which the first fruits of the harvest are laid out on a church altar, an offering to the mystery and miracle of nature and life. Siems's abundant, ripe wine grapes are transfigured into supernatural emblems, even as, like the body of Christ, they remain inescapably natural and intensely physical.

In general, the Parthenon is transfigured by either wry wit or romanticism. In Carl Palazzolo's ingenious image, it is a bright mote in the eye of the beholder. In Michael Nakoneczny's comic image it is a shelter for a figure too big to fit in it. From a distance it watches a bust of Robert Arneson sniffing, with comic pleasure, a glass of red wine. Terry Allen's bird is so excited by the glass of sparkling red wine it stands next to—"Wow," the bird exclaims—that it can't help but lay an egg. The Parthenon is the embryonic chick within. On the other hand, Bob Nugent romantically embeds the temple in a vineyard seen at night by a harvest moon, which all but dissolves it in the lush landscape. In Don Farnsworth's image it dissolves into a rosy mist, giving spiritual presence. For Nathan Oliveira the Parthenon is explicitly divine—the home of the gods—as the angelic wing that looms in the sky above it suggests. Chihung Yang also transcendentalizes it, as the view of the blue sky through its columns suggests. He worshipfully looks up to it, and the mystical grapes that float next to it, from the earth below. The wine spirit clearly makes these artists' spirits soar—makes them lose themselves in pure spirit—and the Parthenon on the Benziger heights symbolizes the spiritual heights—the renewal of spiritual integrity—it makes possible.

Whatever the complexities of meaning and technique in the Imagery works, they have one fundamental purpose: to exhibit the wine they are associated with to the best advantage. Just as works of art must be exhibited to be appreciated, so, in a sense, works of wine must be exhibited to be appreciated. In the case of the latter, this involves a complex ritual that customarily begins with the opening of the wine bottle, pouring the wine into a suitable glass, appraising its aroma, savoring its taste, and finally drinking it, enjoying every drop. The whole ceremonial process is optimally a consummate sensual experience—profoundly stimulating and erotic, yet also reflective. With Imagery wines, an innovative new step is added, heightening the whole experience: before one opens the bottle one looks at the artistic label on it. This is more than a matter of reading a label to know the contents of a bottle. This label invites special attention; it is an intriguing work of art. One lingers with it the way one lingers with a glass of good wine. One attends to

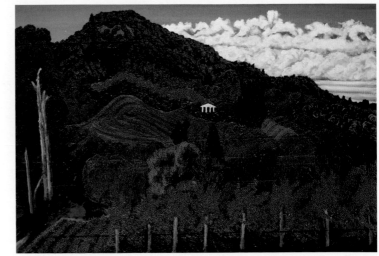

JACK STUPPIN

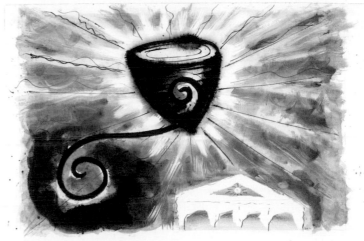

GREGORY AMENOFF

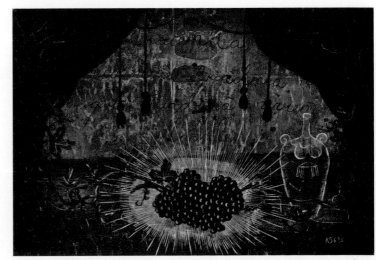

ANNE SIEMS

both with curiosity and love, rather than casually. (Initially the Imagery labels gave little or no information about the wine—that was available on a separate label—but existed as autonomous works of art.)

Subliminally, the label raises one's expectations of the wine: the uniqueness of the art anticipates the uniqueness of the wine. If the Imagery labels are museum quality, as they are, so by association and suggestion the wines they adorn must be museum quality. The Imagery Series label is the first experience of the Benziger wine, and since it is invariably a good experience we know the wine will be good. Thus, one becomes a connoisseur of art looking at the Imagery labels, which prepares one to become a connoisseur of wine drinking the Imagery wines. In sum, the art on the outside of the bottle whets our appetite for the wine on the inside. It is an essential, intimate part of the experience of enjoying the wine. Its quality belongs to the quality of the wine. In a sense, the dynamic art label announces the wine the way the satyrs and maenads who accompanied Dionysus announced his presence, reminding us that wine is the elixir of the gods.

One could say that the Imagery labels are a brilliant advertising strategy for a luxury wine—which it is—but it is something more. It is not simply a tour de force of seductive packaging and what has been called "aesthetic management,"[5] but, more crucially, involves a rhetoric of display that enhances the value of what is already regarded as inherently valuable. Indeed, it is about the synergistic value effect the convergence of things of intrinsic value—art and wine—can have. It is about using spectacle to further life values and creativity, rather than using spectacle to falsify them, which is the usual way spectacle operates, as Guy Debord emphasizes. It is about finessing spectacle for the sake of significant life experience.

According to Debord, in spectacle "all that once was directly lived has become mere representation."[6] The spectacle is a "concrete inversion of life," indeed, a "negation of life," involving the downgrading of *being* into *having*."[7] The spectacle puts the spectator into a passive, contemplative position, in which he is alienated from his own agency and personality: "the more he contemplates [the spectacle], the less he lives."[8] In capitalism, Debord argues, all commodities tend toward the condition of spectacle, that is, they tend to be valued more for their appearance than function or use. They are fetishized into pure appearance and reified into things in themselves.

At first, the Imagery labels appear to be a form of spectacle. They seem to turn the wine bottle into a glamorous spectacle, inviting the spectator to contemplate it as an astonishing appearance, no doubt collectable. Indeed, it seems to exist to be exhibited. To open it would be to disturb the perfection of its appearance. The labels seem to hype the wine in the bottle as "spectacular," preempting it as a personal experience, and unconsciously alienating us from it. It is no longer the elixir of life to be imbued with gusto—a passionate substance that contains and concentrates in itself the life force, which arouses and adds to our life force when it is consumed—but a glorious abstraction, that stands or falls on its dazzling appearance. On closer observation, something subtler—and seemingly impossible in the modern society of spectacle—occurs: the art labels finesse spectacle, undoing its effects. They affirm life, and the life force in the wine, convey the sense of spontaneous agency and intense individuality usually missing in everyday life, and generate an intense feeling of being that cannot be reduced to simple having and that is in general not easy to have.

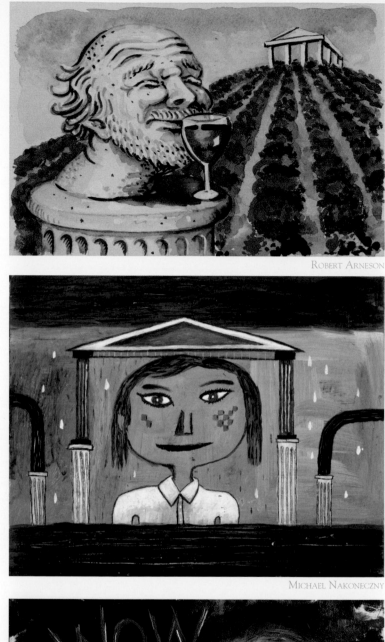

ROBERT ARNESON

MICHAEL NAKONECZNY

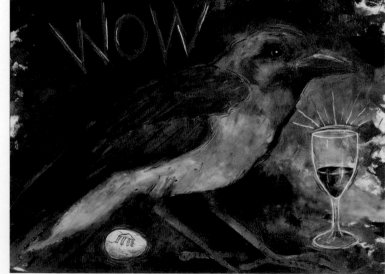

TERRY ALLEN

The Imagery label inverts the scale of spectacle, which tends to be larger than life—beyond life. A commodity that is a spectacle seems larger than life, however materially small. The smallness of the label, relative to the size of the bottle, and for that matter the work of art from which it derives, gives one a sense of intimacy altogether lacking in the contemplation of spectacle. The label reminds us that drinking wine, especially fine wine, is an unusually intimate act. One does not "have" good wine; it "has" one—possesses one completely—for it has the power to give one an unadulterated sense of being, and being alive. The label also reminds us that drinking wine is an esthetic experience—a very special kind of sensory experience, involving many senses and the emotions they evoke. Finally, the art label is a spontaneous creation, reflecting the artist's individuality and personal experience of wine. It is not the product of false consciousness, which is what spectacle epitomizes, indeed, apotheosizes.

One pours wine with one's hands, and holds a glass of wine in one hand: it is the scale of the hand that is replicated, as it were, in the art label. The hand is not a passive instrument, but "grasps" the lifeworld through its activity. It has its own special intuitive sense of the lifeworld. The works of art that became Imagery labels are crafted by hand, reminding us of the careful craft—the special intuitive feeling for wine—that goes into the making of Benziger wines. Both the artists and the Benzigers, through their direct agency, have invested their love of life into their vision of wine. In no way can it be said that they are interested in spectacle, for spectacle does not love life, but, as Debord says, prefabricates it.[9]

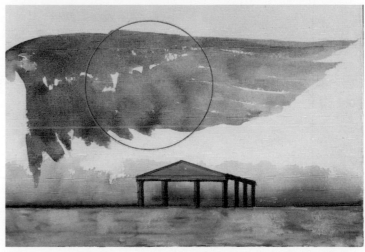

DON FARNSWORTH

NATHAN OLIVEIRA

NOTES

1. Fred Tasker, "The Fine Art of Labels," *Miami Herald*, May 26, 1994

2. Benziger Imagery Series wines have in fact often been responded to with the same incomprehension as avant-garde art. As Tasker notes, "wine writers didn't know what to make of…their boldest experiment," the International Imagery wine, "a Bordeaux-style blend of cabernet sauvignon and cabernet franc wines from France, Chile, Australia, and California." "Los Angeles Times critic Dan Berger decided he liked the flavor but didn't like the idea." Like avant-garde art, the International Imagery wine was impossible to classify: "It's like you don't know whether you're playing soccer or rugby. Here comes the ball; what do I do?" The wine was a "logistical nightmare" to produce, as Chris Benziger said, but integrating its "layers and layers of complexity"—"the French grapes gave it breeding, the Chilean grapes brought elegance, Australia gave it power and California gave it personality"—was a creative feat, not unlike that of bringing together different layers of meaning in a singularly work of art. The experimental extreme to which the Benzigers carry winemaking is not unlike that of the most daring avant-garde artists.

3. Jane Harrison, *Prolegomena to the Study of Greek Religion*. New York: Meridian, 1955, p.446.

4. *Ibid.*, p.430.

5. See Bernd Schmitt and Alex Simonson, *Marketing Aesthetics: The Strategic Management of Brands, Identity, and Image*. New York: Free Press, 1997. According to Schmitt and Simonson, the major issue of marketing today is "the strategic management of corporate and brand identities" (p.XIII). The Problem is to create "an attractive and lasting identity" for a product. The best way of doing so is by means of "brand aesthetics, i.e., attractive visual and other sensory markers and symbols that represent the organization and its brands appropriately and dazzle customers through sensory experiences." The Imagery Series labels are a dazzling aesthetic strategy for achieving a distinctive identity for Benziger wines, all the more so because it is impossible to duplicate the labels. They are one of a kind works of art, suggesting that Benziger Imagery Series wines are one of a kind wines, which in fact they are.

6. Guy Debord *The Society of the Spectacle*. New York: Zone Books, 1995, p.12.

7. *Ibid.*, pp. 14, 16.

8. *Ibid.*, p.23.

9. *Ibid.*, p.141.

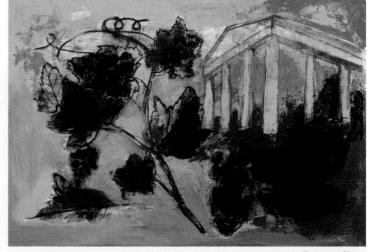

CHIHUNG YANG

ART FOR WINE:
THE STORY BEHIND IMAGERY

BOB NUGENT

BOB NUGENT

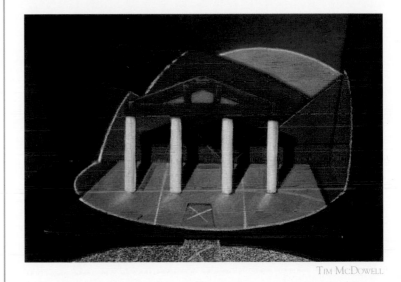

TIM McDOWELL

*I*n the summer of 1983 I took my family to a polo match where the festivities included jazz and wine tasting. My daughter Erin loved horses, and I had become a fan of polo during my college days. Early in the afternoon a scuffle broke out between two men in the wine tasting tent. I went to see what the ruckus was about and ended up pulling them apart with the aid of another fellow who was serving wine. That person was Joe Benziger. Joe had come to pour wine from his family vineyard and he, too, had brought his wife and kids to enjoy the afternoon activities. After separating the combatants, Joe and I then collected our two families for a picnic together beside the polo fields. It was during this chance meeting that I learned about his family's winery.

After casually keeping in touch for more than a year, I got a call from Joe. His family had sourced larger quantities of Cabernet, Merlot, and Zinfandel. During the process he came upon a small lot of Chardonnay whose quality was so exceptional he wanted it to be handled differently. The amount produced was too little to market nationally, so the wine would only be available at the winery. It caught Joe's imagination and he wanted to explore the idea of a custom artist label. I was excited about the challenge and in response conceived the "Vine Triptych": one image, segmented and separated into three equal parts—three different labels. In order to realize the triptych at work, three bottles of the wine would need to stand side by side, something that to my knowledge had not been done before. For package design we decided on a wooden box. The three bottles would be placed together creating visual unity in the label and highlighting both the art and the wine.

As an artist I wanted the image to stand on its own, without the typical lettering and information one is usually confronted with on a wine label. The winery honored my request by printing its name, the wine varietal and other required information on the back. The response to both the wine, which won several awards at wine competitions and the label design was most gratifying. The wine sold quickly, pleasing the partners at the winery who remarked, "Wow! Let's do this again." The following year a second series of labels would beautify a new Zinfandel release. The winemakers were having fun experimenting with these small lot wines, and I felt we artists should have some fun too. I had enjoyed the whole process of working within the size constraints of a wine label and still having the freedom to create what I wanted.

I invited Tim McDowell, an artist and friend from Mystic, Connecticut, to make the artwork for the second series. Tim visited the winery here in California and produced six images, three of which were selected for the Zinfandel "Vineyard Set." The bottles were grouped in a similar three-bottle package with only Tim's image and signature on the front of each.

In the process of creating these images, Tim painted an old Parthenon-like structure—not the Greek ruin on the Acropolis, but the funky structure that sits on the terraced hillside vineyards overlooking the Benziger Family Ranch in Glen Ellen. During a meeting with the winery partners it was decided that Tim's choice to include our "parthenon" was a good idea and should become an integral component of all subsequent labels. Mike Benziger, a winemaker and Joe's older brother, remarked

that this might be a problem: he had just told the staff to tear down the structure. He ran from the meeting to stop its destruction. Once viewed with whimsical affection and, in the early days, held together with baling wire, our "parthenon" has since gone through several renovations; it now symbolizes the ancient arts of winemaking and visual expression and is an emblem of the Imagery Artist Collection.

It was at this point that the Collection came into its own. The winemakers were experimenting more and more with small lots of less common varietals whose special qualities would be lost in blending them with larger quantities of juice. A new series of labels would be necessary to handle these unique grapes from individual vineyards. For my part, I saw this as an opportunity to have fantastic labels featuring images created by artists whose work I admired, artists who would create works based upon their own interests without interference or scrutiny from the winery. I knew there must be other artists that would get a kick out of it. Our "parthenon" would be the one element necessary to unify the collection. I also knew that if I was going to entice the very best that the art world had to offer I would have to come up with a hook—something the artists could all buy into to justify creating something for someone other than themselves.

I researched the history of the wine label, concentrating on paper labels produced from the late 18th century up to current developments. In the process, I discovered that when Baron Philippe de Rothschild had commissioned his first labels from modern artists in the late 1950's he rewarded them with five cases of wine from that bottling and five cases of wine from his private cellar. When I told the Benziger family about this they decided to adopt a similar policy for the Imagery Program. Now, each commissioned artist is paid a uniform honorarium: their work becomes part of the Imagery Artist Collection and the artist receives ten cases of wine labeled with their image . . . art for wine. I believe this is truly the reason most artists agree to participate in the program. There are few things more enjoyable than giving someone a good bottle of wine with your art and name on it. I personally find it very satisfying.

Over the years the labels have evolved in format and style. The TTB (Alcohol and Tobacco Tax and Trade Bureau), the federal agency that regulates and approves wine labels, excludes anything obviously objectionable, and requisite information, including the name of the winery, varietal content, vintage and alcohol content, must appear on the bottle's front label. Artists are told about these and other restrictions the government places on wine labels; but even with these regulations, the mission of the program, which is to feature the work of the artist, has not changed. For us it is still the most important component of the label.

I made a point of talking with Robert Arneson, an early participant in the program about the rules and regulations involved, as he had a reputation for creating controversial work. Arneson's bust of the late Mayor of San Francisco George Moscone, commissioned by the City, had recently been rejected for questionable references. Arneson's response to my concerns was, "You mean I can't do my usual?" And I said, "Sorry Bob, not this time." He chose to put himself on the label, his head on a pedestal, quaffing a glass of wine.

I don't set deadlines for the artists. Deadlines do not necessarily inspire meaningful, quality work. All of the artists are busy with their own careers. Some artists have taken a couple of months to make a piece for us, while others have taken years. If we don't receive an image in time for the current year's release, we use it on a new label the following year. In my contact letter to each artist I state, "At first this may sound a little commercial, but hear me out before you decide." Some of the artists cringe at

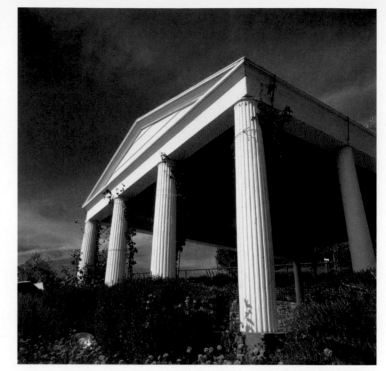

PHOTO CREDIT: DAVID KEISTER

the idea of producing a label, but once they get the full story they usually come on board. I assure them that everything, especially the wines, will be first rate. I personally oversee all the reproduction and printing of the labels to ensure quality.

We also guarantee each artist that the image they produce will be used. We will never refuse an artist's image as long as it meets government requirements. I believe that is why the program works. We do not make editorial judgments on the work we receive. Once an artist is selected, based on the quality of their work, they are invited to make an image in any medium and style of their choice for a future wine release. The only requirement we have is that each artist include some interpretation of our "parthenon," the winery's trademark. Otherwise the artist is given full creative freedom. I think that is another reason why we have been able to interest quality artists in the program.

Today, Joe makes twelve to sixteen new wines each year for the artist collection. Each winter, once we know how many wines will be bottled, he and I sit down and match the images with the wines. We make our decision based upon grape variety, wine style and the bottle's shape and color. With each new Imagery release a new label image emerges. This is because the images are used only once. Even if Joe produces a second vintage of the same varietal, the wine is destined to be different, so each new wine receives a unique new label. When a wine is gone, the image is retired to the permanent collection, which to date numbers over 190, the work of 140 different artists. We have selected one image from each artist in the collection for this publication.

As an artist I travel extensively in the U.S., Europe, Asia and South America. While doing so I am continually looking for new artists whose work I find inspiring. For example, Carlos Estevez, an artist from Cuba, whom I discovered during a visit to the Havana Biennial, created a label. A number of artists who have produced labels for us often refer other artists to me. A majority of these artists I know by reputation and meet during my travels. When I can, I visit their studios. Meeting the artists and learning about their work has been one of the most enjoyable aspects of building the collection.

In the early days, I would meet with the partners and show them slides of contemporary artwork. Often they were curious about why I had selected certain artists, and the session became an impromptu art history lesson. As a teacher, it was fun for me to educate them about the artists and their work. As the partners' knowledge increased and their tastes for contemporary art became more sophisticated, they became more enthusiastic about the program and the art world in general. At the same time the Benzigers taught me about wine, an education that has become an essential part of my life and my relationship to the Artist Collection Program.

It is now my sole responsibility to find the artists, issue contracts and arrange for the display of their pieces at Imagery Estate Winery. I work as a liaison between the artist and the winery protecting their rights while maintaining the quality of the program. It is unusual to work for a company that pays you to be an advocate for the artists they commission.

While we have had a number of artists who are recognized both nationally and internationally, we have also included many young, regional artists whose dynamic, energized work I feel is important to showcase. I select the artists based upon the strength of their work, not purely on their reputation. I look for artists who express a deep and abiding personal vision in the context of their work. Their skill, devotion and pure enjoyment of the creative process must match that of the winemakers. Because we accept every artwork produced we must have total confidence before we

CARLOS ESTEVEZ

commission him or her to produce an image. And most importantly, the Benzigers have remained true to the initial intent of the program by being supportively inconspicuous. In every aspect of the wine business it has been their policy to hire professionals and then leave them to manage their own programs. To this day the Benzigers have put their faith in me, and in the artists and their ability to produce quality work. Their confidence in my vision has made it possible for me to have a personal stake in the success of the Artist Collection.

The Imagery Artist Collection is quite eclectic. While I have been responsible for seeking out and procuring the work, I did not want this to be a collection with a single point of view. Most every aspect of the contemporary art world has been represented both in style and content. And though all the final label images must be by nature, two- dimensional, sculptors and conceptual artists are also represented.

The Benziger family asked me to coordinate the artist collection program twenty years ago because they knew little about the contemporary art scene and wanted to create a unique program that allowed artists to make the images they were passionate about—the kind of passion Joe has for making wine. Joe's creative efforts have resulted in exotic, bold and unusual wines. He and the other members of the family have fueled my enthusiasm in creating a top quality collection, by artists that explore the limits of their abilities and talent. They, too, strive to break new ground with their own creative work. I know it is the blend of these art forms that makes the Imagery Artist Collection exceptional.

ACKNOWLEDGEMENTS

I have wanted to document the Imagery Estate Winery's Artist Collection for over ten years and I am pleased that the opportunity presented itself now during the 20th Anniversary of the artist's label series. A project of this size and scope becomes a collaboration of many individuals and I have been fortunate to have a very dedicated team working with me. They all have been most generous with their time and expertise.

First and foremost I am indebted to my two studio assistants, Natalie Hardcastle and Samantha Lange, for all their assistance. Natalie worked for many months compiling information on the artists and was the primary editor for the book. She has been with me for several years and has made it possible for me to take on projects of this kind. Natalie is now leaving for New York to pursue her own art career. She has been a most valued assistant and I will miss her dearly. Samantha came on board early this year and has worked with Natalie and I over the past few months. She has been a tremendous help with research, compiling information and editing.

Several other individuals have assisted me over the past few months and I want to thank Donn Brannon, Deborra Clayton, Georgina Balkwell and Jeanette Long for their contributions, advice and additional editing. Erin McCabe assisted with design decisions. Kathan Brown was kind enough to permit me the use of a number of statements and observations she made while several of the artists worked at Crown Point Press in San Francisco. Linda Kramer and Leia Jervert of the Nancy Graves Foundation provided much needed assistance as I did my research. I wish to acknowledge all of the galleries and dealers representing the artists for their help.

In the early stages of the Imagery Artist Collection Bruce Rector was a lightning bolt of enthusiasm and support. I wish to thank Kathy Gehrett of the winery staff for her persistence in seeing this publication realized. Paulette Nolan and Karen Ernsberger, also of the winery team, contributed to the book's success. I am extremely grateful to the Benziger Family Winery partners who have had the foresight to support a truly unique program. Their patronage of the arts goes far beyond this collection.

I want to acknowledge Sheryl Benesch, Dean Wilkendorf and Rick Bell of The Lab in Santa Rosa, California for their fine photography work and digital imaging. Diane Spencer Hume, the principle designer for the book, has been extremely helpful and patient with me. Elliott Mackey of the Wine Appreciation Guild provided his encouragement and enthusiasm when I needed it. I am especially indebted to Donald Kuspit for traveling all the way from New York to view the collection. He has written a wonderfully illuminating essay on art and wine.

I wish to express my appreciation to the 133 artists who have participated in the program for their enthusiasm and for producing excellent work. I am grateful for the understanding of my daughters; Erin, Georgina and Rebekka who have seen little of me over the past few months. To my wife Lynda, who has always given me the gift of time and the support I have needed, obrigado. And to Joey Benziger, a good friend and colleague for over twenty years, thanks for making such great wine.

—Bob Nugent

THE ART OF WINE MAKING

JOE BENZIGER

*I*n the wine industry, tradition often tempers creativity, individuality and imagination. But at Imagery Estate, where we make wine from a desire to go beyond the expected and where the images on our wine labels are as different as the wines we craft, creativity is pushed to the edge. As a winemaker, I have had many occasions to learn and create.

As an artist and teacher, Bob Nugent enjoys the same fortune. Through Bob's career as a professional artist, I have had the pleasure of meeting hundreds of the world's most promising artists. And as I see the results of their creative pursuits, they, in turn, inspire me to create. Made from rare varietals and from renowned California vineyards, my art is the wine that results from coalescence among winemaker, grower, and visual artist.

Although this book honors the hundreds of talented artists within, to me it is a celebration of the two that have come together—the wine and the art, the winemaker and the artist.

I thank Bob for introducing my family and me to the world of contemporary art. We hope that you will have an opportunity to visit our winery and experience the art of Imagery, both vinous and visual.

Cheers,
Joe Benziger

Artists & Images

JOHN ALEXANDER

The first time I met John, he was in his studio playing catch football with his assistant. As the evening went on, I observed him editing prints, selecting drawings for a show, and later working on a painting while at the same time talking on the phone. The energy he displayed was amazing and comes through, I think, in the work.

—Bob Nugent

Born: 1945 Beaumont, Texas
Lives and works in New York, New York

EDUCATION
1970 M.F.A. Southern Methodist University, Dallas, TX
1968 B.F.A. Lamar University, Beaumont, TX

GRANTS AND AWARDS (selected)
1984 John Simon Guggenheim Memorial Foundation
1981 National Endowment for the Arts Fellowship

ONE PERSON EXHIBITIONS (selected)
2003 Art Museum of Southeast Texas, Beaumont, TX
2002 Imago Galleries, Palm Desert, CA
2002 El Paso Museum of Art, El Paso, TX
2002 Pillsbury and Peters Fine Art, Dallas, TX
2002 The McKinney Avenue Contemporary, Dallas, TX
2002 Bendley Gallery, Scottsdale, AZ
1998 Galerie Simonne Stern, New Orleans, LA
1997 Gerald Peters Gallery, Dallas, TX
1996 Marlborough Gallery, New York, NY (catalog)
1996 Maryland Institute of Art, Baltimore, MD
1996 Fullerton College, Fullerton, CA
1995 Dorothy Goldeen Gallery, Santa Monica, CA

GROUP EXHIBITIONS (selected)
1997 The Art Museum at Florida International University, Miami, FL
1997 Galerie Simonne Stern, New Orleans, LA
1997 Museum of Contemporary Art, San Diego, CA
1996 Harn Museum of Art, University of Florida, Gainesville, FL
1996 Gerald Peters Gallery, Dallas, TX
1995 Parchman Stremmel Galleries, San Antonio, TX
1995 Galerie Milan, São Paulo, Brazil

PHOTO CREDIT: BOB NUGENT

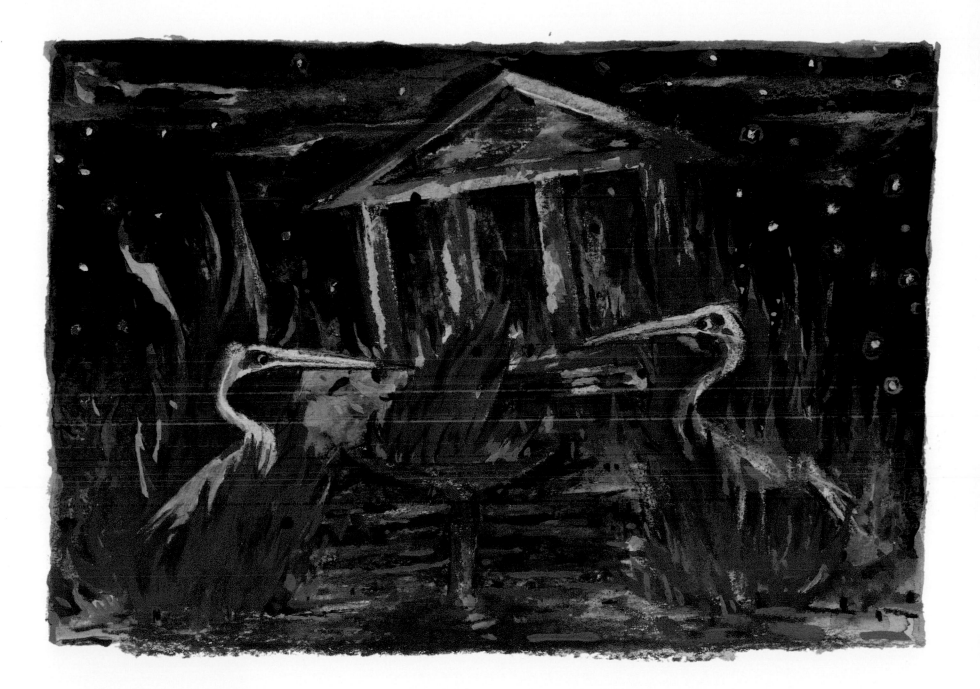

"FOR A HOT NEW WINE" 1992
WATERCOLOR ON PAPER
8" x 10"

3

TERRY ALLEN

Terry Allen is a true Renaissance man. With noteworthy accomplishments in writing and composing music, and in performance art, painting, drawing and sculpture, he has established himself as a true recorder of contemporary life and the human condition.

—Bob Nugent

Born: 1943 Wichita, Kansas
Lives and works in Santa Fe, New Mexico

EDUCATION
1966 B.F.A. Chouinard Art Institute, Los Angeles, CA

GRANTS AND AWARDS (selected)
2003 NEA Matching Grant/Bemis Center for Contemporary Art, Omaha, NE
1992 Wexner Center for the Arts Artist's Residency Fellowship, Columbus, OH
1986 Isadora Duncan Award, San Francisco, CA
1986 John Simon Guggenheim Memorial Fellowship
1985 National Endowment for the Arts Fellowship
1982 Awards in Visual Arts (AVA)
1978 National Endowment for the Arts Fellowship
1970 National Endowment for the Arts Fellowship

ONE PERSON EXHIBITIONS (selected)
2005 "Stories from Dugout," Blaffer Gallery, University of Houston, TX
2005 "DUGOUT III: Warboy (and the backboard blues)," UH Wortham Theatre, Houston, TX
2004 Gallerie Paule Anglim, San Francisco, CA
2004 DUGOUT I at LA Louver Gallery, Venice, CA
2004 (HOLD ON to the house), Santa Monica Museum of Art, CA
2004 DUGOUT III: Warboy (and the backboard blues), Los Angeles Theatre Works at the Skirball Cultural Center, CA

GROUP EXHIBITIONS (selected)
2003 "25TH Anniversary Exhibition," Sonoma State University, University Art Gallery, Rohnert Park, CA
2003 "Humor As Art: Selections from the Permanent Collection," Palm Springs Desert Museum, Palm Springs, CA
2001 "Radical Past: Contemporary Art & Music in Pasadena 1960-74," Armory Center for the Arts, Pasadena, CA
2001 "Art and Wine: Benziger Imagery Series," Palo Alto Art Center, Palo Alto, CA
2001 "200 Years of Folly: Legacy of Goya's Caprichos," Muskegon Museum of Art, Muskegon, MI
2000 "Ed Hamilton's Printer's Proofs Lithographs of 1969-1989," Toby Moss Gallery, Los Angeles, CA
2000 "Pleasure Treasure: Recent Acquisitions from the Collections of Eileen and Peter Norton," The Harriet & Charles Luckman Fine Arts Complex at California State University, Los Angeles, CA
1997 "Household Goods," Texas Gallery, Houston, TX
1997 Contemporary Sculpture, The Figurative Tradition, Leigh Yawkey Woodson Art Museum, Wausau, WI
1997 Scene of the Crime, Armand Hammer Museum, University of California at Los Angeles, Los Angeles, CA

PHOTO CREDIT: PAUL O'CONNOR 2003
COURTESY OF L.A. LOUVER GALLERY

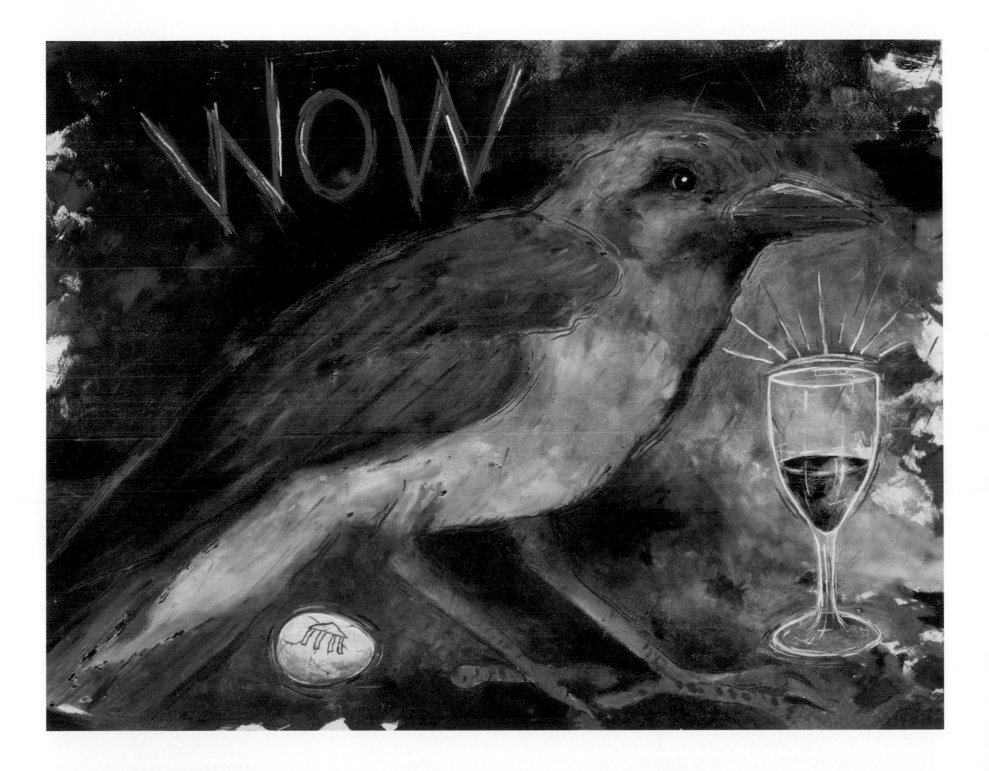

"Untitled" 1993
MIXED MEDIA ON PAPER
18-3/4" x 24-1/2"

GREGORY AMENOFF

Designing the label for Benziger represented a great opportunity; however, it was always clear to me that people don't drink what's on the outside of the bottle—it's the contents that delight. That said, the challenge for me was to use imagery I was comfortable with but not simply work out of the same sensibility I employ when making a painting. Hence my first label, which landed on a Cabernet Franc, was an image of a luminous red crucible floating in space. The charms of wine are poetic and sometimes elusive, and I offered that image in that spirit. My next image was based around a landscape (Glen Ellen, California) framed in a grape leaf and surrounded by four orbs. Each one tinted to represent the variety of colors one finds in red wines from the orange to the violet cast. Over the years between the first and second image my work had moved more towards the language of landscape, hence the earth orientation of my second label for Benziger. But again, the wine is the noun and the label can only serve as a frail adjective.

—Gregory Amenoff, 2005

Born: 1948 St. Charles, Illinois
Lives and works in New York, New York and Santa Fe, New Mexico

EDUCATION
1994 Honorary Doctor of Fine Arts, Massachusetts College of Art, Boston, MA
1970 B.A. in Art History, Beloit College, Beloit, WI

GRANTS AND AWARDS (selected)
1997 American Academy of Arts and Letters Purchase Award
1989 National Endowments for the Arts Fellowship (Painting)
1981 National Endowments for the Arts Fellowship (Painting)
1981 C.A.P.S. (New York State Council on the Arts Award)
1980 National Endowments for the Arts Fellowship (Painting)
1980 Louis B. Comfort Tiffany Foundation Grant
1979 Artist Foundation of Massachusetts
1976 Massachusetts Bicentennial Painting Award

ONE PERSON EXHIBITIONS (selected)
2004 "Gregory Amenoff, Recent Work," DNA Gallery, Provincetown, MA
2003 "Gregory Amenoff, Paintings and Works on Paper," Salander O'Reilly Galleries, New York, NY
2003 "Raimondi Collects: A 25 Year Survey of Gregory Amenoff," John Raimondi Gallery at Vitale, Caturano and Co. Boston, MA
2003 "Gregory Amenoff: Recent Work," Gerald Peters Gallery, Santa Fe, NM
2000 "Gregory Amenoff, Selected Paintings, Drawings and Prints, 1987- 1999," Wright Museum of Art, Beloit College, Beloit, WI

GROUP EXHIBITIONS (selected)
2004 "The Self-Reliant Spirit," Nielsen Gallery, Boston, MA
2002 "Painting in Boston, 1950-2000," DeCordova Museum and Sculpture Park, Lincoln, MA
2002 "Dickenson to Amenoff: American Artists on the Cape," Pennsylvania Academy of Fine Arts, Philadelphia, PA
2002 "Invitational Exhibition of Painting and Sculpture," American Academy of Arts and Letters, New York, NY
2001 "176TH Annual Exhibition, National Academy of Design," National Academy of Design, New York, NY
1999-2000 "Beyond the Mountains: The Contemporary American Landscape," Newcomb Art Gallery, Tulane University, New Orleans, LA (traveling exhibition)
1998 "D'Apres Nature," Galerie Vidal-Saint-Phalle, Paris, France

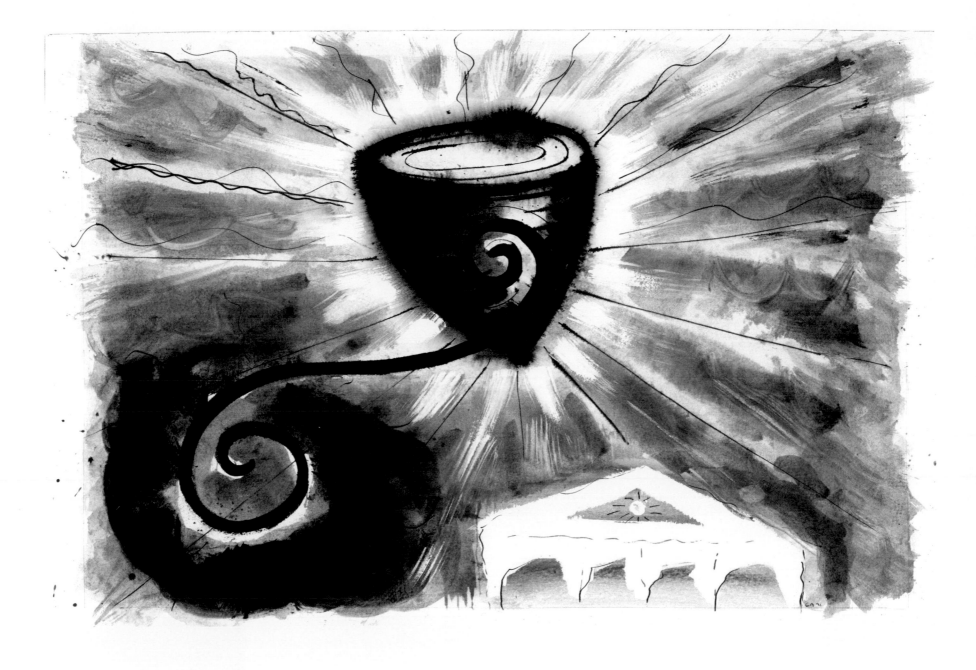

"UNTITLED" 1992
WATERCOLOR/GOUACHE ON PAPER
18" x 27"

7

DAVID ANDERSEN

The suppositions which influence my work have evolved from my early interests in natural systems, thermodynamics, modern physics and philosophical constructs. During the past few years I have been intrigued by the philosophy of dumb logic which holds that the solution to many problems is often the answer originally thought to be the most ludicrous. A related conjecture suggests that any idea pushed far enough in either direction will become its opposite. Examples of this concept occur when left wing becomes right wing, pain turns to pleasure, the spontaneous transforms to the contrived and the absurd becomes profound. Our existence is filled with similar paradoxes and ambiguities where events, tragic or otherwise, appear to be unfair, ridiculous or just. It is through my work that I utilize, order and confront these absurdities.

—David Andersen

Born: 1957 Logan, Utah
Lives and works in Milwaukie, Oregon

EDUCATION
1988 M.F.A. Brigham Young University, Provo, UT

GRANTS AND AWARDS (selected)
2003 CCC Foundation Grant
2000 Center for Learning and Teaching Grant
1998 Teaching Excellence Grant
1997 California Arts Council Grant
1994 Nevada State Council on the Arts Fellowship
1993 Sierra Arts Foundation Fellowship

ONE PERSON EXHIBITIONS (selected)
2005 "SACCO," Cruzando Traques, San Diego, CA
1999 "Pretty Dumb Paintings," Esther Claypool Gallery, Seattle, WA
1999 "Good Luck," Debra Owen Gallery, San Diego, CA
1997 "David Andersen," California Center for the Arts Museum, Escondido, CA

GROUP EXHIBITIONS (selected)
2005 "HEADS," Two Person Exhibition, Spokane Falls Community College, Spokane, WA
2004 "On Tray," Two Person Exhibition, The Basement, Boise, ID
2003 "Oregon Biennial," Portland Art Museum, Portland, OR
2002 "Oregon Outdoor Sculpture Biennial," Oregon City, OR
2002 International Society of Illustrators, New York, NY
2001 "Lust and Chance," Henry Art Gallery, Seattle, WA
2000 "Art Alive," San Diego Museum of Art, Balboa Park, CA
1999 Museum of Contemporary Art, La Jolla, CA

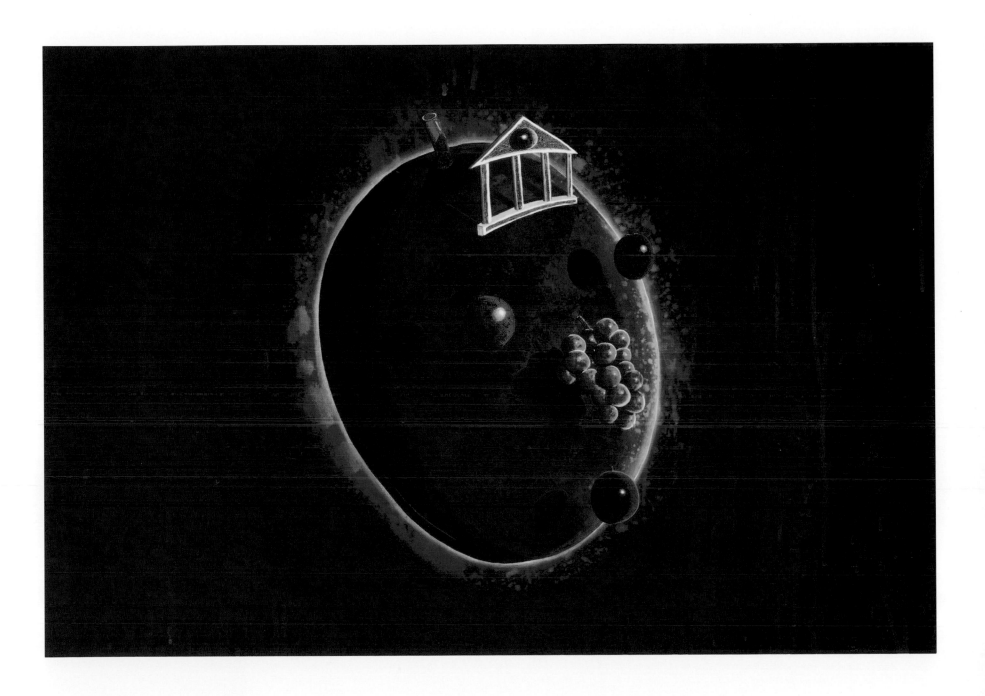

"Untitled" 2000
OIL ON CANVAS
22" x 32"

ROBERT ARNESON
(1930-1992)

One of the most important figures in contemporary ceramics, Robert Arneson was always a bit of a controversial figure. He was one of the few artists that I needed to impress with the fact that he must watch his P's and Q's when it came to producing an image for the wine. As I indicated in my preceding essay, he always had the tendency to walk the line between what was acceptable and what was inappropriate. In person he was always a kind and gentle figure highlighted with a bit of whimsy. He made me feel good and chuckle when I was with him.

—Bob Nugent

Born: Benicia, California

EDUCATION
1958 M.F.A. Mills College, Oakland, CA
1954 California College of Arts and Crafts, Oakland, CA

GRANTS AND AWARDS (selected)
2002 Anonymous Was A Woman Grant Award
1999 New York Foundation for the Arts Grant
1995 Empire State Crafts Alliance Grant
1993 The Evelyn Shapiro Foundation Grant

ONE PERSON EXHIBITIONS (selected)
1986 "Retrospective Exhibition," organized by Des Moines Art Center, Des Moines, IA (traveling exhibition)
1983-1984 Crocker Art Museum, Sacramento, CA
1983 "Moscone Bust Exhibition," Triton Museum of Art, Santa Clara, CA (traveling exhibition)
1982 "The Alice Street Drawings, Paintings, and Sculptures, 1966-67," Nelson Gallery, University of California at Davis, CA
1976 "Painting and Sculpture of California: The Modern Era," San Francisco Museum of Modern Art, San Francisco, CA (traveling exhibition)

GROUP EXHIBITIONS (selected)
1985 "California Sculpture Show," Fisher Gallery, University of Southern California, Los Angeles, CA (traveling exhibition) (catalog)
1984-1986 "Disarming Images: Art for a Nuclear Disarmament," circulated by The Art Museum Association of America (traveling exhibition) (catalog)
1984 "Art of the States: Works from a Santa Barbara Collection," Santa Barbara Museum of Art, Santa Barbara, CA (catalog)
1984 "Drawings Since 1974," Hirshhorn Museum and Sculpture Garden, Smithsonian Institution, Washington, D.C. (catalog)
1984 "Crime and Punishment," Corpus Christi State University, Corpus Christi, TX
1983 "Art Against War," San Francisco Art Institute, San Francisco, CA
1983 "The Sculptor as Draftsman," Whitney Museum of American Art, New York, NY
1983 "Inside Self Someone Else," The Dayton Art Institute, Dayton, OH

Art © Estate of Robert Arneson/Licensed by VAGA, New York, NY

PHOTO CREDIT: KURT FISHBACK

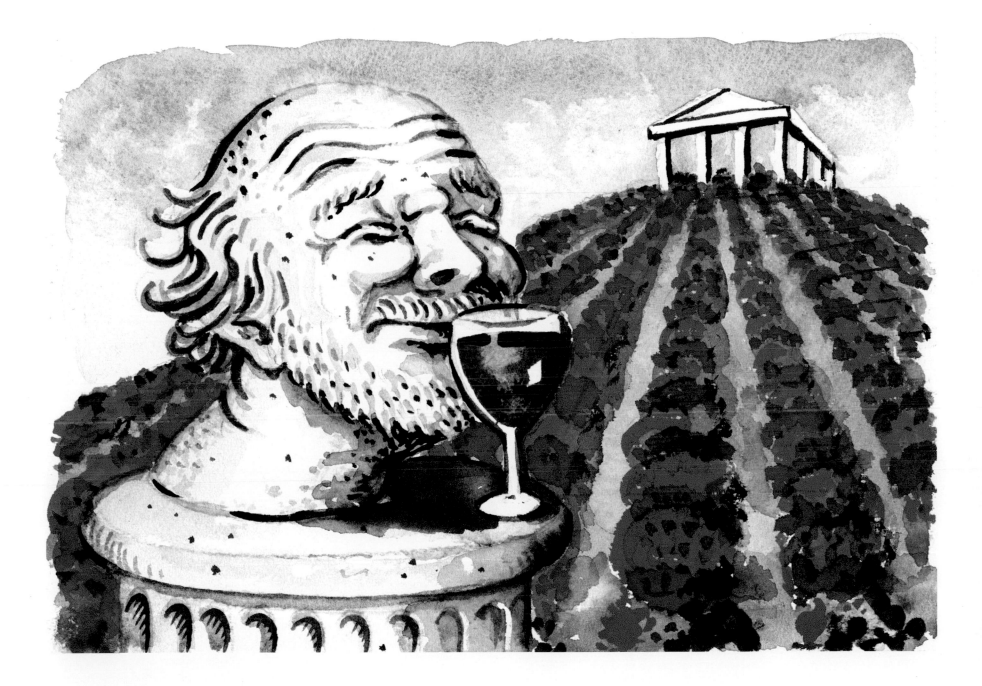

"Old Bacchus Awakened" 1990
WATERCOLOR ON PAPER
10-1/4" x 14-1/4"

CHESTER ARNOLD

I have always tried to make passionate ideas and feelings regarding the world into paintings that follow yet expand upon the visual traditions of the Art-staging metaphors for the sake of moral imperatives, surrendering regularly to the beauty and mystery of the materials, and through them the deep fascinations in the visions they reveal.

—Chester Arnold

Born: 1952 Santa Monica, California
Lives and works in Sonoma, California

EDUCATION
1987	M.F.A. San Francisco Art Institute, San Francisco, CA
1970-1974	College of Marin, Kentfield, CA
1966-1969	Private Teachers, Munich, Germany

GRANTS AND AWARDS (selected)
1998	Milley Award
1997	Artist in Residence, Tamarind Institute Lithography Center
1996	Westaf/National Endowment for the Arts Foundation Grant
1990	Marin Arts Council Individual Artist Grant

ONE PERSON EXHIBITIONS (selected)
2004	"Reconstruction," Catharine Clark Gallery, San Francisco, CA
2003	"A Soul's Geography," Dominican University, San Rafael, CA
2003	"Destinies Manifest," Sonoma Valley Museum of Art, Sonoma, CA
2002	"In Memorium," San Jose Museum of Art, San Jose, CA
2002	Tacoma Art Museum, Tacoma, WA
2001	San Jose Museum of Art, San Jose, CA
2000	Susan Cummins Gallery, Mill Valley, CA

GROUP EXHIBITIONS (selected)
2004	"A Not So Still Life: 100 Years of California Still Life Painting," Pasadena Museum of Art, Pasadena, CA
2003	"Collection Highlights," San Jose Museum of Art, San Jose, CA
2003	"Sprout: An Exhibition Celebrating New Growth," Catharine Clark Gallery, San Francisco, CA
2003	"Collection Highlights," Palo Alto Cultural Center, Palo Alto, CA
2003	"Nature Remains," Off the Preserve, Napa, CA
2001	"Underfoot," Associacão Alumni, São Paulo, Brazil (traveling exhibition) (catalog)
2000	"The Great Novel," Palo Alto Cultural Center, Palo Alto, CA
1999	International Biennial of Graphic Arts, Ljubljana, Slovenia

"UNTITLED" 1996
OIL ON PANEL
13-3/4" x 20"

13

CHARLES ARNOLDI

Ultimately, what I would really love to do is make good enough paintings that other people who want to make paintings would say 'God I wish I made those paintings.' To me that's the ultimate thing, that if another person who feels the way I do about paintings, says 'I wish I could do that!' That's it.
—From an interview with William Turner for *Venice Magazine*, May 1995

Born: 1946 Dayton, Ohio
Lives in Malibu, California and works in Venice, California

EDUCATION
1968 Attended Chouinard Art Institute, Los Angeles, CA

GRANTS AND AWARDS (selected)
1982 National Endowment for the Arts Fellowship
1982 "Maestro Fellowship," California Arts Council
1975 John Simon Guggenheim Memorial Fellowship
1974 National Endowment for the Arts Fellowship
1972 "Wittkowsky Award," Art Institute of Chicago, IL
1969 "Young Talent Award," Los Angeles County Museum of Art Contemporary Arts Council

ONE PERSON EXHIBITIONS (selected)
2002 "Charles Arnoldi, Harmony of Line and Color," Busan Metropolitan Art Museum, Busan, Korea (catalog)
1987 "Arnoldi: Just Bronze," University Art Museum, California State University, Long Beach, CA (catalog)
1986 "Arnoldi: Recent Paintings," University of Missouri-Kansas City Gallery of Art, Kansas City, MO (catalog)
1986 "Charles Arnoldi, A Survey: 1971-1986," Arts Club of Chicago, Chicago, IL (catalog)
1984 "Charles Arnoldi: Unique Prints," Los Angeles County Museum of Art, Los Angeles, CA (catalog)

GROUP EXHIBITIONS (selected)
2004 "Lost But Found: Assemblage, Collage and Sculpture, 1920-2002," Norton Simon Museum, Pasadena, CA (catalog)
2000 "Celebrating Modern Art: The Anderson Collection," San Francisco Museum of Modern Art, San Francisco, CA (catalog)
1999 "Radical Past: Contemporary Art and Music in Pasadena, 1960-1974," Armory Center for the Arts, Pasadena, CA (catalog)
1986 "70s to 80s: Printmaking Now," Museum of Fine Arts, Boston, MA (catalog)
1983 "The 38TH Corcoran Biennial Exhibition of American Painting: Second Western States Exhibition," Corcoran Gallery of Art, Washington, D.C. (catalog)
1981 "Los Angeles Prints, 1883-1980," Los Angeles County Museum of Art, Los Angeles, CA (catalog)
1981 "1981 Biennial Exhibition," Whitney Museum of American Art, New York, NY (catalog)
1978 "Painting and Sculpture Today," Indianapolis Museum of Art, Indianapolis, IN (catalog)
1976 "Painting and Sculpture in California: The Modern Era, San Francisco Museum of Modern Art," San Francisco, CA (catalog); also shown at the National Collection of Fine Arts, Smithsonian Institute, Washington, D.C.

"UNTITLED" 1992
WATERCOLOR ON PAPER
7-1/2" x 10-1/2"

JOHN BALDESSARI

I'm really interested in what conceptual leaps people can make from one bit of information to another and how they can fill the space.
—From *View*, www.crownpoint.com

Born: 1931 National City, California
Lives and works in Santa Monica, California

EDUCATION
1957-1959 Otis Art Institute, Los Angeles, CA
1957-1959 Chouinard Art Institute, Los Angeles, CA
1955-1957 M.A. San Diego State College, CA
1955 University of California at Los Angeles, CA
1954-1955 University of California at Berkeley, CA
1949-1953 B.A. San Diego State College, San Diego, CA

GRANTS AND AWARDS (selected)
2003 2ND Place Best Show, Commercial Gallery National by US Art Critics Association for exhibit at Margo Leavin Gallery, Los Angeles
2003 Honorary Doctorate of Fine Arts, San Diego State University and the California State University, CA
2002 Best Web-Based Original Art, AICA USA Best Show Awards
2002 Los Angeles Institute for the Humanities Fellow, sponsored by the University of Southern California
2000 Artist Space, New York, NY
2000 Honorary Doctorate of Fine Arts, Otis Art Institute of Parsons School of Design of the School of Social Research
1999 Spectrum-International Award for Photography of the Foundation of Lower Saxony, Germany
1999 College Art Associations Lifetime Achievement Award
1997 Governor's Award for Lifetime Achievement in the Visual Arts, California
1996 Oscar Kokoschka Prize, Austria
1988 John Simon Guggenheim Memorial Fellowship

ONE PERSON EXHIBITIONS (selected)
2004 "John Baldessari: Somewhere Between Almost Right and Not Quite (With Orange)," Deutsche Guggenheim, Berlin, Germany
2004 Marian Goodman Gallery, New York, NY
2004 "John Baldessari: Recent Maquettes & Prints," Art Affairs, Amsterdam
2003 "John Baldessari: Editionen," Einladung zur Eroffnung, Hamburg, Germany
2002 "John Baldessari: Junctions and Intersections," Margo Leavin Gallery, Los Angeles, CA
2002 "John Baldessari: The Intersection Series," Primo Piano, Rome, Italy

GROUP EXHIBITIONS (selected)
2003 "Jede Fotographie Ein Bild Seimens Fotosammlung," Pinakothek der Moderne, Sammlung Moderne Kunst, Munich, Germany (catalog)
2003 "The Last Picture Show: Artists Using Photography, 1960 – 1982," Walker Art Center in Minneapolis; traveled to UCLA Hammer Museum (catalog)
2003 "Matisse and Beyond: The Painting and Sculpture Collection," San Francisco Museum of Modern Art, San Francisco, CA
2003 "Work Ethic," Baltimore Museum of Art, Baltimore, MD
2002 "Life, Death, Love, Hate, Pleasure, Pain: Selected Works from the MCA Collection," Museum of Contemporary Art, Chicago, IL (catalog)
2002 "From Pop to Now: Selections from the Sonnabend Collection," The Tang Teaching Museum and Art Gallery, Saratoga Springs, NY (traveling exhibition) (catalog)
2002 "The 1970s: Art in Question," Capc Musee d'art Contemporain de Bordeaux, Bordeaux, France
2002 "Visions from America: Photographs From The Whitney Museum Of American Art, 1940-2001," The Whitney Museum of American Art, New York, NY (catalog)

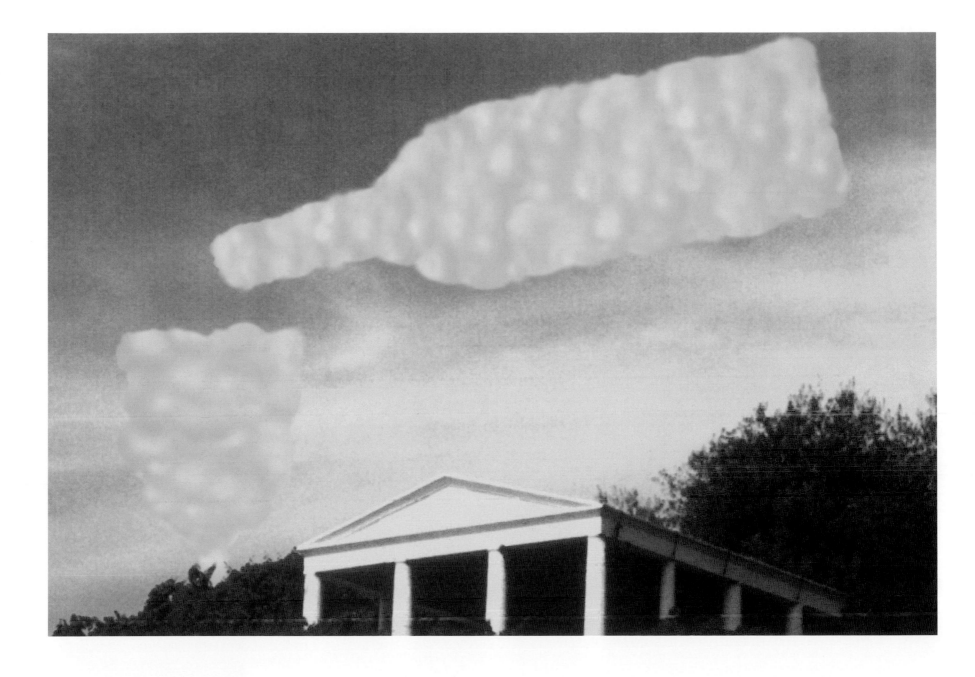

" Untitled" 2000
PHOTO AND DIGITAL MANIPULATION ON PAPER
6-3/4" x 9-7/8"

17

DREW BEATTIE & DANIEL DAVIDSON

The artistic collaboration between these two artists began when Beattie was teaching at the Art Institute of San Francisco and Davidson was a student. They found a way to work with one another while being apart, each artist contributing to the piece separately, on their own time. Their pieces incorporate both abstract and figurative elements from pop culture. In their working process, Drew Beattie and Daniel Davidson sought to develop new metaphors of self in their painted, drawn and collaged imagery. There is a wonderful whimsy to the piece they created together for the label.

—Bob Nugent

Drew Beattie
Born: 1952 Atlanta, Georgia
Lives and works in New York, New York

Daniel Davidson
Born: 1965 San Francisco, California
Lives and works in New York, New York

EDUCATION
1978	M.F.A. School of the Museum of Fine Arts, Boston, MA	1990	B.F.A. San Francisco Art Institute, San Francisco, CA
1974	B.F.A. University of North Carolina at Chapel Hill, NC		

GRANTS AND AWARDS (selected)
1994 Rome Prize in Visual Arts, American Academy in Rome
1993 The Institute for Contemporary Art, P.S. 1, National Studio Program, New York, NY
1993 Marie Walsh Sharpe Art Foundation, Studio Space Program, New York, NY

ONE PERSON EXHIBITIONS (selected)
1996 Joseph Helman Gallery, New York, NY
1996 Stephen Wirtz Gallery, San Francisco, CA
1995 Greenville County Museum of Art, Greenville, SC
1995 "White Room, White Columns," New York, NY
1994 "MATRIX/ BERKELEY 164," University Art Museum, Berkeley, CA
1994 Stephen Wirtz Gallery, San Francisco, CA
1993 Gallery Paule Anglim, San Francisco, CA
1993 Germans Van Eck, New York, NY

GROUP EXHIBITIONS (selected)
1996 "Views from a Golden Hill: Contemporary Artists and the American Academy in Rome," The Equitable Gallery, New York, NY
1995 "Radical Ink," Spaces, Cleveland, OH
1995 "Transformers," Palazzo dei Priori, Fermo, Italy
1995 "Update 1995," White Columns, New York, NY
1995 "Pasted Papers: Collage in the 20TH Century," Louis Stern Fine Art, West Hollywood, CA

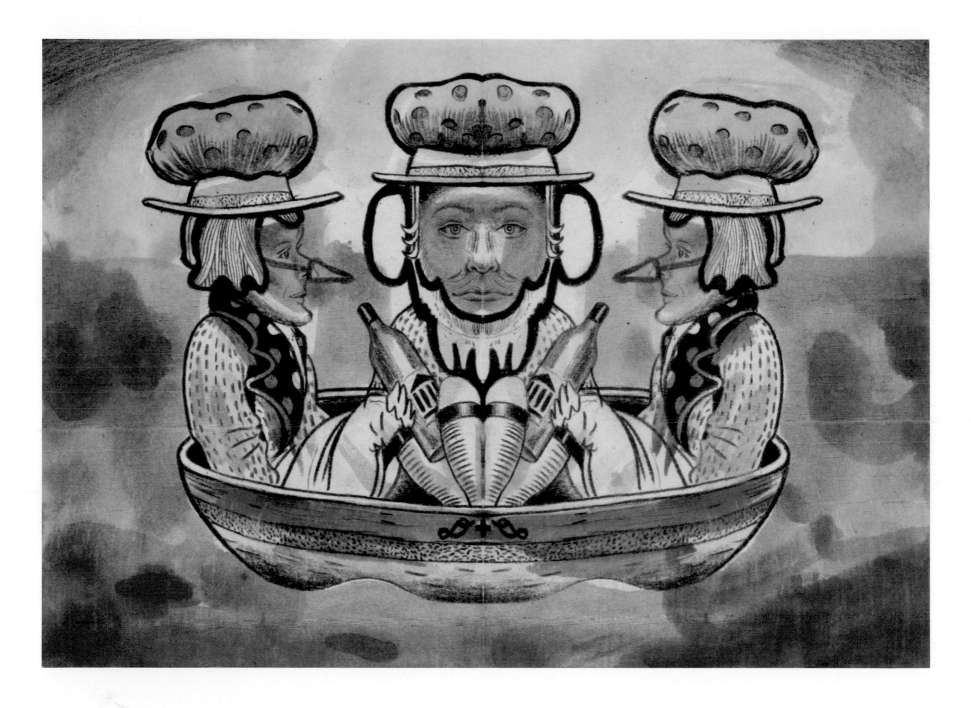

"Drawing No. 494" 1996
WATERCOLOR/PENCIL ON PAPER
11-1/2" x 16-11/16"

19

BARTON LIDICÉ BENES

Barton Benes makes art out of ordinary objects - a fingernail clipping, a few squares of toilet paper, a five-inch fragment of charred insulation, a piece of linen napkin smeared with chocolate souffle, a shard of broken glass, a half dissolved throat lozenge that's been sucked on and spat out. These things are trash, really, the debris of everyday life. The difference is that the fingernail happens to have been clipped from frank Sinatra's finger, the toilet paper was taken from a bathroom at Buckingham Palace, the charred piece of insulation had washed ashore from the wreckage of TWA Flight 800. It was Nancy Reagan who wiped a dribble of chocolate souffle from her lips onto the linen napkin, the shard of glass came from Princess Diana's fatal car crash, and Bill Clinton spat out the throat lozenge. They are trash touched by fame, and the fame transforms them into relics, and Barton Benes transforms the relics into art.

—Excerpt from John Berendt's introduction to Benes' book *Curiosa*

Born: 1942 New Jersey
Lives and works in New York, New York

EDUCATION
1960-1961 Pratt Institute

GRANTS AND AWARDS (selected)
1988 Pollock-Krasner Foundation Grant
1983 Vorhees Grant for Printmaking, Rutgers University
1982 Ariama Foundation for the Arts
1978 New York State Council of the Arts

ONE PERSON EXHIBITIONS (selected)
2003 Galerie Gisele Linder, Besel, Switzerland
2003 North Dakota Museum of Art, Grand Foriss, ND
2002 Lennon Weinberg Gallery, New York, NY
2002 Galleri Stefan Andersson, Umea, Sweden
2000 Galeria III, Lisbon, Portugal

GROUP EXHIBITIONS (selected)
2005 "Money," Museum of Civilization, Quebec, Canada
2005 "HIV/Aids in the Age of Globalization," World Culture Museum, Gothenburg, Sweden
2004 "Co-Conspirators," Orlando Museum of Art, Orlando, FL
2001 "Art at the Edge of the Law," Aldrich Museum, Ridgefield, CT
2000 "View from Here," State Tretakov Gallery, Moscow, Russia
2000 "Money Making," Federal Reserve Board Fine Arts Gallery, Washington, D.C.

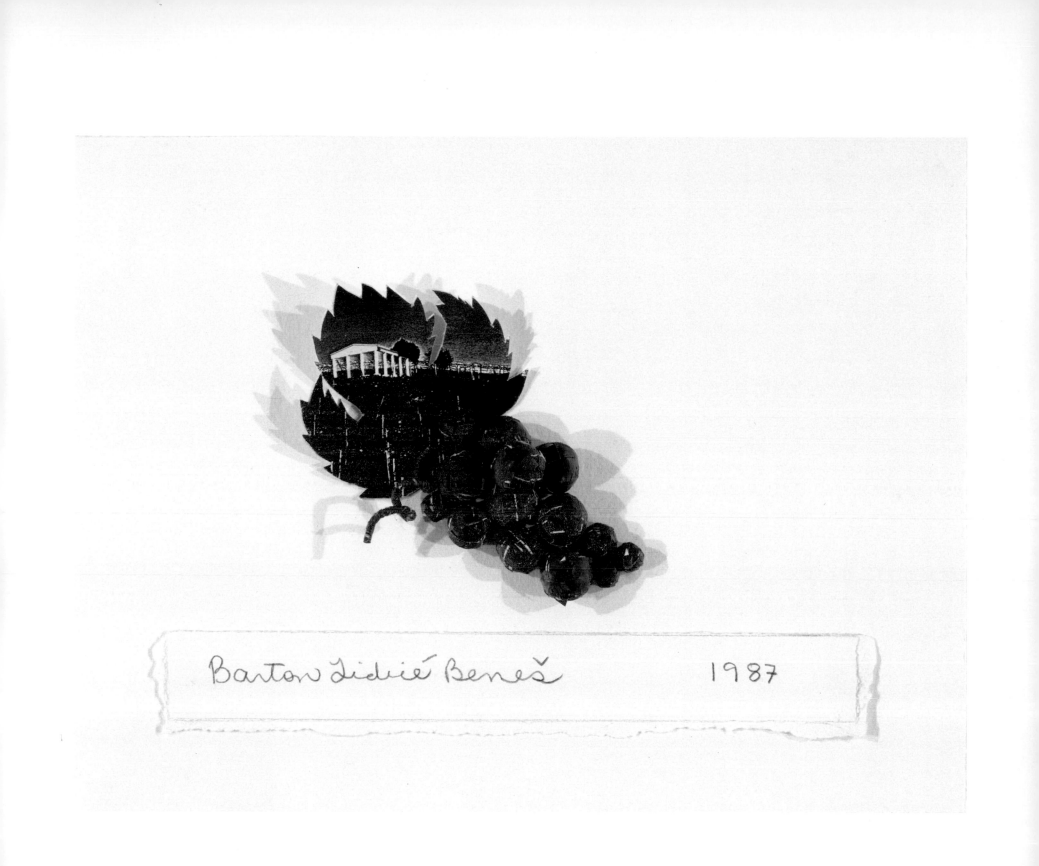

Barton Lidice Beneš 1987

"Untitled" 1987
Xerox photo collage on paper
11" x 14-1/4"

LYNDA BENGLIS

Lynda first gained critical attention during the 1970's when conceptualism was transforming the art world and the line between sculpture and painting began to blur. Using unorthodox methods and materials, she poured latex rubber and foam over armatures to create complex installations. Lynda's interest in process has led her to experiment with glass, metal, wax, pure pigment and even video. With this image Lynda continues to explore the creative process with her foray into photography. Working with the simplest of objects, the wineglass, she created this photogram of the parthenon.

—Bob Nugent

Born: 1941 Lake Charles, Louisiana
Lives and works in New York, New York and Santa Fe, New Mexico

EDUCATION
1964 B.F.A. Newcomb College, Tulane University, New Orleans, LA

GRANTS AND AWARDS (selected)
2000 Honorary Doctorate, Kansas City Art Institute
1990 National Endowment for the Arts Fellowship
1989 National Council of Art Administration
1988 Olympiad of Art Sculpture Park, Korea
1979 National Endowment for the Arts Fellowship

ONE PERSON EXHIBITIONS (selected)
2004 Cheim & Read Gallery, New York, NY
2003-2004 The Bass Museum of Art, Miami, FL
2003-2004 Toomey-Tourell Gallery, San Francisco, CA
1998 Kappatos Gallery, Athens, Greece
1997 The Contemporary Art Gallery, Ahmedabad, IN

GROUP EXHIBITIONS (selected)
2004 The Kunsthalle Wien, Austria
1999 The Museum of Contemporary Art, Queens, NY
1998 The Centro Internazionale Mostre, Rome, Italy
1997 Kunsternes Hus, Oslo, Norway
1995 The Centre George Pomidou, Paris, France

Art © Lynda Benglis/Licensed by VAGA, New York, NY

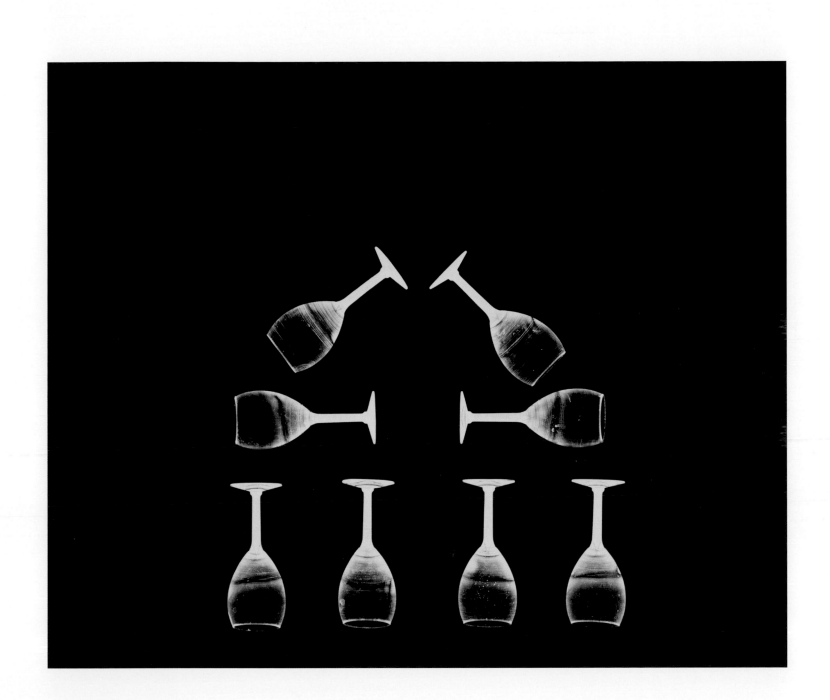

"Untitled" 2002
PHOTOGRAPH
35-1/2" x 38"

23

BILLY AL BENGSTON

Who said a picture is worth a thousand words? That suits me.

—Billy Al Bengston

Born: 1934 Dodge City, Kansas
Lives and works in Victoria, Canada

EDUCATION
1956 Otis Art Institute
1955 California College of Arts and Crafts, Oakland, CA
1952 Los Angeles City College, Los Angeles, CA

GRANTS AND AWARDS (selected)
1987 Tamarind Fellow, Tamarind Lithography Workshop
1982-1983 California Arts Council, Maestro/Apprentice Program
1982 Tamarind Fellow, Tamarind Lithography Workshop
1975 John Simon Guggenheim Memorial Fellowship
1968 Tamarind Fellow, Tamarind Lithography Workshop
1967 National Foundation for the Arts Fellowship

ONE PERSON EXHIBITIONS (selected)
2004 "100 Sweets @ $2004 Prices, Moontang Kilns, and a Little Mr. Nasty," A Cartelle Gallery,
 Marina del Rey, CA
2001 "Dentos & Draculas: 1968-1973," Renato Danese Gallery, New York, NY
1999 "Testing the Waters," Ochi Fine Art, Ketchum, ID
1999 "The Good, The Bad and Nothing Heartless," Rosamund Felsen Gallery, Santa Monica, CA
1997 "Billy Al Bengston: San Felipe to Puerto Escondido," Laguna Art Museum, Laguna Beach, CA

GROUP EXHIBITIONS (selected)
2005 "Paint on Metal: Modern and Contemporary Explorations and Discoveries," Tucson Museum of
 Art, Tucson, AZ
2004 "Standing Room Only: The Scripps 60TH Ceramic Annual," Ruth Chandler Williamson Gallery
 at Scripps College, Claremont, CA
2003 "REBELS IN CLAY: Peter Voulkos and the Otis Group," University Art Gallery, University of
 California at San Diego, La Jolla, CA
2003 "A Happening Place," The Gershman Y, Philadelphia, PA (catalog)
2002 "Ferus," Gagosian Gallery, New York, NY (catalog)
2001 "A Room of Their Own: From Rothko to Rauschenberg/From Arbus to Gober," Museum of
 Contemporary Art, Los Angeles, CA
2001 "Pop Art U.S./U.K. Connections, 1956-1966," The Menil Collection, Houston, TX
2000 "Celebrating Modern Art: The Anderson Collection," San Francisco Museum of Modern Art,
 CA (catalog)
2000 "Made in California: Art, Image, and Identity, 1900-2000; Section 5: 1980-2000," Los Angeles
 County Museum of Art, CA (catalog)

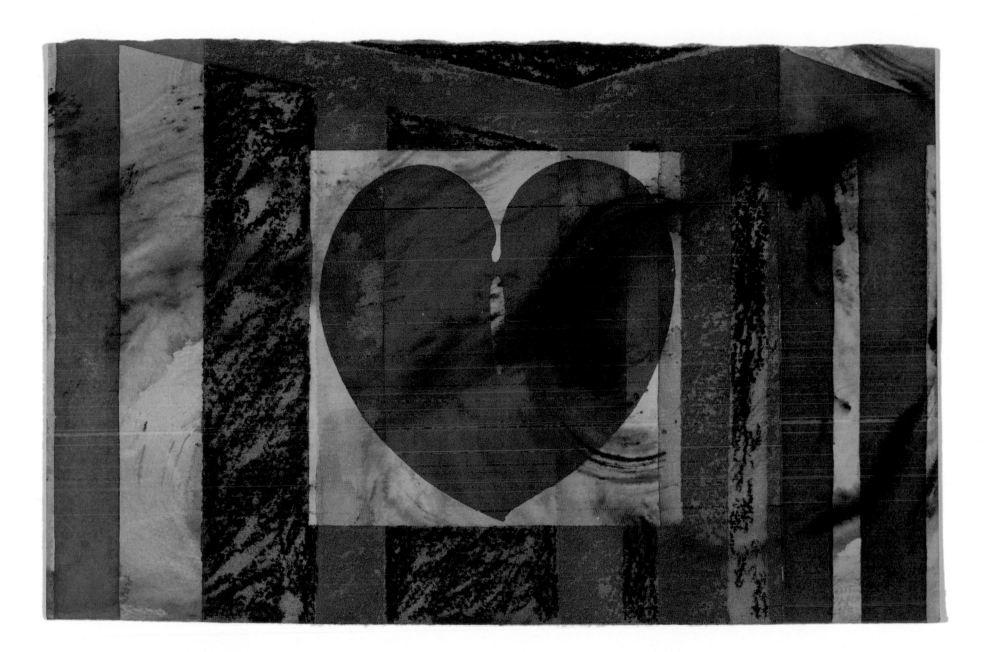

"UNTITLED" 1993
WATERCOLOR/MIXED MEDIA ON PAPER
9-3/4" x 15"

TONY BERLANT

Berlant makes collages out of small tin segments fastened down with steel brads on wooden boards. When I visited Tony, his studio was filled with piles of metal scrap: old signs, tin trays and painted sheet metal, all sorted by color into bins. He cuts shapes from these scraps and nails them onto plywood panels, giving new life to old materials, while maintaining a hint of their origins. More recently Tony has augmented his palette with tin printed especially for his use. The Imagery label here is one such example.

—Bob Nugent

Born: 1941 New York, New York
Lives and works in Santa Monica, California

EDUCATION
1964 M.F.A. University of California at Los Angeles, CA
1963 M.A. University of California at Los Angeles, CA
1962 B.A. University of California at Los Angeles, Summa Cum Laude, CA

ONE PERSON EXHIBITIONS (selected)
2004 "Tony Berlant: New Terrain," L.A. Louver Gallery, Venice, CA
2003 "Tony Berlant: Recent Works," The Contemporary Museum, Honolulu, HI
2003 "What You See Is Who You Are," Lennon Weinberg, Inc., New York, NY
2001 "New Work," Peter Blake Gallery, Laguna Beach, CA
2001 "Tony Berlant," L.A. Louver Gallery, Venice, CA
2001 "New Work," John Natsoulas Gallery, Davis, CA

GROUP EXHIBITIONS (selected)
1998 "Painting Language," L.A. Louver, Venice, CA
1998 "Winter Show," Stroke Gallery, Osaka, Japan
1998 "LA Current: Looking at the Light, 3 Generations of LA Artists," Armand Hammer Museum of Art and Cultural Center, Los Angeles, CA
1997 "Sunshine and Noir: Art in LA, 1960-1997," Louisiana Museum of Modern Art, LA (traveling exhibition)
1997 "Hello Again! A New Wave of Recycled Art and Design," Oakland Museum of California, Oakland, CA
1997 "Art Patterns," Austin Museum of Art, Laguna Gloria, Austin, TX
1997 "Trashformations: Recycled Materials in Contemporary American Art and Design," Whatcom Museum of History and Art, Bellingham, WA (traveling exhibition)
1994 "Worlds in a Box," Whitechapel Art Gallery, London, Great Britain (traveling exhibition)

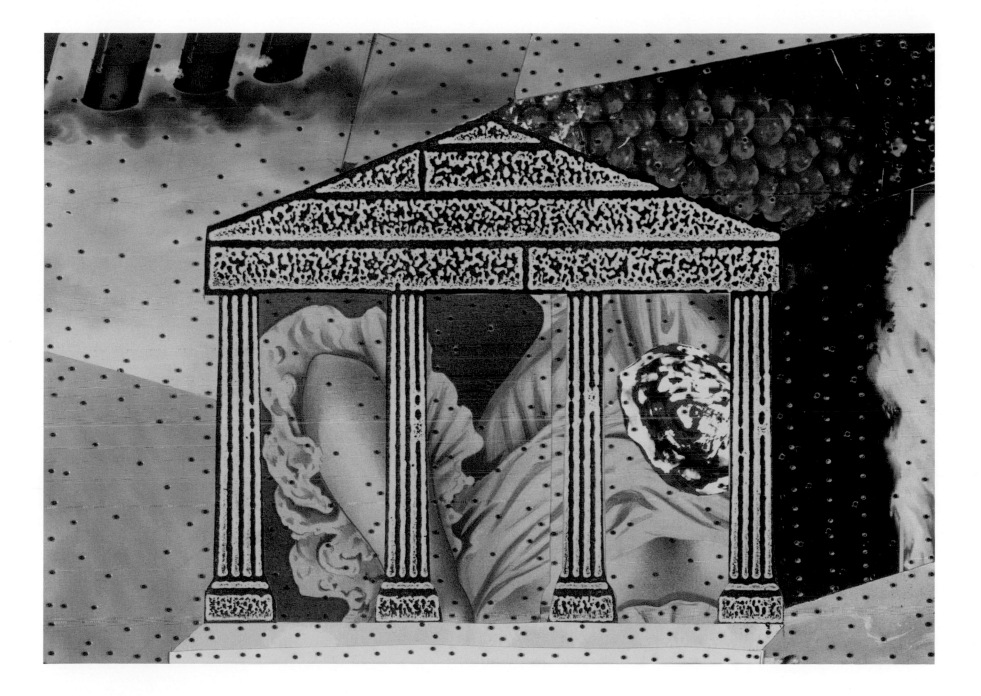

"Untitled Romance" 1991
found tin/collage/brads over plywood
9-5/8" x 14"

27

PEGAN BROOKE

The paintings emanate a rapturous, transfixing light, earning Brooke a position in the pantheon of American Luminists from George Inness to her Bay Area peer, Christopher Brown. She paints deep molten oranges and searing golden whites—sometimes meditatively, in smooth, glassy layers; sometimes aggressively dripping and scraping the paint into a thick, sensual crust.

—Leah Ollman, *Art in America*

Born: 1950 Orange, California
Lives and works in Bolinas, California

EDUCATION
1980 M.F.A. in Painting, Stanford University, Stanford, CA
1977 M.A. in Painting, University of Iowa, Iowa City, IA
1974 B.F.A. in Painting, Drake University, Des Moines, IA
1972 B.A. in Literature, University of California at San Diego, La Jolla, CA

GRANTS AND AWARDS (selected)
2005 Artist Residency, Pont Aven School of Contemporary Art, Pont Aven, France
2003 Artist Residency, Millay Colony for the Arts, Austerlitz, NY
1998 Marin Arts Council Individual Artist Grant, Marin, CA
1992 Marin Arts Council Individual Artist Grant, Marin, CA
1983 Louis B. Comfort Tiffany Foundation Grant (Painting)

ONE PERSON EXHIBITIONS (selected)
2005 Friesen Gallery, Seattle, WA
2005 R.B. Stevenson Gallery, La Jolla, CA
2004 Anne Loucks Gallery, Glencoe, IL
2003 455 Market St. Gallery, San Francisco, CA
2002 R. B. Stevenson Gallery, San Diego, CA
2002 Friesen Gallery, Sun Valley, ID

GROUP EXHIBITIONS (selected)
2005 "Distillations," Institut Franco-Americain, Rennes, France
2004 "The Big Spin," San Francisco Art Institute, San Francisco, CA
2004 "Modern Treasures," Contemporary Fine Arts, San Anselmo, CA
2003 "Is, Was, Will Be," Espace Melanie, Riec-sur-Belon, France (traveling exhibition)
2003 "Pulp Fiction," French Library and Cultural Center/Alliance Francaise, Boston, MA
2002 "Underfoot," Associacão Alumni, São Paulo, Brazil (traveling exhibition) (catalog)
2000 "Art Alive 2000," San Diego Museum of Art, San Diego, CA
1999 "Towards the Millennium, Northern CA Painting," Monterey Museum of Art, Monterey, CA

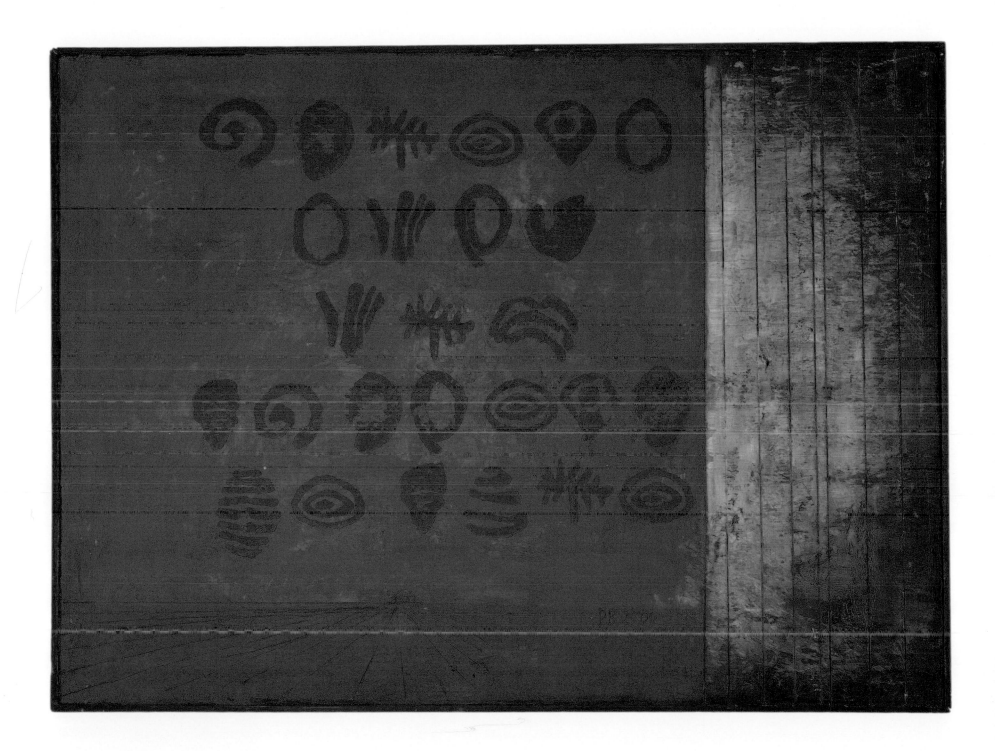

"Honest Talk and Wholesome Wine" 2000-2001
oil on panel
22-1/2" x 30-1/2"

CHRISTOPHER BROWN

Because the parameters for the Imagery Series of wine labels required the artists to work with some aspect of the parthenon, the winery's symbol, it occurred to me to make an image based on something I had remembered seeing the previous year in the Roman forum. Looking up, I had noticed the top of a weathered column, its scarified Ionic capital silhouetted against the blue and clouded sky next to an arcing, windblown Italian Cypress. They seemed a remarkable pair, symbols of Italy, perseverance, the natural and the manmade. I took a quick photo that just as quickly got buried, typically, in a box of unsorted travel snapshots in the back of my studio. But when the project came up I remembered the image, dug up the photo, and used it for the basis for my Benziger label.

—Christopher Brown

Born: 1951 Camp Lejeune, North Carolina
Lives and works in Berkeley, California

EDUCATION
1976 M.F.A. University of California at Davis, CA
1973 B.F.A. University of Illinois, Champaign-Urbana, IL

GRANTS AND AWARDS (selected)
1988 American Academy and Institute of Arts and Letters Award in Art
1987 National Endowment for the Arts Fellowship
1986 Award in the Visual Arts given by the Equitable and Rockefeller Foundations with partial
 support from the National Endowment for the Arts
1985 Eureka Fellowship, The Mortimer Fleischacker Foundation, San Francisco, CA
1984 Regents Junior Faculty Fellowship, University of California at Berkeley, CA
1981 National Endowment for the Arts Special Projects Grant in Art Criticism
1979 National Endowment for the Arts Special Projects Grant in Art Criticism
1978-1979 DAAD Grant: Guest Artist Affiliation with the Academy of Art In Munich

ONE PERSON EXHIBITIONS (selected)
2005 Center for Contemporary Art, Sacramento, CA
2004 Paulson Press, Berkeley, CA
2004 Andria Friesen Gallery, Sun Valley, ID
2004 John Berggruen Gallery, San Francisco, CA
2001 Byron Cohen Gallery, Kansas City, MO

GROUP EXHIBITIONS (selected)
2005 "Artists and Mentors," Sonoma Valley Museum, CA
2005 John Berggruen Gallery, San Francisco, CA
2004 Byron Cohen Gallery, Kansas City MO
2003 John Berggruen Gallery, San Francisco, CA
2002 Andria Friesen Gallery, Sun Valley, ID
2002 Edward Thorp Gallery, New York, NY
2002 "Underfoot," Associacão Alumni, São Paulo, Brazil (traveling exhibition) (catalog)

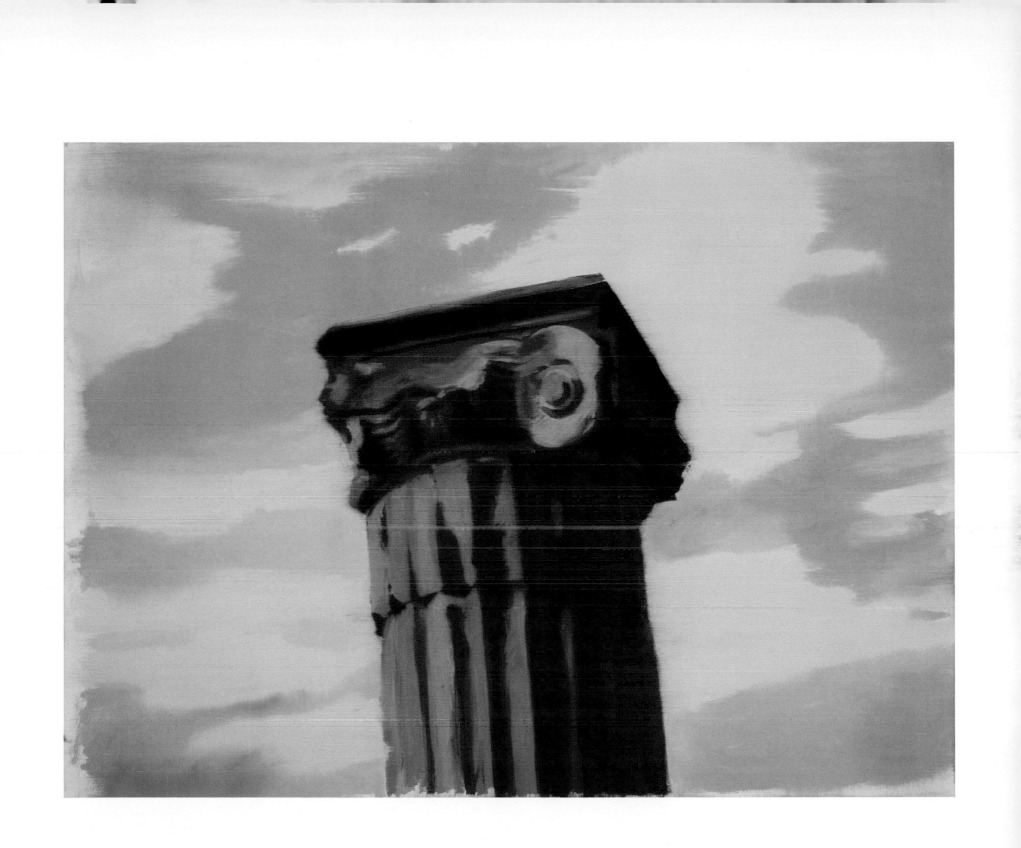

"Untitled" 1996
OIL ON CANVAS
21-1/4" x 29-1/2"

31

JAMES BROWN

The work I do in Mexico has always been considered a single group. *Internal Order* is how I entitle and describe this work. These paintings and works on paper are a response to a demand coming from within myself. They are not a response to a demand outside of my physical being. The work of *Internal Order* is a thoughtful and intuitive process. The palette is limited and strict. These paintings and paper works fulfill the obligations of looking deeply. They fulfill the desire to accept without question. They fulfill a longing to go beyond all that I consider correct and acceptable.

—James Brown

Born: 1951 Los Angeles, California
Lives and works in Merida, Mexico, and Paris, France

EDUCATION
1974-1976 Ecole des Beaux Arts, Paris, France
1974 B.F.A. Immaculate Heart College, Hollywood, CA

GRANTS AND AWARDS (selected)
1984 American Academy and Institute of Arts and Letters, New York, NY

ONE PERSON EXHIBITIONS (selected)
2004 "James Brown: Residencia Oaxaca," Museo de Arte Contemporánea, Oaxaca, Mexico
2004 "James Brown: Elysium," Anthony Grant Fine Art, New York, NY
2003 "James Brown: Plomo," Centro de Arte Contemporaneo de Malaga, Spain
2003 "James Brown: Opera Contro Natura," Galleria d'Arte Moderna y Contemporanea della Republica di San Marino
2001 "James Brown, New Graphic Work," Pace Editions, Pace Gallery, New York, NY

GROUP EXHIBITIONS (selected)
2004 "Artists' Books: Outside of a Dog," Baltic, The Centre for Contemporary Art, Quayside, Gateshead, England
2001 "Tramas y Ensamblajes, Contemporary Artists: Contemporary Weaving," Museum of Contemporary Art, Oaxaca, Mexico
2000 "Los Artistas en la Ceramica," Ceramica de Muel, Zaragoza, Spain
1991 "Books as Art," Boca Raton Museum of Art, Boca Raton, FL
1985 "States of War," Seattle Art Museum, Seattle, WA
1984 "New Narrative Painting," Selections from the Metropolitan Museum of Art, New York, NY
1984 "American Neo-Expressionists," Aldrich Museum of Contemporary Art, Ridgefield, CT
1981 "Drawing Show," White Street Gallery, New York, NY

PHOTO CREDIT: FERNANDO BENGOCHEA

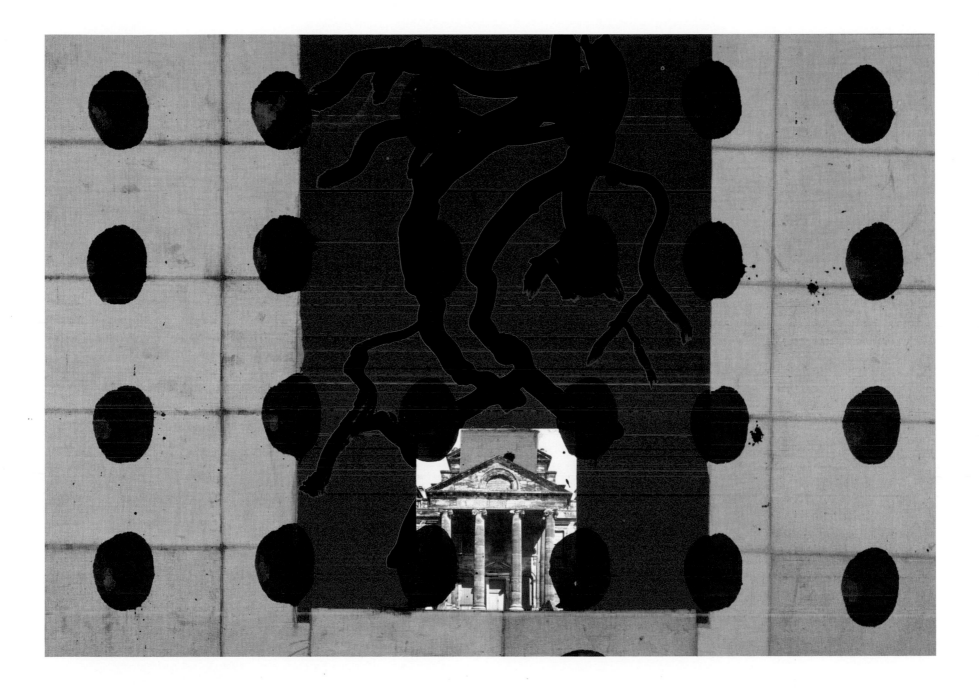

"UNTITLED" 1994
PAINT/COLLAGE ON LINEN
16-1/4" x 23-3/4"

33

BARRY BUXKAMPER

In a 1994 review in *Art Papers*, the writer and critic Susan Knowles described my work as "weirdly beautiful," a phrase I've been smitten with ever since. A phrase, in fact, that has become a kind of back seat driving force in my recent work. Not once, ever, have I thought of my work as even remotely "beautiful." Daffy, dopey, by turns mock-elegant, yes. But never beautiful. And now the notion of an image being visually attractive, downright pretty at times, is both scary and compelling. To be sure, I am still interested in juxtapositions of domestic banality and exotica, areas of intense resolution abutting raw surface and dissolution, but now with some good-looking light and less impertinent subject matter. Now I can actually, for the first time, do a landscape, replete with hummingbirds, bunnies and deer—the most precious of images. Of course, I have to think of the landscape as still life, artificial, theatrical and stagey, and the hummingbirds as stand-ins for our need to view all of nature as exotic, other-worldly, and altogether unfettered: nature as escapist entertainment.

—Barry Buxkamper

Born: 1946 Peoria, Illinois
Lives and works in Nashville, Tennessee

EDUCATION
1972 M.F.A. University of Illinois, IL
1968 B.F.A. University of Texas, TX

ONE PERSON EXHIBITIONS (selected)
2002 Cumberland Gallery, Nashville, TN
1998 Cumberland Gallery, Nashville, TN
1998 Coleman Gallery, Albuquerque, NM
1993 Cumberland Gallery, Nashville, TN
1990 Cumberland Gallery, Nashville, TN

GROUP EXHIBITIONS (selected)
2003 "Real Illusions," Frist Center for the Visual Arts, Nashville, TN
2002 "Underfoot," Associacão Alumni, São Paulo, Brazil (traveling exhibition) (catalog)
2002 "20th Century Painting in Tennessee," Cheekwood Museum of Art, Nashville, TN
2001 "The Bridgestone Collection," Tennessee State Museum, Nashville, TN
1990 "1990 Mint Museum Biennial," Mint Museum of Art, Charlotte, NC
1975 "Whitney Biennial of Contemporary American Art," Whitney Museum of American Art, New York, NY

PHOTO CREDIT: BOB NUGENT

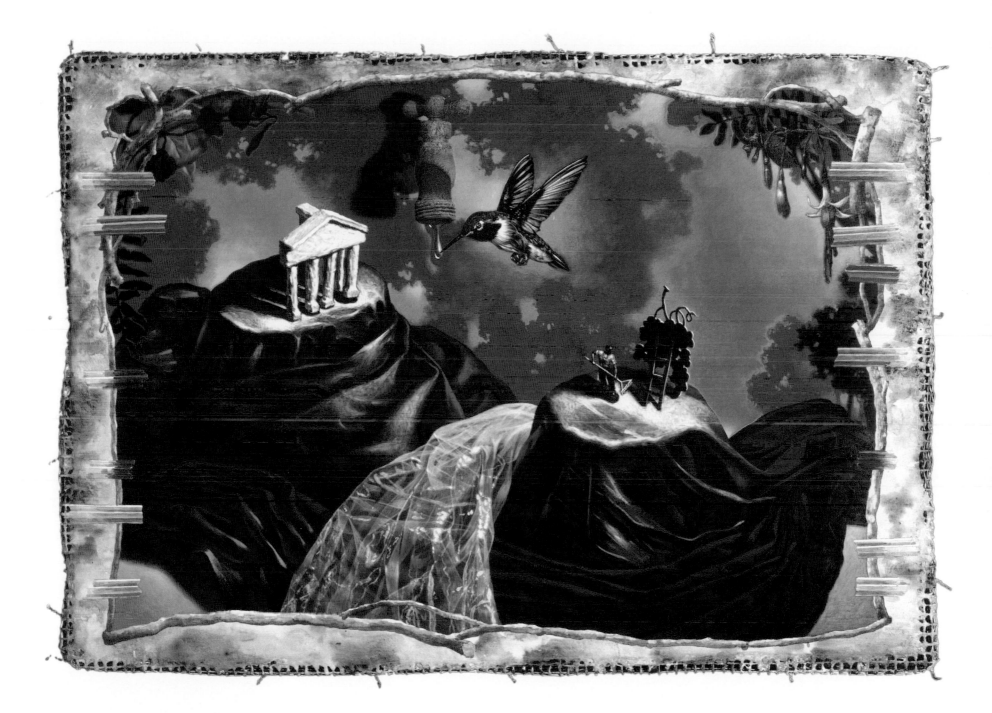

"Untitled" 1998
MIXED MEDIA ON WIRE MESH
17-1/2" x 25-1/4" x 6"

SQUEAK CARNWATH

Squeak is a painter's painter. You can tell she loves the process and she lets her brush strokes show. She layers her paintings in color and meaning using both symbols we can recognize and those that are poignant to her personally. As we stand before the work we feel as though she has opened up a journal giving insight as to the importance of everyday minutia both in her life and in ours.

—Bob Nugent

Born: 1947 in Abington, Pennsylvania
Lives and works in Oakland, California

EDUCATION
1977 M.F.A. California College of Arts and Crafts, Oakland, CA
1970-1971 California College of Arts and Crafts, Oakland, CA
1969-1970 Goddard College, Plainfield, VT

GRANTS AND AWARDS (selected)
2003 Faculty Research Award, University of California at Berkeley, Berkeley, CA
2002 Award for Visual Artists, Flintridge Foundation, Pasadena, CA
2001 Special Recognition Award, Precita Eyes Muralists Association, Inc., for the SFO Art Enrichment project, "Fly, Flight, Fugit," San Francisco, CA
1998 Modern Master, Museum of Art and the Environment, Marin, CA
1996 Alma B.C. Schapiro Residency for a Woman Painter, Yaddo, Saratoga Springs, NY
1994 John Simon Guggenheim Memorial Fellowship
1992 Djerassi Resident Artists Program, Rosenkranz Family Fellowship, Woodside, CA
1985 National Endowment for the Arts Fellowship
1980 National Endowment for the Arts Fellowship

ONE PERSON EXHIBITIONS (selected)
2004 "Squeak Carnwath," Oakland Art Gallery, Oakland, CA
2003 "Squeak Carnwath: Paper Trail," John Berggruen Gallery, San Francisco, CA
2002 "Squeak Carnwath: Still Happy," City of Oakland Craft and Cultural Arts Gallery, State Building, Oakland, CA
2002 "Squeak Carnwath: Selections From The Studio," Allene Lapides Gallery, Santa Fe, NM
2001 "Squeak Carnwath: Selected Paintings," Fayerweather Gallery, University of Virginia, Charlottesville, VA
2001 "Squeak Carnwath: Life Line," John Berggruen Gallery, San Francisco, CA

GROUP EXHIBITIONS (selected)
2005 "Magnolia Editions: Tapestries," JayJay, Sacramento, CA
2005 "Paintings," John Berggruen Gallery, San Francisco, CA
2004 "Innocence Found," DFN Gallery, New York, NY
2004 "Weaving Weft and Warp: Tapestries from Magnolia Editions," San Jose Institute of Contemporary Art, San Jose, CA
2004 "Heritage Fine Arts Collaborative – 10TH Anniversary Exhibition," Heritage Bank of Commerce, San Jose, CA
2004 "It's About Time: Celebrating 35 Years," The San Jose Museum of Art, San Jose, CA
2003 "Rotation," The Johnson Gallery, The Metropolitan Museum of Art, New York, NY
2003 "Rotations: An Alternating Exhibition of 20TH-21ST Century Work," Winston Wachter Mayer Fine Art, New York, NY
2003 "A Way With Words," John Berggruen Gallery, San Francisco, CA
2002 "From Stone and Plate: Contemporary Prints from Tamarind Institute," Conley Art Gallery, California State University, Fresno, CA

PHOTO CREDIT: M. LEE FATHERREE

WILLIAM CASS

This image was inspired by memories of a visit I made to the Benziger Winery in the spring of 2000. It represents a celebration of hard work and nurturing care in a place that is truly magical.

—Bill Cass

Born: 1954 Chicago, Illinois
Lives and works in Harvard, Illinois

EDUCATION
1982 M.F.A. The School of the Art Institute of Chicago, Chicago, IL
1977 B.F.A. University of Illinois, Champaign-Urbana, IL

GRANTS AND AWARDS (selected)
1997 Materials Grant, Department of Art Theory and Practice, Northwestern University
1988 Illinois Arts Council Fellowship
1987 National Endowment for the Arts Fellowship
1986 Arts Midwest National Endowment for the Arts Regional Visual Arts Fellowship
1985 Illinois Arts Council Fellowship
1984 Illinois Arts Council Fellowship
1981 Art Institute of Chicago, Edward L. Ryerson Traveling Fellowship

ONE PERSON EXHIBITIONS (selected)
2001 Tarble Arts Center, Eastern Illinois University, Charleston, IL
1998 Roy Boyd Gallery, Chicago, IL
1998 Peoria Art Guild, Peoria, IL
1995 Roy Boyd Gallery, Chicago, IL
1994 Augen Gallery, Portland, OR
1993 Rockford College, Rockford, IL
1986 Freeport Museum, Freeport, IL

GROUP EXHIBITIONS (selected)
2005 "Just Good Art," Hyde Park Art Center, Chicago, IL
2003 "IMPRESSIONS: Contemporary Illinois Printmakers," The Chicago Athenaeum, Schaumberg, IL
2002 "Transcultural Visions: Polish American Contemporary Art," Princess of Pomerania Castle,
 Szchechen, Poland
2002 "Underfoot," Associacão Alumni, São Paulo, Brazil (traveling exhibition) (catalog)
2001 "Transcultural Visions: Polish American Contemporary Art," Hyde Park Art Center, Chicago, IL
1999 "Art Against Aids," Drake Hotel, Chicago, IL
1998 "The Art of Painting-Chicago," Trinity Christian College, Palos Heights, IL
1997 "Progeny," Carlson Tower Gallery, North Park University, Chicago, IL

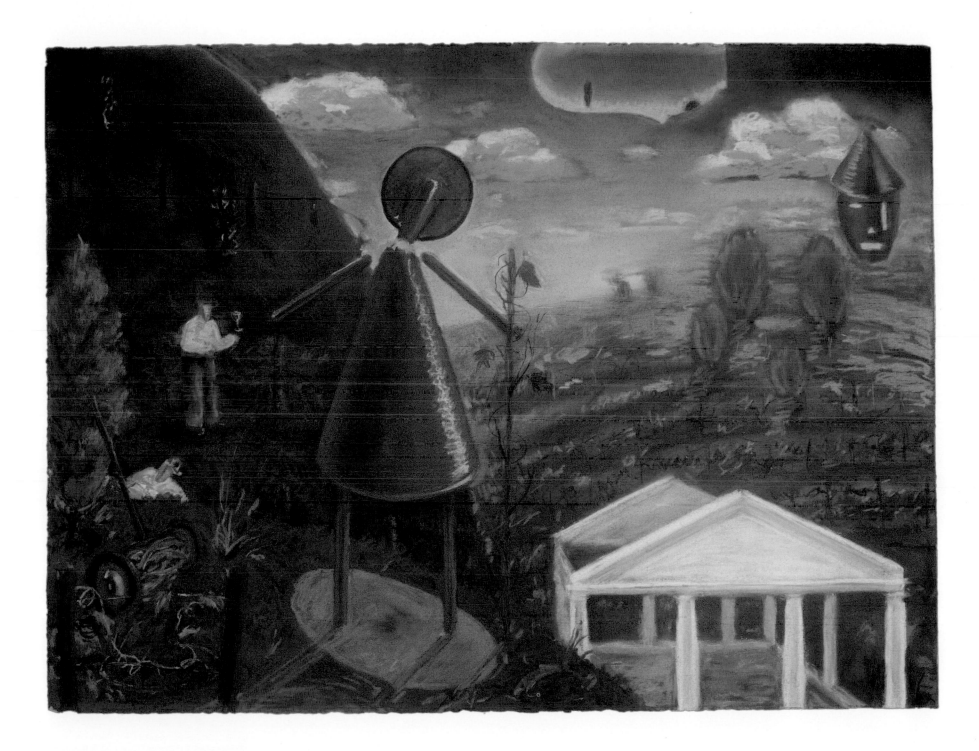

"UNTITLED" 1997
PASTEL ON PAPER
22-1/2" x 30"

ENRIQUE CHAGOYA

Enrique is a painter and printmaker who creates works primarily on paper. He combines images from diverse sources and skillfully shapes them into works of art with powerful and poignant meanings, often poking fun at contemporary icons and society.

—Bob Nugent

Born: 1953 Mexico City, Mexico
Lives and works in San Francisco, California

EDUCATION
1987 M.F.A. University of California at Berkeley, CA
1986 M.A. University of California at Berkeley, CA
1984 B.F.A. in Printmaking, San Francisco Art Institute, San Francisco, CA
1972-1975 Political Economy, Universidad Nacional Autonoma de Mexico

GRANTS AND AWARDS (selected)
1997 Biennial Award, The Louis B. Comfort Tiffany Foundation Grant, New York, NY
1997 Academy Award in Visual Arts, American Academy of Arts and Letters, New York, NY
1996 Eureka Fellowship, Fleischacker Foundation, San Francisco, CA
1995 Artist Fellowship and Residency at Giverny, France, Lilla Wallace Foundation/ Foundation
 Monet
1993 National Endowment for the Arts Fellowship
1992 WESTAF/ NEA Fellowship, for works on paper

ONE PERSON EXHIBITIONS (selected)
2004 "St. George the Dragon," George Adams Gallery, New York, NY
2004 "Reverse Anthropology Archive," De Saisset Museum, Santa Clara University, Santa Clara, CA
2003 "Friendly Cannibals," Lisa Sette Gallery, Scottsdale, AZ
2002 "Recent Works," Paule Anglim Gallery, San Francisco, CA
2001 "Utopian Cannibal: Adventures in Reverse Anthropology," Forum for Contemporary Art, survey
 Saint Louis, MO (catalog)
2001 "Utopian Cannibal: New Adventures in Reverse Anthropology," Lisa Sette Gallery, Scottsdale, AZ
2001 "Beyond Borders," Nevada Museum of Art, retrospective, Reno, NV (catalog)

GROUP EXHIBITIONS (selected)
2001 "Contemporary Devotion," San Jose Museum of Art, San Jose, CA
2001 "We Are Family: Celebrating Diversity, Embracing Similarities," Jewish Community Center Palo
 Alto, CA
2000 "Modern Contemporary," Museum of Modern Art, New York City, NY (catalog)
2000 "Contemporary Narratives in American Prints," Whitney Museum of American Art at
 Champion, Stamford, CT
2000 "Made in California," Los Angeles County Museum, Los Angeles, CA (catalog)
1998 "Selections 1998," The Drawing Center, New York, NY
1998 "Mickey Mouse, an American Icon," The Alternative Museum, New York, NY
1997 "Awards Exhibition," American Academy of Arts And Letters, New York, NY

"Untitled" 2003
CHARCOAL/PASTEL/PENCIL ON PAPER
20-1/8" x 39-1/4"

41

JEFFERY COTE DE LUNA

Based solely on direct observation, my paintings are a visual record of my search for a meaningful equivalent to the model. Direct and unrefined, their forms often retain the pentimenti of my procedure, which involves persistent measuring and reworking over numerous sittings. The content of my work lies in the process of its own creation.

—Jeffery Cote de Luna

Born: 1955 Chicago, Illinois
Lives and works in Chicago, Illinois

EDUCATION
1982 M.F.A. in Painting, Yale University School of Art, New Haven, CT
1980 B.F.A. in Painting, The School of the Art Institute of Chicago, Chicago, IL

GRANTS AND AWARDS (selected)
2004 Faculty Support Grant, Dominican University, River Forest, IL
2003 Summer Research Grant, Dominican University, River Forest, IL
1999 Purchase Award College of Notre Dame of Maryland, Baltimore, MD
1999 Prize Award, Stephan F. Austin State University, Nacogdoches, TX
1990 Visual Arts Residency, Ragdale Foundation, Lake Forest, IL

ONE PERSON EXHIBITIONS (selected)
2004 "I Paessagi Della Sabina," Galleria d'Arte 107, Casperia, Italy
2003 "Paintings and Drawings, 1997-2002," Washington and Lee University, Lexington, VA
2000 "Shaped Panel Paintings," College of DuPage, Glen Ellyn, IL
2000 "Portrait Heads," Xavier University of Louisiana, New Orleans, LA
1999 "Portrait Heads," the Weiss Center for the Arts, Dickinson College

GROUP EXHIBITIONS (selected)
2002 Bowery Gallery, New York, NY
2002 Louisiana State University, Baton Rouge, LA
2001 "Face to Face: Contemporary Portraits," California State University, Chico, CA
2000 "Aim for Arts," Federation of Canadian Artists, Vancouver, B.C. (catalog)
2000 "The Figurative Image," Gettysburg College, Gettysburg, PA
1999 "Contemporary Painting 1999," Erector Square Gallery, New Haven, CT
1999 "Group Drawing Show," The College of William and Mary, Williamsburg, VA
1998 "Heads: Jeffery Cote de Luna & Suzanna Coffey," Halsey Gallery, College of Charleston, NC
1996 "The Seven Deadly Sins," The Oak Park Art League, Oak Park, IL

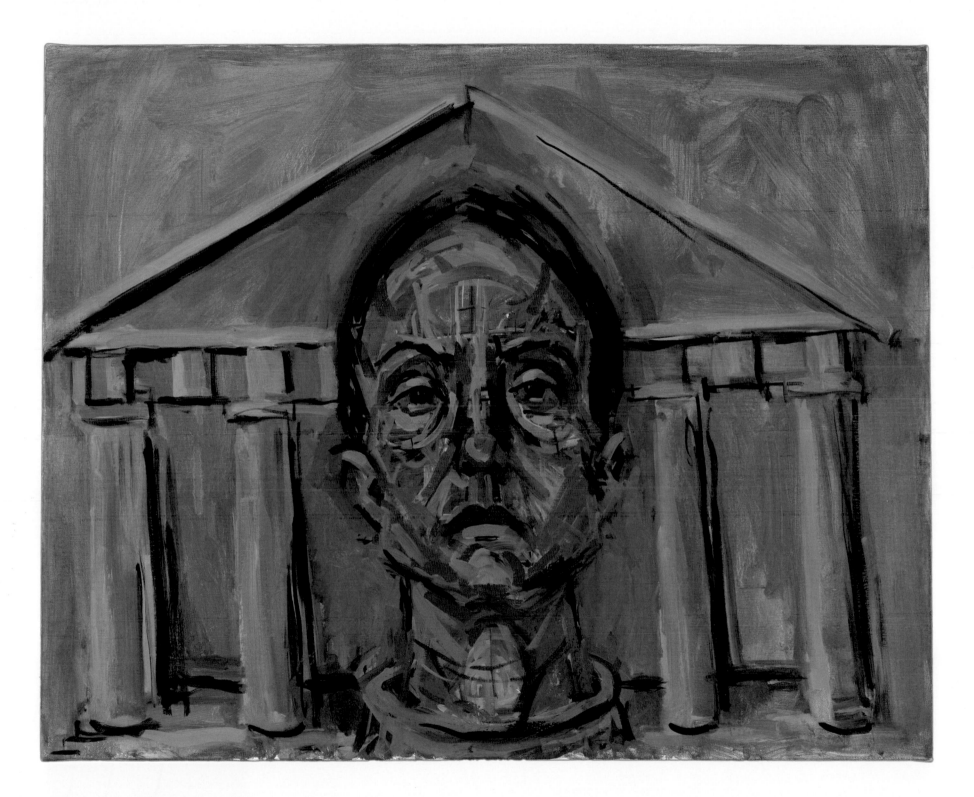

"Portrait Head: Agueda" 2003
oil on canvas
16" x 20"

43

FORD CRULL

Crull explores the expressive power of personal and cultural symbols in a series of densely painted and vividly colored compositions. Crull uses identifiable images such as hearts, wings, crosses, and the human figure, as well as geometrical emblems and abstract forms whose meanings are less explicit. Words, in the form of cryptic, fleeting phrases, also animate Crull's pictorial world. Crull employs a myriad of symbols which variously imply a sexual unfolding, romantic suffering, occult wisdom, and transcendental release. These symbols coexist in a psychic atmosphere in which they overlap, dissolve, and reappear with a kind of furious insistence. There is a strong element of the diaristic in Crull's work, with each painting serving as a kind of painterly journal of reflections and reveries, set loose from their origins in specific events. In a wider sense, these paintings constitute a kind of intensive search to wrest meaning from an anarchy of feeling. As meditations on emotional chaos, they enter into a world of competing impulses and simultaneous transmissions, seeking a resolution that is both cathartic and mysterious.

—Carter Ratcliff

Born: 1952 Boston, Massachusetts
Lives and works in New York, New York

EDUCATION
1981 American Film Institute, Los Angeles, CA
1976 B.F.A. University of Washington, Seattle, WA

ONE PERSON EXHIBITIONS (selected)
2004 Ulster County College, Visiting Artist, Stone Ridge, NY
2004 FosterArt, London, England
2004 Goya-Girl, Baltimore, MD
2004 Cheryl Pelavin, New York, NY
2002 Arte 92, Milan, Italy
2001 Howard Scott Gallery, New York, NY
2000 "Ford Crull, Art Now," Montgomery Museum of Fine Arts, Montgomery, AL

GROUP EXHIBITIONS (selected)
2001 "Confrontations," Zimmerli Art Museum, Rutgers University, NJ
2000 "4 x 4, Four Decades of School of Art Alumni Exhibit," University of Washington, Seattle, WA
1999 "Waxing Poetic: Encaustic Art in America," Montclair Art Museum
1999 Knoxville Museum of Art, Knoxville, TN
1998 Ralls Collection, Washington, D.C.
1998 Andria Friesen Gallery, Seattle, WA
1997 "OVEREENKOMST," Galerie Liga Nieuw Beelden, Leiden, Holland
1993 "The Return of the Cadavre Exquis," The Drawing Center, New York, NY
1993 "Xenographia – Nomadic Wall," Venice Biennale, Venice, Italy

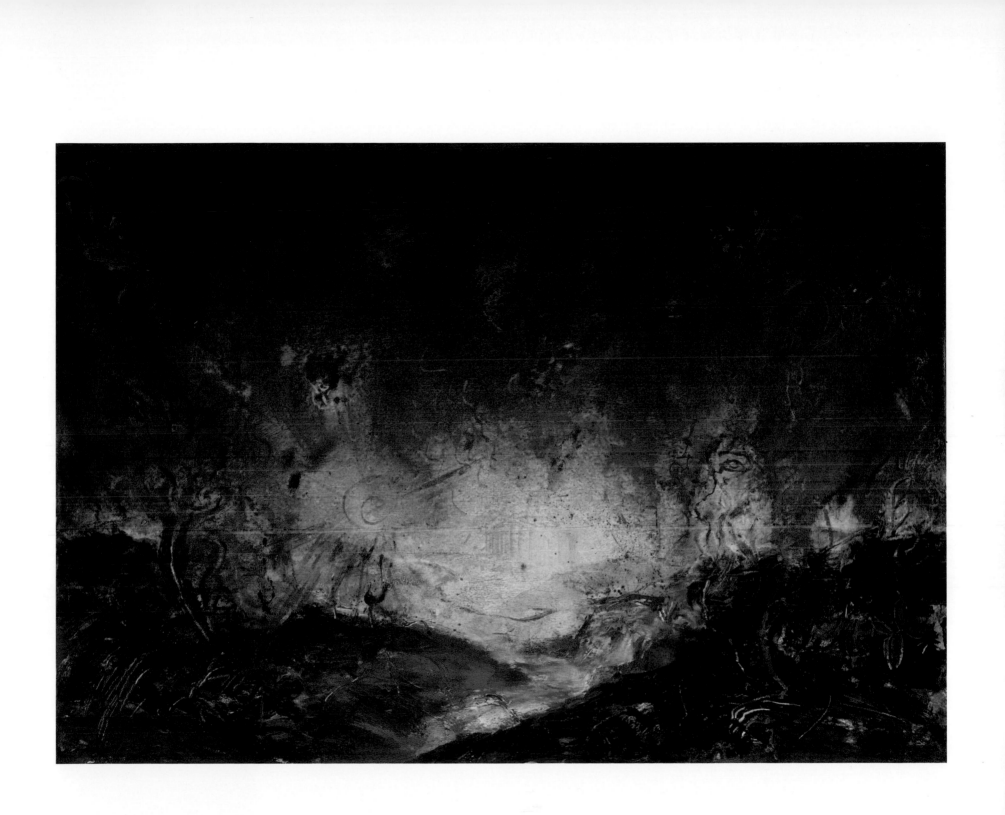

"Benziger Mountain" 2001
OIL ON WOOD WITH STEEL FRAME
16"x 22-1/4" x 2-1/2"

45

ROY DE FOREST

Roy De Forest is a very serious artist, but his seriousness has been disguised by the humor and strangeness of his images. He takes liberties with the characters in his work, bending and elongating their forms. He has a direct approach to the application of paint, often squeezing it directly from the tube. He draws, paints and sculpts images from his own personal fantasies, telling wonderful stories. He creates magic.
—Bob Nugent

Born: 1930 North Platte, Nebraska
Lives and works in Port Costa, California

EDUCATION
1958 M.A. San Francisco State College, San Francisco, CA
1953 B.A. San Francisco State College, San Francisco, CA
1950-1952 California School of Fine Arts, San Francisco, CA

ONE PERSON EXHIBITIONS (selected)
2004 "Recent Paintings," IMAGO Galleries, Palm Desert, CA
2002 LewAllen Contemporary, Santa Fe, NM
2001 Linda Hodges Gallery, Seattle, WA
1997 "New Constructions," George Adams Gallery, New York, NY
1994 John Berggruen Gallery, San Francisco, CA
1993 "New Paintings and Drawings," Frumkin/Adams Gallery, New York, NY
1992 John Berggruen Gallery, San Francisco, CA
1991 Dorothy Goldeen Gallery, Santa Monica, CA

GROUP EXHIBITIONS (selected)
2003 "Three Masters: Roy De Forest, Jack Earl, Richard Shaw," Mobilia Gallery, Cambridge, MA
2003 "Gallery Artists Summer Show," George Adams Gallery, New York, NY
2003 "Animality, Roy De Forest and Others," Linda Hodges Gallery, Seattle, WA
2003 "Sculpture 2003," Art Foundry Gallery, Sacramento, CA
2002 "A Slow Time in Arcadia: Roy De Forest and William T. Wiley 1960-2002," George Adams Gallery, New York, NY
2001 "Robert Hudson and Roy De Forest: Recent Work," John Berggruen Gallery, San Francisco, CA
1998-2001 "Roy De Forest & Gaylen Hansen," Paris Gibson Square Museum, Great Falls, MT (traveling exhibition)
1998 "Wild Things: Artists' Views of the Animal World," John Berggruen Gallery, San Francisco, CA

"Untitled" 1990
MIXED MEDIA ON PAPER
10-1/2" x 15"

MARIANELA DE LA HOZ

My artwork follows the tendencies of the aesthetic trend called Hemofiction in which blood, consciousness, irony, time and space are its structural axes. In this trend the dominant instincts of the characters are revealed, producing an encounter with the own individual's identity, moving towards the unique being's interior.

I could describe my artwork as reality portraits converted in fantastic theatrical scenes, set of mirrors in which I look at myself and you look at yourself, perhaps by finding some relationship with grandmother and mother: an intimate and terrifying nearness.

—Marianela de la Hoz

Born: 1956 Mexico City, Mexico
Lives and works in San Diego, California

EDUCATION
1974-1978 B.F.A. Graphic Design, Metropolitan University, Mexico City, DF

GRANTS AND AWARDS (selected)
2000 Finalist at the Internacional Bienal in Miniature Art "Salle Augustine-Chénier," Ville-Marie, Québec, Canada
1999 Honor Award at the "Second Bienal in Puebla de los Angeles," Iberoamerican University, Puebla, Pue, México
1998 Finalist at the "SOHO International Art Competition," Agora Gallery, New York, NY
1998 Finalist at the Internacional Bienal in Miniature Art, "Salle Augustine-Chénier," Ville-Marie, Québec, Canada
1996 Art Quest Contest Winners Show, Agora Gallery, New York, NY
1995 Winners Show, at the International Art Competition 1995, Agora Gallery, New York, NY

ONE PERSON EXHIBITIONS (selected)
2005 "Hemofiction," Mackey Gallery, Houston, TX
2004 "Miniature Paintings," Polanco Gallery, San Francisco, CA
2003 "Una Dosis de Curare," Museum Casa Diego Rivera, Guanajuato, Gto. México
2002 "Marianela de la Hoz," Monterrey Tecnological Institute of Advanced Learning, Estado de México Campus
1998 El Tule Gallery, Seattle, WA

GROUP EXHIBITIONS (selected)
2003 "From the Realms of Glory," The Cahoon Museum of American Art, Cotuit, MA
2002 "Hasta el Último Detalle," Chopo University Museum, México City, DF
2002 "Muerte," José María Velasco Gallery, México City, DF
2000 "Aniversario 15," México Plastic Artists Association, AIAP-UNESCO, México City, DF
1999 Bancomer 5TH Art Show, México City, DF
1998 Clave Gallery, Caracas, Venezuela
1997 "Los Colores del Pensamiento de Frontera a Frontera," University Museum of Contemporary Art (MUCA), UNAM, México City, DF
1995 Polyforum Siqueiros, México City, DF

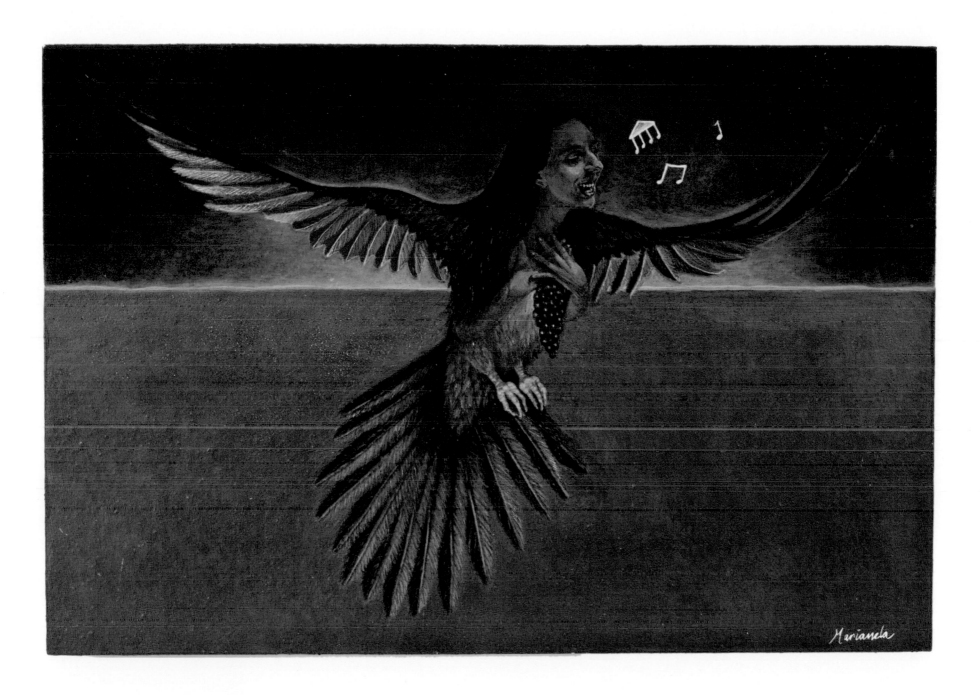

"TASTING NOTES" 2004
EGG TEMPERA ON MASONITE
3-1/8" x 4-5/8" x 1/4"

DAN DEVENING

My paintings are developed through a complex formal structure of material and process defined through concise conceptual parameters. In some recent works, I reference personal digital photographs of complicated, room-size electrical cord installations that are organized to acknowledge and define the architectural parameters of the occupied space. The photographs act as a structural matrix for works that celebrate surface, color and space through specific procedural methodologies that include the use of printmaking rollers and other non-traditional tools that activate the surface and define the image. Although the source images are static, the resulting configurations are full of gravitational energy and directed. It is my desire as a visual artist to create a painting language that incorporates literal references with an extensive formal strategy that emphasizes the substantive potential of my medium. I like to think of the resulting hybridization as a kind of elusive representational abstraction.

—Dan Devening

Born: 1958 Fort Walton Beach, Florida
Lives and works in Chicago, Illinois

EDUCATION
1983 M.F.A. University of Illinois at Chicago, IL
1980 B.F.A. University of Nebraska at Omaha, NE

GRANTS AND AWARDS (selected)
2004 Center for Interdisciplinary Research in the Arts Grant
2002 Illinois Arts Council Visual Artist Fellowship
2002 Northwestern University Faculty Research Grants
1994 National Endowment for the Arts Fellowship
1987 Art Matters, Inc. Artist Fellowship

ONE PERSON EXHIBITIONS (selected)
2003 Kunstverein Recklinghausen, Recklinghausen, Germany
2002 Sybaris Gallery, Royal Oak, MI
2001 Roy Boyd Gallery, Chicago, IL
2001 Isis Gallery, Notre Dame University, South Bend, IN
1996 Chicago Cultural Center, Chicago, IL

GROUP EXHIBITIONS (selected)
2004 "Seamless," Memphis College of Art and Design, Memphis, TN
2004 "Art Metropole," Toronto, Canada
2004 "Printed Matter, Inc.," New York, NY
2003 "En/Of," Heeresbaekerei-kultur, Berlin, Germany
2002 "Painting Today," Renate Schroeder Gallery, Cologne, Germany
2001 "Almost Giddy," Clough-Hansen Gallery, Rhodes College, Memphis, TN
2000 "Seems," Mary and Leigh Block Museum of Art, Evanston, IL
2000 "Out of Line: Drawings by Illinois Artists," Chicago Cultural Center, Chicago, IL
1999 "Tabula Non Rasa," I Space, Chicago, IL

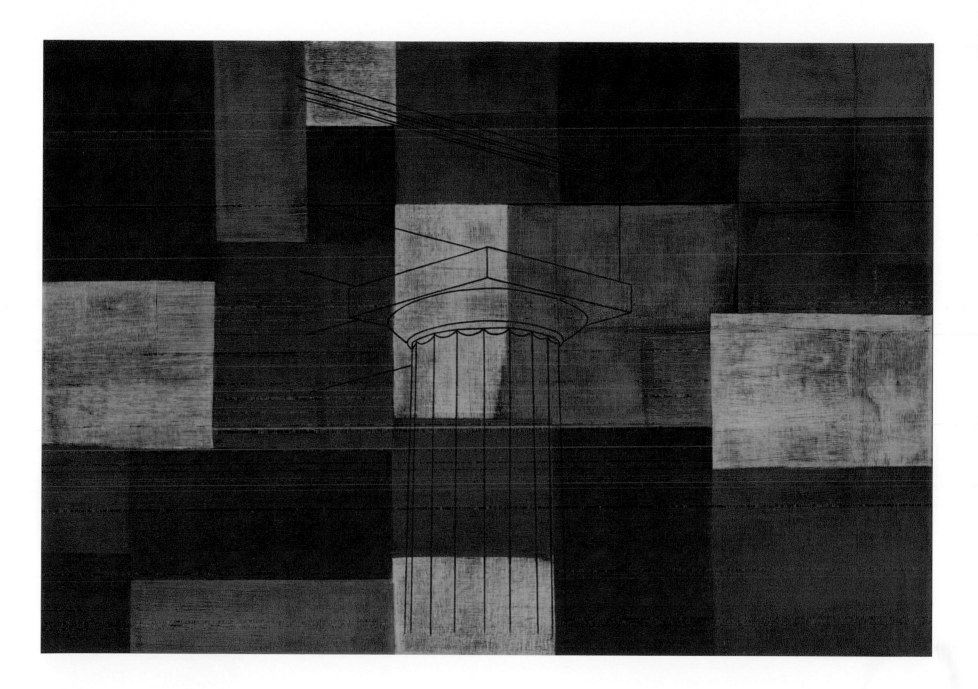

"VINTAGE '97" 1997
ACRYLIC ON CANVAS
24" x 35"

51

DOMINIC L. DI MARE

Most of my work is autobiographical, dealing with and exploring childhood experiences and memories. In the last 13 years I have been investigating the concept of self-portraits and one-of-a-kind books.

—Dominic L. Di Mare

Born: 1932 San Francisco, California
Lives and works in Tiburon, California

EDUCATION
Self Taught

GRANTS AND AWARDS (selected)
1999 Gold Medal, American Craft Council
1987 Fellow, American Craft Council
1981 National Endowment for the Arts Fellowship
1977 National Endowment for the Arts Fellowship

ONE PERSON EXHIBITIONS (selected)
2004 Palo Alto Art Center, Palo Alto, CA
1997 Museum of Contemporary Art, Honolulu, HI
1996 Museum of Art, Racine, WI
1988 Renwick Gallery, Smithsonian Institute, Washington, D.C.
1965 Museum of Contemporary Crafts, New York, NY

GROUP EXHIBITIONS (selected)
2000 Los Angeles County Museum, Los Angeles, CA
1999 Crocker Art Museum, Sacramento, CA
1999 The de Young Museum, San Francisco, CA
1997 Kunstindustrie Museum, Copenhagen, Denmark
1994 Oakland Museum, Oakland, CA
1993 Stedelijk Museum, Amsterdam, Holland
1989 The Grassi Museum, Leipzig, Germany
1978 The Vatican Museum, Rome, Italy

SELF-PORTRAIT

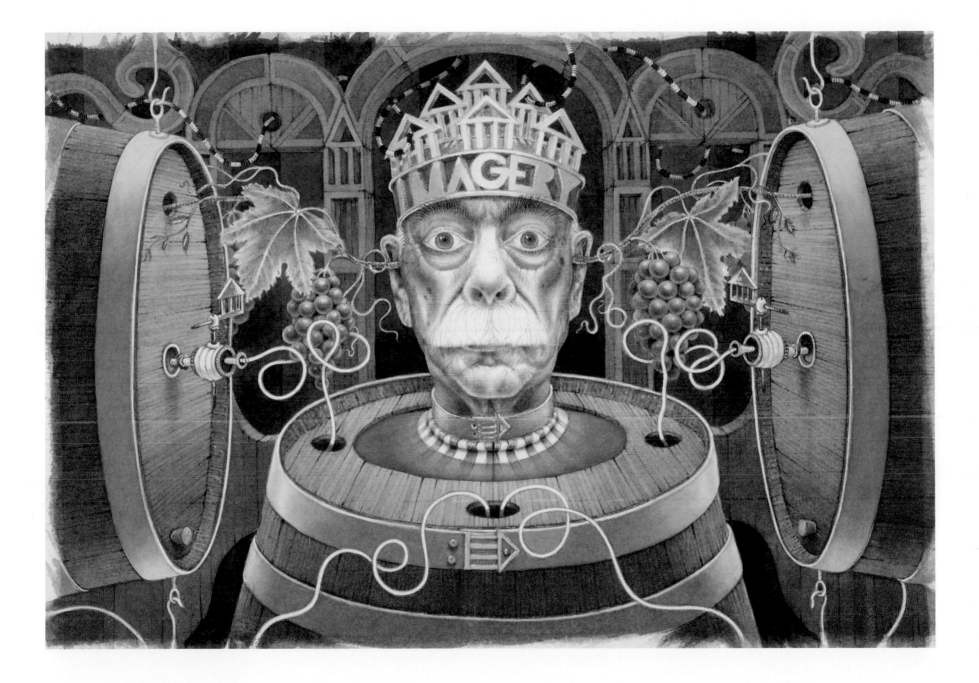

"Untitled (self-portrait)" 2003
PASTEL ON PAPER
9-1/4" x 13-3/4"

53

WANG DONGLING

A rewarding (wonderful) life should be celebrated to its fullest, and never toast to the moon with an empty golden bottle.

—Li Bai, the greatest poet of the Tang Dynasty of China

Born: 1945 Rudong, Jiangsu, China
Lives and works in Hangzhou, China

EDUCATION
1981 M.A. Zhejiang Academy of Fine Arts, Hangzhou, China
1966 Department of Fine Arts, Zhejiang Academy of Fine Arts, Hangzou, China

GRANTS AND AWARDS (selected)
1997 The '97 World Calligraphy Art Biannual Exhibition Grand Prize Award
1994 The Chinese Ten Thousand Years Calligraphy and Painting Exhibition Gold Award
1990 Endowed by the Governor of Minnesota as the "Citizen of the State of Minnesota"
1981 The National Collegiate Calligraphy Exhibition First Prize Award
1979 The National Community Calligraphy Exhibition Second Prize Award

ONE PERSON EXHIBITIONS (selected)
1998 d.p. Fong Galleries, San Jose, CA
1997 Nagoya Zie Mien Gallery, Nagoya, Japan
1994 The Chinese National Art Gallery, Beijing, China
1993 The International Press, Tokyo, Japan
1993 Minnesota State Exhibition Center, Minneapolis, MN
1993 d.p. Fong Galleries, San Jose, CA

GROUP EXHIBITIONS (selected)
1998 "Contemporary Chinese Calligraphy Exhibition," Paris, France
1998 "Contemporary Chinese Calligraphy Exhibition," Hong Kong, China
1998 "Contemporary Chinese Calligraphy Exhibition," Malmo Konsthall Gallery, Malmo, Sweden
1998 "Contemporary Chinese Calligraphy Exhibition," Columbia University, New York, NY
1998 "Chinese Five Thousand Years Civilization Exhibition," Guggenhein Museum, New York, NY
1998 "Chinese Academy of Arts Exhibition," Shanghai Museum of Arts, China
1997 "Contemporary Chinese Calligraphy Exhibition," Tokyo, Japan

LABEL DESCRIPTION
Large Character in Center: The large character in the center is the word for "wine" written in the ancient "oracle bone" style.
Signature Seal: "Nom de plume" of Wang Dongling. Seal hand-carved by artist.
Signature Seal: Hand-carved seal of the artist's formal name "Wang Dongling."
Benziger Seal: Seal of the Benziger Imagery Logo hand-carved by the artist.
Poem: A poem by Li Bai, a drunken poet. Li Bai was the greatest poet of the Tang Dynasty, if not in the entire history of China. In Chinese history and literature, his name is synonymous with poetry and wine. Li Bai wrote numerous poems celebrating the virtues of wine and moonlight. It is said that he drowned when he fell overboard while canoeing on a lake. It happened during one of his favorite past times, drinking and writing poetry in celebration of wine and moonlight.

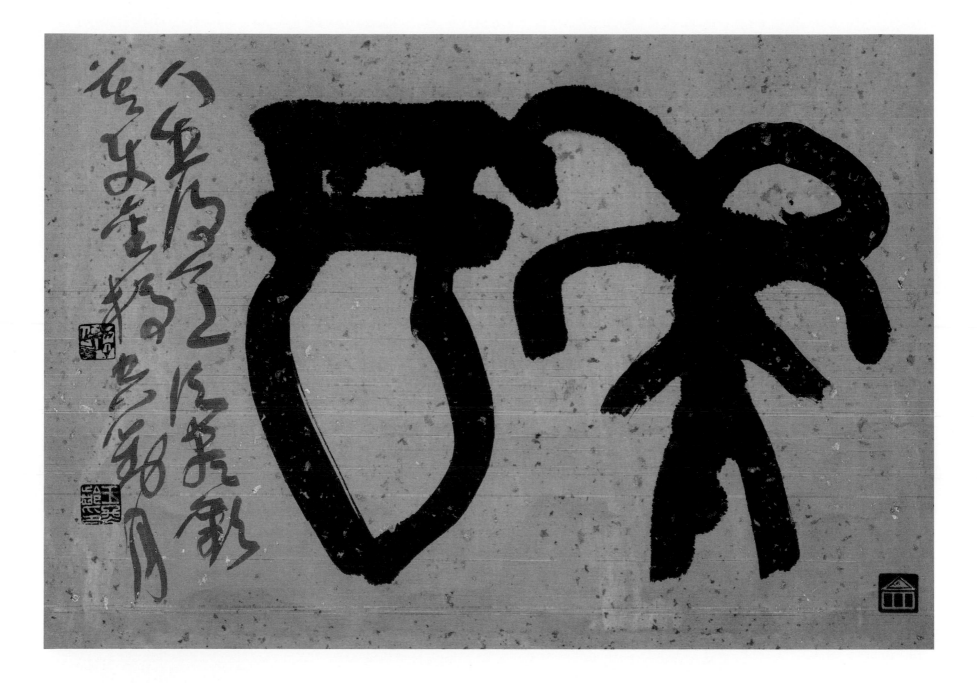

SUSAN MARIE DOPP

Beginning in 1997 I became interested in looking for ways to address experiences I was having of internal quiet and tranquility. My initial attempt was to address that experience figuratively as I had been working for more than a decade. Knowing first hand that this inner state is something completely beyond words, void of imagery and elusive by nature, I found this literal and objective approach to be thoroughly unrewarding. This led to a re-examination of my involvement with figuration and resulted in my rejection of imagery altogether. Reaching for the essential relationships in the geometry of pure form and the dynamics of basic elements going beyond the bonds of dimensional expression provided a release, which was ecstatic, rewarding, and fresh.

—Susan Marie Dopp

Born: 1951 Ft. Hood, Texas
Lives and works in Lodi, California

EDUCATION
1987 M.F.A. in Painting, San Francisco Art Institute, San Francisco, CA
1984 B.F.A. in Painting, San Francisco Art Institute, San Francisco, CA
1972-1975 Corcoran School of Art, Washington, D.C.

GRANTS AND AWARDS (selected)
2004 Yaddo Fellowship
1993 Eureka Fellowship, Fleishhacker Foundation
1988-1989 Artist in Residence, Roswell Museum & Art Center, NM
1988 Society for the Encouragement of Contemporary Art, San Francisco Museum of Modern Art, CA
1984 Robert Howe Fletcher Award, San Francisco Art Institute, CA

ONE PERSON EXHIBITIONS (selected)
2003 San Francisco Museum of Modern Art Artists' Gallery, San Francisco, CA
1999 Susan Cummins Gallery, Mill Valley, CA
1998 Susan Cummins Gallery, Mill Valley, CA
1996 Susan Cummins Gallery, Mill Valley, CA
1995 Susan Cummins Gallery, Mill Valley, CA

GROUP EXHIBITIONS (selected)
2003 "25TH Anniversary Exhibit," San Francisco Museum of Modern Art Artists' Gallery, San Francisco, CA
2003 "Unframed, First Look," Lehmann Maupin Gallery, New York, NY
2003 "Lines Between Lines," Galleria Posada, Sacramento, CA
2001 "Operating Systems," Susan Cummins Gallery, Mill Valley, CA
2001 "El Favor de Los Santos: Contemporary Devotion," San Jose Museum of Art, San Jose, CA
2000 "Piecing It Together: A Visual Journal," Museum of Art and History, Santa Cruz, CA
1999 "Piecing It Together: A Visual Journal," San Jose Museum of Art, San Jose, CA
1995 "Eighteenth Annual Holiday Group Show," Gail Severn Gallery, Ketchum, ID

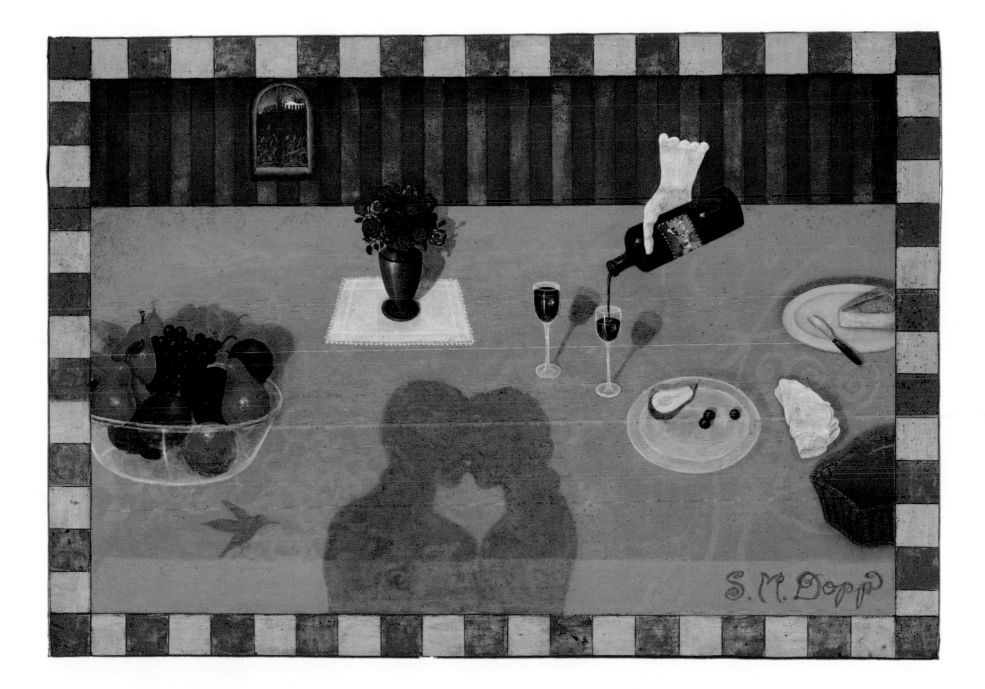

"THE BEST KIND OF LUNCH" 1996
OIL/GESSO ON BRASS/COPPER ON PANEL
15-1/8" x 21-3/8"

JOE DRAEGERT

My first bottle of wine was a bottle of Italian Swiss Colony. It wasn't long until I progressed to Mateus and Blue Nun. Then I moved to California. Thank you, Benziger Family for making great wine.

—Joe Draegert

Born: 1945 Chariton, Iowa
Lives and works in Stockton, California

EDUCATION
1970 M.A. University of California at Davis, CA
1968 B.F.A. Kansas City Art Institute, KS

GRANTS AND AWARDS (selected)
1978-1979 Rome Prize Fellowship in Painting
1968 Logan Painting Award
1967 Full Fellowship to Yale Summer School of Art and Music

ONE PERSON EXHIBITIONS (selected)
1996 Erickson & Elins Gallery, San Francisco, CA
1994 Center for Integrated Systems and School of Engineering, Stanford University, Stanford, CA
1993 Erickson & Elins Gallery, San Francisco, CA
1991 Erickson & Elins Gallery, San Francisco, CA
1990 Erickson & Elins Gallery, San Francisco, CA

GROUP EXHIBITIONS (selected)
1994 Natsoulis Gallery, Davis, CA
1992 Oakland Art Museum, Oakland, CA
1988 E.B. Crocker Museum, Sacramento, CA
1988 Gingrass Gallery, Milwaukee, WI
1988 Palo Alto Cultural Center, Palo Alto, CA
1984 Smith-Anderson Gallery, Palo Alto, CA
1984 Hearst Gallery, St. Mary's College, Moraga, CA
1982 Heller Gallery, University of California at Berkeley, CA

PHOTO CREDIT: BILL FARNAN

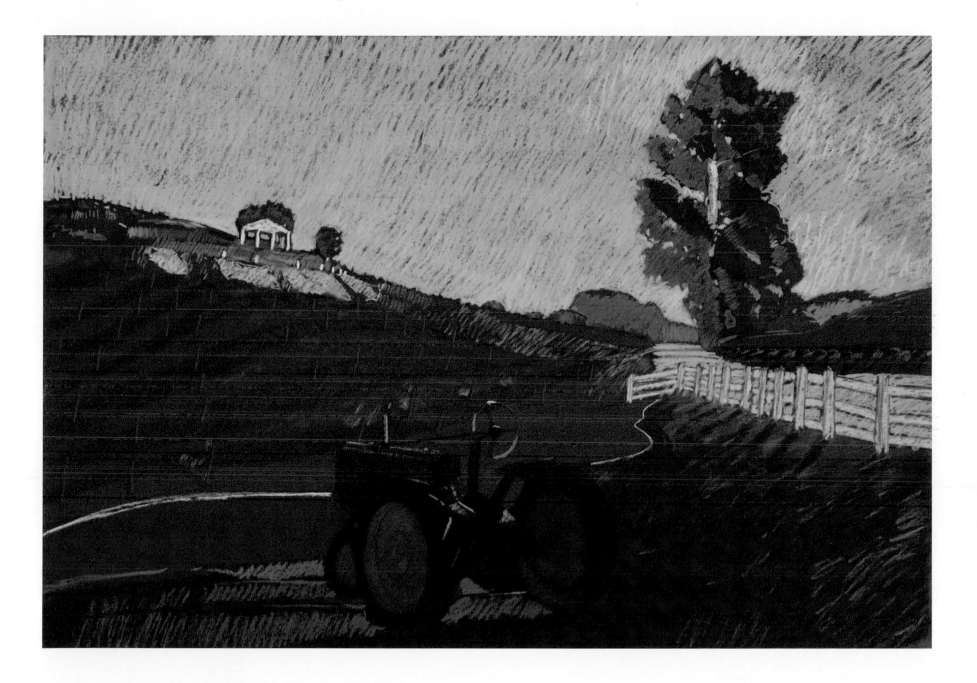

"Untitled" 1998
PASTEL ON PAPER
23-1/2" x 34"

59

MICHAEL DVORTCSAK

I use traditional means: lanscape/still life/figure as symbols in a myth whose central character is light and whose plot involves the coming into being, the sustaining and transformation of life.

—Michael Dvortcsak

Born: 1938 Buffalo, New York
Lives and works in Ojai, California

EDUCATION
1966-1968 M.F.A. University of California at Santa Barbara, CA
1961 B.A. University of California at Santa Barbara, CA

GRANTS AND AWARDS (selected)
1990 American Academy Arts and Letters
1989 Childe Hassam Purchase Award
1982 National Endowment for the Arts Fellowship
1967 Huntington Hartford Fellow

ONE PERSON EXHIBITIONS (selected)
2002 Jan Baum Gallery, Los Angeles, CA
2001 Carnegie Museum of Art, Oxnard, CA
2000 Pamela Auchincloss Gallery, New York, NY
1997 Carnegie Museum of Art, Oxnard, CA
1995 Fullerton Art Museum, Fullerton, CA
1987 Fuller/Goldeen Gallery, San Francisco, CA
1985 James Corcoran Gallery, Los Angeles, CA

GROUP EXHIBITIONS (selected)
2004 "Spiritual Vessel"
2002 "Underfoot," Associacão Alumni, São paulo, Brazil (traveling exhibition) (catalog)
2001 "2ND Invitational Exhibition," California State University Art Center, Camarillo, CA
2000 "1ST Invitational Exhibition," California State University Art Center, Camarillo, CA
2000 "Inaugural Exhibition," Peterson Hall Gallery, Scottsdale, AZ
1987 "Frederick Weisman Collection," Baltimore Museum of Art, Baltimore, MD (traveling exhibition)
1986 "Jeune California," Le Centre National Des Arts Plastiques, Paris, France
1984 "Apocalyptic Visions," Gallery Bellman, New York, NY
1982 "The Robert Rowan Collection," Art Center College, Pasadena, CA

SELF-PORTRAIT

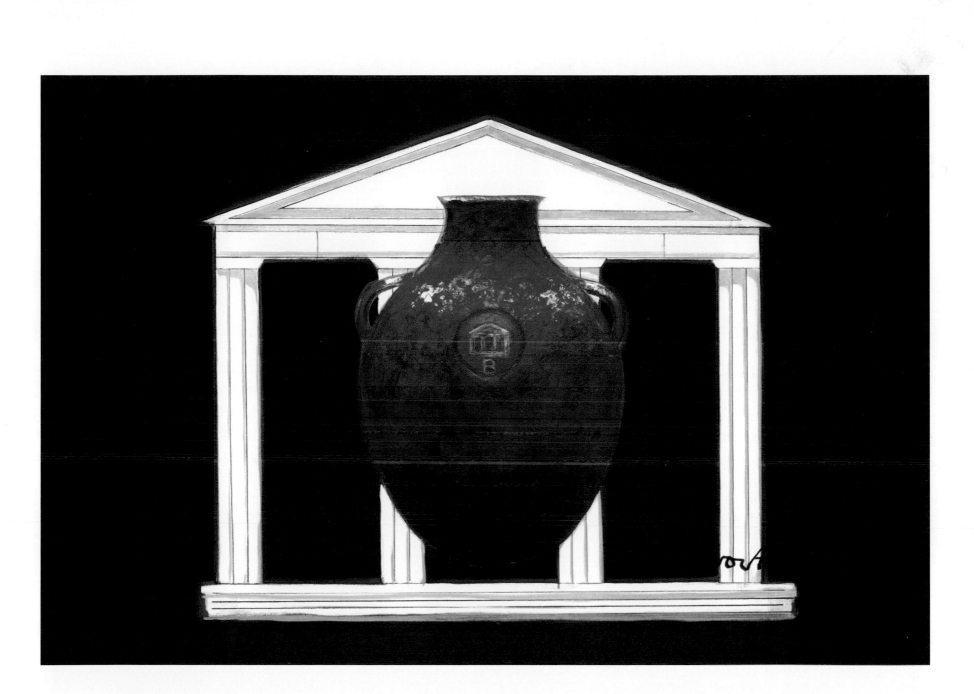

"Untitled" 1998
Oil/Conte on Canvas
24" x 36"

61

ROBERT R. ECKER

Robert R. Ecker has been declared "ingenious" and a "find" by *The New York Times*, and a painter whose "works gleam with wit and art historical reference" by the *Rocky Mountain News*. His mysterious, precisely drafted works grace collections from the Smithsonian to the Denver Art Museum. But this former, longtime professor at the University of Colorado remains somehow below the threshold of popular recognition (and big-name pricing). Many of Ecker's recent paintings are playful acrylic-on-wood, trompe l'oeil "windows" that look out onto dreamlike scenes with suggestions of Edward Hopper, or Joseph Cornell or Renaissance masters, with objects on the "sills"—a dripping paint can, a pair of eyeglasses—that bring the viewer back to the more mundane but even more elusive matter of the illusion's creator.

—Reprinted from the Fall 2004 issue of *Forbes FYI Magazine*

Born: 1936 Waynesboro, Pennsylvania
Lives and works in Escondido, California and Chadds Ford, Pennsylvania

EDUCATION
1965 M.F.A. Pennsylvania State University, PA
1961 Pennsylvania Academy of Fine Arts, PA

GRANTS AND AWARDS (selected)
1996 Colorado Council for the Arts Recognition Award in Painting
1995 Colorado Council for the Arts Recognition Award in Painting
1981 National Endowment for the Arts Fellowship

ONE PERSON EXHIBITIONS (selected)
2004 The Artist's House, Philadelphia, PA
2003 "25 Year Retrospective," Washington State University, Pullman, WA
2002 "25 Year Retrospective," Regis University, Denver, CO
1994 Robischon Gallery, Denver, CO
1991 Denver Art Museum, Denver, CO

GROUP EXHIBITIONS (selected)
2003 "34TH Annual National Exhibition," Palm Springs Desert Museum, Palm Springs, CA
2001 "Invitational Exhibition," Mount St. Mary's College, Los Angeles, CA
2001 "Colorado Art Open," Foothills Art Center, Golden, CO
2000 "Classical Redux," Arts Partnership Gallery, Escondido, CA
1999 "Mezzotint Exhibition," Wichita Art Museum (6 prints), Wichita, KS
1998 "International Mezzotint Exhibition," Davidson Galleries, Seattle, WA
1997 "International Print Exhibition," Portland Art Museum, Portland, OR
1996 "International Print Exhibition," Portland Art Museum, Portland, OR

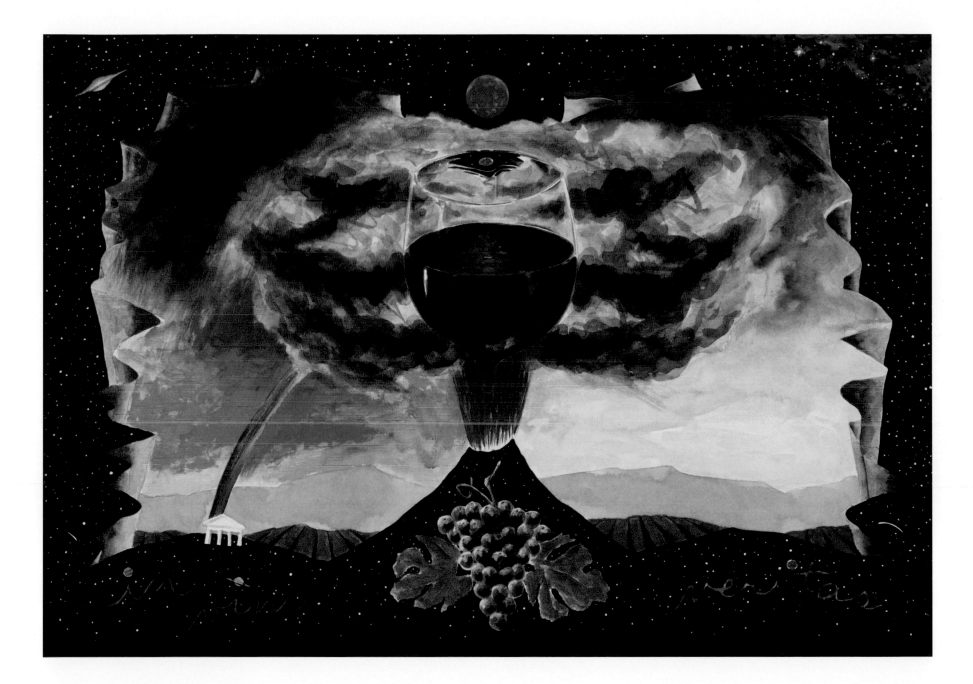

CARLOS ESTÉVEZ

I met Carlos when I attended the Bienal La Habana in 1999. It was one of the most dramatic and impressive exhibitions I have ever attended, and Carlos' work stood out from among the rest. I was so struck by his drawings that I made a point of searching out and visiting his studio. I had not seen such emotionally charged work for a long time and knew he must be included in the collection.

—Bob Nugent

Born: 1969 Havana, Cuba
Lives and works in Havana, Cuba

EDUCATION
1992 Instituto Superior de Arte, La Habana, Cuba

GRANTS AND AWARDS (selected)
2003 Artist in Residence, Citè Internationale des Arts, Paris, France
2003 Artist in Residence, Sacatar Foundation, Isla Itaparica, Salvador de Bahía, Brazil
2002 Artist in Residence, Massachusetts College of Art, Boston, MA
2001 Artist in Residence, TALLIX FUNDRY, Beacon, NY
2000 Artist in Residence, Nordic Artists' Centre, Dale, Norway
1998 Artist in Residence, Fundación Art-OMI, New York, NY
1998 Artist in Residence, UNESCO-ASCHERG en Nordic Artists' Centre, Dale, Norway
1997 Artist in Residence, Gasworks Studios, London, England
1997 Artist in Residence, Academia de San Carlos (UNAM), D.F. México

ONE PERSON EXHIBITIONS (selected)
2003 "The Transparent Being," Couturier Gallery, Los Angeles, CA
2003 "La eternidad cotidiana," Havana Galerie, Zürich, Switzerland
2002 "Circo Metafísico," Diana Lowenstein Fine Art, Miami, FL
2002 "El alma es un lugar," Centro de Arte Contemporáneo Wifredo Lam, Havana, Cuba
2002 "The Dark Theater," ALVA Gallery, New London, CT
2001 "The Theater of the Soul," Chidlaw Gallery, Cincinnati, OH

GROUP EXHIBITIONS (selected)
2002 "En torno al entorno," Centro de Desarrollo de las Artes Visuales, Havana, Cuba
2002 "From a Black Hole," Cuba, Son Space, Molí de Pals, Girona, Spain
2002 "16 Artistas Cubanos en Beirut," Palacio de la UNESCO de Beirut, Lebanon
2002 "Cuba Fusión," Arts Council, Greenwich, CT
2002 "Arte cubano contemporáneo," Muestra colateral a la Bienal de São Paulo, Galería Marta Traba, Memorial América Latina, São Paulo, Brasil
2001 "Contexto: Arte reciente de Cuba en la Colección Permanente," The Bronx Museum, NY
2001 "Tercer Salón de Arte Contemporáneo," Centro de Desarrollo de las Artes Visuales, Havana, Cuba
2001 "Up, Up, & Away," The Viewing Room, New York, NY

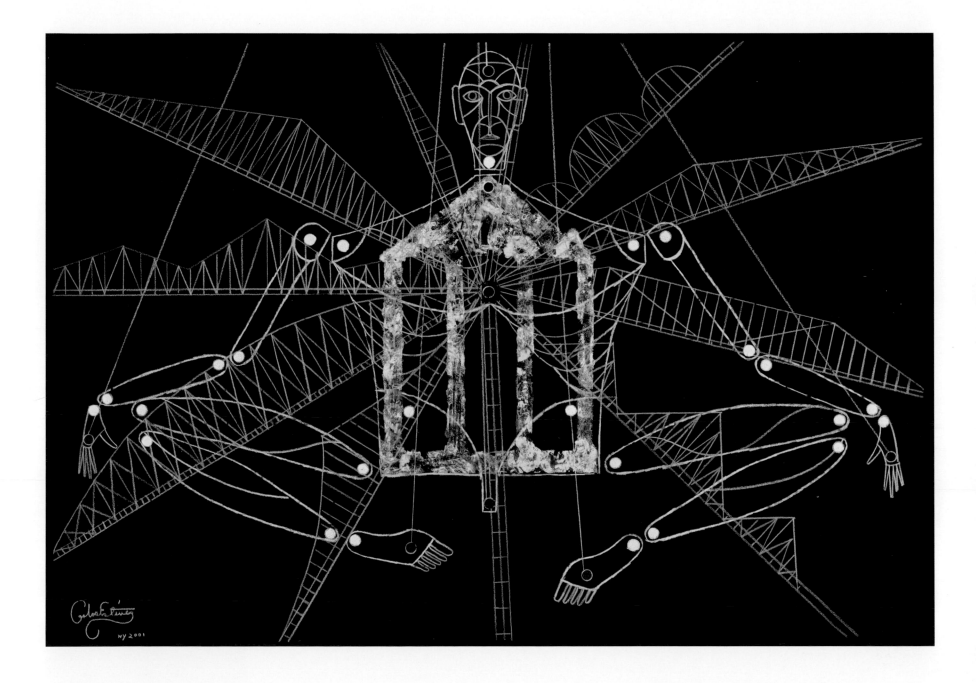

DONALD S. FARNSWORTH

Farnsworth's work has been displayed throughout the United States, Europe and Japan. He is known internationally as a master printmaker, and papermaker, and an authority on the history and manufacture of handmade paper. Most recently he is exploring the mediums of digital imaging and tapestry.

—Bob Nugent

Born: 1952 Palo Alto, California
Lives and works in Oakland, California

EDUCATION
1977 M.A. University of California at Berkeley, CA
1974 B.F.A. San Francisco Art Institute, San Francisco, CA
1973 Chemistry/Printmaking, Laney College, Oakland, CA
1972 The School of the Art Institute of Chicago, Chicago, IL

GRANTS AND AWARDS (selected)
1988 Graphic Arts Council, San Francisco Commission (forty monoprints)
1983 Purchase Award, World Print Four, World Print Council
1979 National Endowment for the Arts, Contributions to the Field Grant
1979 CUSO, Aid funded project to design & construct a paper mill in Dar Es Salaam, Tanzania

ONE PERSON EXHIBITIONS (selected)
2001 "Phase Portraits," Dallas Saunders Fine Art, Ross, CA
1999 B. Sakato Gallery, Sacramento, CA
1991 Brandan Walter Gallery, Santa Monica, CA
1990 Gumps Gallery, San Francisco, CA
1988 Gallerie Petites Formes, Osaka, Japan
1984 Bank of America World Headquarters, Concourse Gallery, San Francisco, CA

GROUP EXHIBITIONS (selected)
2002 College of Santa Fe Monothon, Santa Fe, NM
2000 College of Santa Fe Monothon, Santa Fe, NM
1998 Colombus University Gallery, Columbus, GA
1995 "12TH International Biennial of Graphic Art," Ljubijana, Slovenia
1995 "Within Limits," Galeria Millan, São Paulo, Brazil
1993 "Ten Years of Printmaking: Magnolia Editions," California Museum of Art, Santa Rosa, CA
1992 "Directions in Bay Area Printmaking: 3 Decades," Palo Alto Cultural Center, Palo Alto, CA
1990 "Oakland Artists 1990," Oakland Museum, Oakland, CA
1988 "California Artists," Paul Gallery, Tokyo, Japan
1988 "Paper as Art," New York Museum of Modern Art, New York, NY

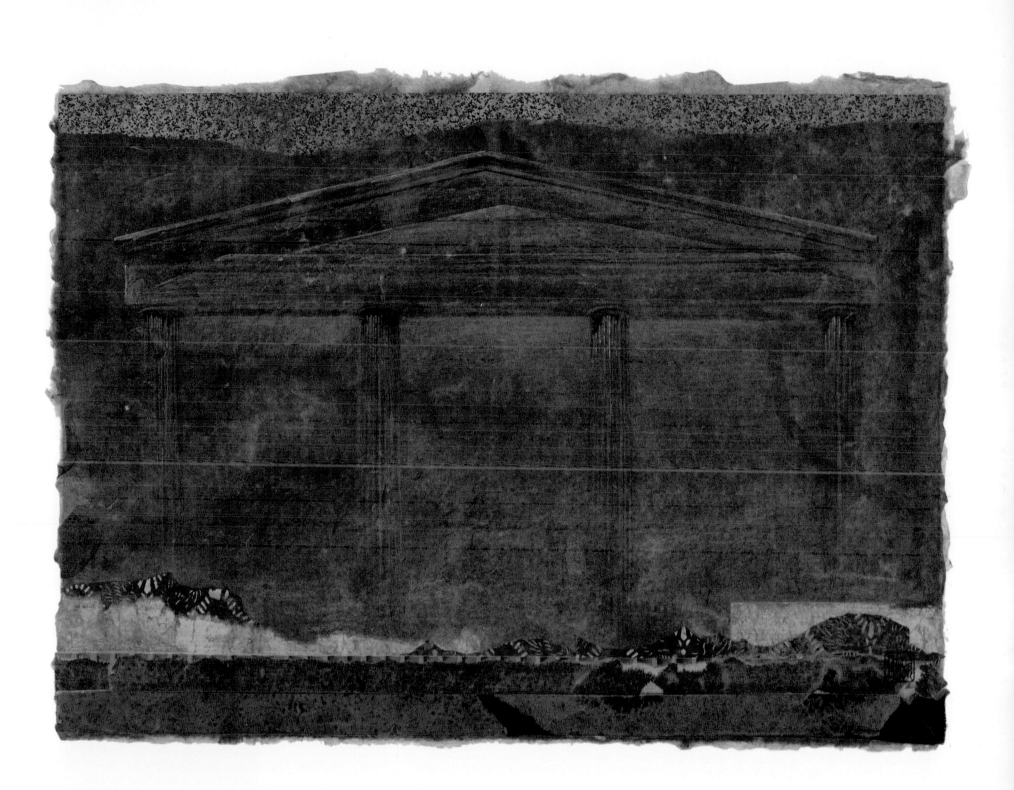

"Untitled" 1987
MIXED MEDIA/PASTEL ON HANDMADE PAPER
17" x 23-1/2"

67

SERGIO FINGERMANN

In my recent paintings I try to create luminous, vibrating surfaces. On these surfaces a drawing can be seen, a particular graphism that does not strive for a definition. This graphism is related to chance. It does not define an image, and yet testifies to the action of time. In these paintings I do not want to define a scale relation for the beholder. I do not clearly define the distance that the beholder should keep from the image. There is a deliberate imprecision as to scale. I am trying to make paintings that allow for a perpendicular reading of the painted surface. A reading that comes from the background, or reveals what is right behind. Painting has to do with time. Time is the artist's material. It has been my material. I would like my paintings to evoke absolute time.

—Sergio Fingermann, January 1992

Born: 1953 São Paulo, Brazil
Lives and works in São Paulo, Brazil

EDUCATION
1979 Degree in Architecture
1974 School of Art, São Paulo, Brazil

GRANTS AND AWARDS (selected)
1992 Galeria São Paulo, São Paulo, Brazil
1992 Museu de Arte Moderna do Rio de Janeiro, Brazil
1991 Galerie Saint Ravy Demangel, Montpellier, France
1991 Galerie Wimmer, Montpellier, France
1990 Galeria São Paulo, São Paulo, Brazil

GROUP EXHIBITIONS (selected)
1991 Bienal de Pintura, Cuenca, Ecuador
1991 Bienal de Havana, Cuba, Artista Convidado
1990 Arte Contemporânea Brasil, Japão, Museu Central de Tokio, Japan
1989 "Impact Art Festival," Museu de Arte de Kyoto, Japan
1989 Gravura Brasileira, Parque Laje, Rio de Janeiro, Brazil
1988 "Gráfica brasiliana," Galeria Segno Gráfico, Venice, Italy
1987 Gravura brasileira, Grand Palais, Paris, France
1986 Bienal de Artes Gráficas, Bradford, England
1986 Bienal de San Juan, Puerto Rico

69

AARON FINK

In painting, on the one hand there is the illusion, on the other the reality - that being the flat, two-dimensional surface to which the paint is applied, the physicality of the paint applied to that surface. For me the intent is to create a visualization of the idea of an image while denying the illusion of it in order to reconcile it with the materiality of the paint itself. The attempt then is that the painting become something else, a vehicle for thought that transposes itself into an object of contemplation.

—Aaron Fink

Born: 1955 Boston, Massachusetts
Lives and works in East Boston, Massachusetts

EDUCATION
1979 M.F.A. School of Art and Architecture, Yale University, New Haven, CT
1977 B.F.A. Maryland Institute, College of Art, Baltimore, MD
1976 Skowhegan School of Painting and Sculpture, Skowhegan, ME

GRANTS AND AWARDS (selected)
1998 Residency, Anderson Ranch, Snowmass, CO
1996 Residency, Anderson Ranch, Snowmass, CO
1987 National Endowment for the Arts Fellowship
1984 Artist Fellowship, Massachusetts Council on the Arts and Humanities
1982 National Endowment for the Arts Fellowship
1979 American Academy in Rome, Prix de Rome, Alternate in Painting
1979 Yale University, Ford Foundation Special Project Grant
1979 Skowhegan Scholarship Award, conferred by the Maryland Institute

ONE PERSON EXHIBITIONS (selected)
2005 Alpha Gallery, Boston, MA
2004 Galerie D'Avignon, Montreal, Canada
2004 Lisa Sette Gallery, Scottsdale, AZ
2004 Elins Eagles-Smith Gallery, San Francisco, CA
2002 Alysia Duckler Gallery, Portland, OR
2002 Pamela Auchincloss/Project Space, New York, NY

GROUP EXHIBITIONS (selected)
2004 "More Than One: Prints and Portfolios from the Center Street Studio, Boston," Iris and B. Gerald Cantor Art Gallery, College of the Holy Cross, Worcester, MA
2002 "Painting in Boston: 1950-2000," DeCordova Museum and Sculpture Park, Lincoln, MA
2000 "A Tribute to John Powers," Hatton Gallery, Colorado State University, Fort Collins, CO
1998 "A Salute to Boston," Wiggin Gallery, Boston Public Library, Boston, MA
1998 "Be Still Dear Art," New England School of Art and Design, Boston, MA
1997 "Attributes of the Artist," The Art Complex Museum, Duxbury
1997 "Working Sources: The Painter and the Photographic Image," Alpha Gallery, Boston, MA
1997 "The Unique Print: Six Innovative Approaches to the Monotype," Starr Gallery, Newton, MA
1996 "Face and Figure," Museum of Fine Arts, Boston, MA

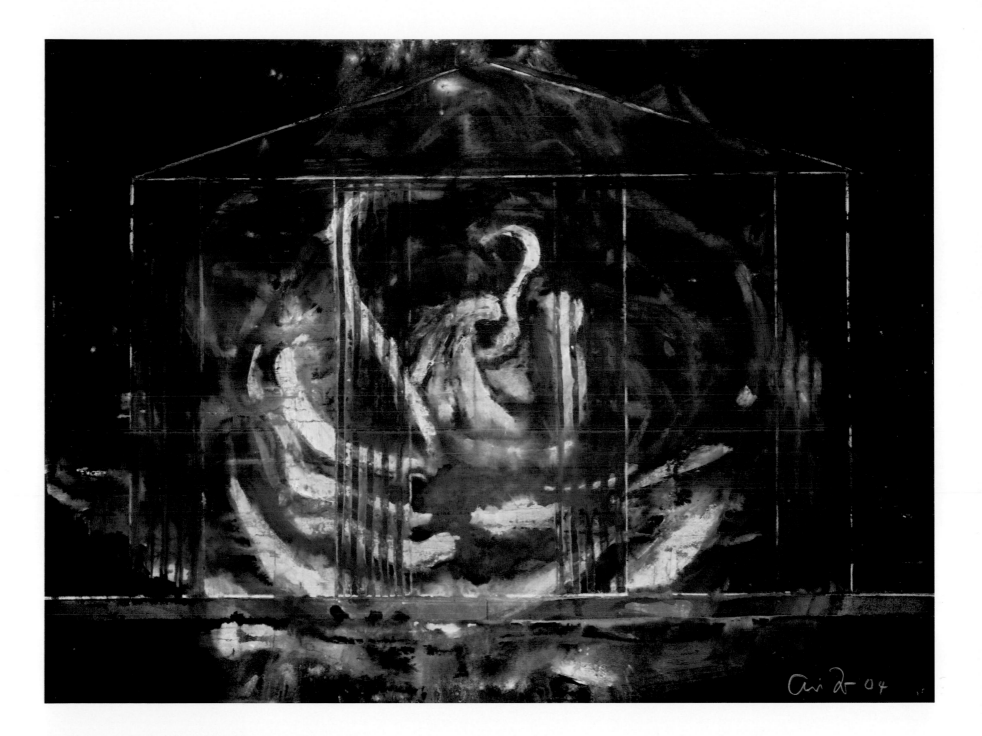

"Untitled" 2004
MIXED MEDIA ON PAPER
22-3/8" x 29-3/4"

71

MARY FRANK

I'm sure work is personal but hope it moves out beyond to others. Work of others that has meaning makes something change in me, break open, realize something I don't know although often right after, I recognize it. I want to work, to be full of experiences of many kinds, but there is also the tender creature. I have worked as a volunteer for an organization, *Solar Cookers International*. They are teaching people in many parts of the world to cook with the sun and pasteurize milk and water against ninety-eight percent of the diseases. It has been a privilege! The great writer, ornithologist, activist, Terry Tempest Williams said to me, "grief dares us to love again." I know this is true.

—Mary Frank

Born: 1933 London, England
Lives and works in New York City, and Bearsville, New York

EDUCATION
Studied with Hans Hoffmann and Max Beckmann

GRANTS AND AWARDS (selected)
1984 Elected to the American Academy and Institute of Arts and Letters
1983 John Simon Guggenheim Memorial Fellowship
1973 John Simon Guggenheim Memorial Fellowship
1968 National Council for the Arts
1961 Ingram Merril Foundation Grant

ONE PERSON EXHIBITIONS (selected)
2003 University of Richmond, VA
2003 D.C. Moore Gallery, New York, NY
2001 D.C. Moore Gallery, New York, NY
2000 Neuberger Museum of Art, Purchase, NY
1998 D.C. Moore Gallery, New York, NY
1996 D.C. Moore Gallery, New York, NY

GROUP EXHIBITIONS (selected)
1993 "Insight/Incite/Insite," Nielson Gallery, Boston, MA
1993 "68TH Annual Exhibition," National Academy of Design, New York, NY
1990-1991 "Seoul International Arts Festival," National Museum of Contemporary Art, Seoul, Korea
1990 "The Unique Print: 80s Into 90s," The Museum of Fine Arts, Boston, MA
1980 "The Painterly Print," The Metropolitan Museum of Art, New York, NY
1979 "Whitney Biennial," Whitney Museum of American Art, New York, NY
1973 "Whitney Biennial," Whitney Museum of American Art, New York, NY

PHOTO CREDIT: INGE MORATH
MAGNUM PHOTOS, INC.

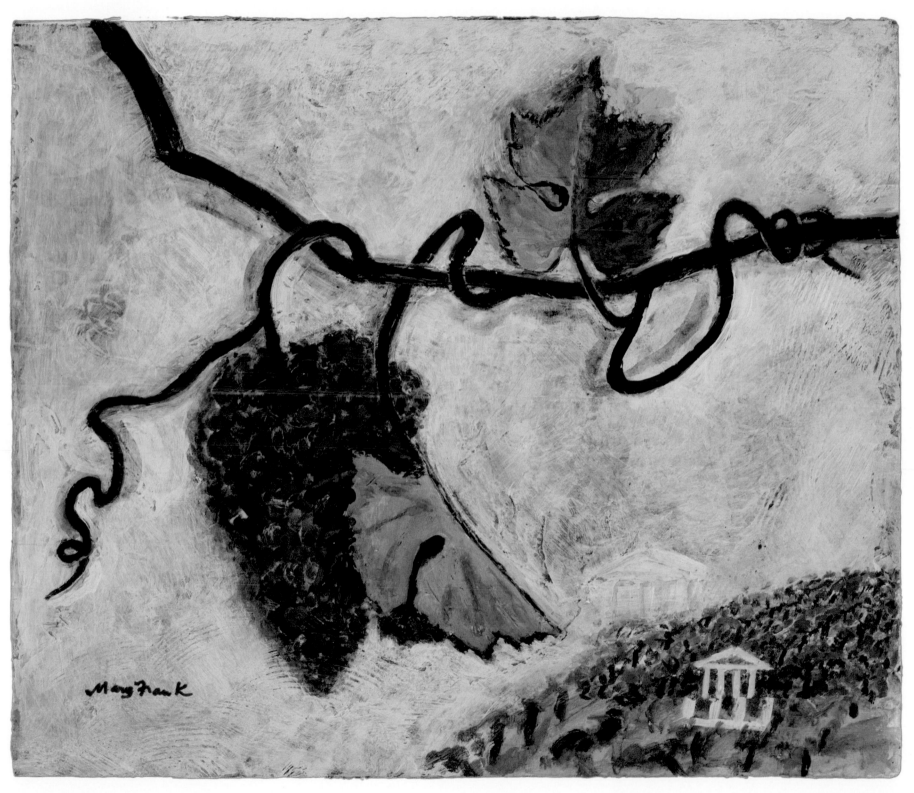

"Untitled" 1995
ACRYLIC ON BOARD
11" x 13"

73

JOHN FRASER

...Fraser's works are filled with subtlety and nuance. With an inventiveness and craft that combines mixed materials, Fraser can alter the ordinary object and transform it into a poetic gesture. In this process, he also produces a vocabulary of related images by which we come to reevaluate our understanding of what is meant by a critical term like Formal Presence.

—Edward M. Maldonado, *John Fraser at the Chicago Cultural Center 1995*

Born: 1952 Chicago, Illinois
Lives and works in St. Charles, Illinois

EDUCATION
1989 M.F.A. Northern Illinois University, De Kalb, IL
1975 B.A. Roosevelt University, Chicago, IL

GRANTS AND AWARDS (selected)
2004 Normal Editions Workshop, Illinois Arts Council Print Project
2003 Robert M. MacNamara Foundation Residency
2002 Illinois Arts Council Individual Artist Fellowship
2000 Illinois Arts Council Fellowship Finalist Award
1992 Arts Midwest/National Endowment for the Arts Regional Visual Arts Fellowship
1990 Illinois Arts Council Fellowship Finalist Award

ONE PERSON EXHIBITIONS (selected)
2005 Roy Boyd Gallery, Chicago, IL
2004 "Selected Works: 1990-2004," St. John's University, MN
2001 Scott White Contemporary, San Diego, CA
1998 Elmhurst Art Museum, Elmhurst Art Museum, Elmhurst, IL
1990 Mitchell Museum, Mt. Vernon, IL

GROUP EXHIBITIONS (selected)
2005 Bentley Projects, Phoenix, AZ
2004 Carrie Seacrist Gallery, Chicago, IL
2004 Scott White Contemporary, Telluride, CO
2003 Mississippi Museum of Art, Jackson, MS
2002 "Underfoot," Associacão Alumni, São Paulo, Brazil (traveling exhibition) (catalog)
2000 Arkansas Art Center, Little Rock, AR
1995 Szinhaz Galeria, Zalaegerszeg, Hungary
1985 Art Institute of Chicago, Chicago, IL

"Untitled" 1995
Pencil/Collar/Mixed Media on Museum Rag Board
24-1/4" x 35" x 5"

75

DAN GAMBLE

My work is constructed from memory (mental images of urban sites and rural land-scape) and painterly process. The surface of each painting has a material presence, created by applying many layers of paint: the physical accumulations evoke decay and disorder. The resulting images are of elaborate structures that represent a struggle to create and maintain order: they are objects influenced by the uncontrollable forces of time and nature.

—Dan Gamble

Born: 1956 in Beloit, WI
Lives and works in Chicago, Illinois

EDUCATION
1986 M.F.A. in Painting and Drawing, The University of New Mexico, NM
1982 B.F.A. in Printmaking, The University of Wisconsin-Milwaukee, WI

GRANTS AND AWARDS (selected)
2001 Illinois Arts Council Fellowship
1999 CAAP Grant Department of Cultural Affairs, City of Chicago, Chicago, IL
1998 CAAP Grant Department of Cultural Affairs, City of Chicago, Chicago, IL
1998 Best of Show 14th Biennial, Evanston & Vicinity Exhibition, Evanston Art Center, Evanston, IL
1997 CAAP Grant Department of Cultural Affairs, City of Chicago, Chicago, IL

ONE PERSON EXHIBITIONS (selected)
2001 "New Work," Roy Boyd Gallery, Chicago, IL
1999 "Paintings," Roy Boyd Gallery, Chicago, IL
1998 "Inventions: The Paintings of Dan Gamble," Chicago Cultural Center, Chicago, IL

GROUP EXHIBITIONS (selected)
2003 "Dark Matter: Dan Gamble and Dann Witczak," Elmhurst Art Museum, Elmhurst, IL
2001 "The Memory of Place: Ben Whitehouse, Dan Gamble, Brian Ritchard," Evanston Art Center,
 Evanston, IL
2001 "Schemata: Dan Gamble and Kathleen McCarthy," Riverside Art Center, Riverside, IL
1998 "14th Biennial, Evanston & Vicinity Exhibition," Evanston Art Center, Evanston, IL
1995 "Chicago Abstract Painters," Evanston Art Center, Evanston, IL

DAVID GILHOOLY

I make what pleases me, what entertains me, what makes me want to get up in the morning. It used to be making a world of us as frogs out of clay. Now I use very little clay to express what I am thinking about... but I am still thinking about us as a people and us as a collection of cultures. But I am using rather than clay or Plexiglas, some totally new mediums: acrylic paint used without the aid of brushes, collages of jigsaw puzzles, assemblages of toys and other such found, decorative junk in shadow boxes, and little collages all made up out of stolen images fixed up on the computer and then made into prints.

—David Gilhooly

Born: 1943 Auburn, California
Lives and works in Newport, Oregon

EDUCATION
1967 M.A. University of California at Davis, CA
1965 B.A. University of California at Davis, CA

ONE PERSON EXHIBITIONS (selected)
2005 Pence Museum of Art, Davis, CA
2004 Linfield College Art Gallery, McMinnville, OR
2001 Nickles Art Museum, University of Calgary, Canada
2001 Eastern Washington State College, Cheney, WA
2001 Halle Ford Museum of Art, Willamette University, Salem, OR

GROUP EXHIBITIONS (selected)
2005 "Best in Show," Museum of Glass, Tacoma, WA
2005 "Scope," Canadian Clay and Glass Museum, Waterloo, Ontario, Canada
2005 "The Artful Teapot," The Kamm Collection
2004 "The Not So Still Life," San Jose Museum of Art, San Jose, CA
2002 "The Artful Teapot," The Kamm Collection
2002 National Museum of Modern Art, Kyoto, Japan
2000 "The Lighter Side of Bay Area Figuration," San Jose Museum of Art, San Jose, CA
2000 "The Anderson Collection," San Francisco Museum of Modern Art, San Francisco, CA

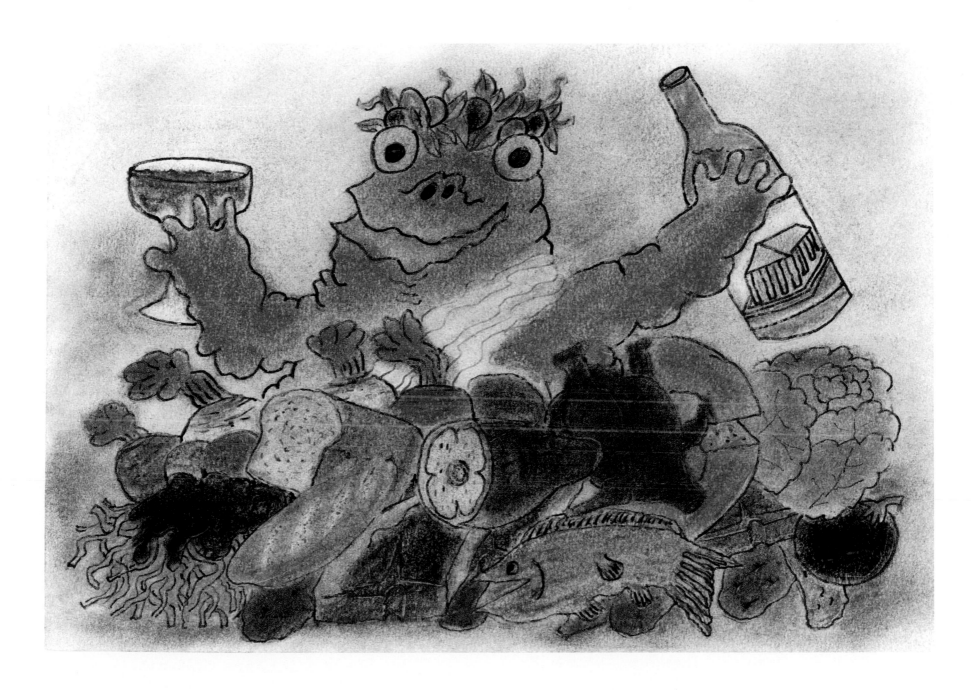

79

SAM GILLIAM

In the poet Pablo Neruda's process, which he calls "Geography of Poetry," he keeps a table of common stones for inspiration. In Miro's process, he incorporates the essence of the constellation. Lucio Fontana and Jackson Pollock utilize the cut canvas. Piet Mondrian moves painting from the canvas to the wall using tape. The Dogon, which is the ancestral culture of Mali, use cut eye slits in their sculpture to project light. They also paint the calendar on the sculpture of the human figure in the form of dots to transcribe time.

These are all stimulating non-linear processes that inspire other directions in one's thinking.

—Sam Gilliam, September 1999

Born: 1933, Tupelo, Mississippi
Lives and works in Washington, D.C.

EDUCATION
1961 M.A. in Painting, University of Louisville, KY
1955 B.A. in Fine Art, University of Louisville, KY

GRANTS AND AWARDS (selected)
1997 Honorary Doctorate of Arts & Letters, University of Wisconsin, Madison, WI
1993 Honorary Doctorate of Fine Arts, Corcoran Gallery and School of Art, Washington, D.C.
1992 Honorary Doctorate of Arts & Letters, University of Louisville, Louisville, KY
1990 Honorary Doctorate of Arts & Letters, Northwestern University, Evanston, IL
1989 National Endowment for the Arts Fellowship
1987 Honorary Doctorate of Fine Arts, Atlanta College of Art, Atlanta, GA
1986 Honorary Doctorate of Fine Arts, Memphis College of Art, Memphis, TN
1980 Honorary Doctorate of Humane Letters, University of Louisville, Louisville, KY
1971 Solomon Guggenheim Memorial Foundation Fellowship
1969 Norman W. Harris Prize, Art Institute of Chicago, Chicago, IL
1967 National Endowment for the Arts Fellowship

ONE PERSON EXHIBITIONS (selected)
2004 "3," Marsha Mateyka Gallery, Washington, D.C.
2004 "Sam Gilliam, Folded & Hinged," Louisiana Art & Science Museum, Baton Rouge, LA
 (traveling exhibition)
2002 "Slats," Marsha Mateyka Gallery, Washington, D.C.
2001 "From Shiraz," Marsha Mateyka Gallery, Washington, D.C.
2000 Georgetown Gallery, Georgetown, KY
1999 "Works '99," Marsha Mateyka Gallery, Washington, D.C.

GROUP EXHIBITIONS (selected)
2003 "Abstract Notions: Selections for the Permanent Collection," University of Massachusetts,
 Amherst, MA
1997 "Seeing Jazz," Smithsonian Institution Traveling Exhibition Service
1997 "After the Fall: Aspects of Abstract Painting Since 1970," Newhouse Center of Contemporary
 Art, Snug Harbor Cultural Center, Staten Island, NY
1995 "44TH Biennial Exhibition of Contemporary American Painting," Corcoran Gallery of Art,
 Washington, D.C.
1995 "Richard Artschwager, Sam Gilliam, Jim Hyde," Baumgartner Gallery, Washington, D.C.
1991 "Abstraction: The 90's," Andre Emmerich Gallery, New York, NY
1989 "The Blues Aesthetic," Washington Project for the Arts, Washington, D.C.
1989 Duke University Museum of Art, Durham, NC (catalog)
1989 California Afro-American Museum, Los Angeles, CA

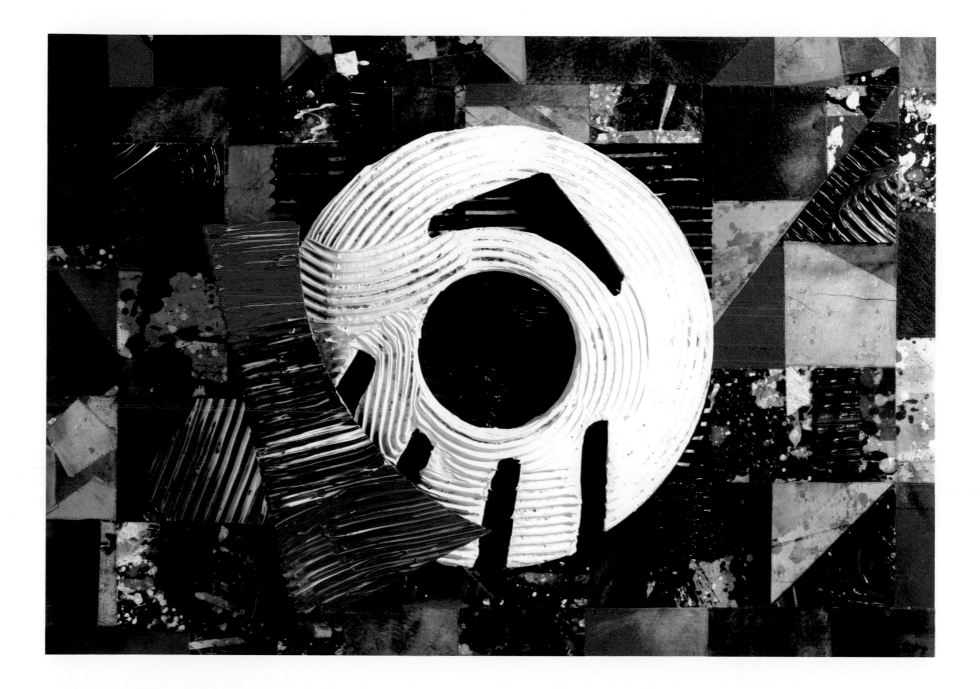

"Untitled" 1992
material/mixed media on panel
34" x 49"

APRIL GORNIK

I am an artist that values, above all, the ability of art to move me emotionally and psychically. I make art that makes me question, that derives its power from being vulnerable to interpretation, that is intuitive, that is beautiful.

—April Gornik

Born : 1953 Cleveland, Ohio
Lives and works in New York City and Sag Harbor, New York

EDUCATION
1976 B.F.A. Nova Scotia College of Art and Design, Nova Scotia, Canada

GRANTS AND AWARDS (selected)
2004 Neuberger Museum Annual Honoree
2003 Guild Hall Museum, Lifetime Achievement in the Visual Arts
2003 Award of Excellence for Artistic Contributions to the Fight Against Aids, American Foundation
 for Aids Research
1990 American Woman's Economic Development Corporation "Breakthrough" Award

ONE PERSON EXHIBITIONS (selected)
2004 The Neuberger Museum, Purchase, New York, NY (traveling exhibition)
2003 Danese Gallery, New York, NY
2002 Huntington Museum of Art, Huntington, WV
2001 Danese Gallery, New York, NY
2000 Edward Thorp Gallery, New York, NY
1998 The University of the Arts, Philadelphia, PA
1998 Museum of American Art of the Pennsylvania Academy of the Fine Arts, Philadelphia, PA

GROUP EXHIBITIONS (selected)
2004 "Images of Time and Place: Contemporary Views of Landscape," Lehman College Art Gallery,
 Bronx, NY
2003 Danese Gallery, New York, NY
2002 "Curious Terrain," Elizabeth Harris Gallery, New York, NY
2002 "Darkness and Brightness," Sears-Peyton Gallery, New York, NY
2001 "Inaugural Exhibition," Michael Kohn Gallery, Los Angeles, CA
2001 "The Private Collection of Steve Martin," Bellagio Gallery, Las Vegas, NV
2001 "Follies," Parrish Art Museum, Southampton, NY
2000 "Drawings 2000," Barbara Gladstone Gallery, New York, NY
2000 "Art of the 80s," Winston Wachter Mayer Fine Art, New York, NY
2000 "Works on Paper 2000," Residence of the American Ambassador of The Slovak Republic,
 Bratislava

"Untitled" 2003
WATERCOLOR ON PAPER
9-1/4" x 13-1/2"

83

NANCY GRAVES
(1939-1995)

During her lifetime, Nancy Graves produced a tremenodus amount of work in a variety of media, including painting, drawing, prints, set design, and film. She had a passion for science, exploring imagery in botany, astronomy, and zoology. She brought these and other diverse subject matter under her scrutiny, laying abstract forms into powerful works that are sure to stand the test of time.

—Bob Nugent

Born: Pittsfield, Massachusetts

EDUCATION
1964 M.F.A. School of Art and Architecture, Yale University, New Haven, CT
1962 B.F.A. School of Art and Architecture, Yale University, New Haven, CT
1961 B.A. Vassar College

GRANTS AND AWARDS (selected)
1992 Awarded Honorary Doctorate of Fine Arts Degree, University of Maryland, Baltimore, MD and Yale University, New Haven, CT
1987 Award of American Art, The Pennsylvania Academy of Fine Arts, Philadelphia, PA
1986 Vassar College Distinguished Visitor Award
1985 Yale Arts Award for Distinguished Artistic Achievement
1976 Skowhegen Medal for Drawing/Graphics
1974 CAPS Grant
1972 National Endowment for the Arts Fellowship
1965 Fulbright-Hayes Grant in Painting, Paris

ONE PERSON EXHIBITIONS (selected)
2001 "Nancy Graves: Paintings, Sculpture, and Works on Paper," Lowe Gallery, Atlanta, GA
1997 "Nancy Graves: Between Painting & Sculpture: A Selection from the Eighties," Knoedler and Company, New York, NY
1995 "Contemporary Galleries Exhibition," National Gallery of Canada, Ottawa, Ontario, Canada
1989 "Nancy Graves: New Sculpture," Knoedler Kasmin Gallery, London, England
1972 "Projects: Nancy Graves," The Museum of Modern Art, New York, NY
1969 "Nancy Graves: Camels," Whitney Museum of American Art, New York, NY

GROUP EXHIBITIONS (selected)
2005 "Paint on Metal: Modern and Contemporary Explorations and Discoveries," Tucson Museum of Art, Tucson, AZ
2003 "From Here to There: Maps as Muse," Hirschl & Adler Galleries, New York, NY
2003 "Artists and Maps: Cartography as a Means of Knowing," The Ronna and Eric Hoffman Gallery of Contemporary Art, Lewis and Clark College, Portland, OR
2002 "Personal & Political: The Women's Art Movement, 1969-1975," Guild Hall, East Hampton, NY
2001 "Models of Observation: Milton Avery, Nancy Graves, Donald Sultan: Flowers; Fishes; Birds; Butterlies," Knoedler & Company, New York, NY
2001 "New York circa 1975," David Zwirner Gallery, New York, NY
2001 "Century City: Art and Culture in the Modern Metropolis," Tate Modern, London, England
2000 "The American Century: Art & Culture, Part II, 1950-2000," Whitney Museum of American Art, New York, NY
1999 "Waxing Poetic: Encaustic Art in America," The Montclair Art Museum, Montclair, NJ (traveled to Knoxville Museum of Art, Knoxville, TN)
1999 "Contemporary Classicism," Neuberger Museum of Art, State University of New York, Purchase, NY (traveled to Tampa Museum of Art, Tampa, FL)

"Untitled" 1992
COLLAGE/MIXED MEDIA ON PAPER
6-5/8" x 10-1/4"

MICHAEL GREGORY

Michael Gregory is a poet and a romantic. For years he investigated those objects that play a major role in our everyday lives. He focuses in on the fleeting nature of life, posing his romantically lit subjects on dark backgrounds. In the image for the label he created the portrait of a cardinal, perched on the parthenon, with its song printed in sheet music as a backdrop.

—Bob Nugent

Born: 1955 Los Angeles, California
Lives and works in Bolinas, California

EDUCATION
1980 B.F.A. San Francisco Art Institute, San Francisco, CA
1976 City College of San Francisco, San Francisco, CA

ONE PERSON EXHIBITIONS (selected)
2005 "Revenants," Gail Severn Gallery, Ketchum, ID
2004 John Berggruen Gallery, San Francisco, CA
2004 "Icons," Nancy Hoffman Gallery, New York, NY
2003 "Michael Gregory, Structural Icons," Gail Severn Gallery, Ketchum, ID
2003 "Michael Gregory, 20 Years: A Survey (1983-2003)," Bolinas Museum, Bolinas, CA
2003 "Common Threads/Uncommon Vision: The Art of Michael Gregory," Evansville Museum of
 Arts, Science and History, Evansville, IN
2003 Flanders Contemporary Art, Minneapolis, MN

GROUP EXHIBITIONS (selected)
2004 "Summertime," Nancy Hoffman Gallery, New York, NY
2003 "The Art of Collecting," Flint Institute of Arts, MI
2003 "Landscape: Unique Views," Nancy Hoffman Gallery, New York, NY
2003 "Small Scale," Nancy Hoffman Gallery, New York, NY
2003 "Theoretically Botanicals," Cumberland Gallery, Nashville, TN
2002 "Across America," TIAA/CREF, New York, NY
2002 "Real(ist) Men," Selby Gallery, Ringling School of Art and Design, Sarasota, FL
2001-2002 "Winter Orchidarium," The Butler Institute of American Art, Youngstown, OH (traveling
 exhibition)
2001 "Evening at Auction," Evansville Museum of Arts, Science and History, Evansville, IN

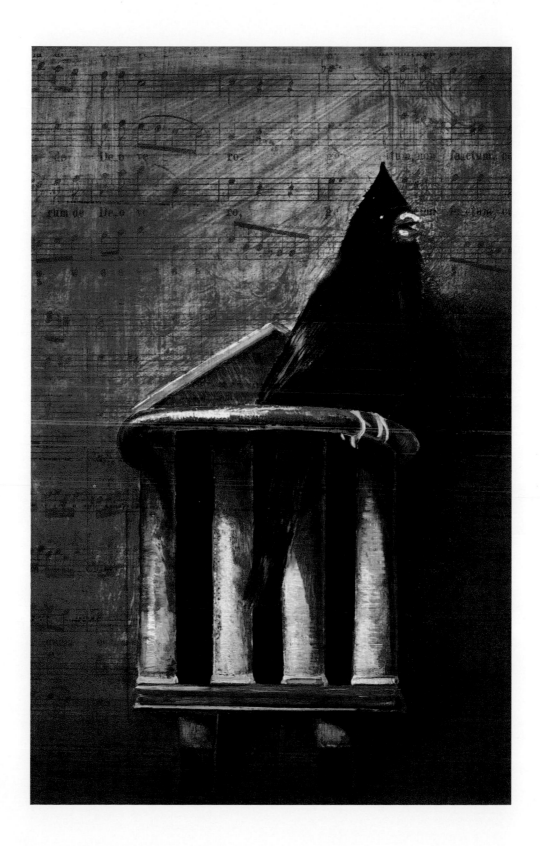

JANE HAMMOND

My work proceeds from a conceptual system I devised as a surrogate for style. Quite a few years ago I assembled a lexicon of found images drawn from a great variety of sources. My intention was to use these images recombinatively (think DNA) and let myself make any kind of painting I wanted with them. I have worked with this strategy for fifteen years, making paintings that are colorful, black and white, perspectival, flat, with language and without, "non-objective," "figurative" and combinations thereof. In addition to a visual variety, the paintings have also been about a variety of ideas, facts, fictions, and feelings. Sometimes my work is about my own experience and inner life and other times it is beyond me. I like the found and the felt. It is important to me that I have an authentic, particular and compelling reason for making each single work. Sometimes I know it before I start and sometimes I find it in the process. But I am not conjugating endless post-modern possibilities. Beyond the intense connection for me to each individual work, I am committed to a process, more than any subject, a conceptual process that I see as open, variable, de-centered, exploratory and unpredictable.

—Jane Hammond

Born: 1950 Bridgeport, Connecticut
Lives and works in New York, New York

EDUCATION
1977 M.F.A. University of Wisconsin, Madison, WI
1973-1974 Arizona State University, Tempe, AZ
1972 B.A. Mount Holyoke College, South Hadley, MA

GRANTS AND AWARDS (selected)
2000 The Joan Mitchell Foundation Grant Award
1992 Artist-in-Residence, Skowhegan School of Painting and Sculpture, Skowhegan, ME
1989 Louis B. Comfort Tiffany Award
1989 New York State Council on the Arts Visual Artists Sponsored Work Award
1989 National Endowment for the Arts Fellowship

ONE PERSON EXHIBITIONS (selected)
2005 Galerie Lelong, New York, NY
2004 Greg Kucera, Seattle, WA
2003 John Berggruen Gallery, San Francisco, CA
2003 Weatherspoon Art Museum, The University of North Carolina, Greensboro, NC
2002 Whitney Museum of American Art at Philip Morris, New York, NY

GROUP EXHIBITIONS (selected)
2004 "Arte Termita Contra Elefante Blanco," Museo ICO, Madrid, Spain
2004 "Constructing Realities, Part 2," Selby Gallery, Ringling School of Art and Design, Sarasota, FL
2003 "On Paper: Masterworks from the Addison Collection," Addison Gallery of American Art,
 Andover, MA
2002 "177TH Annual," National Academy of Design, New York, NY
2001 "Digital Printmaking Now," Brooklyn Museum of Art, Brooklyn, NY
2001 "Curator's Choice: A Personal Look at Prints," Detroit Institute of the Arts, Detroit, MI
2000 "Picturing the Modern Amazon," The New Museum, New York, NY
2000 "The End: An Independent Vision of the History of Contemporary Art," Exit Art, New York, NY

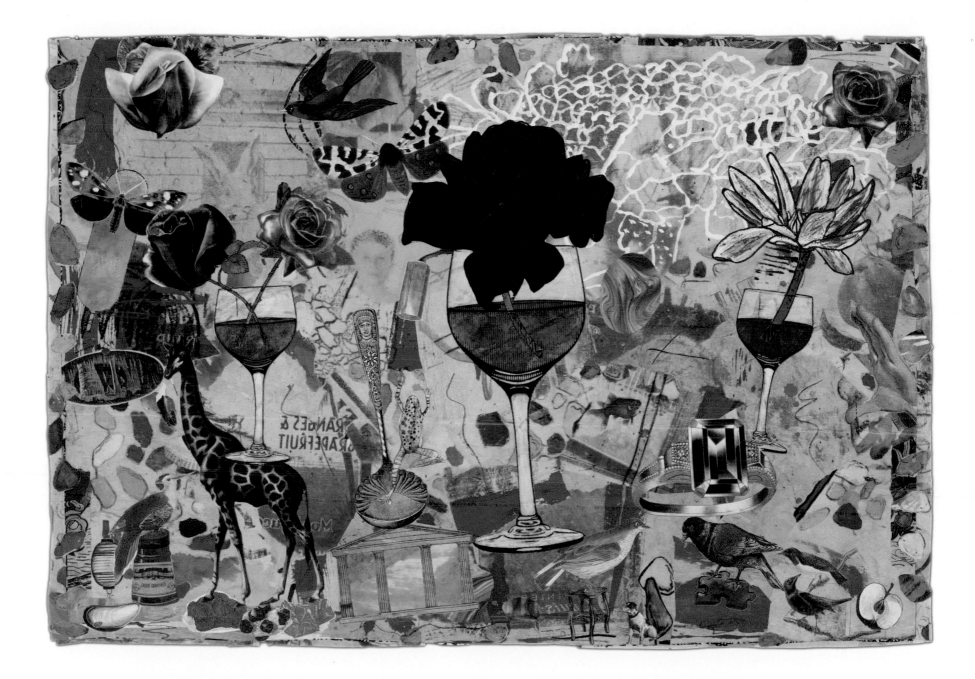

"Untitled" 2002
MIXED MEDIA ON PAPER
20-1/2" x 29-3/4"

GAYLEN HANSEN

I have been painting for sixty-five years. That the painting process continues to yield new challenges and revelations is amazing. My subjects include fish, grasshoppers, dogs, cats, ducks, tulips, stone walls, knights and The Kernal. Some of my work seems to have a peculiar kind of humor.

—Gaylen Hansen

Born: 1921 Garland, Utah
Lives and works in Palouse, Washington

EDUCATION
1953 M.F.A. University of Southern California, Los Angeles, CA
1952 B.S. Utah State Agricultural College, Logen, UT
1940-1944 Art Barn School of Fine Arts, Salt Lake City, UT
1939-1940 Otis Art Institute, Los Angeles, CA

GRANTS AND AWARDS (selected)
2002 Flintridge Foundation
1989 Governor's Award, Washington State
1984 Sambuca Romana Prize, New Museum of Contemporary Art, New York

ONE PERSON EXHIBITIONS (selected)
2004 Linda Hodges Gallery, Seattle, WA
2003 AVC Gallery, New York, NY
2003 Hallie Ford Museum of Art, Salem, OR
2003 Palo Alto Art Center, Palo Alto, CA
2002 Linda Hodges Gallery, Seattle, WA
2001 Linda Hodges Gallery, Seattle, WA
2001 "Northwest Views, Selections from the Safeco Collection," Frye Museum, Seattle, WA
2000 Lew Allen Contemporary, Sante Fe, NM
1996 Galerie Redmann, Berlin
1990 Art Club of Chicago
1985 "Gaylen Hansen Retrospective (Paintings of a Decade)," San Jose Museum of Art, San Jose, CA
 (traveling exhibition)
1981 Glenbow Museum, Calgary, Canada

GROUP EXHIBITIONS (selected)
2004 "Seattle Perspective," Washington State Convention Center, Seattle, WA
2000 "Inaugural Group Exhibition," Linda Hodges Gallery, Seattle, WA
2000 "Bumberbiennale: Paintings 2000," Bumbershoot, Seattle, WA
1999-2000 "Outward Bound: American Art at the Brink of the Twenty-First Century," Washington, D.C.
 (traveling exhibition)
1999 "From Here to the Horizon: Artists of the Rural Landscape," Whatcom Museum of History &
 Art, Bellingham, WA
1997 "A Distinct Vernacualar: Artists of Eastern Washington," Washington State Convention Center,
 Seattle, WA
1996 "Falling Timber," Tacoma Art Museum, Tacoma, WA

"UNTITLED" 1992
PASTEL/CHARCOAL/ACRYLIC ON PAPER
27" x 40"

91

WILLY HEEKS

Circumstance conditions and frames Willy Heeks' paintings such that each is a lustrous inventory of its own particularity. Self-contained and seemingly self-generated, they inexhaustibly spin around an axis of potential: what a line can do, what a brush can do, where color can suddenly flash forth or melt away. Their contemporaneity lies in awareness that anything is possible that can be imagined as seen: sullied marks and atmospheres at the limits of the visual… The paintings of Willy Heeks industriously explore the pleasures of an optical sensuousness, embracing any memory or association encountered in the process. Miraculously, they remain abstract.

—Faye Hirsch, *Arts Magazine*, February 1991

Born: 1951 Providence, Rhode Island
Lives and works in Wakefield, Rhode Island

EDUCATION
1973-1974 Whitney Museum of American Art, Independent Study Program, New York, NY
1973 B.F.A. University of Rhode Island, Kingston, RI

GRANTS AND AWARDS (selected)
2004 Adolph and Esther Gottlieb Foundation Grant
2001 Pollock-Krasner Foundation Grant
1995 Honorary Doctor of Fine Arts, Rhode Island College
1989 National Endowment for the Arts Fellowship
1989 Painting Award, American Academy & Institute of Arts and Letters
1987 National Endowment for the Arts Fellowship
1985 Louis B. Comfort Tiffany Award
1978 National Endowment for the Arts Fellowship

ONE PERSON EXHIBITIONS (selected)
2005 Bentley Gallery, Phoenix, AZ
2005 Elizabeth Leach Gallery, Portland, OR
2004 Brian Gross Fine Art, San Francisco, CA
2003 Chiaroscuro Contemporary Art, Santa Fe, NM
2001 David Beitzel Gallery, New York, NY

GROUP EXHIBITIONS (selected)
2004 "New Directions in Contemporary Art," Sheldon Memorial Art Gallery, Lincoln, NE
2003 "Landscapes Seen and Imagined," Decordova Museum and Sculpture Park, Lincoln, ME
2000 "Six Painters," University Art Gallery, Sonoma State University, Rohnert Park, CA
1999 "Contemporary Painting," Cleveland Museum of Art, Cleveland, OH
1999 "42ND Biennial of Contemporary American Painting," Corcoran Gallery of Art, Washington, D.C.
1991 "Vital Forces: Nature in Contemporary Abstraction," Heckscher Museum, Huntington, NY
1990 "Organic Abstraction," Nelson-Atkins Museum of Art, Kansas City, MO
1988 "Ten Americans," Carnegie Museum of Art, Pittsburgh, PA

PHOTO CREDIT: CATHERINE ALLEN

"Untitled" 2001
MIXED MEDIA ON PAPER
20-1/2" x 29-1/2"

ROBERT HELM

Recently I have been thinking about the universal urge to make images. Everywhere, and long before recorded history, this basic activity can be said to be one of the defining characteristics of our shared humanity. I can't remember a time when I wasn't making visual images of some kind. I feel humbled and gratified to have spent so much of my time indulging this very basic human need.

—Robert Helm

Born: 1943 Wallace, Idaho
Lives and works in Pullman, Washington

EDUCATION
1969 M.F.A. Washington State University, Pullman, WA
1967 B.A. Washington State University, Pullman, WA

GRANTS AND AWARDS (selected)
2003-2004 Flintridge Foundation Award
1992 Governor's Award, State of Washington
1986 National Endowment for the Arts Fellowship
1986 Southeastern Center for Contemporary Art, Winston Salem, North Carolina, Award in the
 Visual Arts
1978 Deutscher Akademischer Austausch Dienst, Berlin, Germany

ONE PERSON EXHIBITIONS (selected)
2003 Linda Hodges Gallery, Seattle, WA
2002 Linda Hodges Gallery, Seattle, WA
1996 "Robert Helm 1981-1993," Boise Art Museum, Boise, ID
1995 "Robert Helm 1981-1993," Washington State University Museum of Art, Pullman, WA
1995 "Robert Helm 1981-1993," Tacoma Art Museum, Tacoma, WA
1994-1995 "Robert Helm 1981-1993," Blaffer Gallery, University of Houston, Houston, TX (traveling
 exhibition)
1991 Edward Thorp Gallery, New York, NY

GROUP EXHIBITIONS (selected)
2002 "Animal as Metaphor," Gail Severn Gallery, Ketchum, ID
2002 "Aviary," Edward Thorp Gallery, New York, NY
1998 Meyerson and Nowinski, Seattle, WA
1998 Cologne Art Fair, Cologne, Germany
1998 Gallery Reddman, Berlin, Germany
1998 L. A. Louver Gallery, Los Angeles, CA
1997 "Five Friends of Edward Kienholz," Galerie Redmann, Berlin, Germany
1990 "With the Grain: Contemporary Panel Painting," Whitney Museum of American Art, New York, NY
1987 "1987 Biennial Exhibition," Whitney Museum of American Art, New York, NY

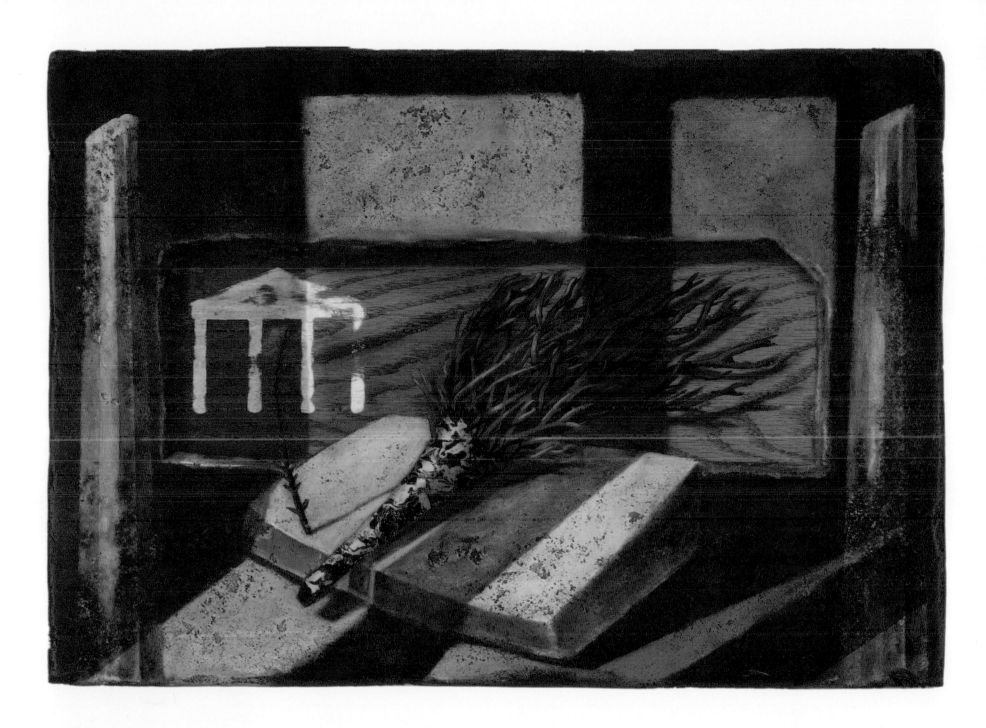

"UNTITLED" 1997
OIL/MIXED MEDIA ON WOOD PANEL
15" x 21"

WADE HOEFER

The landscape is what I know, it's the only thing I'm sure of. Remove the landscape tradition from painting and you're left with a sense of loss: it's innately cherished by the people. I'm not trying to reinvent the wheel; I'm only part of a continuum. These works are meant to slow the velocity of life, to be conversant with a sense of place in history, that continuum, a part of a long tradition. My work is made by hand, wrought in a soulful way. We're only human and we want confirmation of that.

—Wade Hoefer

Born: 1948 Long Beach, California
Lives and works in Healdsburg, California

EDUCATION
1972 M.F.A. California College of Arts and Crafts, Oakland, CA

GRANTS AND AWARDS (selected)
1997 Artist in Residence, Tamarind Institute, Albuquerque, NM
1992-1994 Artist in Residence, Experimental Workshop, San Francisco, CA

ONE PERSON EXHIBITIONS (selected)
2003 Michael Dunev Art Projects, Torroelli de Montgri, Spain
2002 Hemphill Fine Arts, Washington, D.C.
2002 Miller Block Gallery, Boston, MA
2000 Miller Block Gallery, Boston, MA
1998 John Berggruen Gallery, San Francisco, CA
1998 Miller Block Gallery, Boston, MA
1997 Monique Knowlton, New York, NY

GROUP EXHIBITIONS (selected)
2004 Contemporary Art Fair, New York, Miller Block Gallery, Boston MA
2000 "Summer Group Exhibition," David Beitzel Gallery, New York, NY
1999 "Summer Group Exhibition," David Beitzel Gallery, New York, NY
1999 "Landscape, Aspects of the Allegorical," Lisa Kurts Gallery, Memphis, TN
1999 "Fredrick Weisman Collection," Pepperdine University Art Gallery, Malibu, CA
1998 "Monotypes," Hemphill Fine Arts, Washington, D.C.
1997 "Trio of Landscape Artists: Katherine Bowling, April Gornik, Wade Hoefer," David Floria
 Gallery, Aspen, CO
1997 "Gallery Artists," Andria Friesen Gallery, Sun Valley, ID
1996 "American Landscape Painting in the 90's," Harn Museum, Gainesville, FL
1995 Monique Knowlton Gallery, New York, NY

PHOTO CREDIT: MICHAEL DUNEV ART PROJECTS

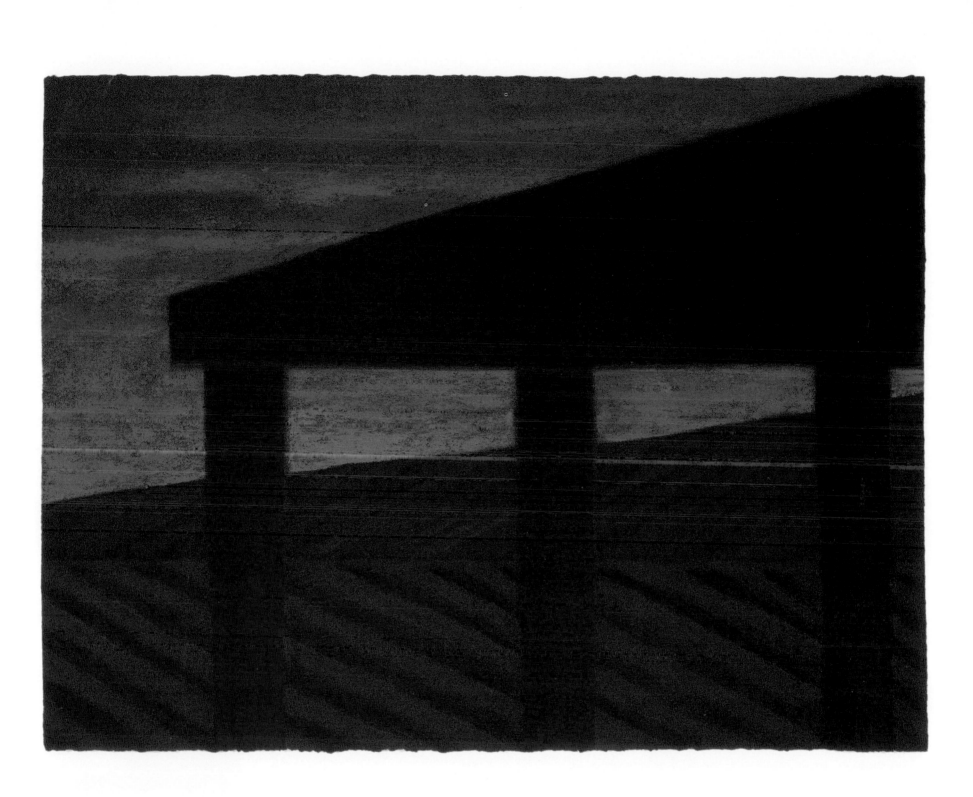

97

ROBERT HUDSON

I've been using chairs and chair images in my 3-dimensional and 2-dimensional work since 1957, when I was a student at the California School of Fine Art (now the San Francisco Art Institute). The image came up again in this label as an extension of a construction I was working on at the time. I was also thinking about a couple of people sitting down and having a glass of wine.

—Robert Hudson
April, 2005

Born: 1938 Salt Lake City, Utah
Lives and works in Cotati, California

EDUCATION
1963 M.F.A. San Francisco Art Institute, San Francisco, CA
1961 B.F.A. San Francisco Art Institute, San Francisco, CA

GRANTS AND AWARDS (selected)
1979 "Tlingit," Public Sculpture Commission under the General Services Administration's Art-in-
 Architecture Program to Execute the Sculpture
1976 John Simon Guggenheim Memorial Fellowship
1972 National Endowment for the Arts Fellowship
1965 Nealie Sullivan Award, San Francisco Art Institute, San Francisco, CA

ONE PERSON EXHIBITIONS (selected)
2004 "Robert Hudson: Sculpture/Constructions," B. Sakata Garo Fine Art, Sacramento, CA
2003 "Robert Hudson: Ceramics," Frank Lloyd Gallery, Santa Monica, CA
2001 "Robert Hudson: Ceramics," Frank Lloyd Gallery, Santa Monica, CA
2001 "Robert Hudson: Works on Paper," Robert Mondavi Gallery, Oakville, CA
2000 "Robert Hudson: Ceramics," Frank Lloyd Gallery, Santa Monica, CA
2000 "Robert Hudson: Ceramics, Drawings," Nancy Margolis Gallery, New York, NY

GROUP EXHIBITIONS (selected)
2004 "25TH Anniversary Exhibition," Sonoma State University Art Gallery, Rohnert Park, CA
2004 "Crown Point Press: Prints," Crown Point Press, San Francisco, CA
2003 "The Other Side," B. Sakata Garo Fine Art, Sacramento, CA
2003 "Color, Form & Figure," John Berggruen Gallery, San Francisco, CA
2002 "Hudson, De Forest, Holland," John Berggruen Gallery, San Francisco, CA
2001 "Hudson/Shaw Ceramics," Byron Cohen Gallery, Kansas City, MO
2001 "Collection of the Artist: Manuel Neri," Benicia, CA
2000 "Santa Barbara's 150TH Birthday Celebration," Santa Barbara, CA
2000 "Made In California, Art, Image and Identity," Los Angeles County Museum, Los Angeles, CA

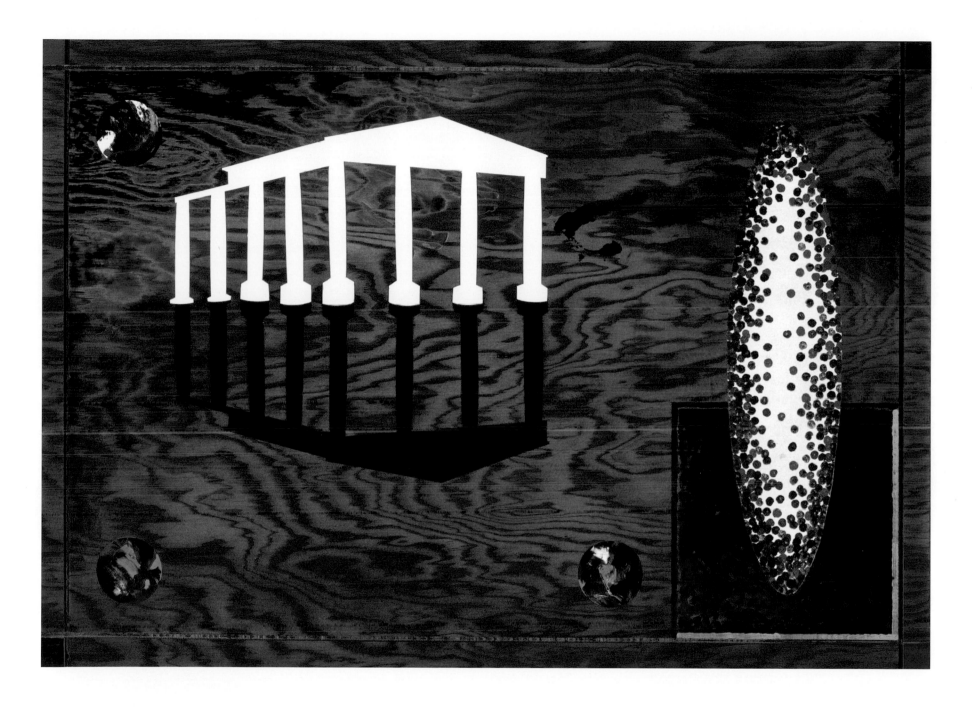

"Untitled" 1990
MIXED MEDIA ON PLYWOOD
16-1/2" x 24"

HOLLY HUGHES

I have a varied studio practice encompassing paintings, works on paper and prints, as well as ceramics. Reweaving dropped threads of development from multiple times and sites in art history, I explore a complex, colorful, image-laden form of abstraction. My work stands in distinct opposition to reductive fields of memory, and along those paths I revel in the fictions that spin off and orbit form. Inspiration from nature as processed through the decorative arts, along with forms referencing the body and a sense of place derived from landscape, merge through recombinatory strategies. Shapes just below the level of noun accumulate and encourage viewers to commit their own acts of expression through associative readings of the painting's stimuli.

—Holly Hughes

Born: 1951 San Antonio, Texas
Lives and works in New York, New York

EDUCATION
1979 B.F.A. State University of New York at New Paltz, NY

GRANTS AND AWARDS (selected)
2001 Best in Show Award, Parrish Art Museum

ONE PERSON EXHIBITIONS (selected)
2003 Shelnutt Gallery, RPI, Troy, NY
1995 Dru Arstark Gallery, New York, NY
1993 Dorry Gates Gallery, Kansas City, MO
1986 David Beitzel Gallery, New York, NY
1984 Peizo Electric, New York, NY

GROUP EXHIBITIONS (selected)
2004 "Abstraction Now," Shelnutt Gallery, Rensselaer Polytechnic Institute, Troy, NY
2001 Parrish Art Museum Show, Southampton, NY
2000 "Virginia Lynch: A Curatorial Retrospective," Rhode Island Foundation, RI
2000 "Generations II: Women Artists at the Millennium," A.I.R., New York, NY
1999 "Drawing in the Present Tense," Parsons School of Design & Aronson Gallery, New York, NY
 (traveling exhibition)
1999 "Peripheral Vision," The Painting Center, New York, NY
1999 "Part of the Fabric," Museum of Rhode Island School of Design, Providence, RI(curated by Holly
 Hughes)
1997 "Art on Paper 1997," Weatherspoon Art Gallery, Greensboro, NC

"UNTITLED" 1996
WATERCOLOR ON PAPER
15-3/4" DIAMETER

101

RICHARD HULL

It is when I take a leap of faith that counts. Then I can go back and make up a story as to why I made certain choices. I develop characters, then make up a fiction for them.

—Richard Hull, 1997 in an interview with
Kathryn Hixson, editor of *New Art Examiner*

Born: 1955 Oklahoma City, Oklahoma
Lives and works in Chicago, Illinois

EDUCATION
1979 M.F.A. The School of the Art Institute of Chicago, Chicago, IL
1977 B.F.A. Kansas City Art Institute, Kansas City, MO
1976 Skowhegan School of Painting and Sculpture, Skowhegan, ME

ONE PERSON EXHIBITIONS (selected)
2003 Carrie Secrist Gallery, Chicago, IL
2003 Robin Rule Gallery, Denver, CO
2001 Carrie Secrist Gallery, Chicago, IL
2001 Robin Rule Gallery, Denver, CO
2001 The Arts Club of Chicago, Collaboration with Ken Vandermark

GROUP EXHIBITIONS (selected)
2004 "Departures," Carrie Secrist Gallery, Chicago, IL
2004 "The Exquisite Snake," Printworks Gallery, Chicago, IL
2004 "The Poetry Center Broadside Show," Judy Saslow Gallery, Chicago, IL
2004 "Water World," South Bend Museum of Art, South Bend, IN
2004 "Modern Shadows," The Painting Center, New York City, NY
1998 Gallery A, Inc., Chicago, IL
1998 "Collaboration '98," Print Works, Chicago, IL
1997 "Landfall Press: Twenty-five Years of Printmaking in Chicago 1935-1995," Maryana Leigh Block
 Gallery, Northwestern University, Evanston, IL

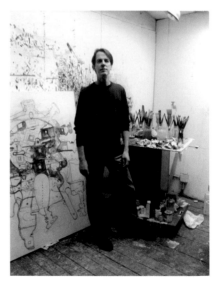

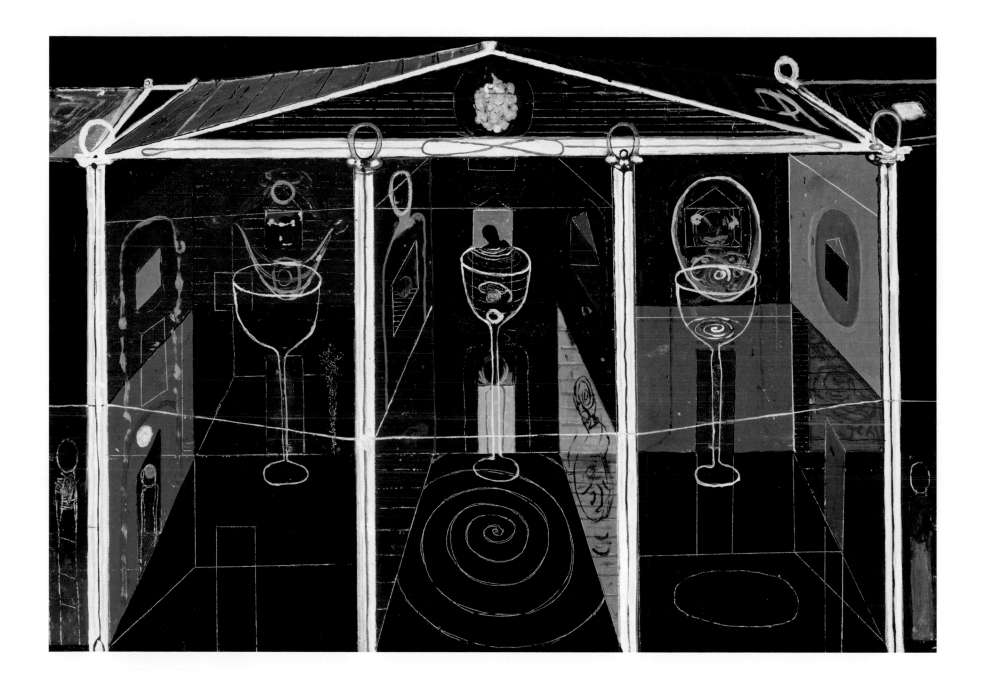

"Untitled" 2001
OIL/WAX ON LINEN
24-1/2" x 35-1/2"

103

DICK IBACH

Most of my work is autobiographical, dealing with both the nobility and stupidity of the human condition.

—Dick Ibach

Born: 1940 Yakima, Washington
Lives and works in Spokane, Washington

EDUCATION
1972 M.F.A. Pratt Institute, Brooklyn, NY
1968 B.A. Seattle University, Seattle, WA

GRANTS AND AWARDS (selected)
1991 Honorable Mention, International Compendium of the Computer Arts: der prix ars electronica, computergraphik
1970 Pratt Institute Fellowship (two years)

ONE PERSON EXHIBITIONS (selected)
1997 Green River Community College, Auborn, WA
1993 Arkansas State University, AR
1992 Linda Hodges Gallery, Seattle, WA
1991 Whatcom Museum, Bellingham, WA
1991 Linda Hodges Gallery, Seattle, WA
1988 Charleston Heights Arts Center, Las Vegas, NV

GROUP EXHIBITIONS (selected)
2003 "Two in Two Out," Spokane Falls Community College, Spokane, WA
1995 "New to the Northwest Collection," Tacoma Art Museum, Tacoma, WA
1995 "Interior Idioms: The Idiosyncratic Art of Eastern Washington," Seafirst Gallery, Seattle, WA
1992 "Northwest Tales: Contemporary Narrative Painting," University of Alaska, Juneau, AK
1991 Dutchass County Art Association, Poughkeepsie, NY
1989 Appalachian State University, Boone, NC
1988 Long Beach Museum of Art, Long Beach, CA
1986 "Third Western States Exhibition," Brooklyn Museum, NY

SELF-PORTRAIT

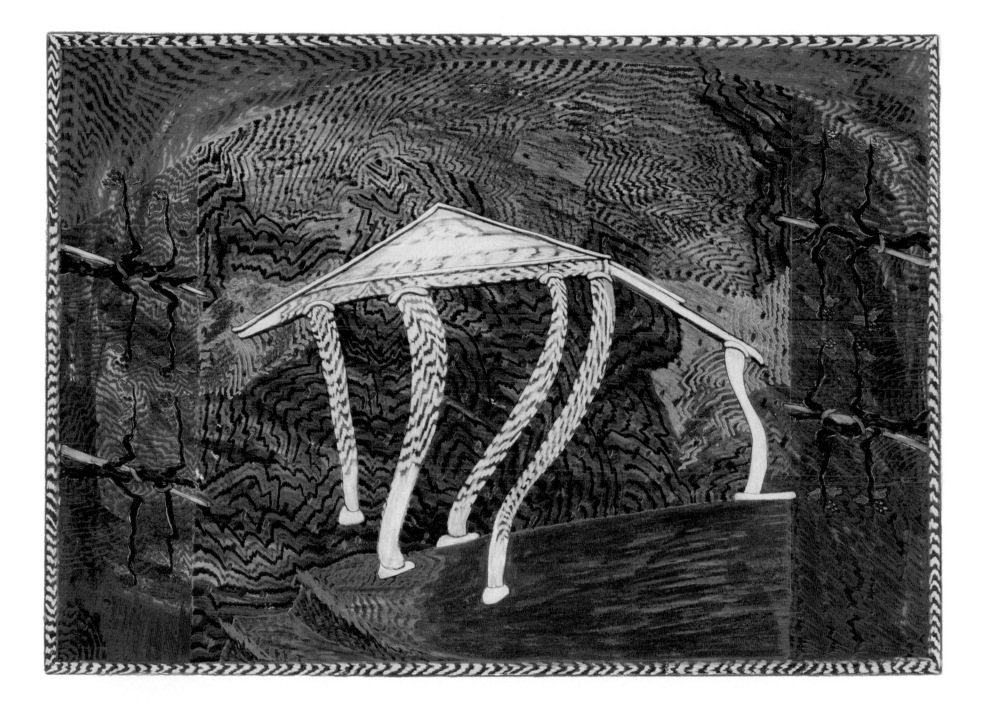

105

SHOICHI IDA

Art is not making a beautiful surface, or drawing a realistic apple. Art is getting to an essence, reaching the senses.

—Shoichi Ida
From *View*, 1989, www.crownpoint.com

Born: 1941 Kyoto, Japan
Lives and works in Ookitayama, Kita-Ku, Kyoto, Japan

EDUCATION
1965 Completed the Post Graduate Course at Kyoto Municipal University of Art, Kyoto, Japan

GRANTS AND AWARDS (selected)
2004 Cultural Award by Japanese Emperor
2000 Award for Person of Merit in Kyoto Prefectural Government
1989 The Suntory Prize '89, Grand Prize
1988 "The 12TH International Print Biennale," Krakow, Poland, Ex Aequo Prize
1986 Award for Excellence in International Cultural Exchange, with Robert Rauschenberg, The
 National Endowment for the Arts, Washington, D.C.

ONE PERSON EXHIBITIONS (selected)
2004 "Shoichi Ida Print: A Way of Thinking," Toyota Municipal Museum of Art, Toyota
1994 Life Gallery TEN, Fukuoka, Japan
1994 Gallery Ueda, Tokyo, Japan
1994 Morioka Crystal Gallery, Morioka Iwate, Japan
1993 Perimeter Gallery, Chicago, IL
1992 Fukuoka Prefectual Museum of Art, Fukuoka, Japan

GROUP EXHIBITIONS (selected)
2003 "East and West Point of Contact," with Robert Kushner, Sheehan Gallery, Whitman College, WA
1997 "International Print Exhibition- 1997," Purchase Prize
1995 "The Grand Prix of Gen Yamaguchi," Numazu
1986 "The 3RD Asian Biennale Bangladesh," Dhaka, Hounourable Mention
1986 "The Exhibition of Contemporary Art-The View of Art," São Paulo, Brazil, Medal Prize
1983 "World Print Four," Purchase Award
1982 "The 7TH British International Print Biennale," Bradford, England, Peter Millard Prize

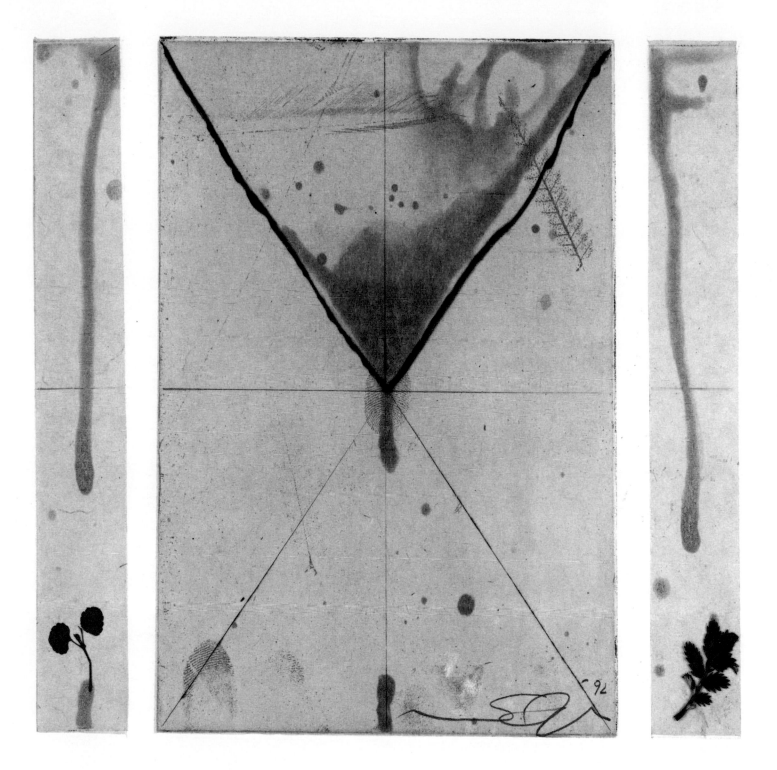

"Between Air and Water, Locus, Red" 1992
etching/drawing/mixed media on paper
15-1/2" x 13-3/4"

107

GONÇALO IVO

Light. Mediterranean colour and the visual opulence of his native land, Brazil, transform Gonçalo Ivo's painting into a plastic event. His work is imbued with a rare, mysterious tonality of colour, the result of his admiration of African art, Cézanne, Mondrian and Giotto. Rigour and deconstruction are also a feature of his painting. A son of the great poet Ledo Ivo, he is constantly acquiring experience with an innovative approach that enables him to convey a lyrical revelation of dance and the essence of colours.

—Yoo-mi Campagnol, Venice, 2002

Born: 1958 Rio De Janeiro, Brazil
Lives and works in Rio De Janeiro, Brazil and Paris, France

EDUCATION
1983 Degree in Architecture, Fluminense Federal University, Brazil
1976 Museum of Modern Art in Rio de Janeiro, Brazil

GRANTS AND AWARDS (selected)
1984 Drawing Prize VIII Carioaca Art Salon, Rio de Janeiro, Brazil
1978 IV Brazil-Japan Biennial

ONE PERSON EXHIBITIONS (selected)
2005 Design Art Gallery, Venice, Italy
2004 Anita Schwartz Galeria, Rio de Janeiro, Brazil
2004 Galerie Flak, Paris, France
2004 Instituto Moreira Salles, Rio de Janeiro, Brazil
2003 Design Art Gallery, Veneza, Italy
2002 "Pinturas," Venice Design Art Gallery, Venice, Italy
2000 "Pinturas," Dan Galeria, São Paulo, Brazil

GROUP EXHIBITIONS (selected)
2004 Arquivo Geral, Galeria Anita Schwartz, Jardim Botânica, Rio de Janeiro, Brazil
2004 Museu de Arte Latino Americana, Long Beach, CA
2004 Palo Alto Art Center, Palo Alto, CA
2004 Banco do Brasil, Rio de Janeiro, Brazil
2003 Laboratoire Sculpture Urbaine, Argel, Algeria
2002 "Exposição de inauguração da Condé Galeria de Arte," Rio de Janeiro, Brazil
2002 Coleção Centro Cultural Candido Mendes, Rio de Janeiro, Brazil
2002 "Exposição de Inauguração da TNT Escitório de Arte," Rio de Janeiro, Brazil
2002 Arco, Dan Galeria, Madrid, Spain

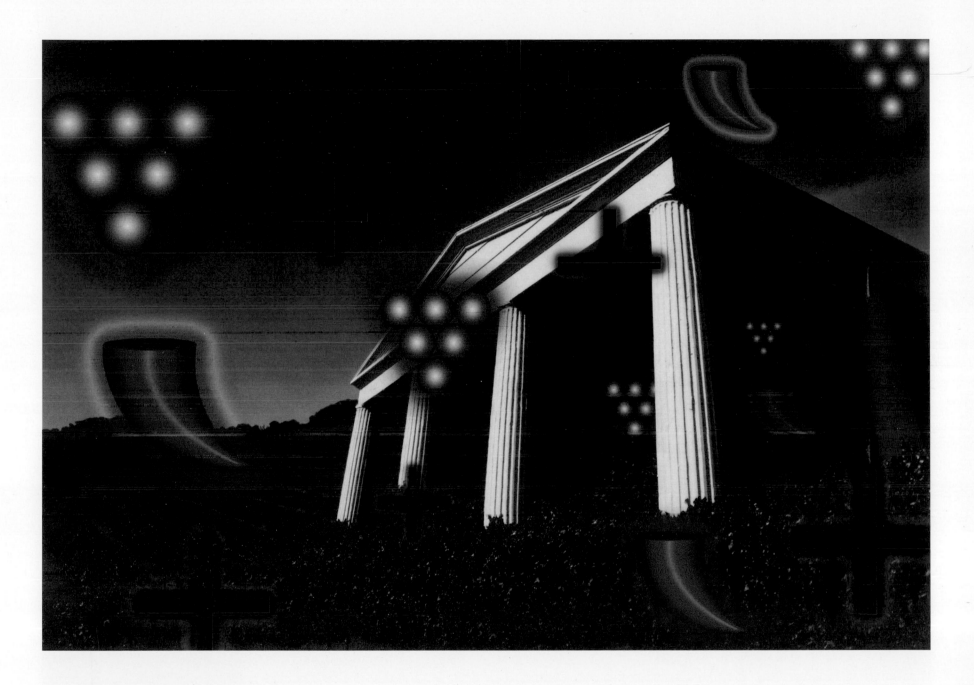

"A Positive Conjuncture" 1997
Transloc Digital Print
9-1/2" x 14"

111

ROBERT KELLY

Robert Kelly is a traveler. And he reveals his travels in his paintings. The road map includes both physical and mental journeys meticulously layered one upon another, always with the evidence of where he has been.

—Bob Nugent

Born: 1956 Santa Fe, New Mexico
Lives and works in New York, New York

EDUCATION
1978 B.A. Harvard University, Cambridge, MA

GRANTS AND AWARDS (selected)
1982 Finalist, Massachusetts Council of the Arts Grant, Drawing
1981 Finalist, Massachusetts Council of the Arts Grant, Painting
1981 Michael Karolyi Memorial Foundation
1981 Artist in Residence, Vence, France
1980 McDowell Colony, Peterborough, NH

ONE PERSON EXHIBITIONS (selected)
2005 AR Contemporary, Milan, Italy
2005 Doug Udell Gallery, Edmonton, Canada
2005 Bentley Gallery, Scottsdale, AZ
2004 John Berggruen Gallery, San Francisco, CA
2004 Linda Durham Contemporary Art, Santa Fe, NM
2004 Anne Reed Gallery, Ketchum, ID
2004 Linda Durham Contemporary Art, New York, NY

GROUP EXHIBITIONS (selected)
2005 "On Fire, Six American Artists," AR Contemporary, Milan, Italy
2005 ADAA Art Fair, John Berggruen Gallery, New York, NY
2005 Palm Beach 3, Scott White Contemporary Art, Palm Beach, FL
2004 Miami/Basel Art Fair, John Berggruen Gallery, Miami, FL
2004 MOMA Lecture Series, Greenwich, CT
2004 "Sean Scully and Robert Kelly," Anne Reed Gallery, Ketchum, ID
2004 "Celebrating 23 Years," Elizabeth Leach Gallery, Portland, OR

FIG. 85. — THE SO-CALLED THESEION AT ATHENS.
(From a photograph).

it is said, from the spoils of Marathon, — w

needed for the prosecution of their

that Athens with their money

additional details concerning the art matters

KURT KEMP

"To tell a story is to try and heal the world." This is an old Yiddish proverb I have written on my studio wall. A narrative attempts to convey a moral position, to heal, illuminate and provoke. These are some of the responses I hope my work can elicit. I have always been attracted to the darker, unlit, parts of our existence, but I am also intrigued by the absurd and humorous. Through the ironic and the comical, I hope to expose the pain and poetry of our relationships and ourselves.

—Kurt Kemp

Born: 1957 Mason City, Iowa
Lives and works in Penngrove, California

EDUCATION
1984 M.F.A. in Printmaking, University of Iowa, Iowa City, IA
1983-1985 Printer and studio assistant for Mauricio Lasansky
1981 M.A. in Printmaking, University of Iowa, Iowa City, IA
1979 B.A. Marycrest College, Davenport, IA

GRANTS AND AWARDS (selected)
2004 Appointed Professor of Prints for University of Georgia Studies Abroad Program in Italy
1999 Appointed Dayton-Hudson Distinguished Artist Teacher Chair, Carleton College, Northfield, MN

ONE PERSON EXHIBITIONS (selected)
2003 "Hen House Drawings," Hooks Epstein Galleries, Houston, TX
2003 "My Constellations," Aurobora Press and Gallery, San Francisco, CA
2000 "I Want to be James Ensor," Hooks-Epstein Galleries, Houston, TX
1999 "New Town," Carleton College Gallery, Carleton College, NM
1999 Mendocino College, Ukiah, CA
1998 "The Drunken Boat," Sonoma Arts Council Gallery, Santa Rosa, CA

GROUP EXHIBITIONS (selected)
2003 "Miniatures," Hooks-Epstein Galleries, Houston, TX
2002 "Round 1," Hooks-Epstein Galleries, Houston, TX
2001 "The Box," Hooks- Epstein Galleries, Houston, TX
2000 "The Potent Image," Mendocino College, Ukiah, CA
2000 "New Works," Susan Cummins Gallery, Mill Valley, CA
1999 "The National Print Invitational," SUNY, Brockport, NY
1999 "Fabled Impressions," American Invitational Exhibition, Lamar Dodd Museum, University of Georgia, Athens, GA

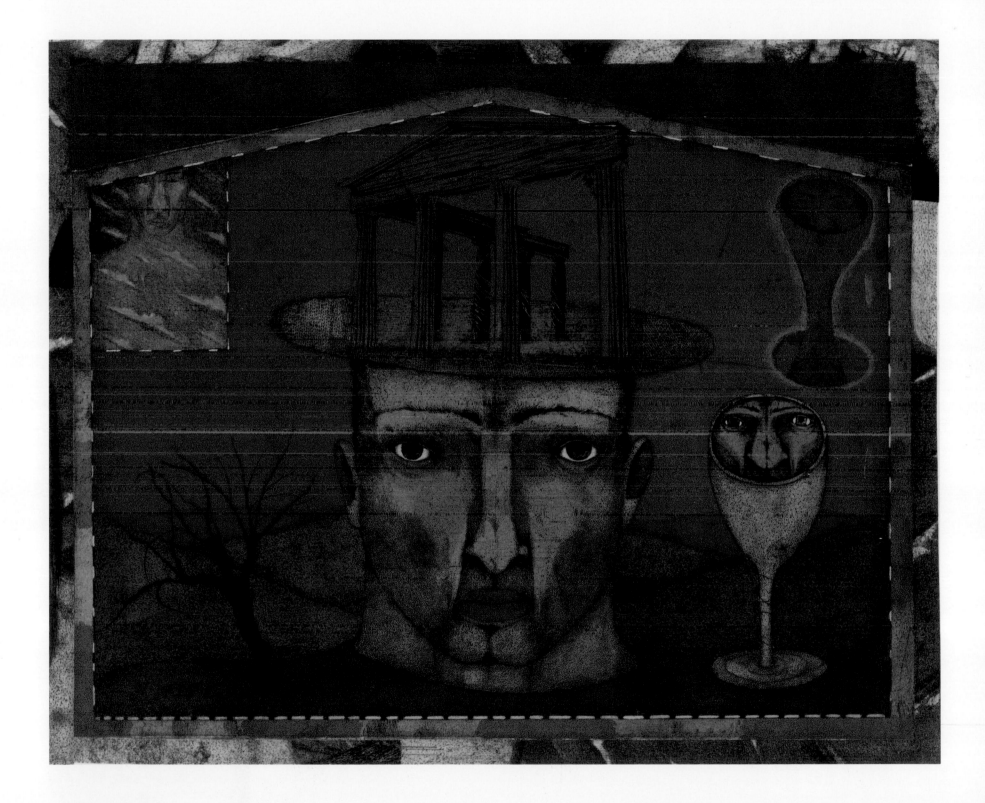

"Untitled" 1993
ETCHING/MIXED MEDIA ON PAPER
12-1/4" x 15-1/4"

115

SARAH KREPP

Sarah Krepp locates her ongoing series of paintings, drawings, and collages under the heading of "white noise," and it is no stretch of the imagination to comprehend the visual equivalent of an electronic hum in the densely layered material, technical, and textural effects of her art. From the beginning of her exhibiting career Krepp has shared with us her passion for process and color. What's been added to her repertoire in recent years is a sophisticated deployment of fragmentary and not quite legible linguistic elements that seemingly invite viewers to "read" her work as well as being absorbed with its optical pleasures.

—2002 Catalog Essay by Buzz Spector

Born: 1939 Evanston, Illinois
Lives and works in Evanston, Illinois

EDUCATION
1979 M.F.A. School of the Art Institute of Chicago, Chicago, IL
1961 B.S. Skidmore College, Saratoga Springs, IL

ONE PERSON EXHIBITIONS (selected)
2005 Roy Boyd Gallery, Chicago, IL
2003 Gallery K, Washington, D.C.
2002 Roy Boyd Gallery, Chicago, IL
1999 Betty Moody Gallery, Houston, TX
1998 Roy Boyd Gallery, Chicago, IL

GROUP EXHIBITIONS (selected)
2005 "Icy/I See," Las Manos Gallery, Chicago, IL
2002 "Underfoot," Associacão Alumni, São Paulo, Brazil (traveling exhibition) (catalog)
2000 "Sheela-na-gig: Tracing the Walled Women," I Space Gallery, Chicago, IL
1999 "Mapping the Difference," Hellenic American Institute, Athens, Greece

"Untitled" 1990
MIXED MEDIA ON PAPER
12-1/4" x 18"

DAVID KROLL

I paint refuges, places to go to for solace. I want my paintings to be destinations of quiet and calm. However, this world is fragile. The elements in the foregrounds of my paintings are items carefully constructed, either by humans or animals. Yet, they are objects easily broken or destroyed. Birds represent messengers from the wild. They embody beauty and fragility. They are visitors that remind us of lands beyond, wilderness. The distant landscapes in my paintings are remembrances of the natural past, vaguely familiar and pleasing.

—David Kroll

Born: 1956 Phoenix, Arizona
Lives and works in Bainbridge Island, Washington

EDUCATION
1986 M.F.A. The School of the Art Institute of Chicago, Chicago, IL
1980 B.F.A. San Francisco Art Institute, San Francisco, CA
1977 The Maryland Institute College of Art, Baltimore, MD

GRANTS AND AWARDS (selected)
1996-1997 Arts Midwest/NEA Regional Visual Artist Fellowship Award
1991 Artist Fellowship Award Illinois Arts Council, Chicago, IL

ONE PERSON EXHIBITIONS (selected)
2004 Zolla/Lieberman Gallery, Chicago, IL
2004 Cumberland Gallery, Nashville, TN
2004 Littlejohn Contemporary, New York, NY
2003 Grover/Thurston Gallery, Seattle, WA
2003 Lisa Sette Gallery, Scottsdale, AZ

GROUP EXHIBITIONS (selected)
2004 "Birdspace," Contemporary Arts Center, New Orleans, LA
2004 "Birds & B(ees)," Geschidle Gallery, Chicago, IL
2004 "IV Centuries of Birds," Clarke Galleries, Stowe, VT; Palm Beach, FL; New York, NY
2002 "Living in the Presence of the Buddha," Lisa Sette Gallery, Scottsdale, AZ
2001 "All-Terrain," Contemporary Art Center of Virginia, Virginia Beach, VA

"Tanagers on Bowl" 2001
OIL ON LINEN
14" x 20"

KAREN KUNC

My work in woodcut prints, etchings and artist books is a visual transform of seemingly mundane invented forms and my everyday environment, both wild and cultivated, into rich, resonate images with deep content. My lifework is thinking on, and looking at, a sense of life lived the world over - how work is done, how nature is shaped, the accident and design of the eternal life struggle. These concepts become a metaphor for my own creative processes.

—Karen Kunc

Born: 1952 Omaha, Nebraska
Lives and works in Avoca and Lincoln, Nebraska

EDUCATION
1977 M.F.A. Ohio State University
1975 B.F.A. University of Nebraska-Lincoln

GRANTS AND AWARDS (selected)
2004 Prize of the Director of the State Museum, VII International Art Triennial Majdanek, Lublin, Poland
2003 2ND Place Award, 6TH Triennale Mondiale D'Estampes Petit Format, Chamalieres, France
2003 Lance Prize, 178TH Annual Exhibition, National Academy of Design Museum, New York, NY
2000 Artist of the Year, Nebraska 2000 Governor's Arts Award
2000 Sponsor's Prize, 5TH Sapporo International Print Biennial, Hokkaido Museum of Modern Art, Japan
1996 Fulbright Scholar Award, for research travel to Finland
1996 Mid-America Arts Alliance/National Endowment for the Arts Fellowship
1992 Nebraska Arts Council Individual Artist Fellowship Master Award

ONE PERSON EXHIBITIONS (selected)
2003 Gallery APA, Nagoya, Japan
2001 Jan Cicero Gallery, Chicago, IL
2000 Galerie Dumont 18, Geneva, Switzerland
1996 Hafnarborg Institute of Culture and Fine Art, Hafnarfjordur, Iceland
1995 Joslyn Art Museum, Omaha, NE

GROUP EXHIBITIONS (selected)
2005 Biennale Internationale d'Estampes Contemporaine de Trois-Rivières, Québec, Canada
2004 "VII International Art Triennial Majdanek 2004," State Museum, Lublin, Poland
2004 "Sublime Present: International Aspects of Contemporary Print," Musashino Art University, Tokyo, Japan
2003 "4TH Egyptian International Print Triennial," Sector of Fine Arts, Cairo and Alexandria, Egypt
2003 "International Print Triennial," Krakow, Poland
2003 International Print and Drawing Exhibition, Silpakorn University, Bangkok, Thailand
2003 "Ink from Wood: Two Traditions," Center for Contemporary Printmaking, Norwalk, CT
2002 "5TH American Print Biennial," Marsh Art Gallery, University of Richmond Museums, VA
2001 International Artists Print Exhibition, Hyndai Arts Centre Gallery, Ulsan, Korea

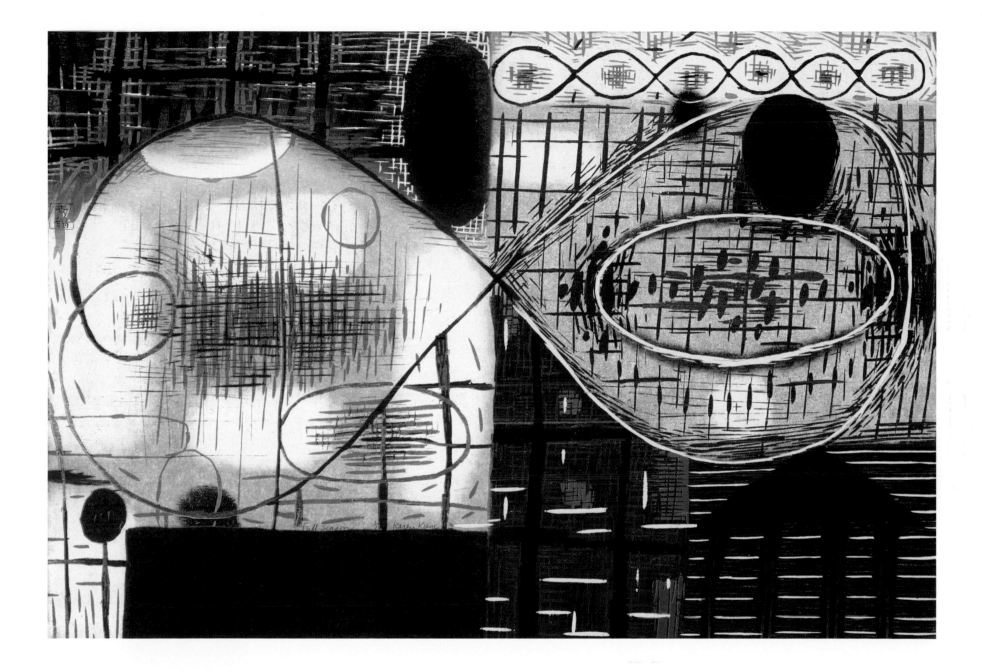

"Full Season" 1996
UNIQUE WOODCUT ON PAPER
14-1/4" x 20-3/4"

125

ROBERT KUSHNER

First recognized as a performance artist in the 1970's, Robert Kushner saw the human figure as his canvas, designing decorative costumes for the pieces he was creating. In the 1980's Robert turned to the figure as subject matter and began to paint nudes in a more conventional manner. More recently flowers have entered his work, but the decorative motif has remained. Taking a stance commonly associated with Matisse, Kushner believes that it is not a detraction to say that an artist's paintings are decorative. To this day his images remain strong and emotionally charged.

—Bob Nugent

Born: 1949 Pasadena, California
Lives and works in New York, New York

EDUCATION
1971 B.A. Visual Arts, University of California at San Diego, La Jolla, CA

ONE PERSON EXHIBITIONS (selected)
2004 "Robert Kushner: Opening Doors," DC Moore Gallery, New York, NY
2003 "Robert Kushner- Sliding Doors: Homage to John Cage," DC Moore Gallery, New York, NY
1999 "Robert Kushner: Silk Leaves/Paper Flowers," Bellas Artes, Santa Fe, NM
1998 "Robert Kushner: 25 Years of Making Art," New Jersey Center For Visual Arts, Summit, NJ
1987 Philadelphia Institute of Contemporary Art, PA (traveling exhibition)
1984 Whitney Museum of American Art, New York, NY
1984 Brooklyn Museum, Brooklyn, NY

GROUP EXHIBITIONS (selected)
2001 "Century City: Art and Culture in the Modern Metropolis," Tate Modern, London, England
2001 The Contemporary Museum, Honolulu, HI
2000 "Patterns: Between Object and Arabesque," Kunsthallen Brandts Klaedefabrik, Odens, Denmark
 (traveled to: Pori Art Museum, Pori, Finland)
1999 "The American Century: Art and Culture, 1900-2000," Whitney Museum of American Art,
 New York, NY
1997 "Art/Fashion," Guggenheim Museum Soho, New York, NY
1997 "A Prayer for Peace: Robert Kushner and Hiroshi Senju," Hiroshima Prefectural Museum, Japan
1997 "Thirty-Five Years at Crown Point Press: Making Prints, Doing Art," The National Gallery of
 Art, Washington, D.C., and Fine Arts Museum of San Francisco, CA, Palace of the Legion of
 Honor
1996 "Division of Labor: 'Women's Work' in Contemporary Art," the Bronx Museum of the Arts,
 Bronx, NY (traveled to: Museum of Contemporary Art, Los Angeles, CA)

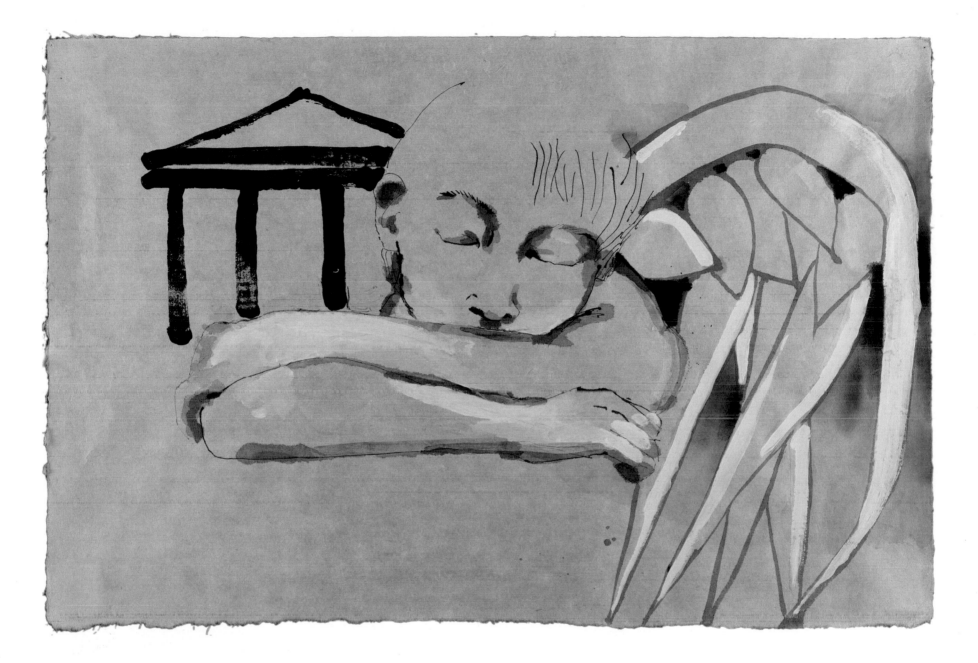

"DRUNKEN ANGEL: 1990
MIXED MEDIA ON PAPER
25-1/2" x 38-3/4"

127

TERENCE LA NOUE

La Noue has traveled extensively, bringing to his work emotions and images from a variety of cultures. Returning to the studio, he weaves and layers them into abstract compositions that carry the memory of the experience. Using paint, roplex, guaze and canvas, he masterfully explores the elements and residue of *being there*.

—Bob Nugent

Born: 1941 Hammond, Indiana
Lives and works in Patagonia, Arizona

EDUCATION
1965-1967 M.F.A. Cornell University, Ithaca, NY
1964-1965 Fulbright Meister Student, Hochschule fur Bildende Kunste, West Berlin, Germany
1960-1964 B.F.A. Ohio Wesleyan University, Delaware, OH

GRANTS AND AWARDS (selected)
1994 Honorary Doctorate of Fine Arts, Ohio Wesleyan University, Delaware, OH
1984 John Simon Guggenheim Memorial Fellowship
1983-1984 National Endowment for the Arts Fellowship
1982-1983 John Simon Guggenheim Memorial Fellowship
1973 New York City Department of Cultural Affairs Grant
1972-1973 National Endowment for the Arts Fellowship

ONE PERSON EXHIBITIONS (selected)
2001 David Beitzel Gallery, New York, NY
2001 Addison/Ripley Fine Art, Washington, D.C.
2001 Imago Gallery, Palm Desert, CA
2000 Zolla/Lieberman Gallery, Chicago, IL
2000 Flanders Contemporary Art, Minneapolis, MN
2000 Robert McClain Gallery, Houston, TX
2000 Tasende Gallery, West Hollywood, CA

GROUP EXHIBITIONS (selected)
1999 "The Story of Prints," Center for Contemporary Graphic Art and Tyler Graphics Archive Collection, Fukushima, Japan
1999 "Forms That Speak," Center for Contemporary Graphic Art and Tyler Graphics Archive Collection, Fukushima, Japan
1997 "Printed Abstraction: 3RD Exhibition of Prints from the Tyler Graphics Archive Collection-Helen Frankenthaler, Terence La Noue, Steven Sorman, Frank Stella," Center for Contemporary Graphic Art, Fukushima, Japan
1997 "Founders and Heirs of the New York School," Museum of Contemporary Art-Tokyo; Te Miyagi Museum of Art; The Museum of Modern Art-Ibaraki, Japan
1996 "New Talent, New Ideas," Charles Cowles Gallery, New York, NY
1996 "Investigations: American Abstraction," Robert McClain & Co. Fine Arts, Houston, TX
1996 Wetterling Gallery, Stockholm, Sweden
1995 Center for Contemporary Graphic Art, Fukushima, Japan

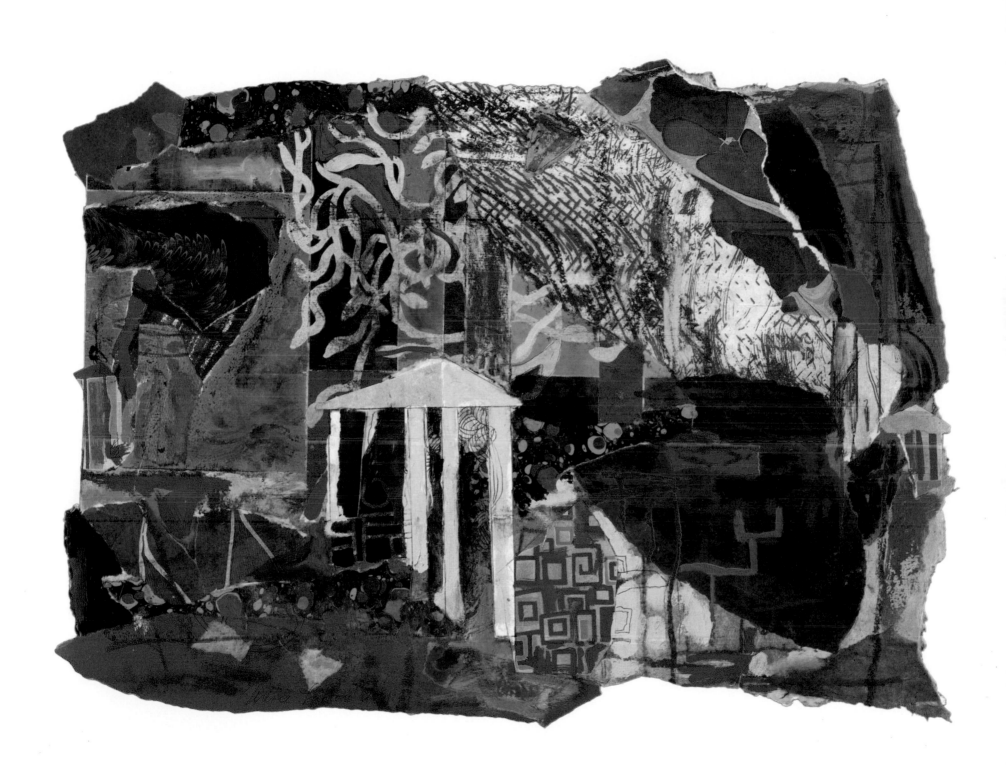

"Acragas" 2001
MIXED MEDIA ON PAPER
14-3/8" x 20"

SUSAN LAUFER

Excavation, decay and rebirth have much to do with Laufer's paintings, affecting stages in their development as well as their final look. They exert appeal because they convey the sense of something lost to us but eventually recovered, unearthed. She excavates the emotional void of the canvas like an archaeologist, making allusions to an ancient culture. Laufer forces the viewer to search for the answers buried beneath the surface.

Born: 1950 Tuckahoe, New York
Lives and works in New York, New York

EDUCATION
1975 M.A. New York University, New York, NY
1972 B.F.A. Boston University, Boston, MA

GRANTS AND AWARDS (selected)
1992 National Endowment for the Arts Fellowship
1985 The Ariana Foundation, Endowment, New York, NY
1985 The Ferkauf Foundation, New York, NY
1984 National Endowment for the Arts Fellowship

ONE PERSON EXHIBITIONS (selected)
1993 Hill Gallery, Birmingham, MI
1993 Soma Gallery, San Diego, CA
1992 Betsy Senior Fine Arts, New York, NY
1992 Center for Contemporary Art, Chicago, IL
1991 Germans van Eck Gallery, New York, NY
1991 Center for Contemporary Art, Chicago, IL

GROUP EXHIBITIONS (selected)
2002 Frederick R. Weisman Art Museum, University of Minnesota, Minneapolis, MN
2002 Associacão Brazil America, Brasilia Binational Center, Instituto Cultural Brasileiro Norte-Americano, Associacão Alumni, Brasilia, Brazil (traveling exhibition)
2002 "Underfoot," Associacão Alumni, São Paulo, Brazil (traveling exhibition) (catalog)
2001 Michael Lord Gallery, Milwaukee, WI
2001 "Iconic Images of Doorways and Windows," New York Studio School, New York, NY
2000 "New York Artists, Gary Stephan, April Gornik, Claus Oldenburg, Susan Laufer," Maruei, Nagoya Aichi, Ken, Japan
2000 "The Landscape Image," New York, Studio School, New York, NY
1998 "Woman, Woman, Woman: Artists, Objects, and Icons," Greenville County Museum of Art, Greenville, SC (catalog)

SUSAN WITH HER DAUGHTER SARAH

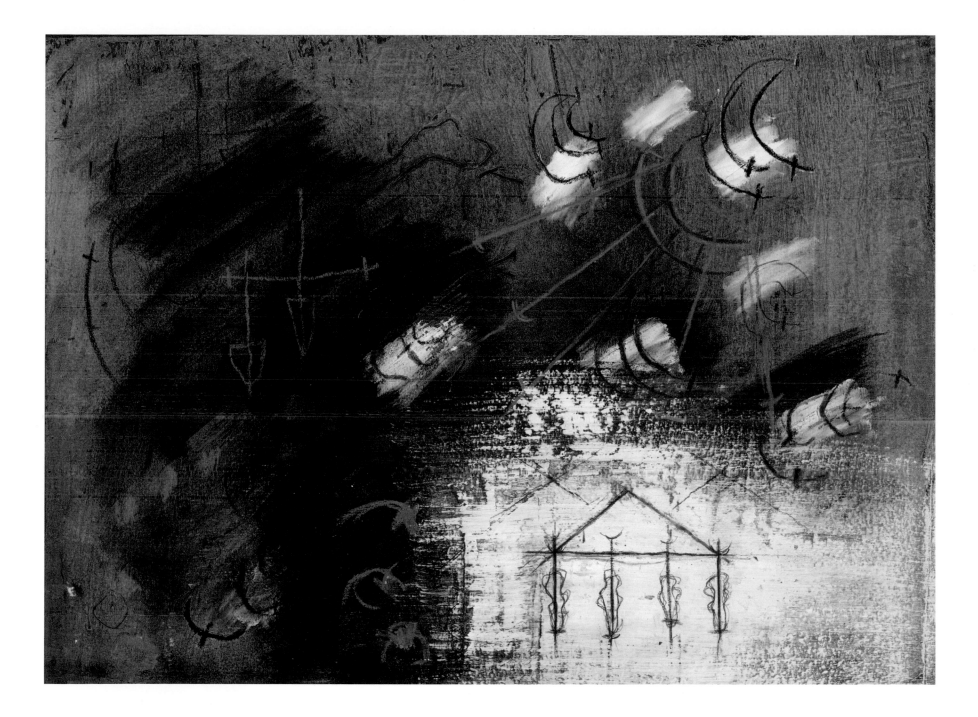

MARK LERE

In 1982 I invited Mark to create a sculpture on the campus of Sonoma State University for an exhibition I was organizing. He submitted plans for a piece called "Water Suites, The Big Bang Theory." The piece had to do with the nature of water and involved digging a sistern several feet deep. In the process of determining the site for the 1500 square foot piece, Mark and I consulted with the university's engineers and grounds crew, checking plans to make sure we were free of any underground utilities. After receiving clearance we proceeded to dig in a large grassy area behind the art building. At about three feet deep we hit something hard and stopped working. We had found the city's main waterline to the university. Mark had obviously found the appropriate site for a piece on water and almost had his own big bang.

—Bob Nugent

Born: 1950 La Moure, North Dakota
Lives and works in Glendale, California

EDUCATION
1976 M.F.A. University of California, Irvine
1973 B.F.A. Metropolitan State College, Denver, CO

ONE PERSON EXHIBITIONS (selected)
1997 Weatherspoon Art Gallery, NC
1992 Margo Leavin Gallery, Los Angeles, CA
1991 John Berggruen Gallery, San Francisco, CA
1989 North Dakota Museum of Art, Grand Forks, ND
1986 Carnegie-Mellon University Art Gallery, Pittsburgh, PA (catalog)
1986 Temple Art Gallery, Temple University, Philadelphia, PA (catalog)
1985 Museum of Contemporary Art (MOCA), Los Angeles, CA (catalog)

PUBLIC SCULPTURE COMMISSIONS (selected)
2005 City of Seattle, Washington, Seattle Scatter, Seattle, WA
2002 City of Kalamazoo, Michigan, Arcadia Commons, Kalamazoo, MI
2001 Microsoft Corporation, San Francisco, CA
1999 The Staples Center, City of Los Angeles, CA
1999 Claremont Colleges, Peter F. Drucker Graduate School of Business Management, Claremont, CA
1996 Calexico, California, GSA Border Station, Associates & Government Services Agency,
 Washington, D.C.
1995 City of Los Angeles, Los Angeles Metro Station Blue Line, Los Angeles, CA

GROUP EXHIBITIONS (selected)
1990 Stephen Wirtz Gallery, San Francisco, CA
1990 Eve Mannes Gallery, Atlanta, GA,
1990 John Berggruen Gallery, San Francisco, CA
1989 Cirrus Gallery, Los Angeles, CA
1989 Kamakura Gallery, Tokyo, American Sculptors: New York, NY and Los Angeles, CA
1989 "Five American Sculptors from the Anderson Collection," Wiegand Gallery, College of Notre
 Dame, Belmont, CA
1989 American Sculptors from the Anderson Collection
1988 The Santa Barbara Museum of Art, Figurative Impulses

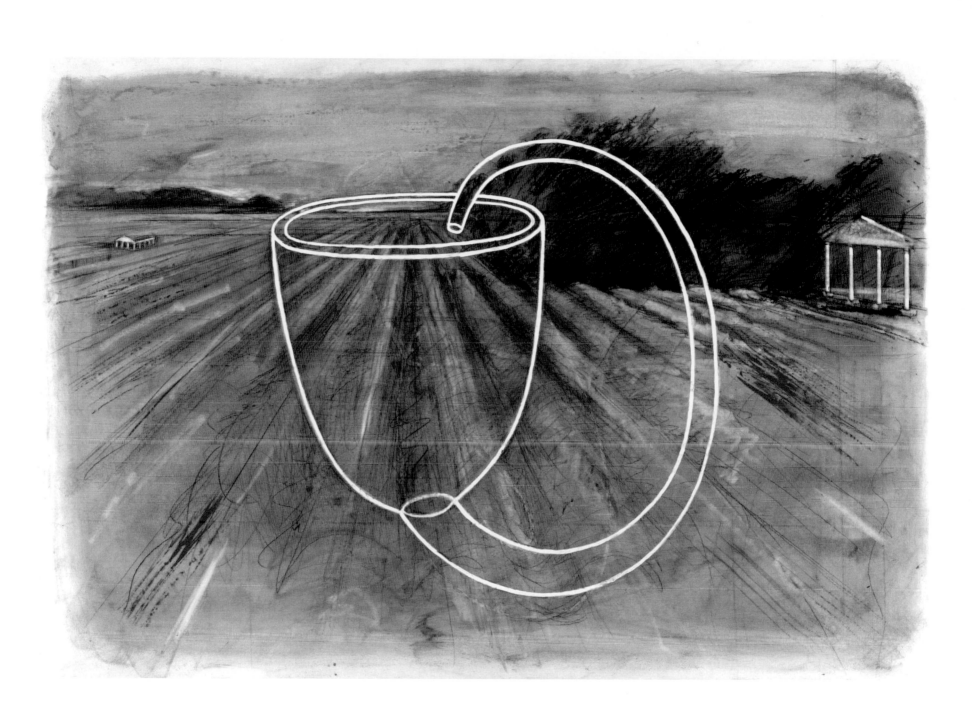

135

SOL LEWITT

Artists are mystics rather than rationalists. They leap to conclusions that logic
cannot reach.

—Sol LeWitt

From *View*, www.crownpoint.com

Born: 1928 Hartford, Connecticut
Lives and works in Chester, Connecticut

EDUCATION
1949 B.F.A. Syracuse University, Syracuse, NY

ONE PERSON EXHIBITIONS (selected)
2004 "Sol LeWitt," The RISD Museum of Art, Providence, RI
2003 "Sol LeWitt: Recent Acquisitions," Addison Gallery of American Art, Phillips Academy,
 Anodver, MA
2003 "Sol LeWitt: Wall Drawings, Gouaches," Galleria Alessandra Bonomo, Rome, Italy
2003 "Sol LeWitt: Wall Drawing," Kunstammlungen Chemnitz, Chemnitz, Germany
2002 "Sol LeWitt: Wall Drawing – New Gouaches," Galerie Sfeir Semler, Hamburg, Germany
2001 "Sol LeWitt: Incomplete Open Cubes," Wadsworth Atheneum, Hartford, CT
2000 "Sol LeWitt: A Retrospective," San Francisco Museum of Modern Art, San Francisco, CA
 (traveling exhibition)

GROUP EXHIBITIONS (selected)
2002 "Underfoot," Associacão Alumni, São Paulo, Brazil (traveling exhibition) (catalog)
2000 "Sculpture 2000," Lyman Allyn Art Museum, CT
1999 "Art in Our Time: 1950 to the Present," Walker Art Center, Minneapolis, MN
1999 "20twenty," Fraenkel Gallery, San Francisco, CA (catalog)
1999 "Sol LeWitt: Sculpture and Drawings; Jenny Holzer: Multiples, SCAI The Bathhouse, Tokyo,
 Japan
1999 "Global Conceptualism: Points of Origin, 1950s-1980s," Queens Museum of Art, NY (traveling
 exhibition)
1998 "Matched Pairs: Sculpture and Drawings," John Webber Gallery, NY
1998 "Sequences: A portfolio of work by 29 artists," Edition Schellmann, NY
1998 "Construction in Process VI - The Bridge," The Artists Museum, Australia
1998 "Group Exhibition," Galerie Lelong, NY
1998 "UTZ: A Collected Exhibition," Lennon, Weinberg Gallery, NY
1998 "Great Graphics," Karen McCready Fine Art, NY

PHOTO CREDIT: BOB NUGENT

"Benziger Print" 1998
WOODBLOCK PRINT
10" x 14"

137

HUNG LIU

I paint from photographs of historical China. These have included 19ᵀᴴ-century images of Chinese female "types," child street acrobats, war refugees, and women laboring at such tasks as pulling a boat upriver, operating an industrial scale loom and walking in circles (like mules) behind the handle of a millstone grinder. As a painter, I want to expose the documentary authority of photographs to the more reflective process of painting; I want to both preserve and destroy the image. Much of the meaning of my painting comes from the way the washes and drips dissolve the historical photographs I paint from, opening them to a slower kind of looking, suggesting perhaps the cultural and personal narratives fixed in the photographic instant. I also weave passages from traditional Chinese bird and flower painting into the photographic field, further agitating the images and evoking a sense of the cultural memory underlying the surfaces of history. In other words, two layers of historical representation, from traditional painting and modern photography, co-exist in my new paintings, and the result, I think, is a kind of mutual liberation and reinvention. I am looking for the mythic pose beneath the historical figure, and the painting beneath the photograph.

—Hung Liu

Born: 1948 Changchun, China
Lives and works in Oakland, California

EDUCATION
1986 M.F.A. in Visual Arts, University of California at San Diego, La Jolla, CA
1981 Graduate Student (M.F.A. equivalent) Mural Painting, Central Academy of Fine Art, Beijing, China
1975 B.F.A. in Education, Beijing Teachers College, Beijing, China

GRANTS AND AWARDS (selected)
2000 Outstanding Alumna Award, University of California at San Diego, La Jolla, CA
1998 The Joan Mitchell Foundation, Inc. Painters Sculptors Grant, New York, NY
1993 Eureka Fellowship, The Fleishhacker Foundation, San Francisco, CA
1992 Society for the Encouragement of Contemporary Art Award, San Francisco Museum of Modern Art, San Francisco, CA
1991 National Endowment for the Arts Fellowship (Painting)
1989 National Endowment for the Arts Fellowship (Painting)

ONE PERSON EXHIBITIONS (selected)
2005 "Fragments," Nancy Hoffman Gallery, New York, NY
2004 "Relic," Bernice Steinbaum Gallery, Miami, FL
2003 "Toward Peng-Lai (Paradise)," Rena Branstein Gallery, San Francisco, CA
2002 "Strange Fruit: New Paintings by Hung Liu," Arizona State University Art Museum, Tempe, AZ
2000 "Where is Mao? 2000," The Art Center, Center of Academic Resources, Chulalongkom University, Bangkok, Thailand

GROUP EXHIBITIONS (selected)
2003 "At Work: The Art of California Labor," Fine Arts Gallery, San Francisco State University, CA
2003 "Vertigo," San Francisco Museum of Modern Art, San Francisco, CA
2002 "Art/Woman/California: Parallels and Intersections, 1950-2000," San Jose Museum of Art, San Jose, CA
2000 "Text and Subtext-Contemporary Art and Asian Women," Earl Lu Gallery, La Salle-Sia College of the Arts, Singapore (traveling exhibition)
1999 "The View From Here," Tretyakov Gallery, Moscow, Russia
1998 "American Stories: Amidst Displacement & Transformation," Setagaya Art Museum, Tokyo, Japan (traveling exhibit)
1996 "American Kaleidoscope: Themes and Perspectives in Recent Art," National Museum of American Art, Washington, D.C. (catalog)
1994 "The 43ᴿᴰ Biennial Exhibition of Contemporary American Painting," The Corcoran, Washington, D.C.

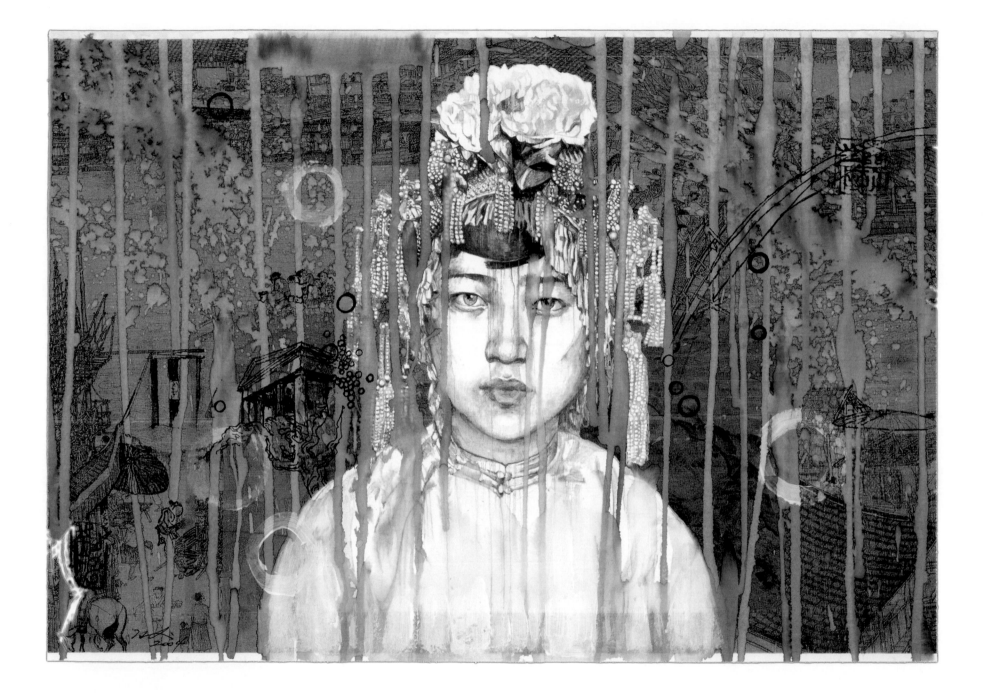

"Untitled" 2004
WATERCOLOR/GOUACHE/INK ON PAPER
13" x 18-3/4"

PAM LONGOBARDI

My recent paintings begin as tondos, or oval shapes, suggestive of a mirror. They serve as "worlds" that model our prevailing experience with nature. Patina fields on copper create a raw, wild environment that is inhabited by pictures of nature, cultural imprints that claim the space, civilize it. The Renaissance belief of painting as a 'mirror of nature' expands to reflect back a constructed view of the universe. I am interested in the idea of the positioning of the ego in an attempt to locate the self amidst the incomprehensibility of nature. Details of human presence such as small suburban homes, or tiny faces, create an entry point, a locus of comfort in a vast realm. They populate the space as an analogy to humanity's need to put our face on the world; the paintings then work as a kind of mapping of painting space as a domination of the universe, a transformation of nature to the fulfillment of ego and pleasure. Scale is subverted as microscopic forms loom gigantic. A system or network of strands and webs connects elements and defines the depth of the space. The voids are filled with particles and vapors. They are not empty.

—Pam Longobardi

Born: 1958 Montclair, New Jersey
Lives and works in Atlanta, Georgia

EDUCATION
1985 M.F.A. Montana State University, Bozeman, MT
1981 B.F.A. University of Georgia, Athens, GA

GRANTS AND AWARDS (selected)
2004 Finalist, Chicago Department of Cultural Affairs, Public Art Program Commission Competition, Chicago, IL
2001 Finalist, Atlanta Hartsfield Airport E-Concourse Expansion Commission Competition, Atlanta, GA
1999 Artist Residency Fellowship, Franz Masereel Center, Kasterlee, Belgium
1996 Visual Artist Fellowship, Tennessee Arts Commission
1994 SAF/NEA Visual Artist Fellowship, Painting
1993 USIA Arts America Lecturing Grant, Helsinki, Finland
1993 College of Liberal Arts Faculty Excellence in Research Award, University of Tennessee, TN

ONE PERSON EXHIBITIONS (selected)
2004 "Artificial Kingdoms," Sylvia Schmidt Contemporary Art, New Orleans, LA
2004 "Worlds Within Worlds," Jacksonville Museum of Modern Art, Jacksonville, FL
2001 "Beyond the Frame," Knoxville Museum of Art, Knoxville, TN
2000 "World World," Lowe Gallery, Atlanta, GA
1998 "Animal/Beautiful," Lowe Gallery, Atlanta, GA (catalog)

GROUP EXHIBITIONS (selected)
2004 "Breathing Space," Metaphor Contemporary Art, Brooklyn, NY
2004 "Birdspace," Hudson River Museum, Yonkers, NY (traveling exhibition)
2003 "Skin: Contemporary Views of the Body," Jacksonville Museum of Modern Art, Jacksonville, FL (catalog)
2003 "Drawing Voices: Encounter," Galerie Entropia, Wroclaw, Poland (collaborative works with Craig Dongoski)
2002 "Pearl of the Third Mind," Gusto House Gallery, Kobe, Japan (collaborative works with Craig Dongoski)
2001 "Saints and Sinners," Piazza Repubblica, Cortona, Italy (traveling exhibition)
2001 "Art and Science International Exhibition," 90TH Anniversary Tsinghua University Global Symposium, National Museum of Fine Art, Beijing, China
1997 "Instinct and Intellect: Leslie Dill, Pam Longobardi, Allison Saar, Kara Walker," Monique Knowlton Gallery, New York, NY

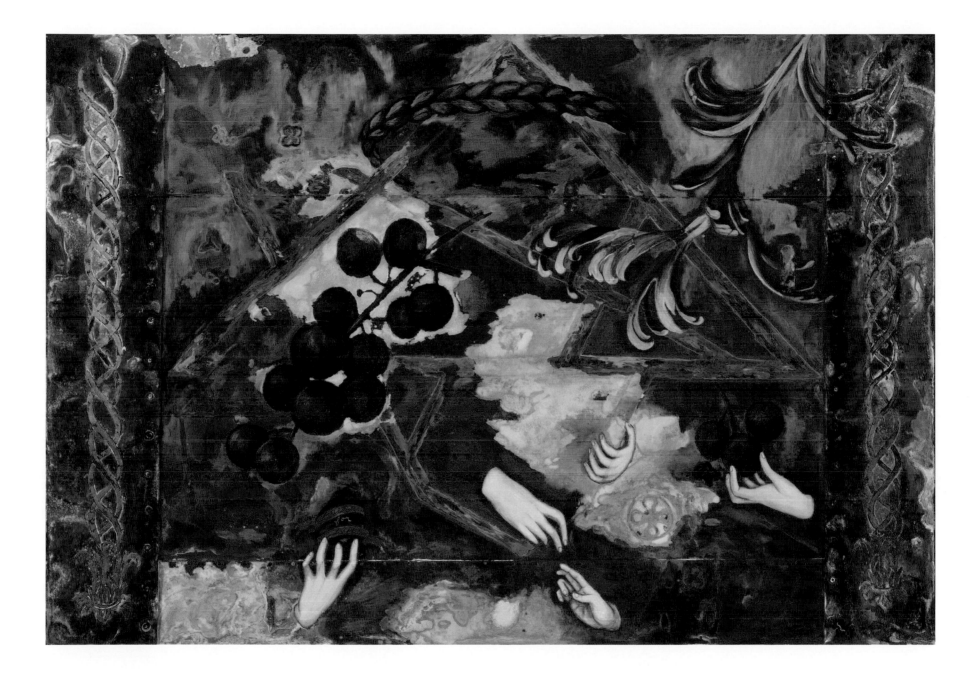

MICHAEL MANZAVRAKOS

We can only witness
as gnarled tendrils, like bony fingers
grapple in the silent struggle
with the dry red earth.

We can only witness
the unlikely marriage
of the suffocating ageless dirt
and the persistent twisted vines.

We can only witness
through the yellow day
through the blue night
and listen in vain
for a straining sound.

We can only witness
and testify to the sweetness of the fruit.

—Michael Manzavrakas

Born: 1951 Minneapolis, Minnesota
Lives and works in Minneapolis, Minnesota

EDUCATION
1969-1974 University of Minnesota

GRANTS AND AWARDS (selected)
1993 Ballinglen Arts Foundation, Residency Fellowship, Co. Mayo, Ireland
1985 Minneapolis Independent Choreographers Alliance, Commission
1980 Minnesota State Arts Board Project Grant
1977 Minnesota State Arts Board Project Grant

ONE PERSON EXHIBITIONS (selected)
1995 Carolyn Ruff Gallery, Minneapolis, MN
1991 Carolyn Ruff Gallery, Minneapolis, MN
1991 Steensland Gallery, St. Olaf College, Northfield, MN
1990 Piper, Jaffray, Hopwood, Inc., Minneapolis, MN
1988 Dolan/Maxwell Gallery, Philadelphia, PA
1987 Thomson Gallery, Minneapolis, MN

GROUP EXHIBITIONS (selected)
2004 AVA Gallery and Art Center, Lebanon, NH
1997 "A Thought Intercepted," California Museum of Art, Santa Rosa, CA
1995 New Navy Pier Show, Chicago, IL
1994 New Navy Pier Show, Chicago, IL
1994 Balkan Context, University of Minnesota, MN
1994 Gallery André Milan, São Paulo, Brazil
1994 "The Artist in Rural Ireland," Philadelphia Art Alliance, Philadelphia, PA
1993 ART 93 London, England
1993 "Original Prints," Royal Academy, London England

KARA MARIA

My paintings reflect my anxiety about the products and pollution of our synthetic culture as it is spread through the media, the military and other sources of corporate sponsored global homogenization. Cheerfully apocalyptic, the work is intended to simultaneously attract and repel, blending beauty and toxicity, as in the supersaturated colors of a smoggy sunset.

—Kara Maria

Born: 1968 Binghamton, New York
Lives and works in San Francisco, California

EDUCATION
1998 M.F.A. University of California at Berkeley, Berkeley, CA
1993 B.A. University of California at Berkeley, Berkeley, CA

GRANTS AND AWARDS (selected)
2001 Jury Award, The Art Council, Grants to Individual Artists Program, San Francisco, CA
1997 Eisner Prize in Art, University of California, Berkeley, CA
1996 Marian Hahn Simpson Fellowship in Art, University of California, Berkeley, CA

ONE PERSON EXHIBITIONS (selected)
2005 Smith Andersen Editions, Palo Alto, CA
2004 "Almost Paradise," Miller/Block Gallery, Boston, MA
2002 "Fools Rush In," Catharine Clark Gallery, San Francisco, CA
2001 "Plastic Picnic," Catharine Clark Gallery, San Francisco, CA
2000 a.o.v., "Plastic Dreams," San Francisco, CA

GROUP EXHIBITIONS (selected)
2004 "Paper Bullets," Intersection for the Arts, San Francisco, CA
2004 "See California Now," Gallery C, Hermosa Beach, CA
2004 "Terrible Danger Ahead!" Pelham Art Center, Pelham, NY (catalog)
2004 "New Prints 2004/Summer," International Print Center New York, New York, NY
2004 Nevada Museum of Art, Robert Z. Hawkins Contemporary Gallery, Reno, NV
2003 "Food Matters: Explorations in Contemporary Art," Katonah Museum of Art, Katonah, NY (catalog)
2003 "Splat, Boom, Pow! The Influence of Cartoons in Contemporary Art," Contemporary Arts Museum, Houston, TX (catalog)
2000 "Abstraction: From Raucous to Refined," Bedford Gallery, Dean Lesher Center, Walnut Creek, CA

"SPLAT, BOOM, POW" 2004
ACRYLIC ON PAPER
16-1/2" x 24"

145

TOM MARIONI

The art of drinking beer with friends is the highest form of art.

—Tom Marioni 1970

Born: 1937 Cincinnati, Ohio
Lives and works in San Francisco, California

EDUCATION
1955-1959 Art School Cincinnati, OH

GRANTS AND AWARDS (selected)
1986 Asian Cultural Council Travel Grant to Japan
1984 National Endowment for the Arts Fellowship
1981 John Simon Guggenheim Memorial Fellowship
1980 National Endowment for the Arts Fellowship
1976 National Endowment for the Arts Fellowship

ONE PERSON EXHIBITIONS (selected)
1993 "Landscapes," Crown Point Press, San Francisco, CA
1993 "Photograms," Robert Koch Gallery, San Francisco, CA
1990 "Starting Over: the Artist's Studio," Capp Street Project, San Francisco, CA
1987 Margarete Roeder Fine Arts, NY
1987 "Cutting the Mustard," A La Limit, Dijon, France
1977 The de Young Museum, San Francisco, CA
1975 Galeria Foksal, Warsaw, Poland

GROUP EXHIBITIONS (selected)
1998 "Out of Actions," Los Angeles Museum of Contemporary Art, Los Angeles, CA
1994 "Lasting Concept," Artists Space, NY
1994 "Solid Concept," Gallery Paule Anglim, San Francisco, CA
1991 "Prints by Sculptors," Crown Point Press, NY
1990 "In Site: Five Conceptual Artists from the Bay Area," University Gallery, University of Massachusetts, Amherst, MA
1989 "Forty Years of California Assemblage," Wight Art Gallery, University of California, Los Angeles, CA

"Untitled" 1996
PENCIL/COLLAGE ON PAPER
16-1/2" x 24-1/2"

147

PAMELA MARKS

What's ironic about Marks' careening visions is that they're carefully composed and wild at the same time. Her shapes spiral exuberantly across the three-dimensional space she's created, a Pollock-like thicket of lines and spirals that seem to recede into infinity. Her globes and pears appear headed for cacophonous birth, through the black vortexes in the middle ground, and into the light in the background. And yet this fertile chaos is meticulously planned, with each squiggle duly occupying its designated niche. The movement has been captured, and stilled like a butterfly pinned to a board.

—Margaret Regan, "Hue and Cry," *Tucson Weekly*, 2003

Born: 1953 Freeport, Illinois
Lives and works in Quaker Hill, Connecticut

EDUCATION
1980 M.F.A. in Painting, University of Arizona, Tucson, AZ
1976 B.F.A. in Painting and Drawing, University of Illinois, Champaign-Urbana, IL

GRANTS AND AWARDS (selected)
1999 MacDowell Colony Fellow, Peterborough, NH
1994 Public Art Purchase Prize for Arizona Health Science Library, University of Arizona, AZ
1991 Tucson Pima Arts Council Visual Arts Fellowship
1986 Artist in Residence, Altos de Chavon, Dominican Republic

ONE PERSON EXHIBITIONS (selected)
2004 Arno Maris Gallery, Westfield State College, Westfield, MA
2003 Davis Dominguez Gallery, Tucson, AZ
2001 New Space Gallery, Manchester College, Manchester, CT
2000 Gaddis Geeslin Gallery, Sam Houston State University, Huntsville, TX
1995 "Bird Paintings," Tucson Airport Authority, Tucson, AZ
1986 Galleria Principal, Altos de Chavon, Dominican Republic
1982 Artspace Gallery, Los Angeles, CA

GROUP EXHIBITIONS (selected)
2003 Foundation Mona Bismarck, Paris, France
2003 Institut Franco-American, Rennes, France
1996 "Irene Leach Memorial Exhibition," Chrysler Museum of Art, Norfolk, VA
1995 Discovery Museum, Bridgeport, CT
1995 "Arizona Biennial," Tucson Museum of Art, Tucson, AZ
1990 "Southwest '90," Museum of Fine Arts, Santa Fe, NM
1987 "Hecho en Chavon," National Museum of Fine Arts, Santo Domingo, Dominican Republic
1985 "Phoenix Biennial," Phoenix Art Museum, Phoenix, AZ

"WILD GRAPES" 2004
WATERCOLOR ON PAPER
16-1/2" x 24-1/4"

149

JOSEPH MARUSKA

There is a story about Maruska as a young painter: When he was just beginning to study fine art, he enrolled in a drawing class. The assignment one session was to draw without traditional tools or materials (i.e. pencils, brush, or ink). Maruska found himself in the ceramics studio, and composed his drawing with clay slip and his bare hands. This was the first exercise in what has flourished into a mature and meditative approach to abstract drawing and painting.

—Selection from a piece by Shana Nys Dambrot

Born: 1963 Los Angeles, California
Lives and works in Los Angeles, California

EDUCATION
1986 B.F.A. University of Southern California

ONE PERSON EXHIBITIONS (selected)
2005 Kimzey Miller Gallery, Seattle, WA
2005 Greenwood Chebithes Gallery, Laguna Beach, CA
2005 Susan Street Fine Art, Solana Beach, CA
2004 Kimzey Miller Gallery, Seattle, WA
2004 Greenwood Chebithes Gallery, Laguna Beach, CA

GROUP EXHIBITIONS (selected)
2000 "Group Show," Galerie 224, Laguna Beach, CA
2000 "Group Show," Patricia Corriea Gallery, Santa Monica, CA
2000 "Group Show," Kimzey Miller Gallery, Seattle, WA
1999 "Group Show," Galerie Christine Colas, Paris, France
1999 "Two Man Show," Kimzey Miller Gallery, Seattle, WA
1999 "Group Show," Patricia Corriea Gallery, Santa Monica, CA
1998 "Group Show," Kimzey Miller Gallery, Seattle, WA
1998 "Group Show," Patricia Corriea Gallery, Santa Monica, CA
1998 "Group Show," Gensler & Associates, Santa Monica, CA

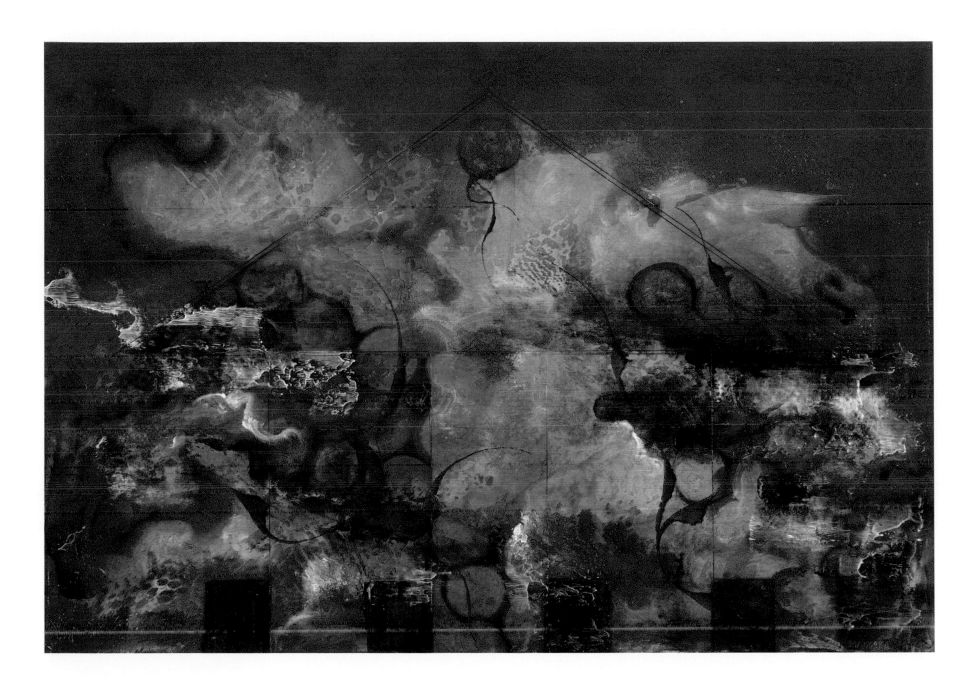

RICARDO MAZAL

A quiet and thoughtful man, Ricardo works from an interior space and composes his imagery based upon personal experience. His reflections on life, art, music and the human psyche are composed masterfully for us to contemplate.

—Bob Nugent

Born: 1950 Mexico City, Mexico
Lives and works in New York, New York and Santa Fe, New Mexico

EDUCATION
1975 M.F.A. University of Illinois Champaign-Urbana, IL
1973 B.A. Universidad Ibero Americana Mexico City, Mexico

GRANTS AND AWARDS (selected)
2002 "Creador Artistico," Sistema Nacional de Creadores de Arte (FONCA), Mexico
1999 "Creador Artistico," Sistema Nacional de Creadores de Arte (FONCA), Mexico
1991 Pollock-Krasner Foundation Grant

ONE PERSON EXHIBITIONS (selected)
2004 "Ricardo Mazal, La Tumba de la Reina Roja: From Reality to Abstraction," Museo Nacional Antropología, Mexico City (catalog)
2004 "Ricardo Mazal, Paintings and Monotypes from the series La Tumba de la Reina Roja," Chiarosco Contemporary Art, Santa Fe, NM
2004 "Ricardo Mazal, Obra Reciente," Mas Art Moderno y Contemporáneo, Barcelona, Spain
2003 "Ricardo Mazal, New Paintings," Elins/Eagles-Smith Gallery, San Francisco, CA
2003 "Ricardo Mazal, New Monotypes," Aurobora Press, San Francisco, CA

GROUP EXHIBITIONS (selected)
2004 "Ray Smith, Fernanda Brunet, Sylvia Fernandez, Ricardo Mazal y Victor Rodríguez," Galería Lucía de la Puente, Lima, Peru
2003 "Siglo XX: Grandes Maestros Mexicanos (The Twentieth Century: Great Mexican Masters)," Museo de Arte Contemporáneo de Monterrey (MARCO), Monterrey, NL
2003 "Abstract Art, New Mexico Artist Series," Anderson Contemporary Art, Santa Fe, NM
2003 "Paper," Ramis Barquet Gallery, New York, NY
2003 ARCO, Galeria Ramis Barquet, Madrid, Spain
2002 "Beau Geste: Abstract Paintings in Torroella di Montgrí," Michael Dunev Art Projects, Torroella de Montgrí, Girona, Spain
2002 "Arte de America Latina," Galeria Lucia de la Puente, Lima, Peru
2002 "Wrapped," Evo Gallery, Santa Fe, NM
2002 "Group Show," Michel Dunev Gallery, Ampurdan, Spain

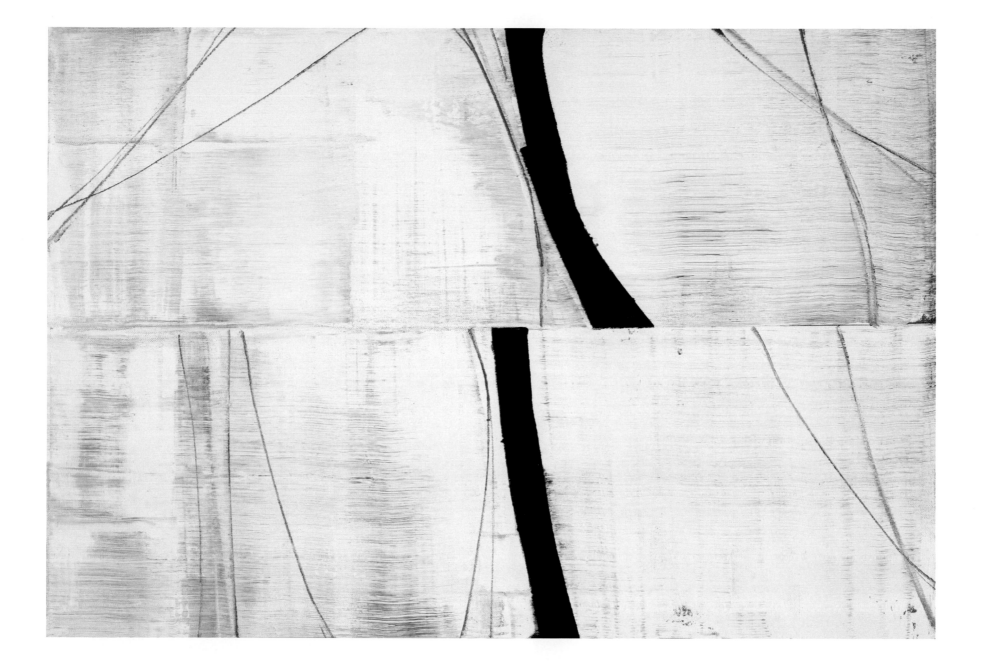

"Benziger Image?" 2003
OIL ON LINEN
24-3/4" x 36"

153

ROBERT MCCAULEY

I work in the corridor between man and nature.

—Robert McCauley

Born: 1946 Mount Vernon, Washington
Lives and works in Rockford, Illinois

EDUCATION
1972 M.F.A. Washington State University
1969 B.A. Western Washington University

GRANTS AND AWARDS (selected)
1999 Illinois Arts Council Fellowship (Painting)
1994 Rockford College Research Grant, Kwakwaka'wakw Culture, Vancouver Island
1991 Illinois Arts Council Fellowship (Drawing)
1982 National Endowment for the Arts Fellowship (Drawing)
1981 Illinois Arts Council Fellowship (Sculpture)

ONE PERSON EXHIBITIONS (selected)
2005 "Robert McCauley: Nature as Teacher," Palo Alto Cultural Center, Palo Alto, CA
2005 K. Kimpton Contemporary Art, San Francisco, CA
2005 Linda Hodges Gallery, Seattle, WA
2004 Perimeter Gallery, Chicago, IL
2004 Gail Severn Gallery, Sun Valley, ID

GROUP EXHIBITIONS (selected)
2005 "Magnificent Extravagance: Artists and Opulence," Racine Art Museum
2004 "Water World," South Bend Museum of Art, IN
2004 "Mark My Word: text, code and literary allusion," Museum of Northwest Art
2002-2003 "Framing the Wild: Animals on Display," University of Wyoming (traveling exhibition)
2002 "Wild Life: The Other Tradition," Polk Museum of Art, FL
2001 "Departure: American Contemporary Landscape," IUN Gallery for Contemporary Art, IN
2001 "Faculty Exhibition," Anderson Ranch, Aspen, CO
1995-1996 "Unpainted to the Last: Moby-Dick and American Art, 1940-1990," Spencer Museum of Art,
 Lawrence, KS (traveling exhibition)

PHOTO CREDIT: BOB NUGENT

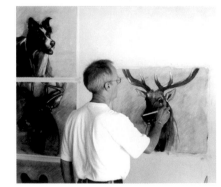

"ROMANTICISM IN THE LAST DECADE OF THE 20ᵀᴴ CENTURY" 1995
OIL/LEAD ON WOOD AND CANVAS
24" x 34-3/4" x 4"

155

FRANCES MCCORMACK

Part of what makes McCormack's works seductive is their abundant passion for the craft of painting. Some of the pleasure of looking at them is in the details: her graceful definition of line, her ability to create a form and make it fade from view. Another of their prime qualities is a finely tuned tension between exuberant form and structure.

—Robert Pincus, *San Diego Union Tribune*, December 23, 2004

Born: 1952 Boston, Massachusetts
Lives and works in Sonoma, California

EDUCATION
1986 M.F.A. University of California at Berkeley, CA
1978 B.A. in English, University of Massachusetts

GRANTS AND AWARDS (selected)
2000 American Academy in Rome, SFAI Fellowship
1997 Djerassi Residency, Painting, Woodside, CA
1996 Buck Foundation, Marin Arts Council, Individual Artist Grant
1991 Buck Foundation, Marin Arts Council, Individual Artist Grant
1987 Buck Foundation, Marin Arts Council, Individual Artist Grant

ONE PERSON EXHIBITIONS (selected)
2004 "Adjacent Things Diminish," R.B. Stevenson Gallery, La Jolla, CA
2004 "Trinitas," Museum of Contemporary Art, Santa Rosa, CA
2000 Aurobora Press, San Francisco, CA
1999 Susan Cummins Gallery, Mill Valley, CA
1998 Jack Meier Gallery, Houston, TX

GROUP EXHIBITIONS (selected)
2004 "Good Vibrations," New Artists from California, Jay/Addington Gallery, Chicago, IL
2004 "Contemporary Perspectives," Museum of Contemporary Art, Santa Rosa, CA
2002 "Selections," R.B. Stevenson Gallery, La Jolla, CA
2002 "Underfoot," Associacão Alumni, São Paulo, Brazil (traveling exhibition) (catalog)
2000 "Art Alive," San Diego Museum of Art, San Diego, CA
1999 San Francisco International Art Exhibit, San Francisco, CA

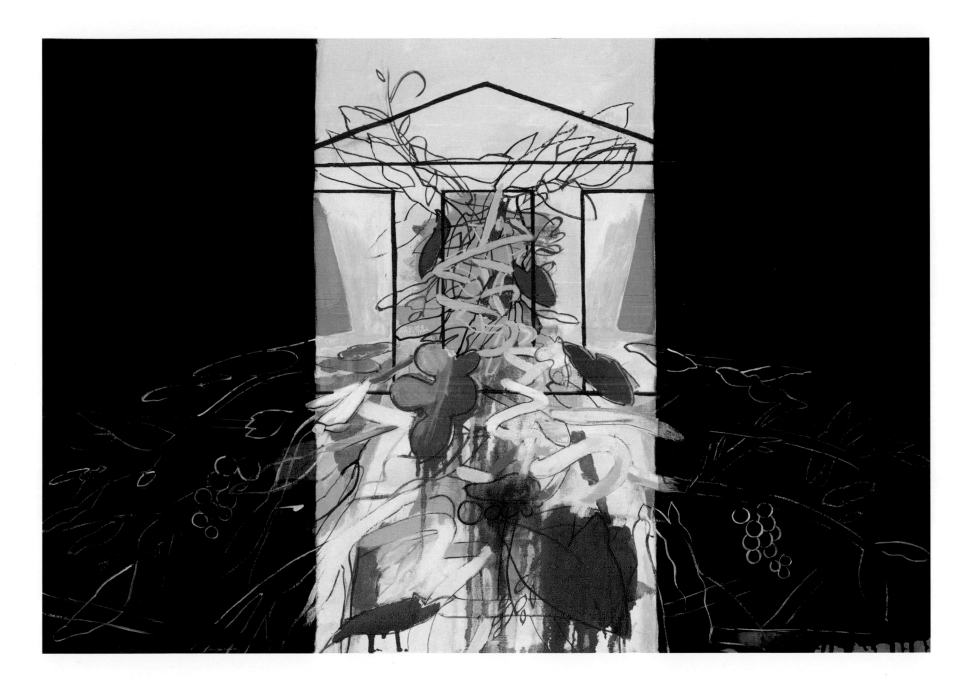

TIMOTHY MCDOWELL

My artwork, by considering as many aspects of nature as I can, takes claim to the micro and the macro, the metaphysical and the phenomenal, as well as the memory of place to inform or connect the viewer to the world outside. I use a chaotic arrangement for organizing these elements into the picture plane, which hopefully activates the viewer's participation in a sense of space.

—Timothy McDowell

Born: 1953 Wichita Falls, Texas
Lives and works in Mystic, Connecticut

EDUCATION
1981 M.F.A. The University of Arizona, Tucson, AZ
1978 B.F.A. Midwestern State University, Wichita Falls, TX

ONE PERSON EXHIBITIONS (selected)
2005 "Solo Exhibition," Robert Kidd Gallery, Birmingham, MI
2004 "Oblique Botany," Anne Reed Gallery, Ketchum, ID
2004 "New Works in Wax," Newzones Contemporary, Calgary, Canada
2003 "Persistence of Botany," Lisa Sette Gallery, Scottsdale, AZ
2003 "Solo Exhibition," Marcia Wood Gallery, Atlanta, GA
1996 "Fragments, Timothy McDowell," Lisa Sette Gallery, Scottsdale, AZ

GROUP EXHIBITIONS (selected)
2002 "Underfoot," Associacão Alumni, São Paulo, Brazil (traveling exhibition) (catalog)
2001 "Neobotanica," Jacksonville Museum of Modern Art, Jacksonville, FL
1997 "Elusive Nature," Phoenix Art Museum, Phoenix, AZ
1997 "5TH Cuenca Biennial of Painting," funded by USIA, Cuenca, Quito and Guayaquil, Ecuador
1996 "Natural Selection," Lisa Sette Gallery, Scottsdale, AZ
1996 "February Invitational," Fotouhi Cramer Gallery, New York, NY

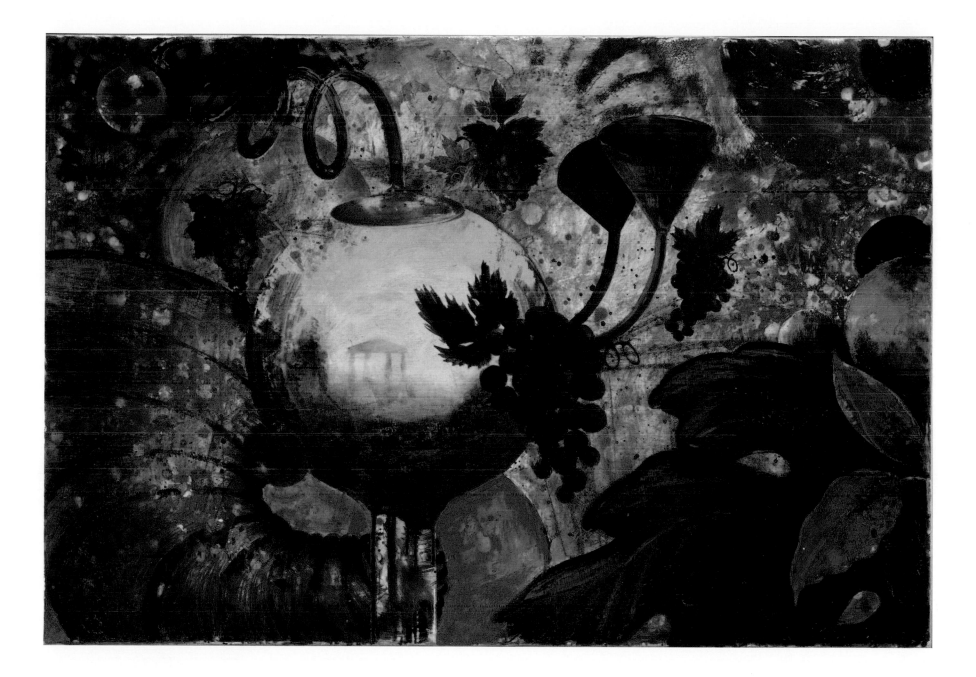

"Alchemico" 1994
encaustic on birch
20-1/4" x 29-5/8"

DEBRA MCKILLOP

Debra McKillop's muted works comment on the nature of time's steady, incremental passage, with hints of archeology. Her palette leans toward gray and demands close scrutiny, and contains strong qualities of motion and metaphor. Hers is a form of meditation without flab or cliché.

—Josef Woodard
"Playful Use of Images has Surreal Results"
LA Times, 17 October 1996, F-16

Born: 1950 Ventura, California
Lives and works in Ventura and Santa Barbara, California

EDUCATION
1996	M.A. California State University, Northridge, CA
1984	Community College Teaching Credential (Lifetime, in Art), University of California at Los Angeles/University of California at Santa Barbara
1978	B.A. Antioch College
1970	A.A. in Studio Art, Ventura College

GRANTS AND AWARDS (selected)
2005	City of Ventura Municipal Art Collection (purchase award)
1997	VC Foundation Grant
1997	Santa Barbara Contemporary Arts Forum (competition award)
1972	Hallmark Award, Bank of America

ONE PERSON EXHIBITIONS (selected)
2002	"Debra McKillop: Works on Paper," Thacher/Brody Art Gallery, Ojai, CA
1999	"Debra McKillop & Donna Granata: Selected Works," CSUCI at Camarillo, CA
1999	"Shards and Vestiges," Albinger Museum, Ventura, CA
1997	"Meditations on Time," North Gallery, California State University at Northridge, CA
1996	"Debra McKillop: Recent Works on Paper," VC Gallery 2, Ventura, CA

GROUP EXHIBITIONS (selected)
2004	"Shakespeare as Muse," Schneider Museum
2004	"The Art of the Print," Ventura County Arts Council, Ventura, CA
2001	"Carnegie Art Museum," Oxnard, CA
2001	"On Site at the Gate," Angels Gate Cultural Center
2000	"VCCCD Faculty Exhibition," California State University Channel Islands Art Center, Ventura, CA
1997	"Multiplicities," Santa Barbara Contemporary Arts Forum, CA
1996	Third Floor Gallery, Ventura City Hall, CA
1991	"21 Artists Respond to the Threat of War," Momentum Gallery, Ventura Arts Council, CA

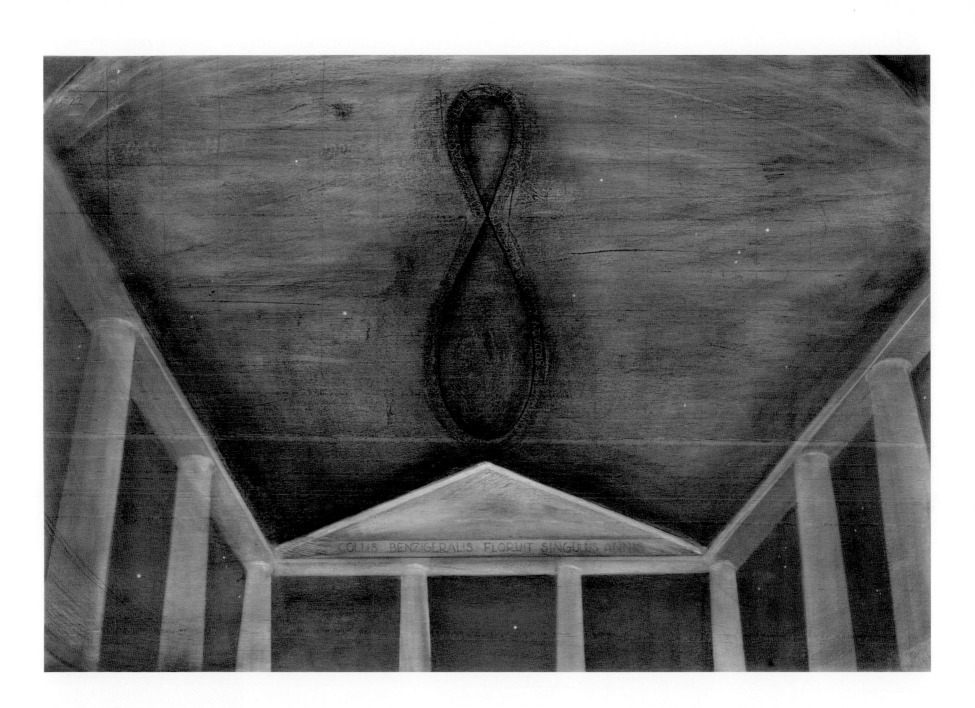

"Collis Benzigeralis"1998
GRAPHITE ON PAPER
16-7/16" x 24"

HUGH JORDAN MERRILL

The drawings are driving, I am the rider in the jump seat, a drifter and hitchhiker along for the ride. We are not rolling across Florida or Alabama in the 1950s, but that time and place are never far away. Over a lifetime you learn to speak many dialects, suitable to many occasions. Especially when you are young, language piles up like leaves and like leaves my words are blown away by even the most boneless wind. The drawings are about memory and return, about an accumulation of marks and images and 40 years of drawing gestures. There may be content and metaphor in these works. There may even be meaning but it is best not to search too deeply for it in a world of words and literal solutions.

—Hugh Jordan Merrill

Born: 1949 Olney, Maryland
Lives and works in Kansas City, Missouri

EDUCATION
1975 M.F.A. Yale School of Art and Architecture, New Haven, CT
1973 B.F.A. Maryland Institute College of Art, Baltimore, MD

GRANTS AND AWARDS (selected)
2005 Trust from Mutual Understanding Foundation
1991 National Endowment for the Arts-Mid-America Arts Alliance
1981 Yaddo Fellowship

ONE PERSON EXHIBITIONS (selected)
2005 "Language and Touch, Large Drawings by Hugh Merrill," Morgan Gallery, Kansas City, MO
2004 "Rolling Wave; sculptures for Granada Park," Roeland Park, KS
2004 "Art of Memory," Public Arts Commission for the Sanford-Kempton Health Facility, Columbia, MO
2004 "Fast and Fugitive," Print Installation Goddard Gallery, Daum Museum, Sedalia, MO
2004 "Fast and Fugitive," Print Installation University of Sydney, Sydney, Australia

GROUP EXHIBITIONS (selected)
2003 "25TH Anniversary Exhibition," Purdue University
2003 "For Sydney," Printworks Gallery, Chicago, IL
2003 "Pandora's Box," Epic Center, Columbia College, Chicago, IL
2003 " Magic Mats," SLOP Art, COCA, St. Louis, MO
2003 " Multiple Perspectives," Southern Graphics Council Conference Exhibition, Boston, MA
2000 "Life Cycles Installation," Santa Barbara Contemporary Arts Forum, Santa Barbara, CA
1997 "Our City/Ourselves," Portrait of a Community Collaboration with Christian Boltanski for the Kemper Museum of Contemporary Art and Design, Kansas City, MO
1996 "Nova Huta Rising," Mobile for the Works Festival, City Hall, Edmonton, Alberta, Canada

PHOTO CREDIT: SHARI HARTBAUER

"DEEP END II" 1995
UNIQUE PRINT WITH COLLAGE ON PAPER
22" x 29-1/4"

163

KENNA MOSER

The paintings begin with antique letters glued to wood panels and followed with a signature layer of beeswax. The beeswax is applied hot, smoothed and buffed. Familiar objects are carefully reconsidered and painted on top of the beeswax. The resulting paintings recall 17TH-century botanical etchings and natural history journals. They speak to a personal relationship with history and the natural environment.

—Kenna Moser

Born: 1964 London, Ontario, Canada
Lives and works in Bainbridge Island, Washington

EDUCATION
1988 B.F.A. Honors, Queens University, Kingston, Ontario, Canada

GRANTS AND AWARDS (selected)
2002 Resident Artist, Djerassi Resident Artists Program, Woodside, CA
1994 WESTAF/NEA Regional Fellowship for Painting, Western States Arts Federation, Santa Fe, NM
1992 Artist Fellowship, Painting, Arts Council of Santa Clara County, San Jose, CA

ONE PERSON EXHIBITIONS (selected)
2005 Gail Severn Gallery, Ketchum, ID
2004 Linda Hodges Gallery, Seattle, WA
2004 Greenwood Chebithes Gallery, Laguna Beach, CA
2004 Gallatin River Gallery, Big Sky, MT
2001 Susan Cummins Gallery, Mill Valley, CA

GROUP EXHIBITIONS (selected)
2004 "Mark My Word," Museum of Northwest Art, La Conner, WA
2003 "Cut, Copy, Paste: The Art of Contemporary Collage," deSaisset Museum, Santa Clara, CA
2003 "Art in Embassies," American Embassy, Brussels, Belgium
2002 "Cabinets of Wonder," Palo Alto Cultural Center, Palo Alto, CA
2002 "Underfoot," Associacão Alumni, São Paulo, Brazil (traveling exhibition) (catalog)
2000 "The Game of Chance," Block Museum, Northwestern University, Evanston, IL (traveling exhibition)
1996 "Small Wonders," San Francisco Folk and Craft Museum, San Francisco, CA
1994 "In the Spirit of Nature," San Jose Museum of Art, San Jose, CA

"GRAPEVINE" 1996
BEESWAX/VINTAGE DOCUMENT/OIL PAINT ON MAHOGANY
7-3/4" x 11-1/2"

165

ED MOSES

I have been an admirer of Ed Moses' work since I was in college over thirty-five years ago. As the years have passed the work has become more powerful and beautiful—not a sweet kind of beauty, but one based upon a certain gritty quality that lingers on your mind even after you have left the room. That is why I keep coming back for more.

—Bob Nugent

Born: 1926 Long Beach, California
Lives and works in Venice, California

EDUCATION
1958 M.A. University of California, Los Angeles, CA
1955 B.A. University of California, Los Angeles, CA

GRANTS AND AWARDS (selected)
1995 Honorary Doctorate, Otis College of Art and Design
1984 California Arts Council Commission
1980 John Simon Guggenheim Memorial Fellowship
1976 National Endowment for the Arts Fellowship

ONE PERSON EXHIBITIONS (selected)
2004 "New Paintings," Brian Gross Fine Art, San Francisco, CA
2004 "Cross-Cut," Christopher Grimes Gallery, Santa Monica, CA
2003-2004 "Criss-Cross," Imago Galleries, Palm Desert, CA
2003 "Ed Moses," LA Louver Gallery, Venice, CA
2002 "Broken Roja," Klein Artworks, Chicago, IL
2002 "Recent Paintings," Brain Gross Fine Art, San Francisco, CA
2002 "Ed Moses," LA Louver Gallery, Venice, CA
1996 "A Retrospective of Paintings and Drawings, 1951-1996," The Museum of Contemporary Art, Los Angeles, CA

GROUP EXHIBITIONS (selected)
2005 "Conversations," Natural History Museum, Los Angeles, CA
2004 "Paper," Patricia Faure Gallery, Santa Monica, CA
2003 "Recent Works by Marco Casentini, Teo González & Ed Moses," Brian Gross Fine Art, San Francisco, CA
2002 "August 2002," La Louver, Venice, CA
2001-2003 "Watercolor: In the Abstract," (traveling exhibition)
2001 "Abstraction: Ed Moses and Rana Rochat," Gallery of Contemporary Art, Lewis & Clark College, Portland, OR
1999 "Made in America: Contemporary Paintings and Sculpture from the Norton Simon Museum," Norton Simon Museum and Armory Center for the Arts, Pasadena, CA

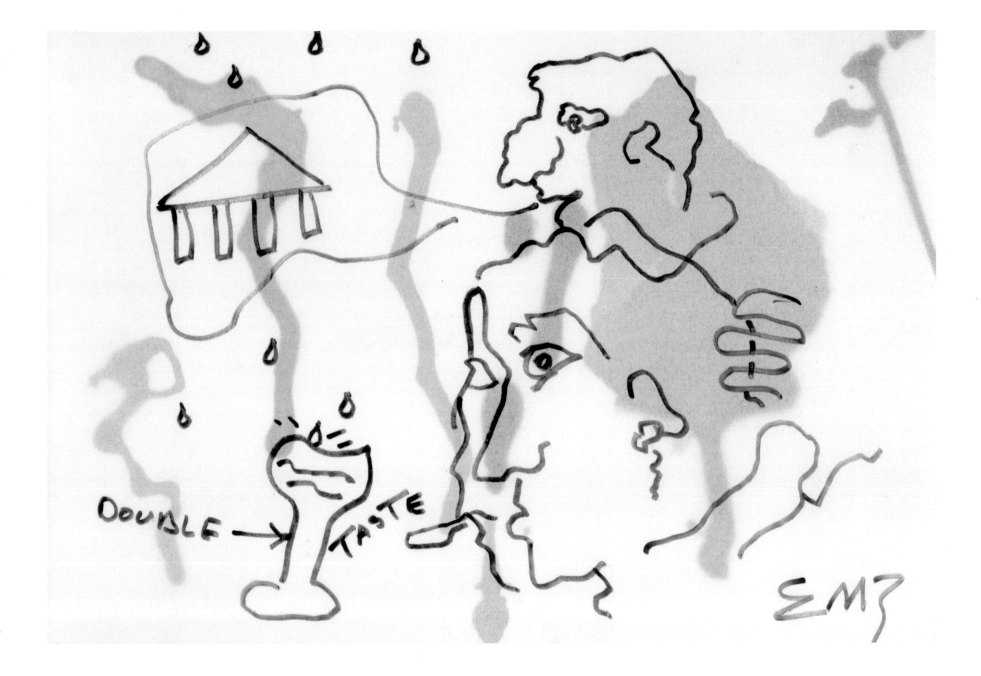

"Untitled" 1992
ACRYLIC/INK ON PAPER
10" x 12"

MICHAEL NAKONECZNY

Michael has a wonderful way of seeing the world. And he documents his life through the eyes of what appears to be a primitive. But I am reminded of what Paul Klee said about his work: "It took me 60 years to learn to draw like a child." Michael's work is like that—sensitive, intelligent and done with the naïveté of a child.

—Bob Nugent

Born: 1952 Detroit, Michigan
Lives and works in Chicago, Illinois and Fairbanks, Alaska

EDUCATION
1981 M.F.A. University of Cincinnati, Cincinnati, OH
1979 B.F.A. Cleveland State University, Cleveland, OH
1973-1976 Kent State University, Kent, OH

GRANTS AND AWARDS (selected)
1995 Illinois Arts Council Fellowship
1994-1995 Arts Midwest/NEA Fellowship
1990 Ohio Arts Council, Individual Artist Fellowship
1987 Awards in the Visual Arts 7 in conjunction with a traveling exhibition

ONE PERSON EXHIBITIONS (selected)
2005 Grover Thurston Gallery, Seattle, WA
2004 South Bend Regional Museum of Art, South Bend, IN
2004 "Paintings from the Ice Box," Zolla/Lieberman Gallery, Chicago, IL
2002 "Chicago to Fairbanks," Zolla/Lieberman Gallery, Chicago, IL
2001 "Three Stories," Clark Gallery, Lincoln, MA

GROUP EXHIBITIONS (selected)
2004 "XXX All Alaska Juried Exhibition," Anchorage Museum of History and Art, Anchorage, AK
2004 "A Sharp Eye: An Art Dealer's 40-Year Journey," Evanston Art Center, Evanston, IL
2003 "25ᵀᴴ Anniversary Show," Purdue University Gallery, West Lafayette, IN
2003 "Made in Fairbanks," UAF Museum, Fairbanks, AK
2001 "New Faces/New Work," Anchorage Museum of History and Art, Anchorage, AK
2000 "Tamarind: 40 Years," University of New Mexico Art Museum, Albuquerque, NM
2000 "Out of Line: Drawings by Illinois Artists" Chicago Cultural Center, Chicago, IL
2000 "Exquisite Corpse Exhibition," Printworks Gallery, Chicago, IL

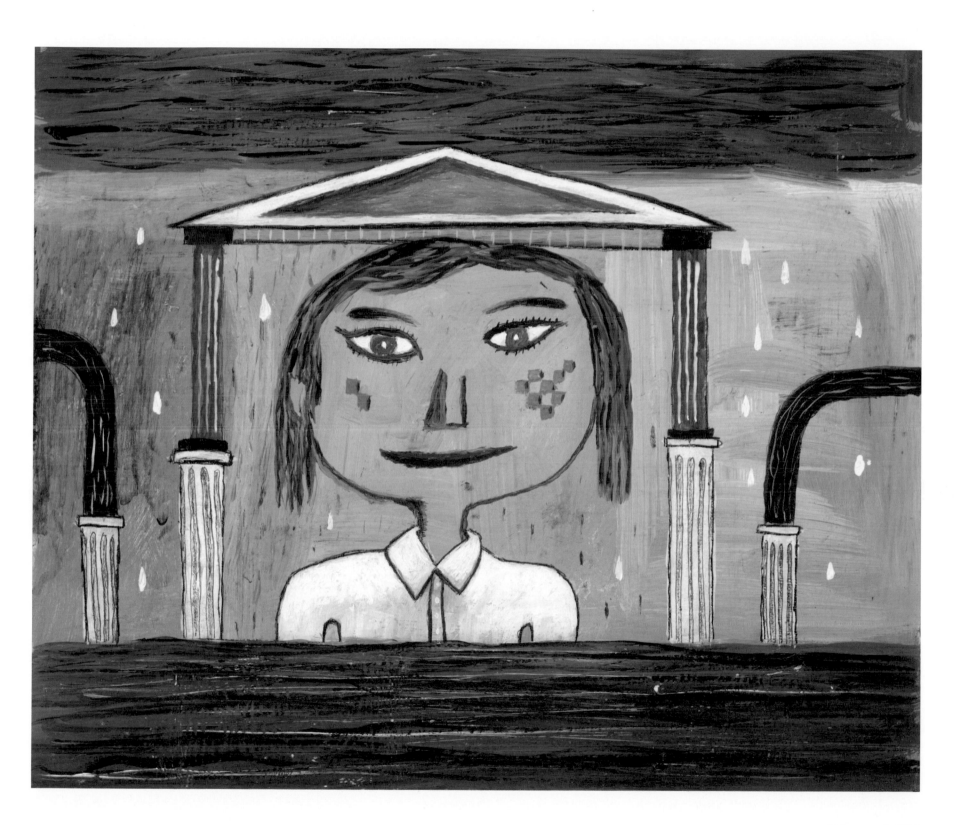

DANN NARDI

Characterized by a subtle elegance of materiality and form, Dann Nardi's sculpture resonates at a second glance. Using commonplace materials deployed in a simple structural syntax, Nardi's work doesn't scream for our attention, but viewers receptive to its quietude encounter an art of elemental dignity and unexpected emotional impact.

—Buzz Spector
From Essay on *Middle Ground*, Exhibition 1995

Born: 1950 Shelbyville, Illinois
Lives and works in Normal, Illinois

EDUCATION
1978 M.S. Illinois State University
1976 B.S. Illinois State University

GRANTS AND AWARDS (selected)
1988 National Endowment for the Arts Fellowship
1988 Illinois Arts Council Fellowship Grant
1987 Illinois Arts Council Fellowship Grant
1986 National Endowment for the Arts Fellowship
1986 Illinois Arts Council Fellowship Grant
1983 Illinois Arts Council Fellowship Grant

ONE PERSON EXHIBITIONS (selected)
1997 Bradley University, Peoria, IL
1992 Roy Boyd Gallery, Chicago, IL
1990 Roy Boyd Gallery, Chicago, IL
1989 Fay Gold Gallery, Atlanta, GA
1988 Roy Boyd Gallery, Chicago, IL

GROUP EXHIBITIONS (selected)
1997 "Pier Walk '97," Navy Pier, Chicago, IL
1995 "Five Sculptors," Klein Art Works, Chicago, IL
1995 "Mapping, St. Paul Companies," St. Paul, MN
1990 "Monuments and Memorials," State of Illinois Gallery, Chicago, IL
1988 "Dann Nardi/Anne Wilson," Chicago Cultural Center, Chicago, IL

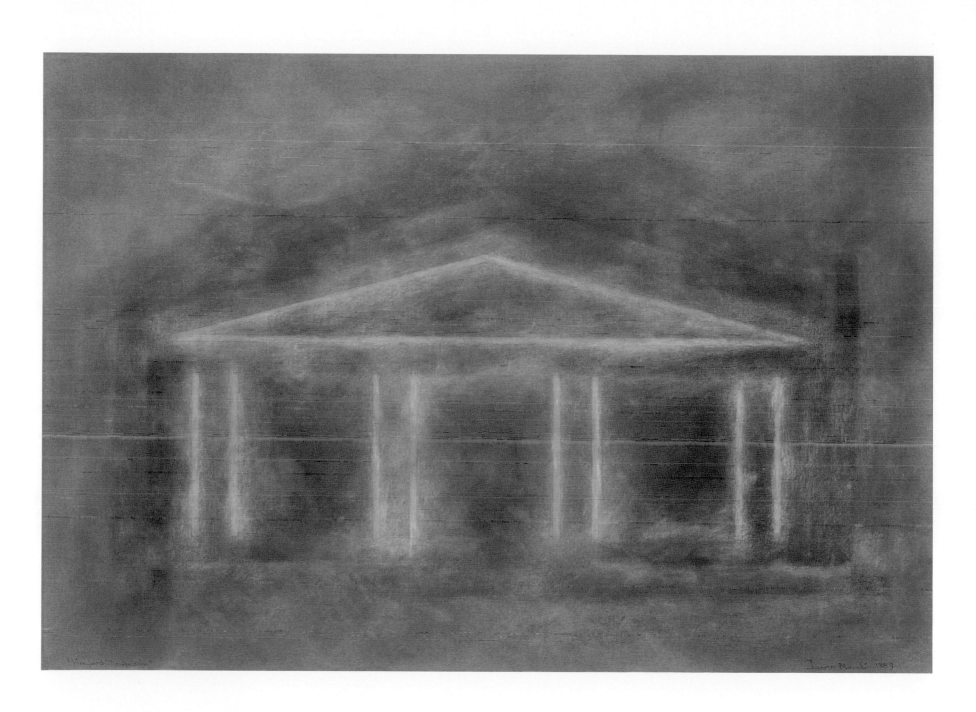

"VINEYARD IMPRESSION" 1987
PASTEL/PENCIL ON PAPER
21" x 30"

171

DAVID NASH

David Nash is an English Land artist, part of a tradition of artists who are individually different in their approaches to making art but are linked in that their primary work is executed in the rural or wild outdoors. Although Nash makes some work that is ephemeral in the landscape, most of his works are sculpture pieces, sometimes portable, sometimes not. He employs traditional forms fashioned by straightforward handwork occasionally augmented by natural forces like fire or erosion. He usually works with wood from whole trees that have died; through his intervention, they receive new life as sculpture. He generally finds his forms in the wood: the way it has grown, the way it splits, or—sometimes—the way it burns. He looks for form that is basic, or seems to be underlying, and then emphasizes it, repeats it, or improvises on it.

—From *View*, about the artist, www.crownpoint.com

Born: 1945 Esher, Surrey, England
Lives and works in Blaenau Ffestiniog, North Wales

EDUCATION
1969-1970 Chelsea School of Art

GRANTS AND AWARDS (selected)
1981-1982 Resident Sculptor, Yorkshire Sculpture Park
1979 Prizewinner, International Drawing Bienniale, Cleveland, OH
1978 Grizedale Forest Sculpture Residency
1975 Awarded Welsh Arts Council Bursary

ONE PERSON EXHIBITIONS (selected)
2004 "David Nash," Metta Gallery, Madrid, Spain
2004 "Making and Placing," Tate Gallery, St. Ives, England
2004 "Twmps and Eggs," Lelong Gallery, Paris, France
2004 "Pyramids Rise, Spheres Turn and Cubes Stay Still," Annely Juda Gallery, London England
2004 "David Nash: Recent Works," Haines Gallery, San Francisco, CA

GROUP EXHIBITIONS (selected)
1994 "New Sculpture," L.A. Louver, Venice, CA
1993 "Black Through Green," Laumier Sculpture Park, St. Louis, MO
1992-1993 "The Artist's Hand," Phoenix Art Museum, Phoenix, AZ
1991 "Hortus Cambrensis," Erdigg, Clywd Centrum Sztuki Wspolezesnej Zamek Njuazdowski, Poland
1991 "Charred Sculptures," Museum Filkwang, Essen, Germany

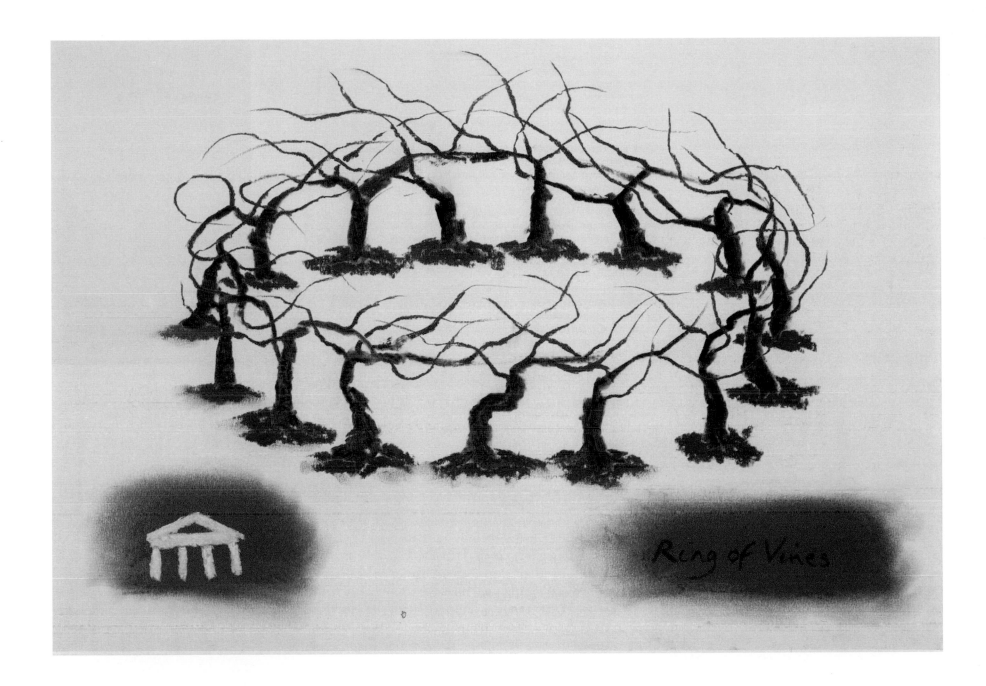

"RING OF VINES" 1993
PASTEL ON PAPER
16" x 23-1/2"

JOHN NAVA

"It is difficult to categorize the work of John Nava, for he works outside current trends. He also eludes the label of realist."

—Louis Fox
Catalog Essay, One Man Show
Wright Gallery, NYC, 1997

Born: 1947 San Diego, California
Lives and works in Ojai, California

EDUCATION
1973 M.F.A. Villa Schifanoia Graduate School of Fine Art, Florence, Italy
1969 B.A. College of Creative Studies, University of California at Santa Barbara

GRANTS AND AWARDS (selected)
2003 Interfaith Forum on Religion, Art and Architecture-Design Honor Award for Visual Art

ONE PERSON EXHIBITIONS (selected)
2003-2004 "John Nava: Selected Work," Ventura County Museum of History and Art (catalog)
2003 "John Nava: Preparatory Works for the Los Angeles Cathedral Tapestries," Studio Channel Islands Gallery, California State University Channels Islands, Camarillo, CA
2001 "The Communion of Saints: Fifteen Tapestries for the Cathedral of Our Lady of the Angels," Hendrik Pickery Zeal of the Halls of the Belfry Tower, Grote Markt, Bruges, Belgium
1999 Van De Griff Gallery, Santa Fe, NM
1997 Wright Gallery, New York, NY (catalog)
1994 "Modernism," San Francisco, CA

GROUP EXHIBITIONS (selected)
2004 "Face to Face: Selected American Portraits," Sullivan Goss Gallery, Montecito, CA (catalog)
2004 "11TH Annual Realism Invitational," Klaudio Marr Gallery, Santa Fe, NM
2003 "5TH Annual Realism Invitational," Jenkins Johnson Gallery, San Francisco, CA (catalog)
2002 "9TH Annual Realism Invitational," Van De Griff/Marr Gallery, Santa Fe, NM
2001 "Representing LA," Frye Art Museum, Seattle, WA, (traveling exhibition) (catalog)
1999 "Re-presenting Representation IV," Arnot Museum of Art, Elmira, NY (catalog)
1999 "Indomitable Spirits-the Figure at the End of the Century," The Art Institute of Southern California, Laguna Beach, CA (catalog)
1999 "Winter Flowers," Wright Gallery, New York, NY

PHOTO CREDIT: MATTHEW SANDERS

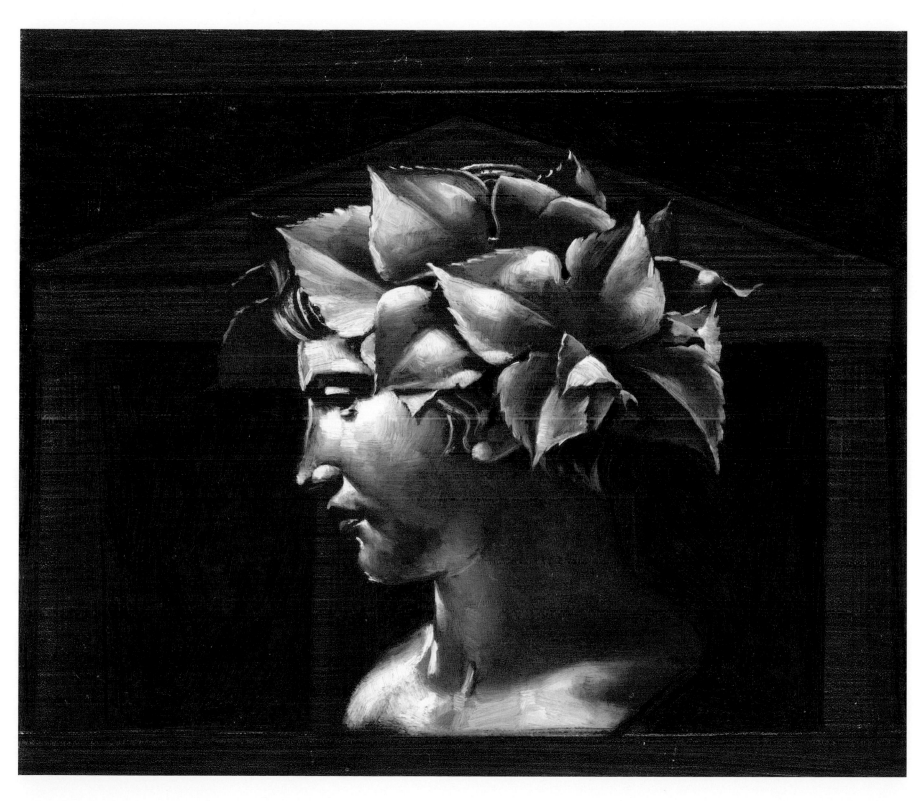

"Untitled" 1994
OIL ON CANVAS
10-1/8" x 12"

175

GLADYS NILSSON

Gladys Nilsson is a highly inventive painter, a fact of artistic identity that can either be overlooked, denied, or confused by those who perceive watercolor as a traditional, even minor, medium or by those who associate working on paper primarily with drawing. Both stereotypes are anathema to this artist, whose repertoire of materials has included acrylics, plexiglas, and canvas, but whose passion for watercolor and paper has taken precedence since 1962. Moreover, Nilsson "craves intimacy, a private moment, with a small piece of paper," again a preference that knowingly runs counter to the modern equation between ambitious painting and monumental scale.

—Lynda Roscoe Hartigan, 1996
From essay for "Gladys Nilsson-Jim Nutt, Works on Paper"
Staller Center for the Arts, University Art Gallery
State University of New York at Stonybrook

Born: 1940 Chicago, Illinois
Lives and works in Wilmette, Illinois

EDUCATION
1962 Graduate School of Art Institute Chicago

GRANTS AND AWARDS (selected)
2004 Wm. A. Patton Prize for Watercolor, The 179TH Annual, National Academy Museum, New York, NY
1974-1989 National Endowment for the Arts Fellowship

ONE PERSON EXHIBITIONS (selected)
2005 Jean Albano Gallery, Chicago, IL
2003 Jean Albano Gallery, Chicago, IL
2003 Adrian College, Adrian, MI
2002 "Watercolors," Quincy Art Center, Quincy, IL
2001 Tacoma Art Museum, Tacoma, WA
2000 Rosemont College, Rosemont, PA

GROUP EXHIBITIONS (selected)
2004 "The 179TH Annual: Invitational Exhibition of Contemporary American Art," National Academy Museum, New York, NY
2003 "The Ganzfeld (unbound)," Adam Baumgold Gallery, New York, NY
2000 "Chicago Loop: Imagist Art 1949-1979," Whitney Museum of American Art, Fairfield County, CT
1999 "Jim Nutt/Gladys Nilsson," Kalamazoo Institute of Arts, Kalamazoo, MI
1998 "Making Marks," Milwaukee Art Museum, Milwaukee, WI
1997 "Humor Us," Nevada Institute of Contemporary Art, Las Vegas, NV
1992-1993 "Parallel Vision: Modern Artists & Outsider Art," Los Angeles County Museum, Los Angeles, CA

PHOTO CREDIT: JIM NUTT

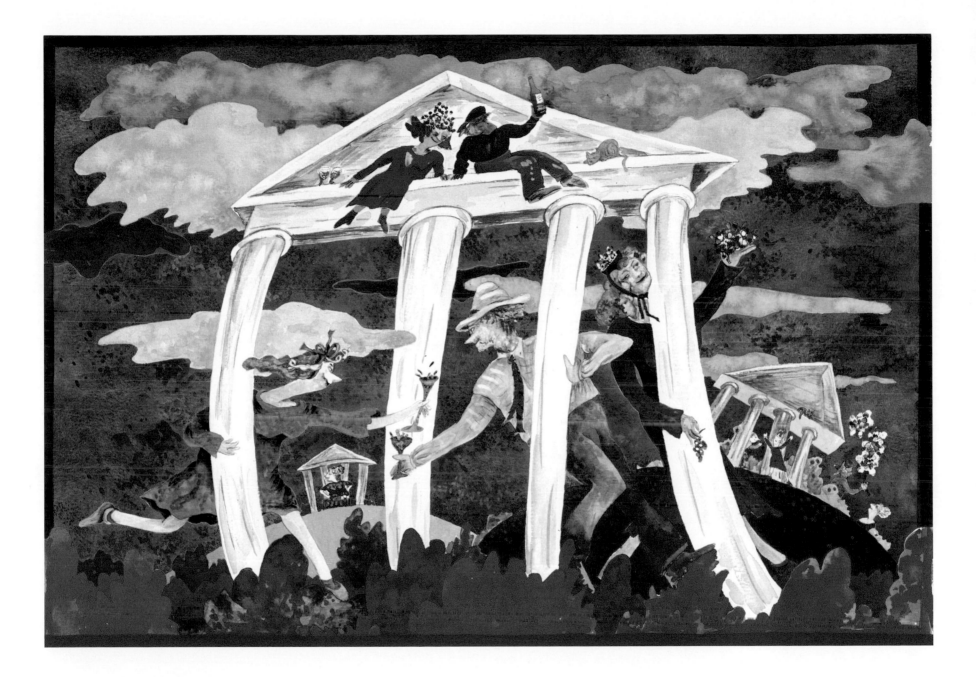

"Parthanonomus" 2000
WATERCOLOR ON PAPER
13-3/4" x 20-1/8"

177

GARY NISBET

My work begins on a base of layered collage recalling the history of those surfaces. The paintings feature forms drawn from the domestic realm of home, garden, library and table. In them I explore the themes of growth and nurture, cycles of life and family. Connection, rhythm, ceremony, purpose, belonging; the newly formed arrangements painted over the history of collaged surface seems an appropriate juxtaposition to represent everyday life.

—Gary Nisbet

Born: 1956 Glendale, California
Lives and works in Boston, Massachusetts

EDUCATION
1975 California State University at Northridge, Northridge, CA
1974 California State University at San Francisco, San Francisco, CA

GRANTS AND AWARDS (selected)
2002 "Golden Acorn Volunteer Award," Washington State, PTA
1993 Northwest Poets and Artists Calendar
1992 "First Place," Eastside Association of Fine Arts

ONE PERSON EXHIBITIONS (selected)
2004 Grover Thurston Gallery, Seattle, WA
2004 Anne Reed Gallery, Ketchum, ID
2003 Pulliam Deffenbaugh Gallery, Portland, OR
2002 Grover Thurston Gallery, Seattle, WA
1999 Lisa Harris Gallery, Seattle, WA

GROUP EXHIBITIONS (selected)
2005 Greenwood Chebithes Gallery, Laguna Beach, CA
2004 "Introducing Collage," Hidell Brooks Gallery, Charlotte, NC
2003 "Still Life Redefined," Anne Reed Gallery, Ketchum, ID
2002 "America," The Ralls Collection, Washington, D.C.
2002 "Visual Language of Birds," Anne Reed Gallery, Ketchum, ID
1995 "Ex Libris," Cornish College, Seattle, WA
1995 "Pacific Northwest Annual," Bellevue Art Museum, Bellevue, WA
1995 "Visionaries," Bumbershoot, Significant Northwest Artists, Seattle, WA

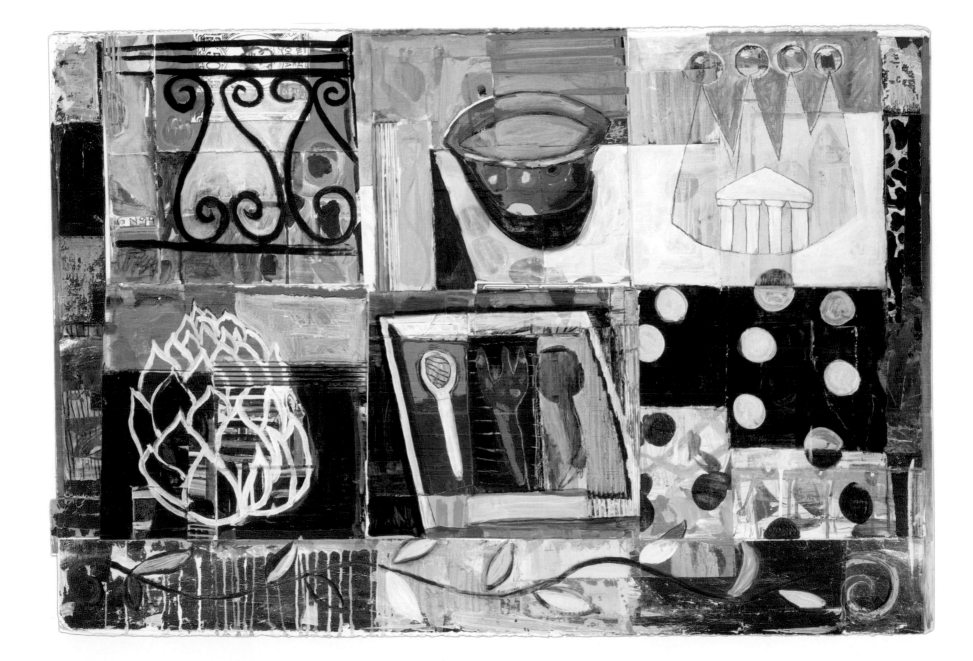

"Untitled" 1996
MIXED MEDIA ON PAPER
30-1/2" x 44-1/2"

BOB NUGENT

"The vital layer, the layer of earth that supports life, that is the real theme of Nugent's works." This generative layer exists below "the earth's crust, where our feet touch the ground," as Nugent says. Nugent's art is a meditation on this layer, "where seeds, roots, plants, start to gestate." And it is something more: just as the survivors of the Holocaust are said to be witnesses to man's inhumanity to man, that is, to man-made death, more unnerving and intolerable than natural death. So Nugent's art is a witness to the ecological Holocaust that is occurring virtually everywhere in the world. It is just as intolerable and disturbing as the Jewish Holocaust. Nugent's art is a reminder that unless man's inhumanity to nature stops—unless we make a deliberate effort to preserve the vital layer—man will self-destruct."

—Donald Kuspit, critic, New York City

Born: 1947 Santa Monica, California
Lives and works in Santa Rosa, California

EDUCATION
1971 M.F.A. University of California at Santa Barbara
1969 B.A. College of Creative Studies, University of California at Santa Barbara

GRANTS AND AWARDS (selected)
2001 U.S. State Department Cultural Exchange Grant, São Paulo, Brazil
1994 Research Grant, São Paulo, Brazil, California State University
1990 Artist Fellowship, California Arts Council
1986 Fulbright Foundation Travel Grant, Brazil
1979 National Endowment for the Arts Fellowship
1977 Louis B. Comfort Tiffany Foundation Grant

ONE PERSON EXHIBITIONS (selected)
2005 Elins/Eagle-Smith Gallery, San Francisco, CA
2005 Flanders Contemporary Art, Minneapolis, MN
2003 Robert Kidd Gallery, Birmingham, MI
2003 Cumberland Gallery, Nashville, TN
2001 Dan Galeria, São Paulo, Brazil
2001 Fresno Museum of Art, Fresno, CA

GROUP EXHIBITIONS (selected)
2004 Triton Museum of Art, Santa Clara, CA
2003 Associacão Alumni, Rio de Janeiro, Rio de Janeiro, Brazil
2002 Pinacoteca do Estado de São Paulo, Sao Paulo, Brazil
2000 Museum of Latin American Art, Long Beach, CA
1999 Galerie Felixe Jeneweina Mêsta Kutné Hory, Czech Republic
1998 Jyvaskyla Art Museum, Jyvaskyla, Finland
1990 Nordjyllands Kuntsmuseum, Aalborg, Denmark
1990 Leopold-Hoesch Museum, Duren, Germany

PHOTO CREDIT: CAROL FARROW

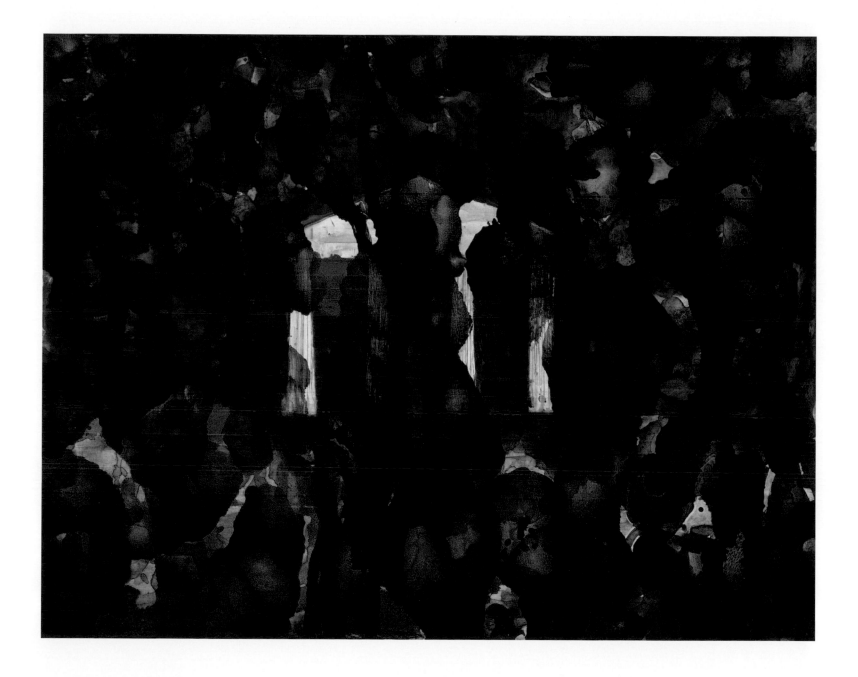

"Harvest Moon Vineyard" 1996
OIL AND ALKYD ON PANEL
16-3/4" x 21-1/2"

181

JOHN OCHS

Three things motivate and shape my work: pure pleasure, challenge, and the engagement in a visual and critical dialogue with other painters, past and present. The pure pleasure I derive from painting is just that: complete and utter expressive gratification, akin to faith in its steadfastness. The challenge comes in many forms, particularly in not knowing exactly where a work is going to go. The dialogue is the response and physical reaction from my intuition, found in the work itself, both ordinary and esthetic. Clement Greenberg clarifies this distinction in his essay *Intuition and The Esthetic Experience*: "The intuition that gives you the color of the sky turns into an esthetic intuition when it stops telling you what the weather is like and becomes purely an experience of the color."

—John Ochs

Born: 1969 Kansas City, Missouri
Lives and works in Kansas City, Missouri

EDUCATION
1992 B.F.A. Minneapolis College of Art & Design, MN
1987-1989 Johnson County Community College, Overland Park, KS

GRANTS AND AWARDS (selected)
2004 "2004 pARTnership Awards," Kansas City Business Committee for The Arts

ONE PERSON EXHIBITIONS (selected)
2005 "Spur Art," Woodside, CA
2004 Robert Steele Gallery, New York, NY
2003 Leedy-Voulkos Art Center, Kansas City, MO
2002 The Wichita Center for the Arts, Wichita, KS
2000 Jan Weiner Gallery, Kansas City, MO

GROUP EXHIBITIONS (selected)
2004 "Scope London," London, England
2004 "Summer Eyes/Summarize: Biennial 2004," Jan Weiner Gallery, Kansas City, MO
2004 "Kansas City Flatfiles," H&R Block Artspace, Kansas City, MO
2003 "Summer Show," Robert Steele Gallery, New York, NY
2002 "Subluna," Shaw Hofstra & Associates, Kansas City, MO
2002 "Beyond Bounds- Beyond Borders," Johnson County Community College Gallery of Art,
 Overland Park, KS
2000 "River Market Regional Exhibition," Kansas City Artists Coalition, Kansas City, MO
1999 "KARMA," Joseph Nease Gallery, Kansas City, MO

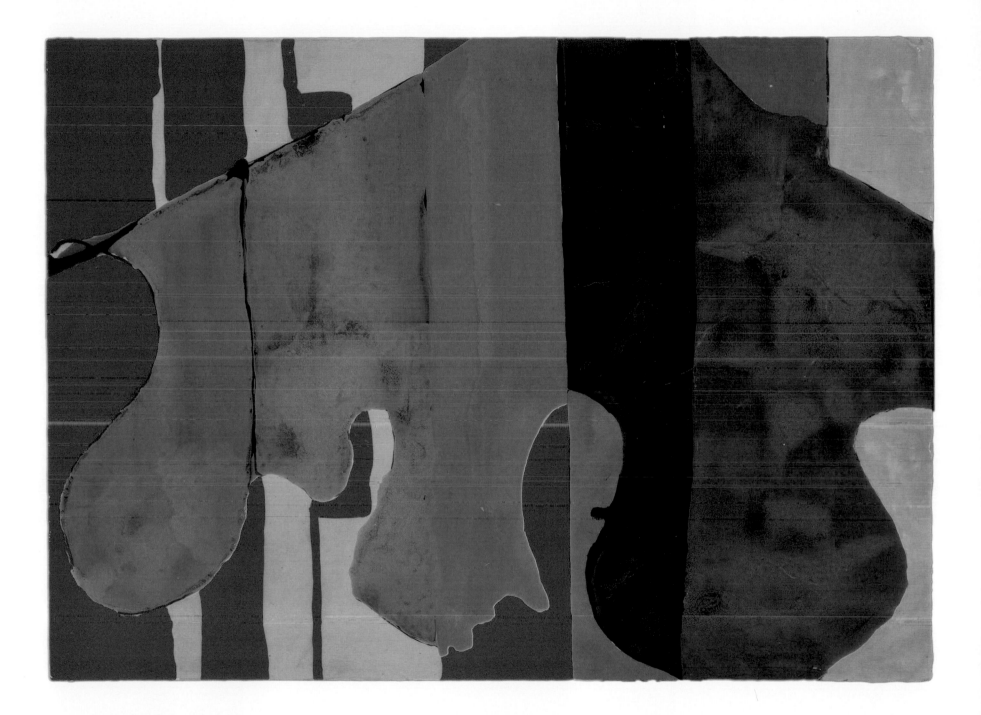

"Untitled" 2002
SHELLAC ON BOARD
23" X 32"

183

NATHAN OLIVEIRA

Oliveira has described his paintings as emotionally charged in themselves, and he has said he wants to "make a spiritual contribution." He has frequently explored the relationship between people and animals, and sometimes has painted figures and landscapes that have magical, or shamanistic overtones.

—From *About the Artist*, www.crownpoint.com

Born: 1928 Oakland, California
Lives and works in Stanford, California

EDUCATION
1952	M.F.A. California College of Arts and Crafts, Oakland, CA
1951	B.F.A. California College of Arts and Crafts, Oakland, CA

GRANTS AND AWARDS (selected)
1996	Distinguished Artistic Achievement Honor, California Society of Printmakers
1996	Honorary Doctorate, San Francisco Art Institute, San Francisco, CA
1984	Academy Award in Art, American Academy of Arts and Letters, New York, NY
1974	National Endowment for the Arts Fellowship
1968	Honorary Doctorate, California College of Arts and Crafts, Oakland, CA
1964	Tamarind Lithography Fellowship, Los Angeles, CA
1963	Tamarind Lithography Fellowship, Los Angeles, CA
1958	John Simon Guggenheim Memorial Fellowship

ONE PERSON EXHIBITIONS (selected)
2002	"Nathan Oliveira," San Jose Museum of Art, CA, (traveling exhibition)
2001	"Singular," John Berggruen Gallery, San Francisco, CA
2001	"Recent Paintings," Marsha Mateyka Gallery, Washington, D.C.
2001	"Copper Plate Nudes II: New Etchings and Watercolors," Crown Point Press, San Francisco, CA
2000	"Nathan Oliveira: Figurative Watercolors from 1965 to 2000 and New Site Monotypes," John Berggruen Gallery, San Francisco, CA
1998	"Nathan Oliveira: The Windhover Paintings," Graduate Theological Union, Berkeley, CA
1997	"Variations in Time/Nathan Oliveira/Monotypes and Monoprints," Fine Arts Museums of San Francisco, CA
1996	"Nathan Oliveira: Recent Paintings and Related Works," Salander-O'Reilly Galleries, New York, NY

GROUP EXHIBITIONS (selected)
2001	"Hounds in Leash," The Albuquerque Museum, Albuquerque, NM
2001	"Stamp of Impulse—Abstract Expressionist Prints," Worcester Museum, Worcester, MA
2001	"Modernism and Abstraction: Treasures from the Smithsonian American Art Museum," (traveling exhibition)
2000	"Thirty-Fifth Anniversary Exhibition," Riva Yares Gallery, Scottsdale, AZ
2000	"Cross-Currents in Modern Art: A Tribute to Peter Selz," Achim Moeller Fine Art, New York, NY (catalog)
1999	"Artes de Outras Partes," Mãe D'Àgua das Amoreiras, Lisbon, Portugal
1998	"Centennial Exhibition, 1989-1998," American Academy of Arts and Letters, New York, NY
1997	"Thirty Years at Crown Point Press," Fine Arts Museums of San Francisco, San Francisco, CA (catalog)

PHOTO CREDIT: KURT FISHBACK

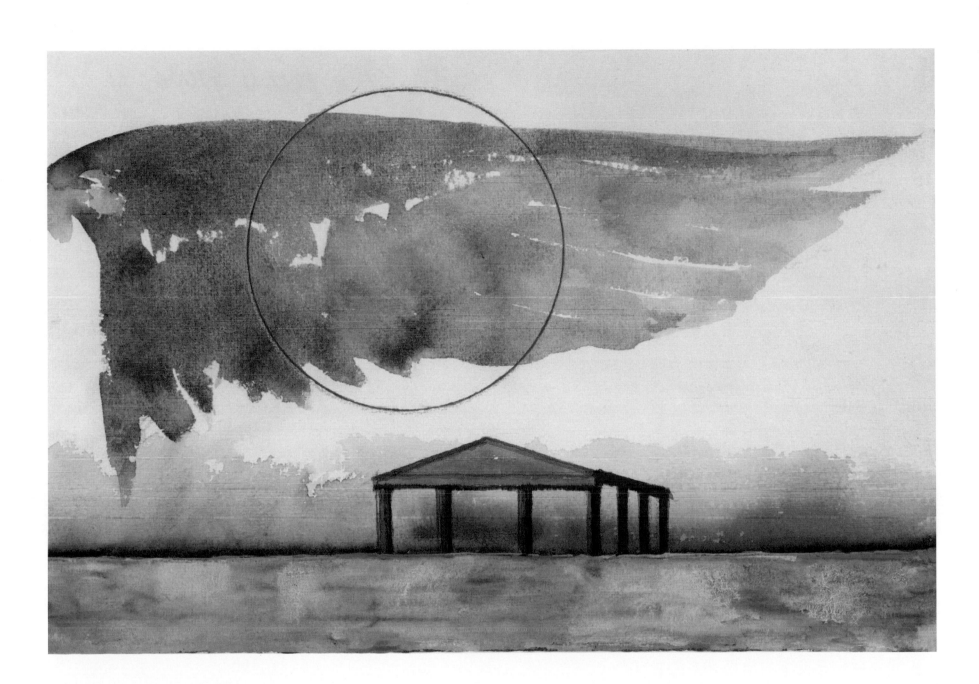

DEBORAH OROPALLO

The subject of my work has shifted over the past twenty years, paralleling changes in my life. Contemporary events, family, personal and cultural memory, have played an important role. Art is about curiosity, childhood, observation, and is, for me, exposed primarily through the visual manipulation of overlooked objects.

—Deborah Oropallo

Born: 1954 Hackensack, New Jersey
Lives and works in Berkeley, California

EDUCATION
1983	M.F.A. University of California at Berkeley, Berkeley, CA
1982	M.A. University of California at Berkeley, Berkeley, CA
1979	B.F.A. Alfred University, Alfred, NY

GRANTS AND AWARDS (selected)
1993	Fleischhacker Award
1991	National Endowment for the Arts Fellowship
1987	Englehard Award ICA Boston

ONE PERSON EXHIBITIONS (selected)
2005-2006	"Deborah Oropallo," Boise Art Museum, ID
2004	"Replica," Stephen Wirtz Gallery, San Francisco, CA
2002	"General Purpose," Weinstein Gallery, Minneapolis, MN
2002	"Oropallo on Paper: 1990-2001," Montalvo Gallery, Saratoga, CA
2001-2003	"How-To: The Paintings of Deborah Oropallo," San Jose Museum of Art, San Jose, CA (traveling exhibition)
2001	"Material Handling," Stephen Wirtz Gallery, San Francisco, CA
2000	"New Paintings and New Prints," James Harris Gallery, Seattle, WA

GROUP EXHIBITIONS (selected)
2003-2004	"The Not-so Still Life: A Century of California Painting and Sculpture," San Jose Museum of Art, CA
2003	"On the Surface: Contemporary Paintings by Bay Area Women," Monterey Museum of Art, CA
2003	"Eight Years: The Editions of Gallery 16," San Francisco, CA
2003	"UC Berkeley Art Alumni Group Exhibit 2002," Worth-Ryder Gallery, Berkeley, CA
2001	"Objects Considered," Bedford Gallery, Dean Lesher Regional Center for the Arts, Walnut Creek, CA
2000	"Celebrating Modern Art: Works from the Anderson Collection," San Francisco Museum of Modern Art, San Francisco, CA
1993	"43RD Corcoran Biennial," Corcoran Gallery of Art, Washington, D.C.
1989	"1989 Whitney Biennial," Whitney Museum of American Art, New York, NY

"Untitled" 1990
OIL ON PAPER
13-1/4" x 17-1/4"

187

CARL PALAZZOLO

These images are markers for loss, memory and hopefully poetry. The iconography shifts, but the painting's center is constant.

—Carl Palazzolo

Born: 1945 Torrington, Connecticut
Lives and works in Rhinebeck, New York and Robin Hood, Maine

EDUCATION
1969-1970 Boston Museum School, Independent Graduate Study
1965-1969 Boston Museum School
1966-1968 Tufts University Museum School Program

GRANTS AND AWARDS (selected)
1987 National Endowment for the Arts Fellowship
1985 "Clarissa Bardett Traveling Scholarship Alumni Award," School of the Boston Museum of Fine Arts
1975 "Bicentennial Traveling Exhibition Grant," Massachusetts Council on the Arts

ONE PERSON EXHIBITIONS (selected)
2003 Lennon Weinberg Gallery, New York, NY
2002 Robert Bowman Gallery, London, England
2001 "Recent Work," Robert Bowman Ltd., London, England
1999 "Carl Palazzolo: Private Viewing, An Exhibition of Recent Watercolors,"Miller Block Gallery, Boston, MA
1997 "Carl Palazzolo: A Personal History of Italian Film," Lennon, Weinberg, Inc., New York, NY
1995 "Carl Palazzolo," Stephen Wirtz Gallery, San Francisco, CA

GROUP EXHIBITIONS (selected)
2004 "Naked," June Fitzpatrick Gallery, Portland, ME
2004 "Reflection," Rebecca Ibel Gallery, Columbus, OH
2002 "Underfoot," Associacão Alumni, São Paulo, Brazil (traveling exhibition) (catalog)
2001 "Reflection," Rebecca Ibel Gallery, Columbus, OH
2000 "Drawing Rooms: Carl Palazzolo, Denyse Thomasos, Robin Hill," Lennon, Weinberg, Inc., New York, NY
1997 "The Eccentric Image," Icon Gallery, Brunswick, ME
1994 "Truth Be Told: It's All About Love," Lennon, Weinberg, Inc., New York, NY
1994 "Novices Collect: Selections from the Sam and May Gruber Collection," The Currier Gallery of Art, Manchester, NH
1992 "On The Edge: Forty Years of Maine Painting," Maine Coast Artists, Rockport, ME (traveling exhibition)

PAINTING BY PALAZZOLO

"ROBINHOOD" 1996
GOUACHE ON ACETATE
12" X 17"

JEANETTE PASIN-SLOAN

In the beginning, the distortions in my reflective objects were unconscious. They've become much more conscious now. But I've always thought that my best work was right on the edge of disorder. I think it's as much about disorder as it is about harmony and balance.

—Jeanette Pasin-Sloan

Born: 1946 Chicago, Illinois
Lives and works in Santa Fe, New Mexico

EDUCATION
1969 M.F.A. University of Chicago
1967 B.F.A. Marymount College, Tarrytown, NY

ONE PERSON EXHIBITIONS (selected)
2004 J. Cacciola Gallery, NY
2001 Gerhard Wurzer Gallery, Houston, TX
1999 Tatistcheff and Company, Inc, New York, NY
1997 Gerhard Wurzer Gallery, Houston, TX
1997 Tatistcheff and Company, Inc, New York, NY
1995 University of Wisconsin, Milwaukee , WI (catalog)
1995 Tatistcheff and Company, Inc, New York, NY

GROUP EXHIBITIONS (selected)
2000 "Prints by American Artists," Wichita Falls Museum and Art Center, Wichita Falls, TX
1999 "Contemporary American Realist Drawings from the Jalane and Richard Davidson Collection,"
 Art Institute of Chicago, Chicago, IL (catalog)
1996 "Objects of Personal Significance: Exhibits USA," organized by Mid-America Arts Alliance
 (traveling exhibition) (catalog)
1996 "Second Sight: Printmaking in Chicago 1935-1995," Mary and Leigh Block Gallery, Northwest-
 ern University, Evanston, IL (catalog)
1991 "Presswork: The Art of Women Printmakers," National Museum of Women in the Arts,
 Washington, D.C. (catalog)

RAFAEL PEREA DE LA CABADA

Rafael Perea de la Cabada is the kind of artist the contemporary (art) world is no longer supposed to produce, much less sustain. Broad-minded, well-versed in and deeply respectful of the culture he inhabits and those that intrigue him, Perea is ferociously devoted to the task—not just the role, but the responsibility of giving form to his sensibility through the making of art.

—Peter Frank, Art Critic, 2004

Born: 1961 Mexico City, Mexico
Lives and works in Santa Barbara, California

EDUCATION
1989 M.F.A. University of California Santa Barbara
1985 National School of Painting, Sculpture and Printmaking, Las Esmeralda, Mexico City, Mexico

GRANTS AND AWARDS (selected)
2002 Worship Renewal Grant, Calvin Institute for Christian Worship and the Lilly Endowment Inc., Westmont College, Santa Barbara, CA
2001-2002 Community Arts Grants Program, City of Santa Barbara, CA
1998 Artist in Residence Program, Santa Barbara Foundation, Irvine Foundation and Santa Barbara Museum of Art, Santa Barbara, CA
1991 IAP Visual Art Painting Award, Santa Barbara County Arts Commission and Santa Barbara Arts Fund
1986 National Youth Award (Painting) and Mention of Excellence (Maestro Jesus Reyes Heroles), CREA, SEP, Mexico City, Mexico

ONE PERSON EXHIBITIONS (selected)
2004 "The Drawing Room: A Visual Dialogue," Contemporary Arts Forum, Santa Barbara, CA
1999 "Rafael Perea de la Cabada, Recent Works and The Drawing Room," KAZU, Up to Date Art and Performance Space, Pacific Grove, CA
1998 "Works on Paper," Galerie Kayaman, Dusseldorf, Germany
1998 "U opasnosti prostora," HDLU Poikat Doma, Zagreb, Croatia
1986 "Paintings, Prints and Mixed Medium," Carrillo Gil Art Museum, INBA, Mexico City, Mexico

GROUP EXHIBITIONS (selected)
2004 "Art of the Americas: Latin America and the United States, 1800 to Now!" Santa Barbara Museum of Art, Santa Barbara, CA
2003 "Siquieros Plus! Great Works from the Collection of Latin American Art," Santa Barbara Museum of Art, Santa Barbara, CA
2002 "FORUMulations," Contemporary Arts Forum, Santa Barbara, CA
2000 "From Azaceta to Zuniga: 20TH Century Latin American Art," Santa Barbara Museum of Art, Santa Barbara, CA
1996 "Drawn from LA," Armory Center for the Arts and the Williamson Gallery, College of Design, Pasadena, CA
1996 "Still Life, Still Here," Hunsaker Schlesinger, Bergamont Station, Santa Monica, CA
1995 "Beyond 15 Minutes," Cheney Cowles Museum, Spokane, WA
1993 "The Tenth San Juan, Latin American and Caribbean Printmaking Biennial," San Juan, Puerto Rico
1992 "Sueños from California," University of Texas, El Paso, TX

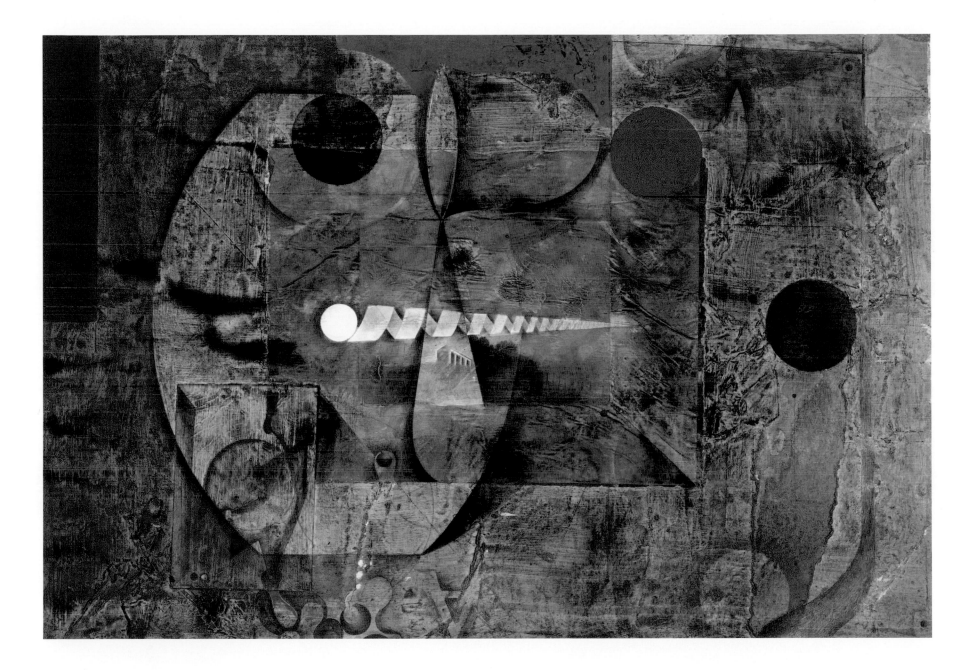

"HARVEST" 2002
MIXED MEDIA ON PAPER
15-3/8" x 24-1/8"

MARK PERLMAN

Each painting seems to have arrived at its condition more through a natural process than the mark making of a human hand. Like aging skin, they bear the physical signs of their life's circumstances and gain depth and subtlety because of it.

—Kathleen Shields

Born: 1950 Pittsburgh, Pennsylvania
Lives and works in Sebastopol, California

EDUCATION
1978 M.F.A. Eastern Michigan
1974 B.F.A. West Virginia University

GRANTS AND AWARDS (selected)
1996 National Endowment for the Arts, Westaf Grant
1988 National Endowment for the Arts, Mid-America Grant

ONE PERSON EXHIBITIONS (selected)
2005 Toomey Tourell Gallery, San Francisco, CA
2004 Lowe Gallery, Atlanta, GA
2003 R.B. Stevenson, La Jolla, CA
1993 Manege, Central Hall, St. Petersburg, Russia
1993 Moscow Central Hall, Moscow, Russia

GROUP EXHIBITIONS (selected)
2004 Toomey/Tourell Gallery, San Francisco, CA
2004 Sonoma Museum of Visual Arts, Santa Rosa, CA
2003 "Inaugural Exhibition," Lowe Gallery, Santa Monica, CA
1995 "The Painted Poem," Palo Alto Cultural Center, Palo Alto, CA
1994 "Company of Light," Palace of Fine Arts, San Francisco, CA
1991 Riverside Art Museum, Riverside, CA
1988 "Texas Triennial Exhibition," Contemporary Art Museum, Houston, TX
1988 "Drawing Invitational," San Diego State University, Mandeville Gallery, La Jolla, CA

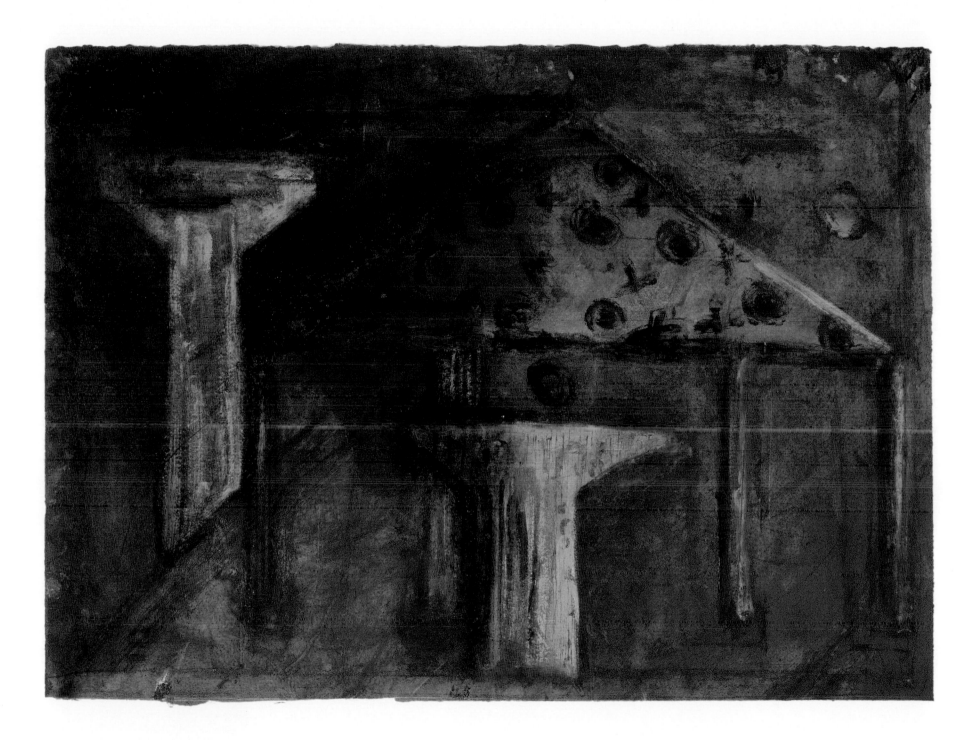

ROLAND PETERSEN

Roland Petersen is frequently asked how he composes and develops his imagery. The rich paint surface that he achieves, as well as his technique, suggest a direct, nearly gestural approach to painting, particularly in the earlier picnic series. However, the formal structure is so pronounced it suggests a rigorous logic dictating the framework of its architecture. Such contradiction has been and remains at the heart of Petersen's work in which he in turn explores and resolves opposing elements within the painting.

—Kim Eagles-Smith, *Roland Petersen, Works on Paper*

Born: 1926 Endelave, Denmark
Lives and works in Pacifica, California

EDUCATION
1970-1971 Stanley William Hayter's Atelier 17, Paris, France
1954 California College of Arts and Crafts, Oakland, CA
1952 California School of Fine Arts, Oakland, CA
1950-1951 Hans Hofmann School of Fine Arts, Provincetown, MA
1950 M.A. University of California at Berkeley, Berkeley, CA
1949 B.A. University of California at Berkeley, Berkeley, CA

ONE PERSON EXHIBITIONS (selected)
2004 "Roland Petersen: Works from the 1950's and 1960's," Hackett-Freedman Gallery, San Francisco, CA
2002 "Roland Petersen: Early Paintings 1958-1969," Hackett-Freedman Gallery, San Francisco, CA
2001 "Roland Petersen: Recent Works," John Natsoulos Gallery, Sacramento, CA
1998 Endelave Museum, Endelave, Denmark
1992 "Retrospective Exhibition," Richard L. Nelson Gallery, University of California at Davis, Davis, CA
1990 "Roland Petersen-Bay Area Paintings of the Sixties," Vanderwoude/Tananbaum Gallery, New York, NY

GROUP EXHIBITIONS (selected)
2003 "With an Eye and A Passion: Allan Jeffries Marion Collection," Bakersfield Museum of Art, Bakersfield, CA
2002 "Geometry," Hackett-Freedman Gallery, San Francisco, CA
2001 "California Printmakers Association: Group Exhibition," Marin Civic Center, San Rafael, CA
1995 Andre Milan Gallery, São Paolo, Brazil
1993 Artists' Contemporary Gallery, Sacramento, CA
1993 Pence Gallery, Davis, CA
1992-1993 "California Painting, The Essential Modernist Framework," California State University, Fine Arts Gallery, Los Angeles, CA; and California State University, University Art Gallery, San Bernardino, CA
1992 Hall of Pictures, Uman, Russia

PHOTO CREDIT: CARYL RITTER

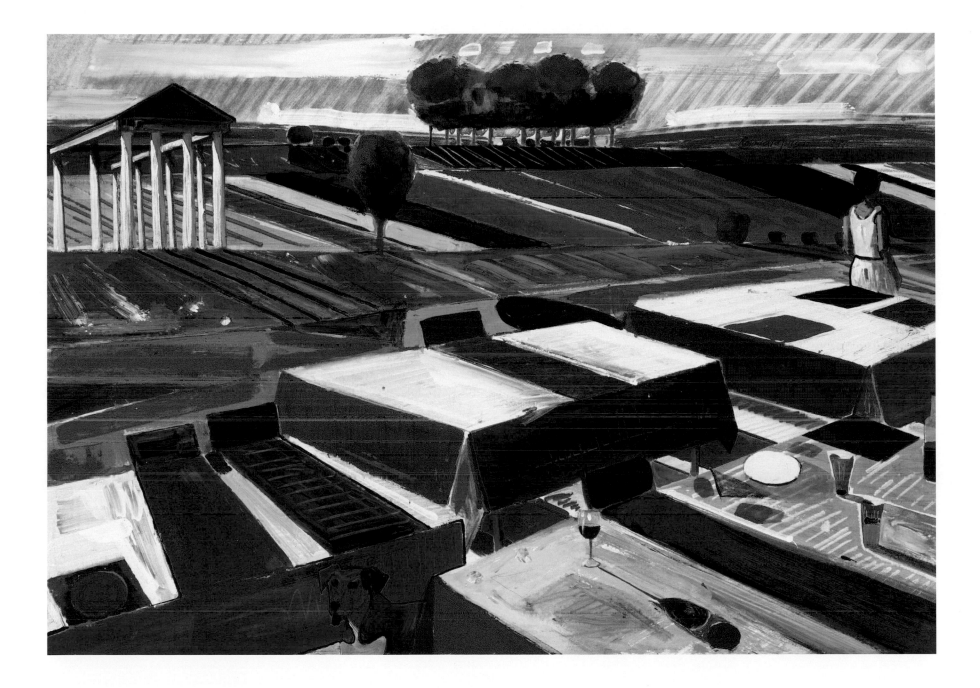

"Untitled" 1997
ACRYLIC ON PAPER
19-1/2" x 28-1/2"

JUDY PFAFF

I think one of the things about being an artist is that you should be allowed to test murky, unclear, unsure territory or all you have left are substitutes that signify these positions. Having it all together is the least interesting thing in art, in being alive.
—Judy Pfaff, *View*, 1988 www.crownpoint.com

Born: 1946 London, England
Lives and works in New York City and Kingston, New York

EDUCATION
1973 M.F.A. Yale University, New Haven, CT
1971 B.F.A. Washington University, Saint Louis, MO
1970 Norfolk Summer School of Music and Art, Norfolk, CT
1968 Southern Illinois University, Edwardsville, IL
1965 Wayne State University, Detroit, MI

GRANTS AND AWARDS (selected)
2004 MacArthur Fellowship
2003 Nancy Graves Foundation Grant
2002 American Academy of Design, New York
1999 Honorary Doctorate, Pratt Institute, New York
1998 U.S. Representative for the Bienal de São Paulo
1986 National Endowment for the Arts Fellowship (Sculpture)
1983 John Simon Guggenheim Memorial Fellowship (Sculpture)
1979 National Endowment for the Arts Fellowship (Sculpture)

ONE PERSON EXHIBITIONS (selected)
2005 "Regina," commisioned set design for American Symphony Orchestra, Fisher Center, Annandale-on-Hudson, NY
2005 "Judy Pfaff: Installations, Prints & Drawings," Butler Institute of American Art, Youngstown, OH
2004 "Judy Pfaff: Installations, Prints & Drawings," Carl Solway Gallery, Cincinnati, OH
2004 "Judy Pfaff: Recent Work," Bellas Artes Gallery, Santa Fe, NM
2004 "En Restauro," Installation, Institute of Contemporary Art (ICA) Ramp Projects, University of Pennsylvania, Philadelphia, PA
2004 "Judy Pfaff: Recent Prints and Drawings," Ulster County Community College, Stone Ridge, NY
2003 "Neither Here Nor There," Installation, Ameringer/Yohe Gallery, New York, NY

GROUP EXHIBITIONS (selected)
2005 "Judy Pfaff, Jane Rosen," Braunstein/Quay Gallery, San Francisco, CA
2004 "Collage: The Art of Attachment," Elena Zang Gallery, Shady (Woodstock), NY
2004 "Judy Pfaff and Gregg Coniff: Camera and Ink," Milwaukee Art Museum, Milwaukee, WI
2003 "From Surface to Form: Rosen, Morris, Pfaff," William Traver Gallery, Seattle, WA
2003 "Drawings: Squeak Carnwath, Jane Rosen, Judy Pfaff," Sears - Peyton Gallery, New York, NY
2003 "Pressure Points: Recent Prints from the Collections of Jordan D. Schittzer and the Jordan and Mina Schitzer Foundation," El Paso, TX
2002 "The 177TH Annual" National Academy of Design, New York, NY
2002 "American Academy Invitational Exhibition of Painting & Sculpture," The American Academy of Arts and Letters, New York, NY

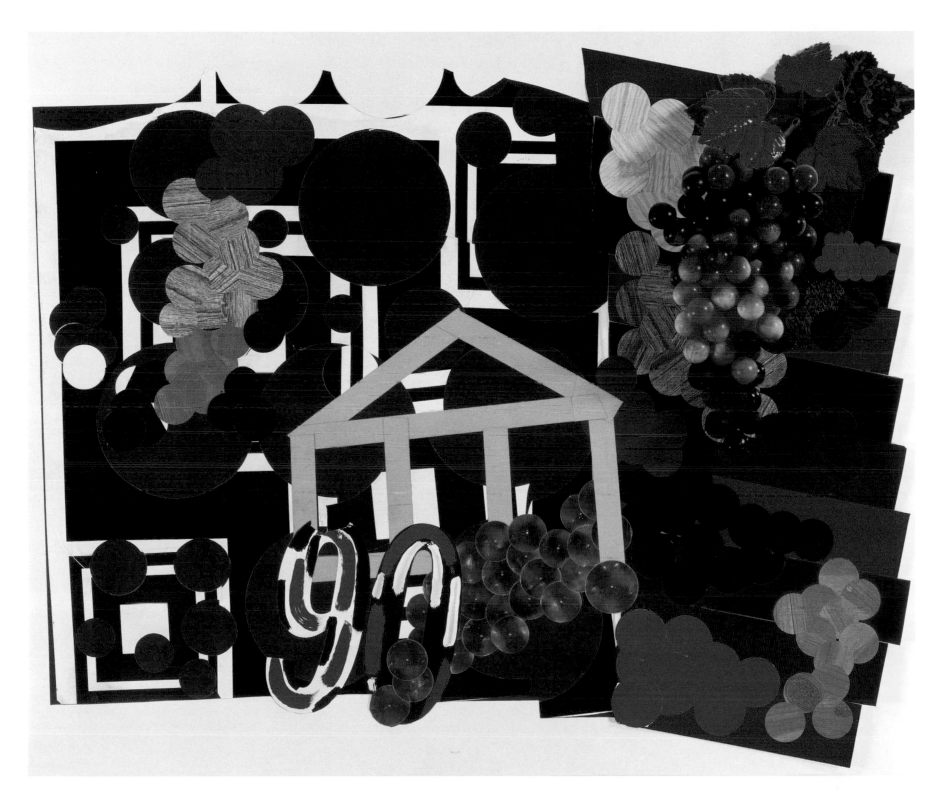

MATT PHILLIPS

I prefer to let my work speak for itself. I have had a long-standing interest in the monotype and its application to artist books, screens, collage, etc.

—Matt Phillips

Born: 1927 New York, New York
Lives and works in Emeryville, California

EDUCATION
1963 Atelier 17, Paris
1952-1954 Stanford University
1952 M.A. University of Chicago
1952 Barnes Foundation, Merion, Pennsylvania

GRANTS AND AWARDS (selected)
1995 Pollock-Krasner Foundation Grant
1987 Asher B. Edelman Chair, Bard College
1975 National Endowment for the Arts Fellowship
1974 John Simon Guggenheim Memorial Fellowship

ONE PERSON EXHIBITIONS (selected)
2004 de Saisset Museum, Santa Clara, CA
2004 Meyerovich Gallery, San Francisco, CA
2000 Stanford University, Stanford, CA
2000 Fred Baker Gallery, Chicago, IL
2000 Smith Andersen Gallery, Palo Alto, CA
1998 Tyler Museum of Art, Tyler, TX

GROUP EXHIBITIONS (selected)
2004 Smith Andersen Gallery, Palo Alto, CA
2004 "Painterly Print," Metropolitan Museum, New York, NY
1998 Nevada Museum of Art, Reno, NV
1997 "Singular Impressions," National Museum of Art, Washington, D.C.
1987 "Monotypes by Mary Frank, Michael Mazur, and Matt Phillips," Marsha Mateyka Gallery,
 Washington, D.C.
1985 "Contemporary American Monotypes: Six Masters," de Saisset Museum, Santa Clara University, CA
1985 "Contemporary American Monotypes," Chrysler Museum, Norfolk, VA
1984 "Invitational Group Monotype Exhibition," Smith Andersen Gallery, Palo Alto, CA

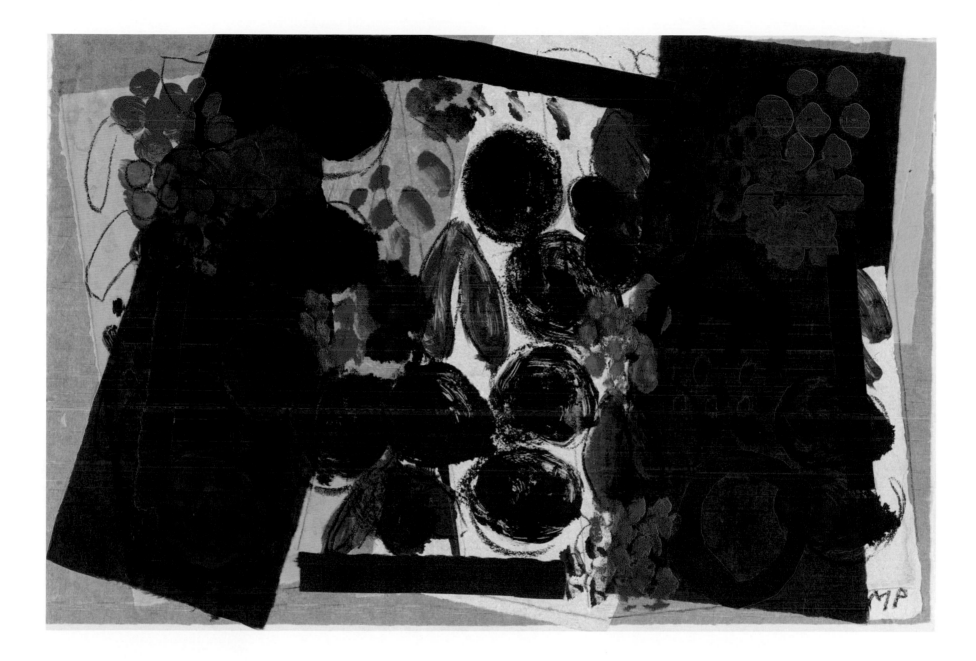

"UNTITLED" 2001
MONOPRINT AND COLLAGE ON PAPER
13-5/8" x 20-3/8"

JOHN PITTMAN

I consider myself a painter and a craftsman. I make beautifully articulated objects that are primarily concerned with formal artistic problems. I work in a reductive process of arrangement and rearrangement, intuitively seeking that simple and natural elegance that rings of truth and is truly beautiful. I am searching for refined composition, subtle coloration and sensual surface nuance. I believe that above all there is a natural order, a harmony, and that art at its best affords a glimpse of the sublime. In this regard, and as a contemporary artist, I recognize that I am perhaps an anachronism. Much of today's art addresses other issues. I consider myself a painter and a craftsman.

—John Pittman

Born: 1948 Detroit, Michigan
Lives and works in St. Charles, Illinois

EDUCATION
1973 M.F.A. School of the Art Institute of Chicago, Chicago, IL
1970 B.A. Kenyon College, Gambier, Ohio

GRANTS AND AWARDS (selected)
2002 Illinois Arts Council Fellowship

ONE PERSON EXHIBITIONS (selected)
2005 Herron School of Art, Indianapolis
2002 Roy Boyd Gallery, Chicago, IL
2001 Evanston Art Center, Evanston, IL
2000 Roy Boyd Gallery, Chicago, IL
1999 Thomas McCormick Gallery, Chicago, IL

GROUP EXHIBITIONS (selected)
2003 Klein Art Works, Chicago, IL
2002 Quint Contemporary Art, La Jolla, CA
1999 Fleisher Ollman Gallery, Philadelphia, PA
1996 Klein Art Works, Chicago, IL
1996 College of DuPage, Glen Ellyn, IL
1996 Judith Racht Gallery, Harbert, MI
1996 Adam Baumgold Fine Art, New York, NY
1995 Kay Garvey Gallery, Chicago, IL
1995 Adam Baumgold Fine Art, New York, NY

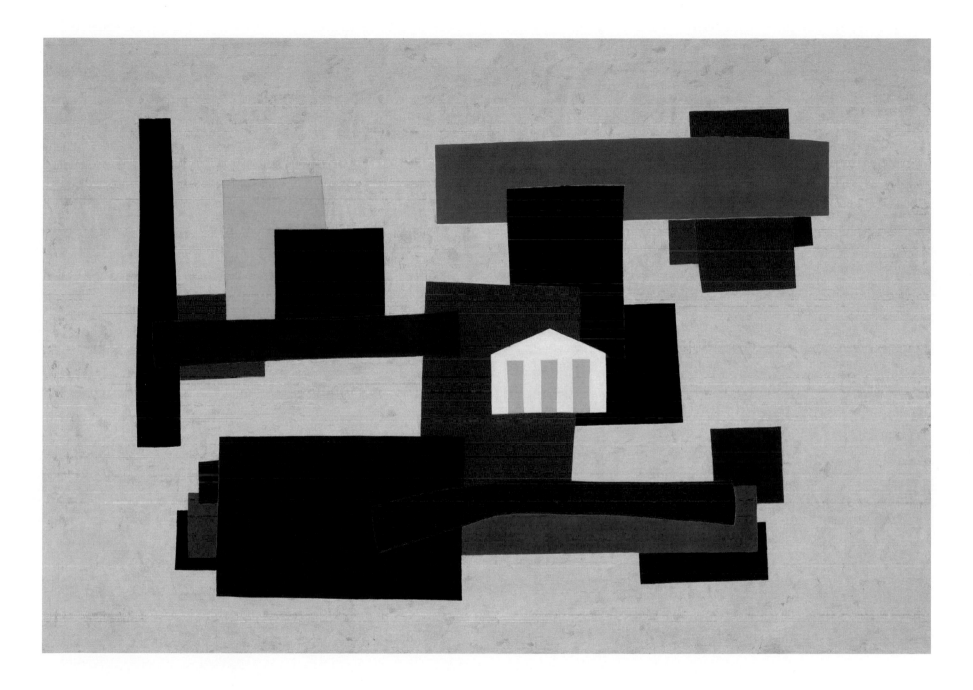

"For Benziger" 1997
ALKYD/LINEN ON PANEL
14" x 20-3/8"

FRED PLOEGER

This current body of work is drawn from my love of history and a deep appreciation for the legacy of all those who strove to define the essence of human spirituality. The non-objective work uses multiple layers of paper and fragments of other materials to create bas relief compositions that speak to the origins of painting. The allegorical work is made up of representational imagery drawn from a variety of cultures and historical milieu: the great cathedrals of Europe, Shinto shrines and Buddhist temples of Japan, the grand Mosques of the Near East and elements drawn from Celtic design and early Christian illuminated manuscripts—all are used to produce compositions that speak to the asic complexity of the human spirit and the common need for enlightenment that bridges all human endeavor across history. In a time of great technological change it is difficult for most of us to find the time to pause and reflect on the human condition. It is the intent of these paintings to provide substance for introspection and dialogue within the viewer—to strike a chord of intuitive speculation that will lead to a greater understanding of self within the context of contemporary issues.

—Fred Ploeger

Born: 1945 Spokane, Washington
Lives and works in Lebanon, New Hampshire

EDUCATION
1973 M.A. Eastern Washington University, Cheney, WA
1971 B.A. Eastern Washington University, Cheney, WA
1968 Audited drawing classes at San Jose State University, San Jose, CA
1967 Audited painting classes at Hiroshima City College, Hiroshima, Japan

ONE PERSON EXHIBITIONS (selected)
2004 The Lyceum Gallery, Deeryfield School, Manchester, NH
2004 The New England Gallery, New England College, Henniker, NH
2003 The Millbrook Gallery, Concord, NH
2001 AVA Gallery, Lebanon, NH
2000 St. Botolph Club, Boston, MA

GROUP EXHIBITIONS (selected)
2004 "Tondo," a series of collaborative works with Bob Nugent and Michael Manzavrakos, AVA
 Gallery, Lebanon, NH
1986 "Woodstock National," Woodstock, NY
1986 "16TH Annual Works on Paper Exhibition, Southwest Texas State University, San Marcos, TX
1984 "16TH Art on the Green," Coeur d'Alene, ID
1981 "The Governor's Invitational," State Capitol Museum, Olympia, WA
1981 Touchstone Center for the Visual Arts, Spokane, WA

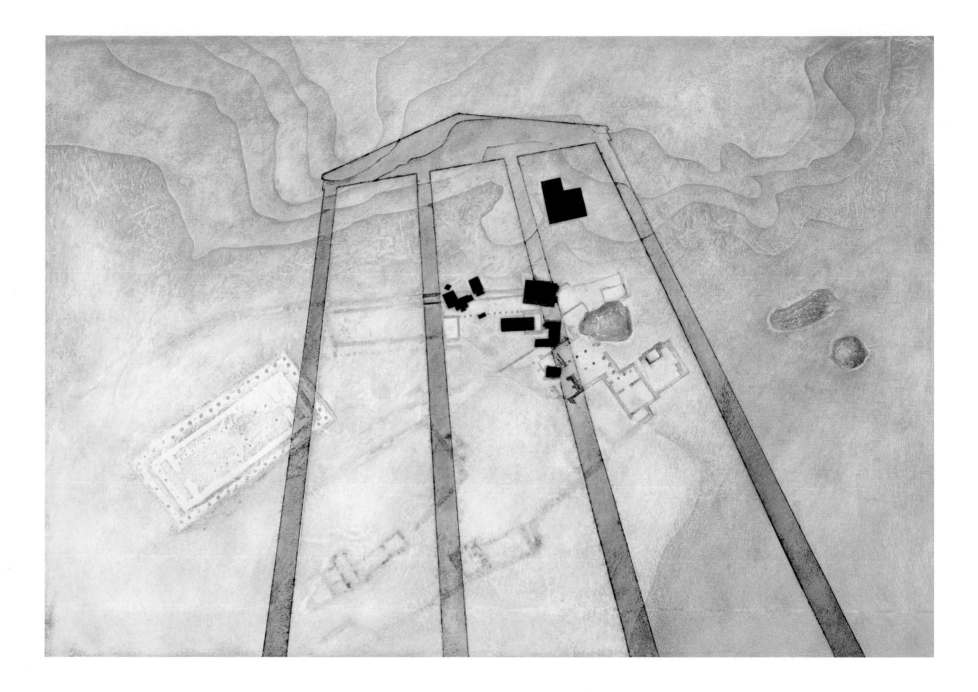

"Untitled" 2004
EMBOSSED PAPER/GESSO/WATERCOLOR ON PAPER
20-1/2" x 29-1/2" x 1/2"

GORDON POWELL

Gordon Powell's abstract sculptures are an elegant fusion of traditional woodworking techniques inspired by a variety of cultures. The strength of his work is marked by his ability to transform understated utilitarian forms into evocative expressions of both movement and stillness, balance and instability. This tension is also aided by the contradictions between the distilled logic of his works, meticulous construction and the mystery of their intended purpose.

—John Brunetti, critic/curator, 2003

Born: 1947 Decatur, Illinois
Lives in River Forest, Illinois and works in Chicago, Illinois

EDUCATION
1980 M.F.A. University of Illinois, Chicago, IL
1975 B.F.A. School of the Art Institute of Chicago, IL

GRANTS AND AWARDS (selected)
2005 American Academy in Rome, Artist Residency, Rome, Italy
2003 Krems Residency, Krems, Austria
2000 Enrichment Grant, School of the Art Institute of Chicago, IL
1998 Enrichment Grant, School of the Art Institute of Chicago, IL
1997 Illinois Arts Council, Visual Artists Fellowship
1994 Visiting Artist, American Academy in Rome
1993 Yaddo, Artist Residency, Saratoga Springs, NY
1988 Rome Prize, American Academy in Rome, Sculpture Fellow
1986 National Endowment for the Arts Fellowship

ONE PERSON EXHIBITIONS (selected)
2004 Racine Art Museum, Courtyard Installation, Racine, WI
2003 Perimeter Gallery, New York, NY.
2003 MacNider Museum, Mason City, IA
2000 "Gordon Powell New Work," Perimeter Gallery, Chicago, IL
2000 "Gordon Powell Sculpture," William Rainey Harper College, Palatine, IL

GROUP EXHIBITIONS (selected)
2005 "Magnificent Extravagance: Artist and Opulence," Charles A. Wustum Museum of Fine Arts, Racine, WI
2002 "Natural Forms, Sculpture at Northeastern University," Chicago, IL
1998 "Warm," I Space Gallery in Chicago, Gallery of the University of Illinois Champaign, Urbana, IL
1997 "Beauty, Dallas Geichman Powell" Ukrainian Institute of Modern Art, Chicago, IL (traveling exhibition)
1996 "Small Wonder," San Francisco Craft and Folk Museum, San Francisco, CA
1995 "Material Junction: 3 Chicago Sculptors," Evanston Arts Center, Evanston, IL
1990 "Summer 1990," Rosa Esman Gallery, New York, NY
1988 "Emerging Sculptors," Sculpture Center, New York, NY

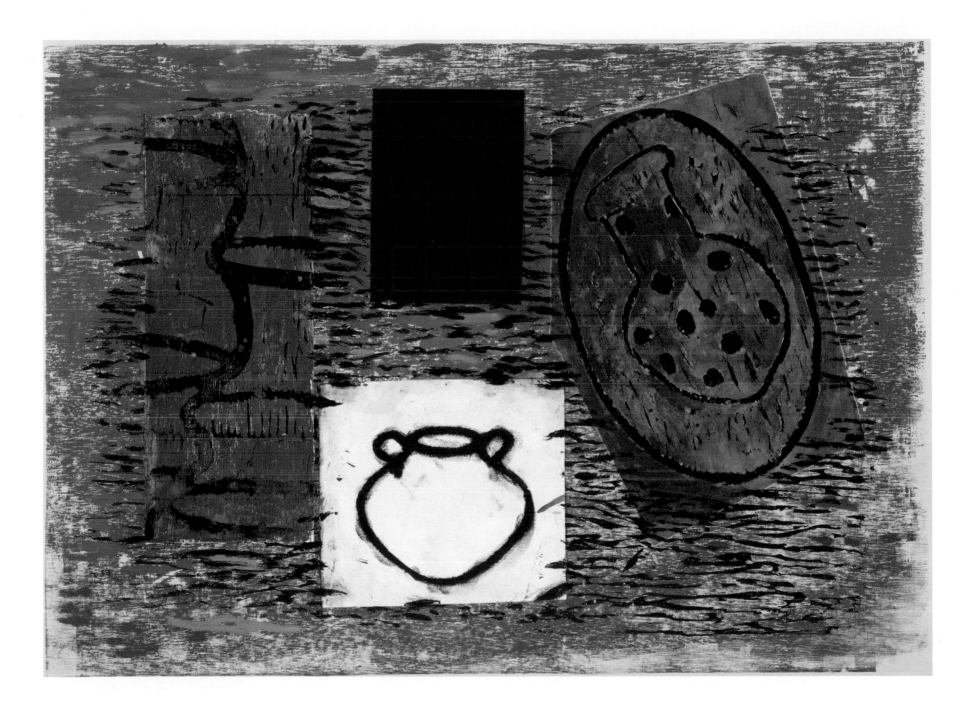

"Untitled" 1995
CHARCOAL/MIXED MEDIA/WOODCUT ON PAPER
15" x 20-3/4"

207

PAUL RESIKA

You're lucky if you make a good picture.

—Paul Resika

Born: 1928 New York, NY
Lives and works in New York, New York

EDUCATION
1950-1953 Venice and Rome
1945-1947 Hans Hofmann School, New York, NY

GRANTS AND AWARDS (selected)
1994 Elected, American Academy of Arts and Letters
1984 John Simon Guggenheim Memorial Fellowship
1979 Elected, National Academy of Design
1977 Academy-Institute Award in Art, American Academy and Institute of Arts and Letters
1969 Ingram Merrill Grant
1961 Hiligarten Prize and Henry Ward Ranger Purchase Fund, National Academy of Design
1959 Louis B. Comfort Tiffany Foundation Grant

ONE PERSON EXHIBITIONS (selected)
2005 Salander O'Rielly Galleries, New York, NY
2004 Berta Walker Gallery, Provincetown, MA
2003 Berta Walker Gallery, Provincetown, MA
2002 Salander O'Rielly Galleries, New York, NY
2002 Hackett-Freedman Gallery, San Francisco, CA
1996 Provincetown Art Association, Provincetown, MA

GROUP EXHIBITIONS (selected)
2005 National Academy of Design, New York, NY
2003 National Academy of Design, New York, NY
2000 "Beyond the Mountains: The Contemporary American Landscape," Newcomb Art Gallery,
 Tulane University, New Orleans, LA (traveling)
1999 "Three Painters," The Painting Center, New York, NY
1999 Hackett-Freedman Gallery, San Francisco, CA
1998 National Academy of Design, New York, NY
1998 "Select Works: A Group Exhibition Featuring Emerging and Established Artists," Hackett-
 Freedman Gallery, San Francisco, CA
1998 "Seeing the Essential: Selected Works by Robert De Niro, Sr., Leland Bell and Paul Resika,"
 Hackett-Freedman Gallery, San Francisco, CA

PHOTO CREDIT: BLAIR RESIKA

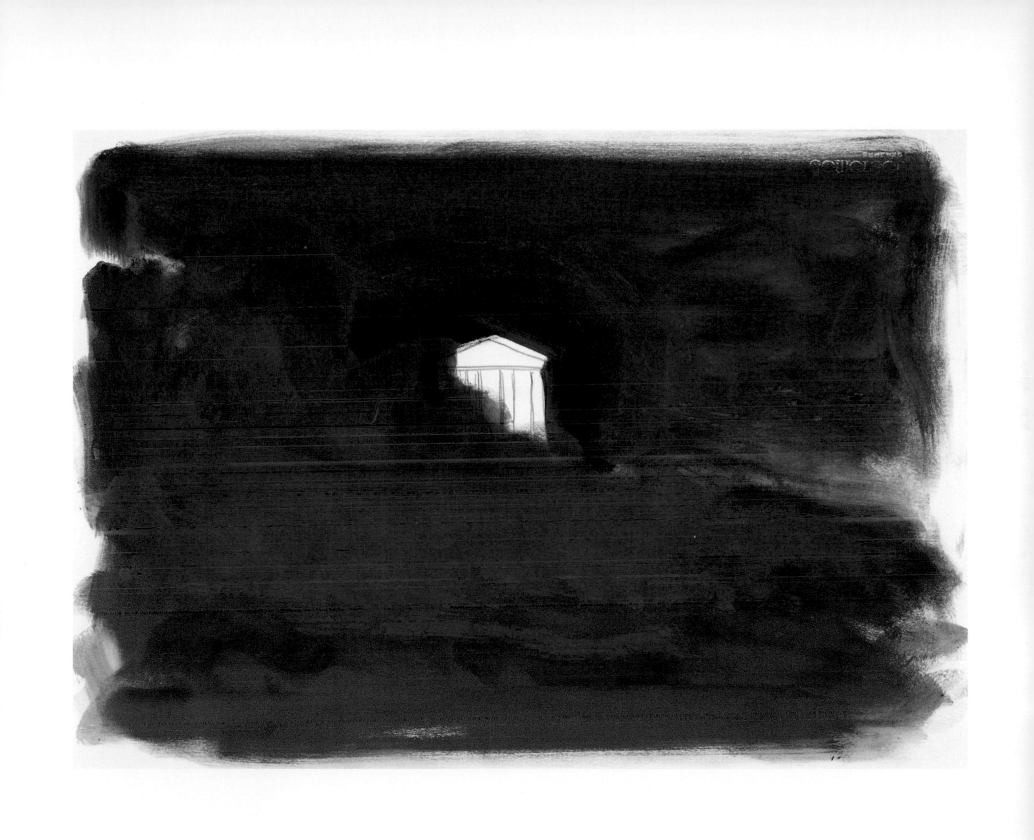

"Untitled" 2003
PASTEL/GRAPHITE ON PAPER
17-1/4" x 24-1/4"

209

GUSTAVO RAMOS RIVERA

There exists more than just a constancy of healthy contradiction, as well in the inventions of Gustavo Ramos Rivera. His irregular geometric figures, his lyric content, his planes of primary colors contrasting with grays, his graffiti and the titles of each work constitute the qualities of a game controlled by the rules of entertainment. His references to common places and to an untroubled childhood world give him a perspective of understanding, truly valuable in the context of good and evil, beauty and ugliness. Paintings that not only promise the sabotage of an asphyxiating life without humor, but also the opportunity for fantasy as a moral way of acting—an extension of our qualities. Ramos Rivera represents in his work the primary human quality, generous in good feelings and capable of error.

—From Guillermo Santamarina
October, 1991, Mexico D.F.

Born: 1940 Villa Acuña Coahuila, Mexico
Lives and works in San Francisco, California

EDUCATION
Self Taught

GRANTS AND AWARDS (selected)
1992 Fleishacker Foundation
1992 Eureka Fellowship

ONE PERSON EXHIBITIONS (selected)
2005 Hackett-Freedman, San Francisco, CA
2005 Gallery Ex-Convento del Carmen, Guadalajara, Mexico
1999 John Berggruen Gallery, San Francisco, CA
1998 Smith Andersen Editions, Palo Alto, CA
1998 Wilfred von Guten Gallery, Thun, Switzerland

GROUP EXHIBITIONS (selected)
1994 Charles Campbell Gallery, San Francisco, CA
1993 M.H. De Young Memorial Museum, San Francisco, CA
1993 Gallerie Rahn, Zurich, Switzerland
1992 San Jose Museum of Art, San Jose, CA
1991 "The Painted Monotype," Joan Prats Gallery, New York, NY
1991 Museo Nacional de Bellas Artes, Santiago, Chile
1988 Alternative Museum, New York, NY
1976 The Mexican Museum, San Francisco, CA

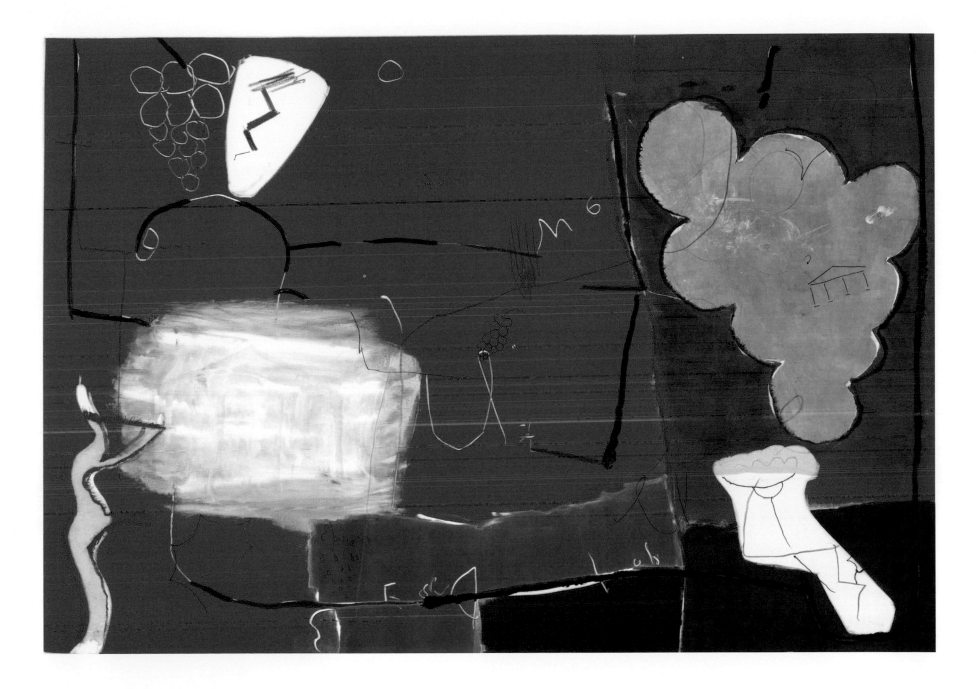

"Untitled" 2003
MONOPRINT
23-3/4" x 34-1/2"

211

ANDREW SAFTEL

I combine historical imagery, references to the daily flow of events, and personal philosophical musings to create works that respond to contemporary culture. I want to prompt reflection of what is lost: the passenger train, the agricultural economy, the jazz era, the primeval forest. Images of the natural world, such as plants and animals, are paired with images of technology and progress to symbolize two still interdependent elements seeking a balance.

The layering of the paitings is geological, a build-up of thoughts, emotions and physical interactions buried in the layers of paint. We see only the surface, but everything underneath influences what the surface eventually becomes. I use color to represent time, the spectrum changing as the day moves on, the cycle of days creating an atmosphere of hope and reassurance.

—Andrew Saftel
February, 2005

Born: 1959 New Bedford, Massachusetts
Lives and works in Pikeville, Tennessee

EDUCATION
1981 B.F.A. San Francisco Art Institute, San Francisco, CA

GRANTS AND AWARDS (selected)
2003 Artist Residency, Spring Concentration, Penland School of Crafts
1999 Individual Artist Fellowship, Tennessee Arts Commission
1998 Tennessee-Israel Visual Artists Exchange

ONE PERSON EXHIBITIONS (selected)
2005 Lanoue Fine Art, Boston, MA
2005 Huntsville Museum of Art, Huntsville, AL
2005 Savannah College of Art and Design, Savannah, GA
2004 Lowe Gallery, Santa Monica, CA
2004 University Art Gallery, The University of the South, Sewanee, TN
2003 Gallery Camino Real, Boca Raton, FL

GROUP EXHIBITIONS (selected)
2003 "The Art of Tennessee," Frist Center for the Visual Arts, Nashville, TN
2002-2003 "A Century of Progress: Twentieth Century Painting in Tennessee," Cheekwook Museum of Art, Nashville, TN (traveling exhibition)
1994 "Tennessee Twelve: Painting Today," Tennessee State Museum, Nashville, TN
1992 "Gallery Artists Exhibition," Lowe Gallery, Santa Monica, CA
1990 "Gallery Artists Exhibition," Virginia Miller Gallery, Miami, FL
1990 "Southern Visions," Sarratt Gallery, Vanderbilt University, Nashville, TN

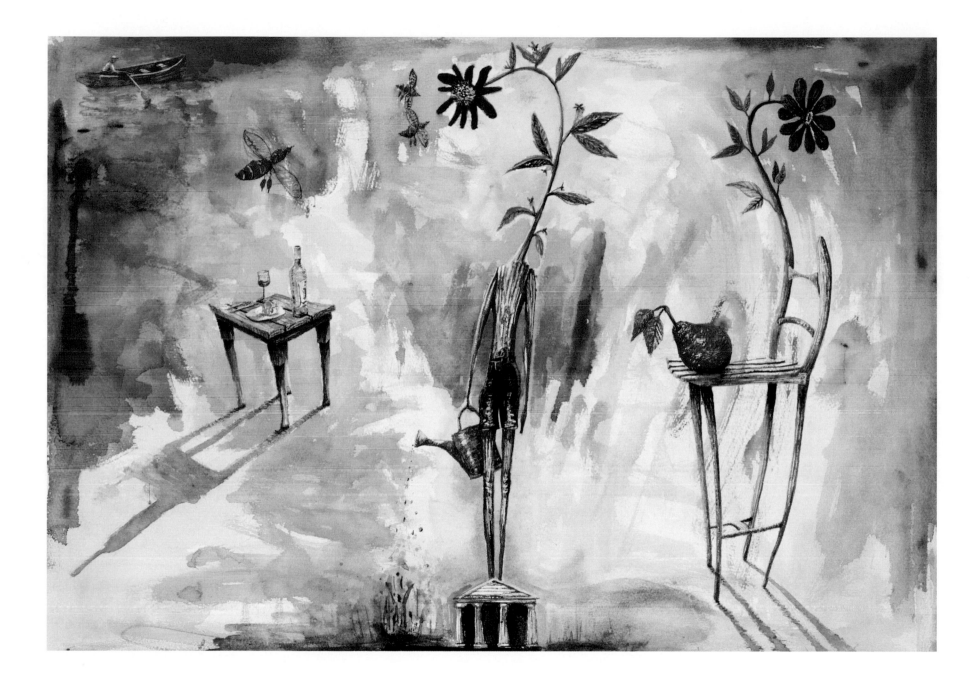

"OFFERING" 2004
WATERCOLOR ON PAPER
22-1/2" x 30"

213

DAVID SHAPIRO

...David Shapiro, a 59-year-old New York-based artist, has attracted a considerable following: his abstractions are soothing and hypnotic. Each work is divided into a series of adjacent panels featuring one of the motifs Shapiro is best known for—patterns of circles, tangles of squiggly lines, and screen-like grids. Although the panels have the potential to clash, Shapiro's juxtapositions are harmonious, reflecting the cerebral artist's deft touch and mastery of composition, which is influenced in part by Japanese art.

—Stephen May
ARTnews/Summer 2003

Born: 1944 Brooklyn, New York
Lives and works in New York, New York

EDUCATION
1968 M.F.A. Indiana University
1966 B.F.A. Pratt Institute
1965 Skowhegan School

ONE PERSON EXHIBITIONS (selected)
2006 Nicolas Metivier Gallery, Toronto
2006 Numark Gallery, Washington, D.C.
2005 Perimeter Gallery, Chicago, IL
2005 Lowe Gallery, Atlanta, GA
2005 Lowe Gallery, Santa Monica, CA

GROUP EXHIBITIONS (selected)
1995 US Print Grafikan Paja Himmelblau Tampere, Finland
1995 "Frameless," Inaugural International Invitational Biennial, Mie Cultural Center, Ise, Japan
1990 "Eleventh British International Print Biennial," Bradford Art Galleries and Museums (traveling to the Royal College of Art, Henry Moore Galleries, London)
1990 "Echo Press: A Decade of Printmaking," Indiana University Museum of Art, Bloomington, IN (catalog)
1990 "Art on Paper," Weatherspoon Art Gallery, University of North Carolina at Greensboro
1989 "Myth Symbol Dream: Structures of the Unconscious," Delaware Center for Contemporary Arts, Wilmington
1989 Graphic Biennial, exhibition sponsored by U.S.I.A., Ljubljana, Yugoslavia (traveling to University of Florida Gallery, Gainsville, FL)
1989 "Mind and Matter," exhibition sponsored by U.S.I.A. (traveling exhibition) (catalog)

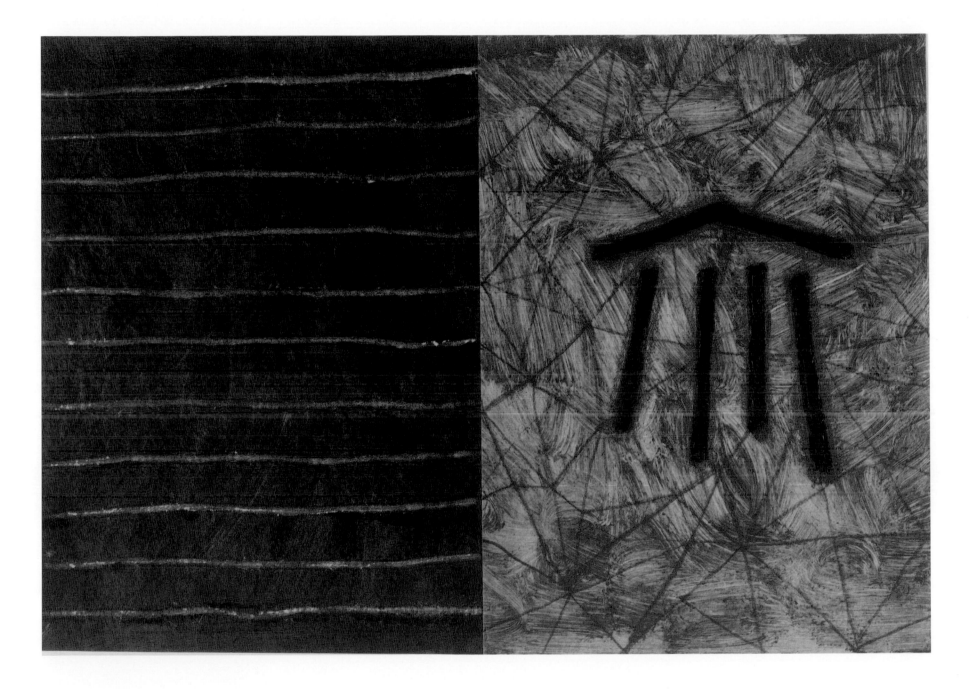

"Untitled" 1990
Ink on paper
6-7/8" x 10"

215

ALAN SHEPP

Alan Shepp's stone abstractions convey humanistic themes. Shepp is clearly at ease with the communicative aspects of the language of art…

—Phyllis Tuchman
Alan Shepp, The Language of Stone

Born: 1935 Cleveland, Ohio
Lives and works in Napa, California

EDUCATION
1963	M.F.A. University of Washington, Seattle, WA
1958	B.F.A. Cleveland Institute of Art, Cleveland, OH
1957	B.A. Bowling Green State University, Bowling Green, OH

GRANTS AND AWARDS (selected)
1998-2001	National Review Committee for Fulbright Scholars, Egypt, Israel
1995	C.S.U. Research/Travel Grant, Peru
1991	Senior Fulbright Fellowship, Egypt
1979	National Endowment for the Arts Fellowship
1974	California State University Research/Travel Grant, Italy
1970	State Arts Council Grant, Minnesota
1963-1964	Fulbright Fellowship, Italy

ONE PERSON EXHIBITIONS (selected)
2003	Art Foundry Gallery, Sacramento, CA
1996	Stephen Wirtz Gallery, San Francisco, CA
1992	Stephen Wirtz Gallery, San Francisco, CA
1991	Monterey Peninsula Museum of Art, Monterey, CA
1990	"Poems," Stephen Wirtz Gallery, San Francisco, CA

GROUP EXHIBITIONS (selected)
2002	Art Foundry Gallery, Sacramento, CA
2002	Sculpture Invitational, University of San Francisco, CA
2002	"Sculpture/2002, 15 West Coast Sculptors," Art Foundry Gallery, Sacramento, CA
1999	The Art of Collaborative Printmaking, Smith Anderson Editions, de Saisset Museum, Santa Clara University, Santa Clara, CA.
1998	"Printmaking, Smith Anderson Editions," Nevada Museum of Art, Reno, NV
1996	"Fulbright 50TH Anniversary Exhibition," California State University Long Beach, CA
1993	"California Eclectic," Trans America Pyramid Lobby, San Francisco, CA
1993	"West Art and the Law," Bank of America Security Pacific Gallery, San Francisco, CA (traveling exhibition)
1993	"Images in Bronze," China Basin Building Gallery, San Francisco, CA
1990	"Group Sculpture Show," Stephen Wirtz Gallery, San Francisco, CA

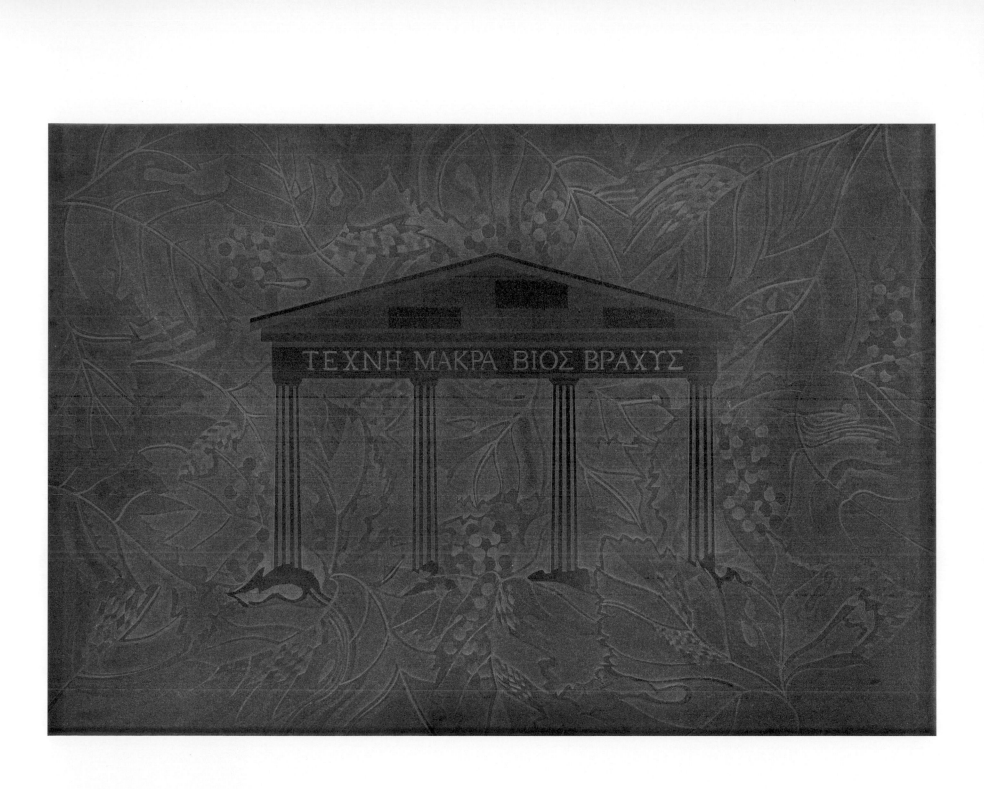

"Untitled" 2003
Sandblasted glass
17-1/4" x 24-4/5"

217

ANNE SIEMS

Anne Siems evokes a mysterious world of her own making as she places iconic female figures in imaginary landscapes… Though Siems uses many of the same symbols repeatedly, the specific narrative always remains allusive.

—Margaret Mathews-Berenson

Born: 1965 Berlin, Germany
Lives and works in Seattle, Washington

EDUCATION
1991 M.F.A. in Fine Art, Hochschule Der Kunste, Berlin, Germany
1986-1987 Fulbright Scholar, University of the South Sewanee, TN

GRANTS AND AWARDS (selected)
1997 Residency, OCAC 90TH Anniversary
1996 Neddy Award Nominee, Seattle, WA
1996 Artist Trust Grant
1987 Fulbright Scholarship

ONE PERSON EXHIBITIONS (selected)
2004 "Daydream," Catharine Clark Gallery, San Francisco, CA
2004 "Home," David Lusk Gallery, Memphis, TN
2004 Grover Thurston Gallery, Seattle, WA
2002 "Bloom," Catharine Clark Gallery, San Francisco, CA
2000 "New Work: Anne Siems," Southwest Texas State University San Marcos, TX

GROUP EXHIBITIONS (selected)
2004 "Reading Meaning with Squeak Carnwath, Lesley Dill, Leslie Enders Lee and Anne Siems,"
 Scripps College
2002 "Romancing the Everyday," The Arts Center, Petersburg, FL
2002 "Underfoot," Associacão Alumni, São Paulo, Brazil (traveling exhibition) (catalog)
2000 "The Great Novel Exhibition," Palo Alto Arts Center, CA
1997 "Out of Eden," Kemper Museum for Contemporary Art and Design, Kansas City, MO

ANNE WITH HER DAUGHTER EVA

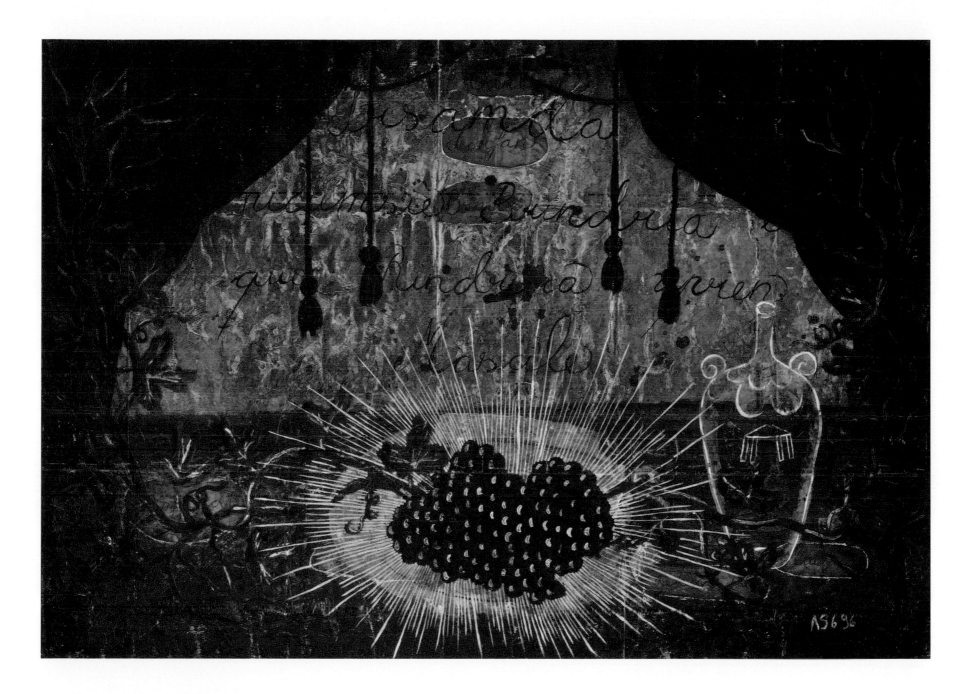

"IRSANDA" 1996
MIXED MEDIA ON PAPER/CLOTH
24-1/2" x 34-3/4"

219

HANS SIEVERDING

Painting for me is a quest; a way to be in touch with life, conviction, the unexposed; a process of confronting the conflict of existence. My paintings are evolutions. They emerge from layers of many studies, superimposed upon one another, joined by color and form. Out of the spontaneous process of painting and coalescence comes the meaning. The finished paintings are the final destination of my thoughts, the answers to my quest.

—Hans Sieverding, 2005

Born: 1937 Wenstrup, Germany
Lives and works in Michelstadt and Berlin, Germany

EDUCATION
Studied at Wilhelm Wiacker, Duisburg, Germany

ONE PERSON EXHIBITIONS (selected)
2004 Kunstverein Marburg: Himmel, Hölle, 1,2,3, Marburg, Germany
2004 Galerie Zellermayer ,Berlin, Germany
2002 Galerie Wild, Frankfurt, Germany
2002 Kunsthalle Darmstadt: wirklich utopisch, Darmstadt, Germany
2002 Dominikanerkirche, Osnabrück, Germany
2002 Galerie Peschkenhaus, Moers, Germany
2002 Kunstverein, Eislingen, Germany
2002 Galerie Wild, Frankfurt, Germany
2002 Galerie Kohinoor, Karlsruhe, Germany

GROUP EXHIBITIONS (selected)
2005 Künstlerhaus: 12 german positions, with the Darmstädter Sezession, Graz, Austria
2005 Kunstmuseum: in figura, with Westdeutscher Künstlerbund, Herne, Germany
2004 ART COLOGNE, with Galerie Epikur, Wuppertal, Köln, Germany
2004 Gallery Rasmus: four artists - two countries, Odense/Kopenhagen, Denmark
2004 Kunstpalast Düsseldorf: Große Kunstausstellung NRW, Düsseldorf, Germany
2002 Kunstrai, Amsterdam, Netherlands
2002 mit Galerie de Lange Emmen, Netherlands
2002 Galerie Veronica Kautsch, Michelstadt, Germany
2002 Große Kunstausstellung NRW, Düsseldorf, Germany
2001 Galerie de Lange, Emmen, Netherlands
2001 NE-Galerie, Darmstadt, Germany

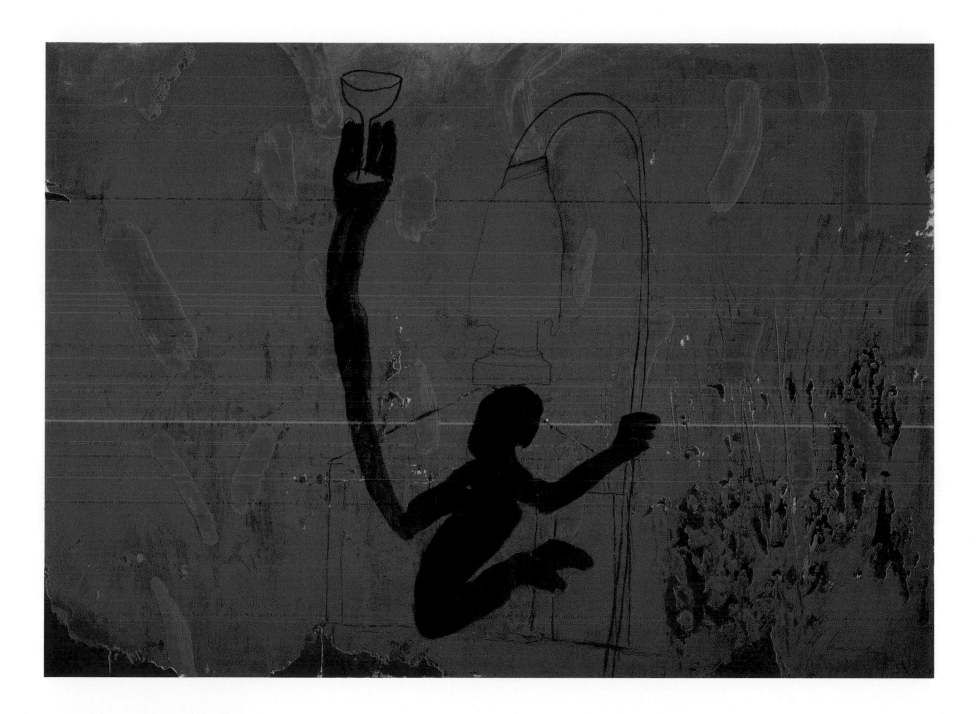

ALEXIS SMITH

Without question one of the most popular artworks among visitors to the winery is the Alexis Smith image for the 2003 Viognier. Alexis created a wonderful retro piece that I think stirs memories of times past for all that view it. For me it mirrors the delicate and proper Quaker grandmother of mine, who refused to go outside or sit in the sun without a full compliment of clothes and gloves to cover her pale skin. The only thing missing is the hat.

—Bob Nugent

Born: 1949 Los Angeles, California
Lives and works in Los Angeles, California

EDUCATION
1970 B.A. University of California at Irvine

GRANTS AND AWARDS (selected)
2002 C.O.L.A. Individual Artist Fellowship, Los Angeles
2001 Honorary Doctorate, Otis College of Art & Design, Los Angeles
2000 Epoxy Terrazzo Job of the Century, National Terrazzo and Mosaic Association
1999 Terrazzo Job of the Year, National Terrazzo and Mosaic Association
1995 Residency, The Rockefeller Foundation Study Center, Bellagio, Italy
1987 National Endowment for the Arts Fellowship
1983 Key to the City, Grand Rapids, MI
1976 National Endowment for the Arts Fellowship

ONE PERSON EXHIBITIONS (selected)
2004 "LUST/RUST/DUST," Artemis Greenberg Van Doren Gallery, New York, NY
2003 "Living Dangerously," Margo Leavin Gallery, Los Angeles, CA
2003 "The Sorcerer's Apprentice and Past Lives: Installations by Alexis Smith and Amy Gerstler,"
 The University of Wyoming Art Museum
2002 "Local Color," David Floria Gallery, Aspen, CO
2002 "Real World: Collage Works 1981-2002," Modernism, San Francisco, CA
2001 "The Sorcerer's Apprentice," with Amy Gerstler, Museum of Contemporary Art, San Diego, CA
2000 "The Sorcerer's Apprentice," with Amy Gerstler, Miami Art Museum, FL
2000 "Fools Rush In," Ameringer Howard, Boca Raton, FL
1999 "Words to Live By," Margo Leavin Gallery, Los Angeles, CA
1997 "My Favorite Sport," Wexner Center for the Arts, Ohio State University, Columbus, OH

GROUP EXHIBITIONS (selected)
2004 "Now and Then Some," Peggy Phelps Gallery, Claremont Graduate University, Claremont, CA
2003 "Raid the Icebox," Margo Leavin Gallery, Los Angeles, CA
2002 "C.O.L.A. 2002," Japanese American National Museum, Los Angeles, CA
2002 "Collage Culture," Everson Museum of Art, Syracuse, NY
2002 "Parallels and Intersections: Art / Women / California 1950-2000," San Jose Museum of Art, CA
2001 "Beau Monde: Toward a Redeemed Cosmopolitanism: Site Santa Fe 2001 Biennial," Site Santa
 Fe, NM
2001 "Postmodern Americans: a Selection," The Menil Collection, Houston, TX
2001 "A Way with Words: Selections from the Whitney Museum of American Art," Whitney Museum
 of American Art at Philip Morris, New York, NY
2000 "Made in California," Los Angeles County Museum of Art, Los Angeles, CA

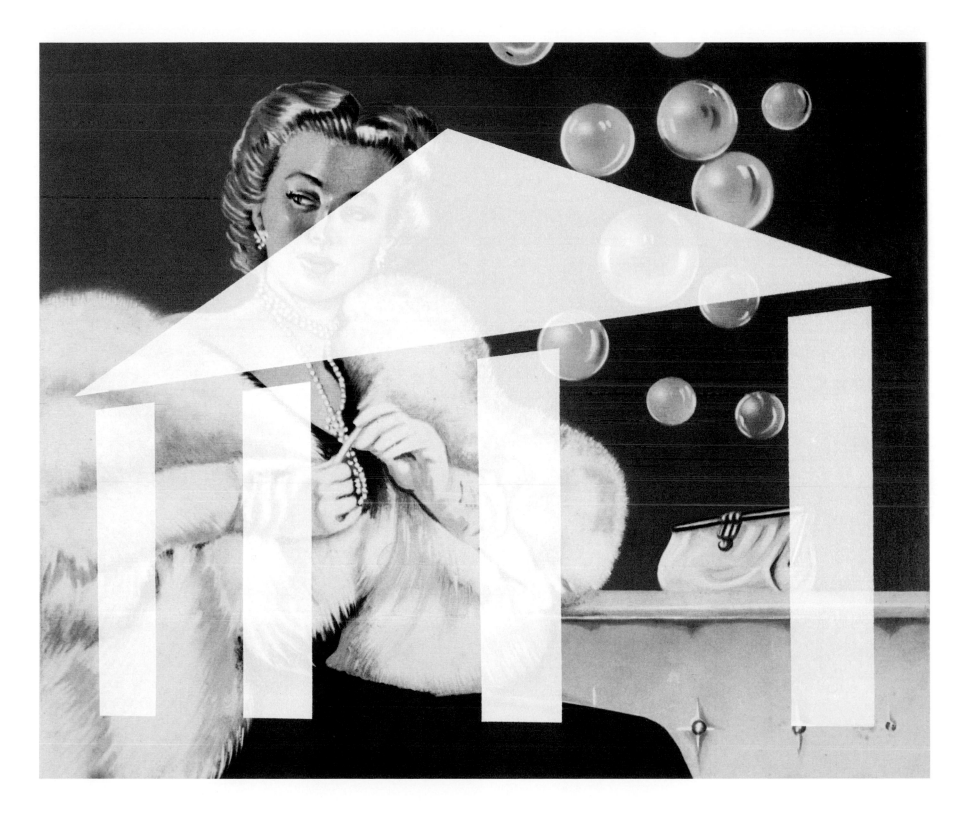

HASSEL SMITH

Teaching along side of David Park and Clifford Still, Hassel Smith influenced many a young painter over his long career. At age 90 Hassel Smith paints with the enthusiasm of a youngster and continues to explore his life long pursuit of abstraction.

—Bob Nugent

Born: 1915 Sturgis, Michigan
Lives and works in Rode Nr. Bath, England

EDUCATION
1938 California School of Fine Arts, San Francisco, CA
1936 B.S. in Art History, Northwestern University, Chicago, IL

GRANTS AND AWARDS (selected)
1941 Rosenberg Fellowship

ONE PERSON EXHIBITIONS (selected)
1988 College of Notre Dame, Belmont, CA
1988 Monterey Museum of Art, Monterey, CA
1988 Cleveland Brige Gallery, Bath, England
1988 "Hassel Smith," Natsoulas-Novelozo Gallery, Davis, CA
1987 Blum Helman Gallery, Santa Monica, CA
1985 John Berggruen Gallery, San Francisco, CA
1984 Gallery Paule Anglim, San Francisco, CA
1983 San Jose Museum of Art, San Jose, CA
1982 Gallery Paule Anglim, San Francisco, CA

GROUP EXHIBITIONS (selected)
1988 "Lost and Found in California, Four Decades of Assemblage Art," James Corcoran Gallery, Santa Monica, CA
1980 "Neri and Smith," Gallery Paule Anglim, San Francisco, CA
1980 Tortue Gallery, Los Angeles, CA
1979 "Annual Drawing Invitational," Central Washington State College, Ellensburg, WA
1979 "Aspects of Abstract: Recent West Coast Abstract Painting and Sculpture," E. B. Crocker Gallery, Sacramento, CA
1976 "Painting and Sculpture in California: The Modern Era," Smithsonian Institute, Washington, D.C.
1976 "American Painter Living in England," Sponsored by Windsor and Co. (traveling exhibition)
1973 "A Period of Exploration," San Francisco 1945-1950, The Oakland Museum, CA

"Untitled" 1992
pastel/magic marker on paper
13" x 20"

225

WILLIAM SMITH

My work is a humorous and satirical social commentary on the perils of human nature. I strive to create an environment that is vivid, playful and animated, a world that is beautiful and innocent yet where something very wrong is taking place unbeknownst to the caricatured allegories that populate this backwards paradise. The piece I made for Imagery derives from the myth of Dionysius infused with my own inventions and symbology.

—William Smith

Born: 1970 Kentfield, California
Lives and works in Penngrove, California

EDUCATION
1998 M.F.A. Printmaking, West Virginia University
1996 B.F.A. Printmaking, Sonoma State University

GRANTS AND AWARDS (selected)
2003 Third Place Juror's Award, "Sonoma Creates," Sonoma Valley Museum of Art, Sonoma, CA
2002 Mary Lee and John Marcom Purchase Award, "Delta National Small Prints Exhibition,"
 Bradbury Gallery, Arkansas State University, Jonesboro, AR

GROUP EXHIBITIONS (selected)
2004 "A Breach in the Ghostly Skin," 21 Grand Gallery, Oakland, CA
2004 "Bound By Habitat," Museum of Contemporary Art, Santa Rosa, CA
2003 "Opposites Attack," Roshambo Gallery, Healdsburg, CA
2003 "Sixteenth Annual McNeese State University Works on Paper," Abercrombie Gallery, McNeese
 State University, Lake Charles, LA
2002 "Delta National Small Prints Exhibition," Bradbury Gallery, Arkansas State University,
 Jonesboro, AR
2002 "Underfoot," Associacão Alumni, São Paulo, Brazil (traveling exhibition) (catalog)
2001 "Prints by Eight," A St. Gallery, Santa Rosa, CA
2001 "Operating Systems," Susan Cummings Gallery, Mill Valley, CA
2000 "Small Works," S-Mova, Santa Rosa, CA
2000 "Art Communicates," S-Mova, Santa Rosa, CA
1999 "Ink & Clay," University Art Gallery, California State Polytechnic University, Pomona, CA
1999 "Positive/Negative 14," Slocumb Gallery, East Tennessee State University, Johnson City, TN
1998 "Staring at the Walls for the Dailys," M.F.A. Thesis Exhibition, Paul Mesaros Gallery, West
 Virginia University, Morgantown, WV
1998 "California Small Works," California Museum of Art, Santa Rosa, CA
1997 "West Virginia Juried Exhibition," West Virginia Cultural Center, Charleston, WV
1997 "Lagniappe," Print Exhibition and Portfolio Exchange, Louisiana State University Gallery, Baton
 Rouge, LA
1996 "Print Matters," University Gallery, California State University, Long Beach, CA
1996 "Expressions of the Male Soul," Wilson St. Gallery, Santa Rosa, CA

"Untitled" 2002
MIXED MEDIA ON PAPER
16-7/16" x 24"

JOAN SNYDER

In 1989, as Director of the University Art Gallery at Sonoma State University, I showed "Joan Snyder Collects Joan Snyder," an exhibition organized by Betty Klausner for the Santa Barbara Contemporary Arts Forum. In her foreword for the catalog Klausner wrote, "Whether abstract or representational, encrusted with gobs of paint or spare and singular, landscape or narrative, lyrical or discordant, her art is intimately linked with significant personal events and relationships. Snyder's trained hand responds to her world of family, lovers, friends, and ideas to create her distinctive imagery. All her work reflects the hothouse of her moods of joy, anger, and anxiety—but especially the paintings she most loves and squirrels away to share with us in 'Joan Snyder Collects Joan Snyder.'" It was the experience of living with this exhibition that made me fall in love with her work.

—Bob Nugent

Born: 1940 Highland Park, New Jersey
Lives and works in Brooklyn, New York

EDUCATION
1966 M.F.A. Rutgers University, New Brunswick, NJ
1962 B.A. Douglass College, Rutgers University, New Brunswick, NJ

GRANTS AND AWARDS (selected)
1983 John Simon Guggenheim Memorial Fellowship
1974 National Endowment for the Arts Fellowship

ONE PERSON EXHIBITIONS (selected)
2005 Sawhill Gallery, James Madison University, Harrisonburg, VA
2004 "Joan Snyder: Works on Paper 1970's and Recent," Betty Cunningham Gallery, New York, NY
2003 "New Work," Elena Zang Gallery, Shady, NY
2002 "The Nature of Things," Nielsen Gallery, Boston, MA

GROUP EXHIBITIONS (selected)
2005 "From the Heart," Nielsen Gallery, Boston, MA
2005 "Upstarts and Matriarchs: Jewish Women Artists and the Transformation of American Art," Mizel Center for Arts and Culture, Denver, CO
2004 "Collage: The Art of Attachment," Elena Zang Gallery, Shady, NY
2004 "About Painting," The Tang Museum, Skidmore College, Saratoga Springs, NY
2004 "March Heat," Nielsen Gallery, Boston, MA
2004 "Inside/Out," Elena Zang Gallery, Shady, NY
2003 "178TH Annual Exhibition," National Academy of Design, New York, NY
2002 "Personal and Political: The Women's Art Movement, 1969-1975," Guild Hall Museum, East Hampton, NY

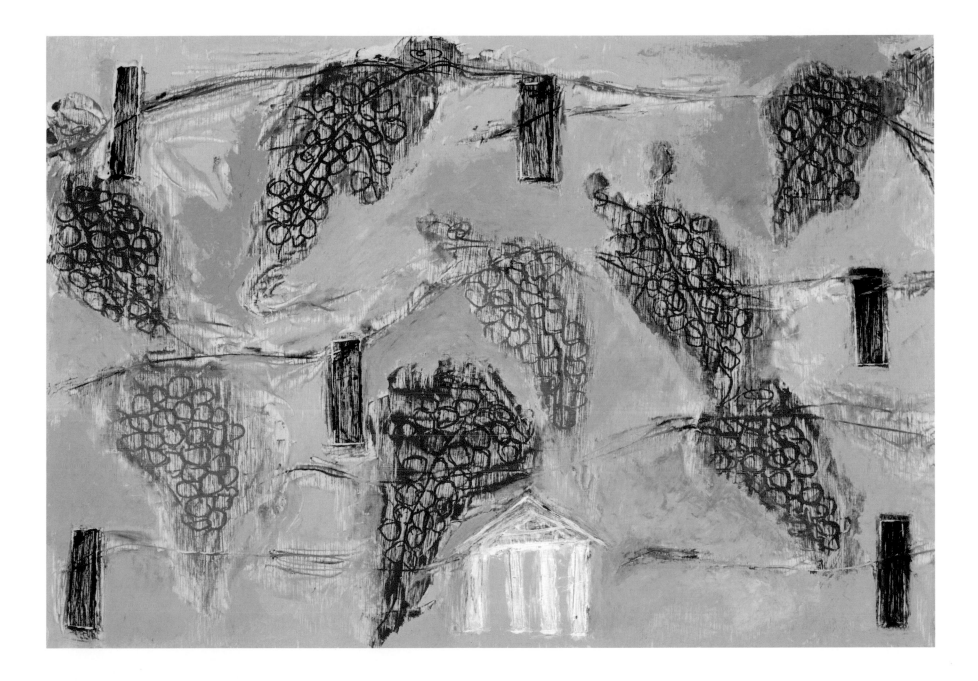

"Untitled" 1995
MIXED MEDIA/WOODBLOCK PRINT
16-1/2" x 24"

STEVEN SORMAN

I paint what isn't, all the while trying to make it look real.

—Steven Sorman

Born: 1948 Minneapolis, Minnesota
Lives and works in Ancram, New York

EDUCATION
1971 B.F.A. University of Minnesota

GRANTS AND AWARDS (selected)
1991 Second Bhrat Bhavan International Biennial of Prints, Merit Award
1982 Rockefeller Foundation
1982 American Center Artist in Residence, Paris
1980 Merit Award, World Print III
1979 Minnesota State Arts Board
1979 Bush Foundation

ONE PERSON EXHIBITIONS (selected)
1999 Wetterling Gallery, Stockholm, Sweden
1998 Wetterling Teo Gallery, Singapore
1998 Contemporary Arts Center, Cincinnati, OH
1994 Tyler Graphics, New York, NY
1993 University of Iowa Museum of Art

GROUP EXHIBITIONS (selected)
2004 "Print Matters: The Kenneth E. Tyler Gift," Tate Liverpool, Tate Modern, England
2001 "Impression to Form," Singapore Art Museum
2000 "175TH Annual Exhibition," National Academy of Design, New York, NY
1999 "Forms That Speak: CLGA and Tyler Graphics Archive Collection," Fukushima, Japan
1999 "23RD International Biennial of Graphic Arts," Jubljana, Slovenia
1997 Museum of American Art, Washington, D.C.
1996 "Beyond Print," Lasalle, Sia College of the Arts, Singapore
1992 "Contemporary American Art Exhibition," Tokushima Modern Art Museum, Japan

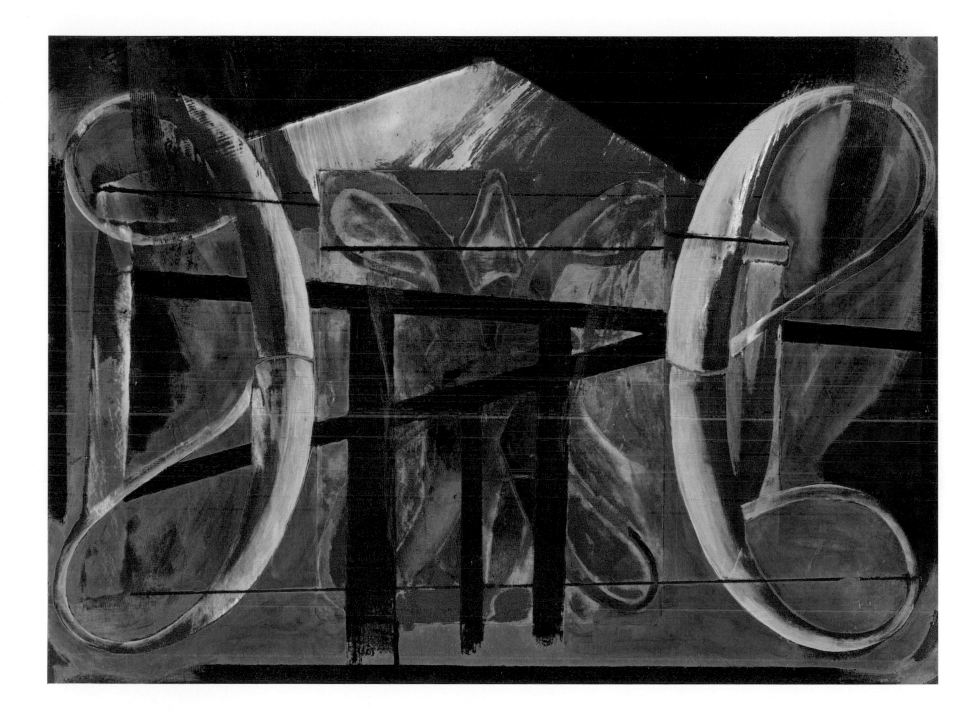

"Untitled" 1993
OIL/ENCAUSTIC ON BOARD
13" x 18"

231

BUZZ SPECTOR

My art makes frequent use of the book, both as subject and object, and reflects my concern with relationships among public history, individual memory, perception and desire.

—Buzz Spector

Born: 1948 Chicago, Illinois
Lives and works in Ithaca, New York

EDUCATION
1978 M.F.A. University of Chicago, Chicago, IL
1972 B.A. Southern Illinois University, Carbondale, IL

GRANTS AND AWARDS (selected)
1991 Louis B. Comfort Tiffany Foundation Fellowship
1991 National Endowment for the Arts Fellowship
1985 National Endowment for the Arts Fellowship
1982 National Endowment for the Arts Fellowship

ONE PERSON EXHIBITIONS (selected)
2005 Zolla-Lieberman Gallery, Chicago, IL
2004 Marsha Mateyka Gallery, Washington, D.C.
2004 "Re:Reading," Marsha Mateyka Gallery, Washington, D.C.
2003 "Pos(e)itioning the Author," Samek Art Gallery, Bucknell University, Lewisburg, PA
2003 Zolla-Lieberman Gallery, Chicago, IL
2001 Cristinerose Gallery, New York, NY
2001 "Public/Private Peace," (installation), List Art Gallery, Swarthmore College, Swarthmore, PA

GROUP EXHIBITIONS (selected)
2004 "New Commissions," Grand Opening Celebration, The New Princeton Public Library, Princeton, NJ
2003 "Newer Genres: Twenty Years of the Rutgers Archives for Printmaking Studios," Rutgers University, Zimmerdli Art Museum, New Brunswick, NJ
2003 "Publishing Granary's Books: A Conversation in the Margins," Mandeville Special Collections Library, University of California at San Diego, CA
2003 "The Consistency of Shadows: Exhibition Catalogs as Autonomous Works of Art," Betty Rhymer Gallery, School of Art Institute of Chicago, IL
2003 "Building the Book: an exhibition of artists' books," Center Galleries, College for Creative Studies, Detroit, MI
2003 "Re/order," Houghton House Gallery, Hobart and William Smith Colleges, Geneva, NY
2002 "Life Death Love Hate Pleasure Pain," Museum of Contemporary Art, Chicago, IL
1998 "Testo e Contesto: il libro ambiente (Text and Context: the book as attitude)," Palazzo Falconieri, Rome, Italy
1992 "Knowledge: Aspects of Conceptual Art," University Art Museum, University of California at Santa Barbara, Santa Barbara, CA (traveling exhibition)

ROBERT STACKHOUSE

Stackhouse is among the few contemporary artists who call directly upon our common stock of knowledge and our familiar feelings about enclosure and openness, about light and carpentered form and landscape. He puts no obstacles of style or art-world reference between our imaginations and the allusions that drift around each of his sculptures like the atmosphere that gives a particular day its distinctive mood.

—From an essay by Carter Radcliff

Born: 1942 Bronxville, New York
Lives and works in St. Petersburg, Florida

EDUCATION
1967 M.A. University of Maryland, College Park, MD
1965 B.A. University of South Florida, Tampa, FL

GRANTS AND AWARDS (selected)
1991 National Endowment for the Arts Fellowship
1982 National Endowment for the Arts Fellowship
1977 National Endowment for the Arts Fellowship

ONE PERSON EXHIBITIONS (selected)
2003 University of Georgia, Athens, GA
2002 Dennis Morgan Gallery, Kansas City, MO
2002 Klein Art Works, Chicago, IL
2002 University of Missouri, St. Louis, MO
2001 Museum of Art, University of Arizona, AZ
2000 Urban Architecture, NY

GROUP EXHIBITIONS (selected)
1997 Klein Art Works Chicago, IL
1993 "Recent Works," Morgan Gallery Kansas City, MO
1991 Delaware Art Museum Wilmington, DE
1991 New Editions, Pace Prints New York, NY
1989 "The Boat Show: Fantastic Vessels, Fictional Voyages," Renwick Gallery, Smithsonian Institution Washington, D.C.
1989 "Projects and Portfolios, The 25TH National Print Exhibition," The Brooklyn Museum, NY
1988 "Spectrum- Mary Beth Edelson, Martin Puryear, Italo Scanga, Robert Stackhouse," The Corcoran Gallery of Art, Washington, D.C.

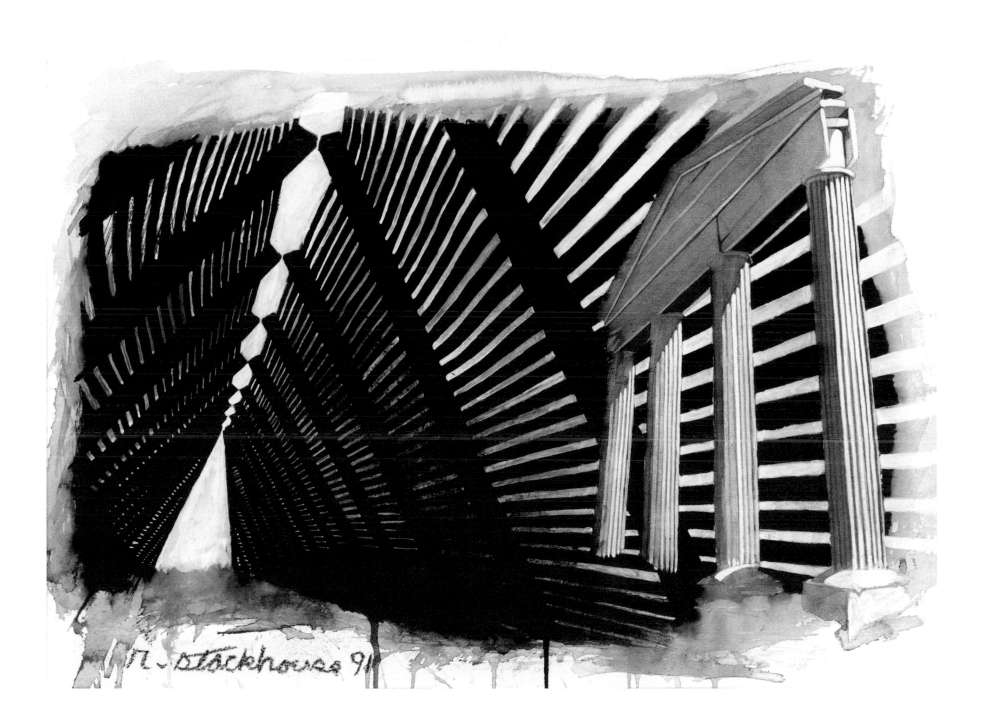

"Untitled" 2001
WATERCOLOR ON PAPER
14-1/4" x 20-1/4"

PAT STEIR

The self is like a bug. Every time you smack it, it moves to another place.
—Pat Steir
From *View*, www.crownpoint.com

Born: 1940 Newark, New Jersey
Lives and works in New York City and Amsterdam, Holland

EDUCATION
1961 B.F.A. Pratt Institute, Brooklyn, NY
1960-62 Pratt Institute, Brooklyn, NY
1958-60 Boston University, Boston, MA
1956-58 Pratt Institute, Brooklyn, NY

GRANTS AND AWARDS (selected)
2004 "What is Called Beauty," Clarice Smith Distinguished Lectures in American Art, Smithsonian
 American Art Museum
1992 Honored by the American Woman's Economic Development Corporation with their Salute to
 Women in the Business of Art
1991 Honarary Doctorate of Fine Art from Pratt Institute, Brooklyn, NY
1982 John Simon Guggenheim Memorial Fellowship

ONE PERSON EXHIBITIONS (selected)
2005 Cheim & Read, New York, NY
2005 "Pat Steir: Drawings," Cook Fine Art, New York, NY
2004 "Abstractions," Cook Fine Art, New York, NY
2003 Galleria Nationale Moderne Borghese, Rome, Italy
2003 Des Moines Art Center, IA
2002 Cheim & Read, New York, NY
2002 University Art Museum, University of Michigan, Ann Arbor, MI
2002 Crown Point Press, San Francisco, CA

GROUP EXHIBITIONS (selected)
2003 "Breathless," Neuberger Museum of Art, Purchase, NY
2002 "Modernism & Abstraction: Treasures from the Smithsonian American Art Museum," National
 Academy Museum, New York, NY
2002 "Modernism & Abstraction: Treasures from the Smithsonian's American Art Museum," Des
 Moines Art Center, Des Moines, IA
2001-2002 "The Inward Eye: Transcendence in Contemporary Art," Contemporary Art Museum, Houston, TX
2001 "The First 10 Years: Selected Works from the Collection," Irish Museum of Modern Art, Dublin,
 Ireland
2001 "Pat Steir, Brice Marden, & Michael Mazur," Boston University, Boston, MA
2000 The National Gallery of Art, Washington, D.C.
2000 "The Permanent Collection," The Whitney Museum of American Art, New York, NY

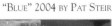

"BLUE" 2004 BY PAT STEIR

Pat Steir

"Untitled" 1995
MIXED MEDIA ON PAPER
13" x 18"

237

GARY STEPHAN

For the better part of this last century we watched artists walk closer and closer to the microphone and the pen making the criteria for visual art its resistance to language, its positive proof, a faded value. After all that, I think of myself as a world builder, constructing places that ultimately are neither rescued nor shielded by language. Places not of empirical dimension but the seamless smearing of senses and thoughts.

—Gary Stephan

Born: 1942 Brooklyn, New York
Lives and works in New York, New York

EDUCATION
1967 M.F.A. San Francisco Art Institute, San Francisco, CA
1961-1964 Pratt Institute, Brooklyn, NY
1960-1961 Parsons School of Design, New York, NY

GRANTS AND AWARDS (selected)
2003 American Academy of Arts and Letters
1985 John Simon Guggenheim Memorial Foundation Fellowship
1975 National Endowment for the Arts Fellowship
1975 New York Council on the Arts Foundation

ONE PERSON EXHIBITIONS (selected)
2001 Baumgartner Gallery, New York, NY
1999 "Same Body Different Day," UMMA, Orono, ME
1998 "A Room with a View," at Sixth@Prince Fine Art, New York, NY
1998 "10 Year Survey," Butler Institute, Youngstown, OH
1998 Hirschl and Adler Modern, New York, NY
1995 Galeria Fernand Alcolea, Barcelona, Spain
1993 Mary Boone Gallery, New York, NY

GROUP EXHIBITIONS (selected)
2003 "Sotheby's New York Exhibition," Sotheby's Gallery, New York, NY
2003 "Invitational Exhibition of Painting and Sculpture," American Academy of Arts and Letters, New York, NY
2002 "177TH Annual Invitational," National Academy of Design, New York, NY
1997 "1998 Annual Benefit," at White Columns Gallery, New York, NY

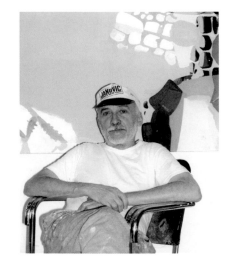

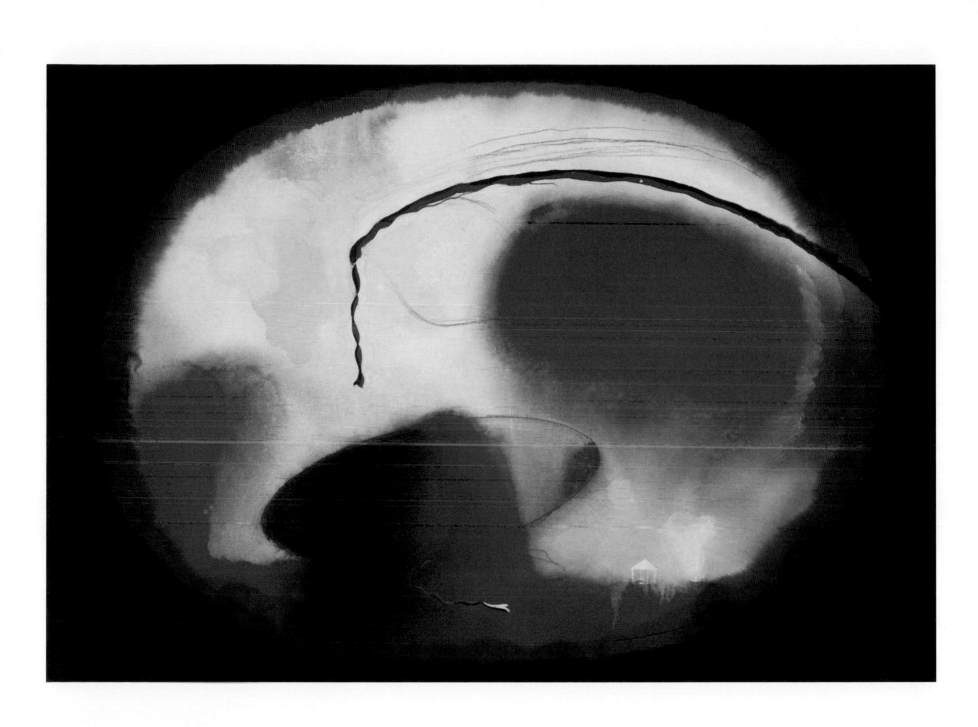

"Untitled" 1993
PASTEL/MIXED MEDIA ON PAPER
21-1/4" x 31"

239

MICHELLE STUART

It isn't to prove anything that one collects and/or re-collects from (a) place. It is to commit to memory. Memory is a beginning, a form of natural history: history not of what transpired culturally, but of what might transform naturally. Observing the metamorphosis in seeds—knowing that one common plant can produce six million seeds—assures the hope of life force and its imprinted pattern of evolution, assures that some memories, whether by chance, change or desire, never die.
—Michelle Stuart, *Natural Histories Catalog*, 1996

Born: 1940 Los Angeles, California
Lives and works in New York City and Amagansett, New York

EDUCATION
Chouinard Art Institute, Los Angeles, CA
The New School for Social Research, New York, NY

GRANTS AND AWARDS (selected)
1996	Academician of the National Academy of Design
1995	American Academy in Rome, Residency, Rome
1990	"Tabula," New York City Art Commission Excellence in Design Award
1990	The Birgit Skiold Memorial Trust Prize, 11TH British International Print Biennale, England
1989	National Endowment for the Arts Fellowship
1989	Art Gallery of Western Australia and Curtin University of Technology, Grant, Australia
1987	New York Foundation for the Arts, Artist's Fellowship
1985	Finnish Art Association Fellowship, Helsinki, Finland
1975	John Simon Guggenheim Memorial Fellowship

ONE PERSON EXHIBITIONS (selected)
1998	"Michelle Stuart: The Heart of the Matter," Southeastern Center for Contemporary Art, Winston-Salem, NC
1998	"Michelle Stuart," Glenn Horowitz, East Hampton, NY
1996	Bellas Artes, Sante Fe, NM (catalog)
1995	Anders Tornberg, Lund, Sweden
1994	Fawbush Gallery, New York, NY
1993	Bellas Artes, Sante Fe, NM
1992	Santa Barbara Contemporary Arts Forum, Santa Barbara, CA

GROUP EXHIBITIONS (selected)
2004	Parrish Art Museum, The Hamptons, NY
2003	"178TH Annual Exhibition," National Academy of Design, New York, NY
1999	"Afterimage: Drawing Through Process," Museum of Contemporary Art, Los Angeles, CA
1999	"Afterimage: Film and Video Program," Museum of Contemporary Art, Los Angeles, CA
1999	"Waxing Poetic: Encaustic Art in America," Montclair Art Museum, Montclair, NJ
1999	"Book as Art," National Museum of Women in the Arts, Washington, D.C.
1999	Radford Art Museum, Radford, VA
1997	"On the Edge: Contemporary Art from the Werner and Elaine Dannheiser Collection," Museum of Modern Art, NY
1997	"Neuberger Museum of Art Biennial of Public Art," Neuberger Museum of Art, Purchase, NY

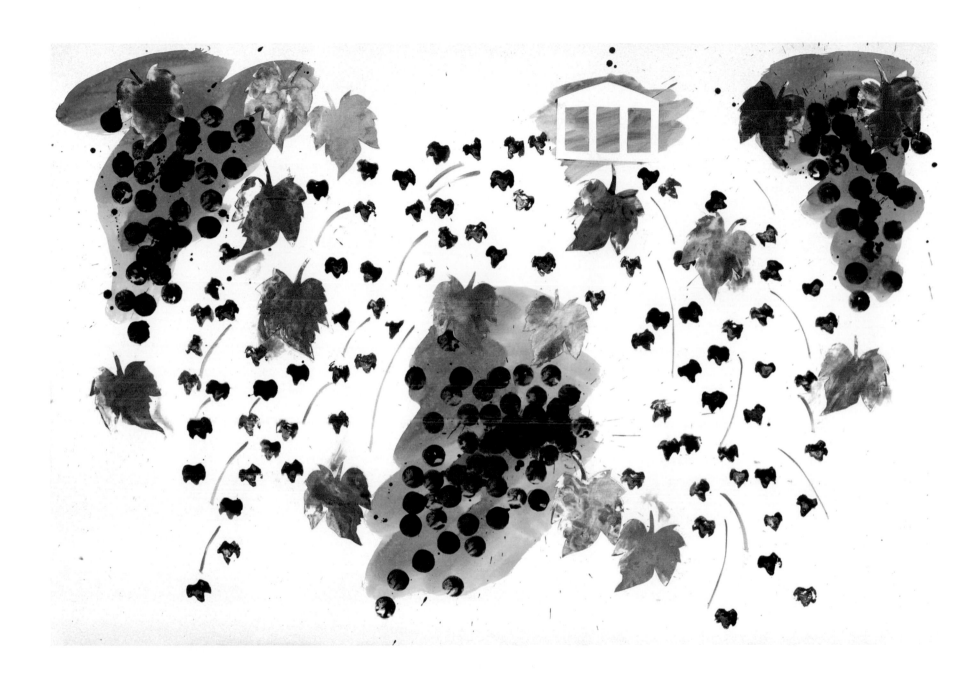

"UNTITLED" 1997
WATERCOLOR AND WINE ON PAPER
23" x 35-1/2"

JACK STUPPIN

There may be a factual (although not veristic) basis to Stuppin's art, but it does not suppress…the liberal invention of the eye. A child of modernism, Stuppin lets the photographers make the pictures; he makes the paintings…his attitude toward color is let it rip, let it glow, let it spill its embarrassment of riches all over the retina…his landscapes are designed not only to provoke emotions but to embody them….It works for Stuppin, much as it has worked for painters throughout the last hundred-plus-years.

—Peter Frank, *Jack Stuppin: Sensual Landscapes*

Born: 1933 Yonkers, New York
Lives and works in Sebastopol, California

EDUCATION
1969 San Francisco Art Institute, San Francisco, CA
1955 B.A. Columbia College, NY

ONE PERSON EXHIBITIONS (selected)
2004 B. Sakata Garo, Sacramento, CA
2003 Herbert Palmer Gallery, Los Angeles, CA
2002 Sonoma County Museum, Santa Rosa, CA
2001 Herbert Palmer Gallery, Los Angeles, CA
1998 School of Fine Arts, Columbia University, New York, NY

GROUP EXHIBITIONS (selected)
2003 San Jose Museum of Art, San Jose, CA
2002 National Endowment of the Arts, Washington, D.C.
2002 Butler Institute of American Art, Youngstown, OH
2002 Crocker Art Museum, Sacramento, CA
2000 de Young Fine Art Museums of San Francisco, San Francisco, CA
1998 Sonoma State University Art Gallery, Rohnert Park, CA
1997 California Academy of Science, San Francisco, CA
1993 Century Association, New York, NY

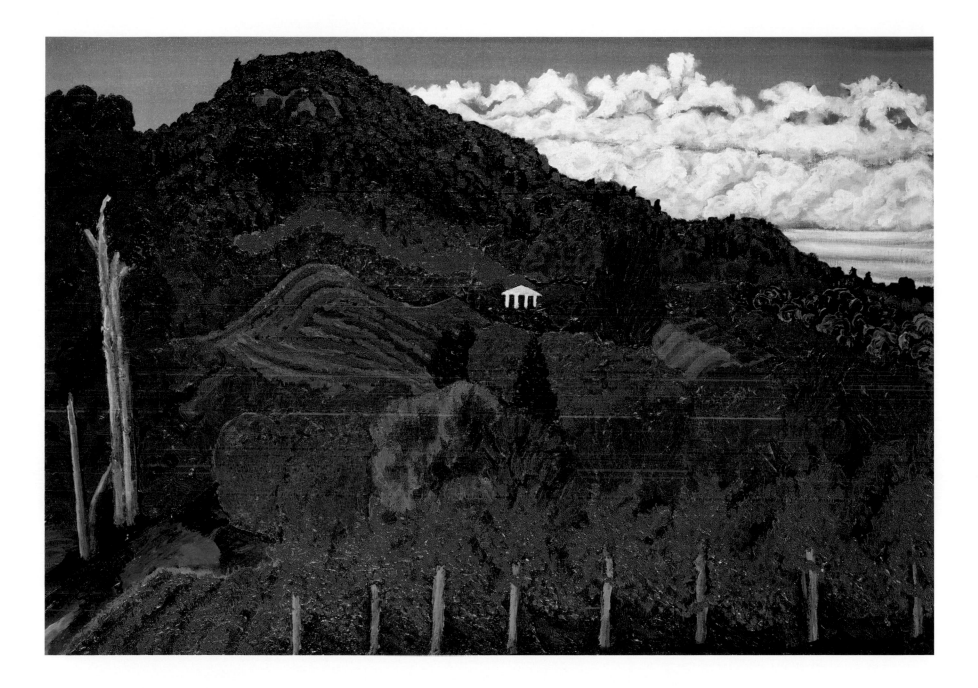

"TEMPLE TRANSFER" 1998
ACRYLIC ON CANVAS
20-1/4" x 29-3/8"

243

ANN TAULBEE

My studio practice and interests revolve around the use of iconic language and cultural interference, caused by, among many things, emotion and technology. Other visual influences include mythologies, idioms and historical symbolic forms and meanings.

—Ann Taulbee

Born: 1959 Hamilton, Ohio
Lives and works in Hamilton, Ohio

EDUCATION
1984 M.F.A. University of Massachusetts, Amherst, MA
1981 B.F.A Miami University, Oxford, OH

GRANTS AND AWARDS (selected)
1993 Visiting Artist, University of Georgia Cortona Program, Cortona, Italy
1991 Artist in Residence, Hand Graphics, Santa Fe, NM
1989 Artist in Residence, Connecticut College, New London, CT
1987 Artist in Residence, University of Wisconsin at Madison, Madison, WI

GROUP EXHIBITIONS (selected)
1998 "Miami Printmakers," Art Academy of Cincinnati, Cincinnati, OH
1995 "Illinois Artists," Firehouse Gallery, Bainbridge, GA
1994 "U.S.A. Within Limits," Documenta Galeria de Arte, São Paulo, Brazil
1993 "Images 1990," Portfolio Exhibition, The Sanford Gallery, Clarion, PA

LARRY THOMAS

Larry Thomas is a consummate draughtsman working in the traditional Baroque style. He brings to this work a wonderful sense of discovery—as if we are the archaeologist unearthing a lost treasure.

—Bob Nugent

Born: 1943 Memphis, Tennessee
Lives and works in Fort Bragg, California

EDUCATION
1979 M.F.A. San Francisco Art Institute, San Francisco, CA
1966 B.F.A. Memphis Academy of Arts, Memphis, TN

GRANTS AND AWARDS (selected)
1997 Visiting Artist/Scholar, American Academy in Rome
1991 Artist in Residence, Sitka Center for Art & Ecology, Otis, Oregon
1988 National Endowment for the Arts Fellowship
1986 Artist in Residence, Djerassi Foundation, Woodside, CA
1984 S.E.C.A. Award, San Francisco Museum of Modern Art, San Francisco, CA
1980 National Endowment for the Arts Fellowship

ONE PERSON EXHIBITIONS (selected)
1999 "From the Figure," Bank of America World Headquarters, Concourse Gallery
1998 "Wing," drawings made at the American Academy in Rome, Susan Cummins Gallery, Mill
 Valley, CA
1996 "Survey of Drawings," Palo Alto Cultural Center, Palo Alto, CA
1995 "Recent Drawings," Rockford College, Rockford, IL
1994 "Larry Thomas, Recent Drawings," Reese Bullen Gallery, Humboldt State University, Arcata, CA
1994 "Larry Thomas, Recent Drawings," The Memphis College of Art, Memphis, TN
1993 "Larry Thomas, Balzac's *Unknown Masterpiece*," Susan Cummins Gallery, Mill Valley, CA

GROUP EXHIBITIONS (selected)
1995 "Frame of Reference," Palo Alto Cultural Center, Palo Alto, CA
1994 "The Exchange Show: San Francisco/Rio de Janeiro," Yerba Buena Center for the Arts, San
 Francisco, CA/Museum of Modern Art, Rio de Janeiro, Brazil (catalog)
1994 "Drawing the Line," Drawings by 15 Bay Area Artists, Susan Cummins Gallery, Mill Valley, CA
1994 "National Drawing Invitational," The Arkansas Arts Center, Little Rock, AR (catalog)
1993-1994 "Faculty Selections," The San Francisco Art Institute, San Francisco, CA
1993 "The Uncommon Flower," The Palo Alto Cultural Center, Palo Alto, CA
1993 "Self Portraits in Black and White," Zyzzyva, Edith Caldwell Gallery, San Francisco, CA
1992-1993 "Directions in Bay Area Printmaking: Three Decades," The Palo Alto Cultural Center, Palo Alto,
 CA (catalog)
1992 "Macau Printmaking, '92," International Invitational Print Exhibition. The Cultural Institute of
 Macau, Macau (catalog)

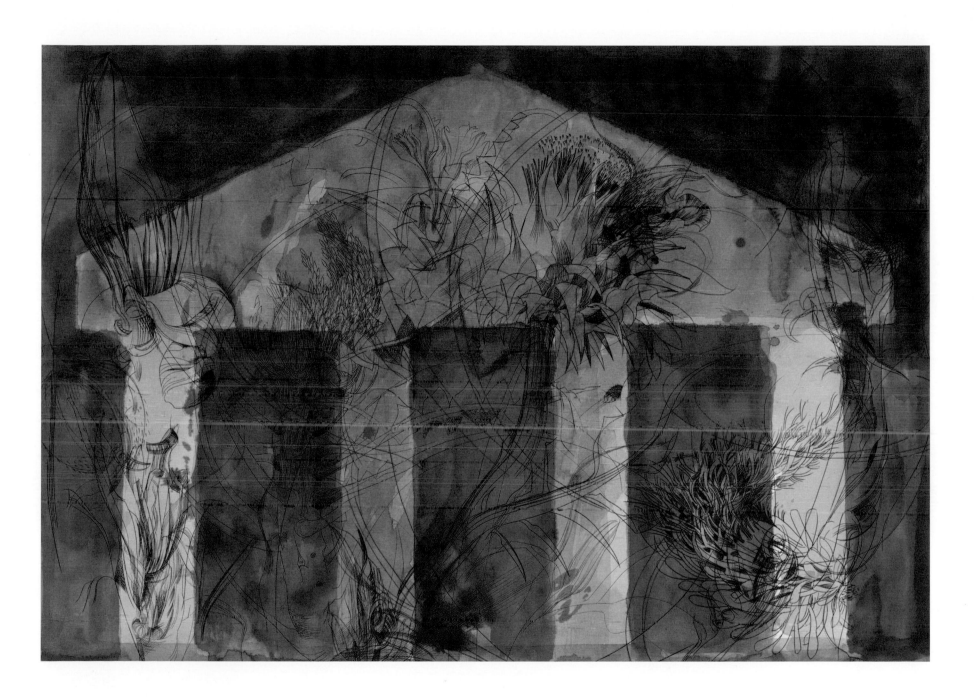

"Untitled" 1995
ENGRAVING/MIXED MEDIA ON PAPER
16" x 23-3/4"

247

CHERYL VAN HOOVEN

The two abiding interests in my work, in my life, are place and photography. I have gone out across the land and gathered images I bring back to my studio or darkroom and there, working the image, I am worked.

I use photography and the process of printing, the meditation of printing, to connect with my plant nature, my animal nature, my rock, sky and water natures, and to engage the spirit of structures.

—Cheryl Van Hooven

Born: 1948 Chicago, Illinois
Lives and works in New York, New York

EDUCATION
1989	Video Production and Editing, School of Visual Arts, New York, NY
1986/1988	Workshops with Barbara Kruger, International Center of Photography, New York, NY
1985	Color Printing, School of Visual Art, New York, NY
1981-1982	Studio work for Irving Penn, New York, NY
1971-1973	Graduate Study in Sociology and Anthropology, Emory University, Atlanta, GA
1970	B.A. in Journalism, University of Georgia, Athens, GA

GRANTS AND AWARDS (selected)
1986	"New Faces," *American Photographer* Magazine, Nominee

ONE PERSON EXHIBITIONS (selected)
2007	"Riverskins" and "Broken Homes," The Print Center, Philidelphia, PA (traveling exhibition)
2001	"Wetlands," Joseph Bellows Gallery, La Jolla, CA
1995	"Retrospective of 10 Years," Banana Republic Store Windows (7 New York Locations)
1994	"Natural Views," Katharina Rich Perlow Gallery, New York, NY
1992	"Native Elements," Puchong Gallery, New York, NY

GROUP EXHIBITIONS (selected)
2002	"This is Not a Photograph," DePaul University in Chicago, IL (traveling exhibition)
2001	"Dreaming," Rosenberg + Kaufman Fine Art, New York, NY
2001	"This is Not a Theme Show," Pittsburgh Center for the Arts, Pittsburgh, PA
2001	"Visual Fragrance: Floral Interpretations," Benham Studio Gallery, Seattle, WA
2001	"This is Not a Photograph," The Aldrich Museum of Contemporary Art, Ridgefield, CT
2000	"Land," Rosenberg + Kaufman Fine Art, New York, NY
1999-2000	"Playing Off Time," The Aldrich Museum of Contemporary Art, Ridgefield, CT
1999	"This is Not a Photograph," Pace University Gallery, Pleasantville, NY

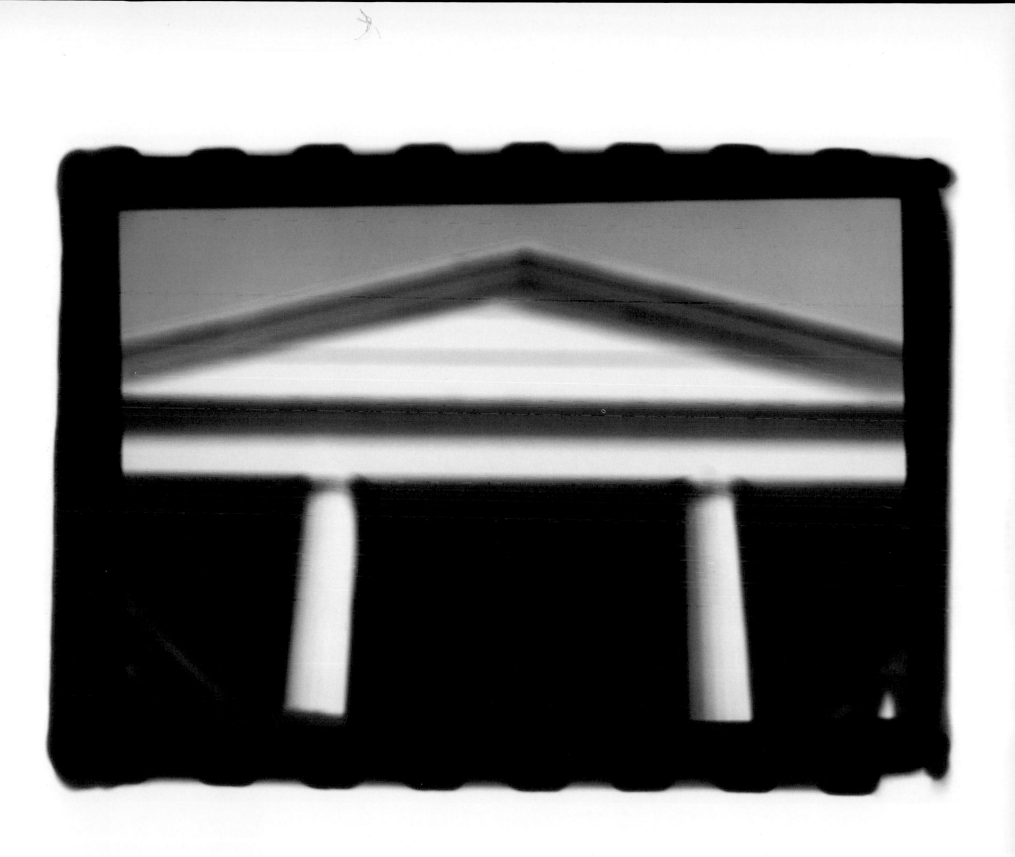

"Untitled (Imagery Parthenon I)" 2003
PHOTOGRAPH
20-3/4" x 28-1/4"

LIBBY WADSWORTH

In my paintings, I explore ways in which visual and verbal language systems interact. I try to ask questions like: How can words and images be made to work together? How does the presence of one, word or image, effect an understanding or interpretation of the other, of the piece as a whole? When we see words and images both as objects and as vehicles for the re-presentation of information, how does this understanding affect our aesthetic experience of a painting? In asking these kinds of questions, I try to establish new relationships and possibilities within the existing framework of historical and contemporary cultural ideas. As a woman artist, I am also searching for ways to locate and place my voice amidst this existing framework created and dominated largely by men. Still life, for me, is a very rich genre because it can engage so directly the domestic realm. It allows me to merge the various worlds I traverse in my daily life. The cups and apples can be read as portraits, or as actors on a stage negotiating an array of possible identities and traditions.

—Libby Wadsworth

Born: 1962 Detroit, Michigan
Lives and works in Eugene, Oregon

EDUCATION
1990 M.F.A. University of Chicago
1987 B.F.A. Art Institute of Chicago
1984 B.A. Williams College

ONE PERSON EXHIBITIONS (selected)
2005 Elizabeth Leach Gallery, Portland, OR
2003 Zolla Lieberman Gallery, Chicago, IL
2001 Elizabeth Leach Gallery, Chicago, IL
2000 Zolla Lieberman Gallery, Chicago, IL
1998 Anne Reed Gallery, Ketchum, ID

GROUP EXHIBITIONS (selected)
2005 "Context," Maude Kerns Art Center, Eugene, OR
2004 "3 Artists," California State University at Chico, Chico, CA
2004 "A Sharp Eye," Evanston Art Center, Evanston, IL
2002 "Megan O'Connell and Libby Wadworth," Jacobs Gallery, The Hult Center, Eugene, OR
2001 "Still Life," Heathmen Hotel, Portland, OR
2000 "Summer Reading," Anne Reed Gallery, Sun Valley, ID
1998 "New Art of the West," Eiteljorg Museum, Indianapolis, IN
1998 "Interior Pauses: Northwest Contemporary Realism, Maryhill Museum of Art, Goldendale, WA

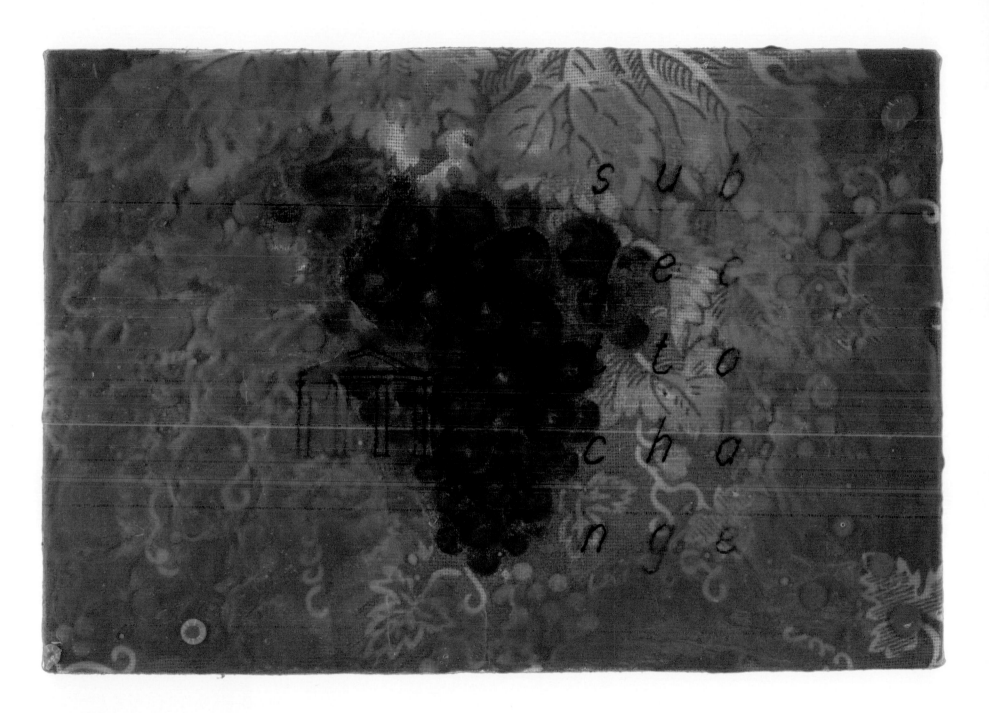

"Untitled" 2001
ENCAUSTIC ON TAPESTRY
7-1/4" x 10-1/4"

JOHN WALKER

It is obvious that John Walker loves to paint. Using a diverse vocabulary of abstract forms his rich metaphysical landscapes communicate to us directly. An imaginative landscape for the label image seems to entrap the Parthenon.

—Bob Nugent

Born: 1939 Birmingham, England
Lives and works in Brookline, Massachusetts

EDUCATION
1961-1963 Academie de la Grande Chaumiere, Paris
1956-1960 Birmingham College of Art

GRANTS AND AWARDS (selected)
2004 Academy Award in Art, American Academy of Arts and Letters, New York, NY
2003 Kahn Award, Boston University
2001 The Benjamin Altman Prize for Excellence in Painting, The 177TH Annual, National Academy
 of Design, New York, NY
1981 John Simon Guggenheim Memorial Fellowship
1970-1972 Harkness Fellowship, New York, NY
1969-1970 Harkness Fellowship
1967-1969 Gregory Fellow, Artist in Residence, Leeds University, Leeds, England

ONE PERSON EXHIBITIONS (selected)
2005 "John Walker: Collage," Knoedler & Company, New York, NY (catalog)
2004 "John Walker: A Winter in Maine, 2003-2004," Center for Maine Contemporary Art, Rockport,
 ME (traveling exhibition) (catalog)
2003 "John Walker: Changing Light," Knoedler & Company, New York, NY (catalog)
2002 "John Walker," Phillips Collection, Washington, D.C.
2002 "John Walker: Oceans, Tidepools and Plein Air Paintings," Wiegand Gallery, Notre Dame de
 Namur University, Belmont, CA
2002 "John Walker: Paintings and Prints," DAAP Galleries, University of Cincinnati, OH
2001 Bowdoin College of Museum of Art, Brunswick, ME

GROUP EXHIBITIONS (selected)
2005 "The Continuous Mark: 40 Years of the New York Studio School," the New York Studio School,
 New York, NY
2004 "American Academy Invitational Exhibition of Painting and Sculpture," American Academy of
 Arts and Letters, New York, NY
2002-2003 "Painting in Boston:1950-2000," De Cordova Museum and Sculpture Park, Lincoln, MA
2002 "The 177TH Annual: an Invitational Exhibition," National Academy Museum, NewYork, NY
2001 "A Master Class: British Class-John Hoyland, John Walker, Basil Beattie, John Edwards,"
 Stephen Lacey Gallery, London, England
1999 "40 Years of American Drawings," Raab Galerie, Berlin, Germany

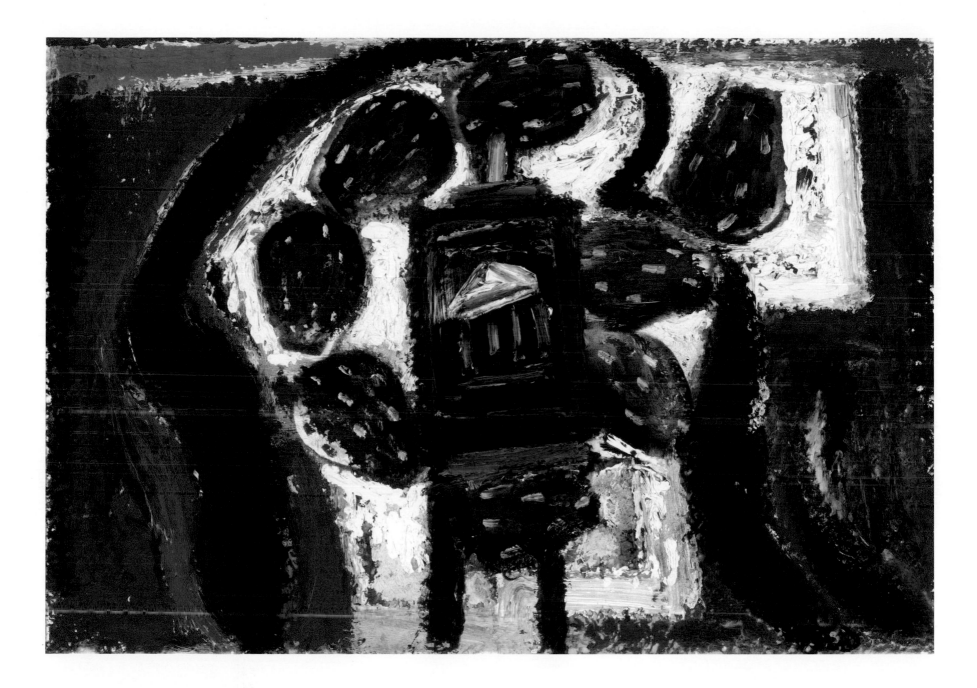

"Untitled" 1996
OIL ON PAPER
16-1/4" x 23-1/2"

253

SUSAN JANE WALP

For most of the 1970's and 1980's, I painted large figure compositions set in largely imaginary interiors. In 1985, feeling that this body of work had run its course, I turned to still life to see if I could find the ground beneath my feet again through the practice of working from direct observation. Much to my surprise, what began as a small and simple effort opened up for me a world of vast possibilities, and I've been focused on still life ever since.

Setting up the still life is the first step. I work by instinct and by what my eyes see. I place, rearrange, add, subtract. At first I have little idea of where I'm going. I just keep trying things and wait for the motif to appear, which can take a long time, but when it happens, it often does so in a flash. The motif serves as a beginning point of a journey that hopefully will lead to an understanding of the relationships before me (of space, of color, of the smallest unit to the largest) and of how the light connects everything and reveals the final image.

Surface and touch are very important to me: working towards a surface that can be receptive, both physically and metaphysically, to many layers of investigation.

I should add that the painting I did for the Imagery Series was a departure from my usual way of working. I used some studies from life, but primarily I worked more from a more imagined image in my mind's eye.

—Susan Jane Walp

Born: 1948 Allentown, Pennsylvania
Lives and works in Chelsea, Vermont

EDUCATION
1979 M.F.A. Brooklyn College, Brooklyn, NY
1971 Skowhegan School of Painting and Sculpture, Skowhegan, ME
1971 New York Studio School, New York, NY
1970 B.A. Mount Holyoke College, South Hadley, MA

GRANTS AND AWARDS (selected)
2004 John Simon Guggenheim Memorial Fellowship
1988 Vermont Council on the Arts Grants for Individual Artists, Honorable Mention
1984 Art Director's Club Award
1984 American Institute of Graphic Arts Award
1984 Society of Illustrators Award
1984 American Illustration Award
1978 New York Creative Arts Public Service Program (CAPS) Fellowship
1977 National Endowment for the Arts Fellowship

ONE PERSON EXHIBITIONS (selected)
2003 Tibor De Nagy Gallery, New York, NY
2000 Victoria Munroe Fine Art, Boston, MA
1998 Hackett Freedman, San Francisco, CA
1996 Hackett Freedman, San Francisco, CA
1996 Fischbach Gallery, New York, NY

GROUP EXHIBITIONS (selected)
2005 "The Continuous Mark," New York Studio School, New York, NY
2005 "Conversation in Paint," Painting Center, New York, NY
2005 College of William and Mary, VA
2005 Eastern Connecticut University, CT
2005 Haverford College, PA
2003 "Zeuxis: A Moveable Feast," Westbeth Gallery, New York, NY
2001 "New Works on Paper," Victoria Munroe Fine Arts, Boston, MA
2001 "Women's View," Haverford College, PA
2001 American Academy Invitational, New York, NY

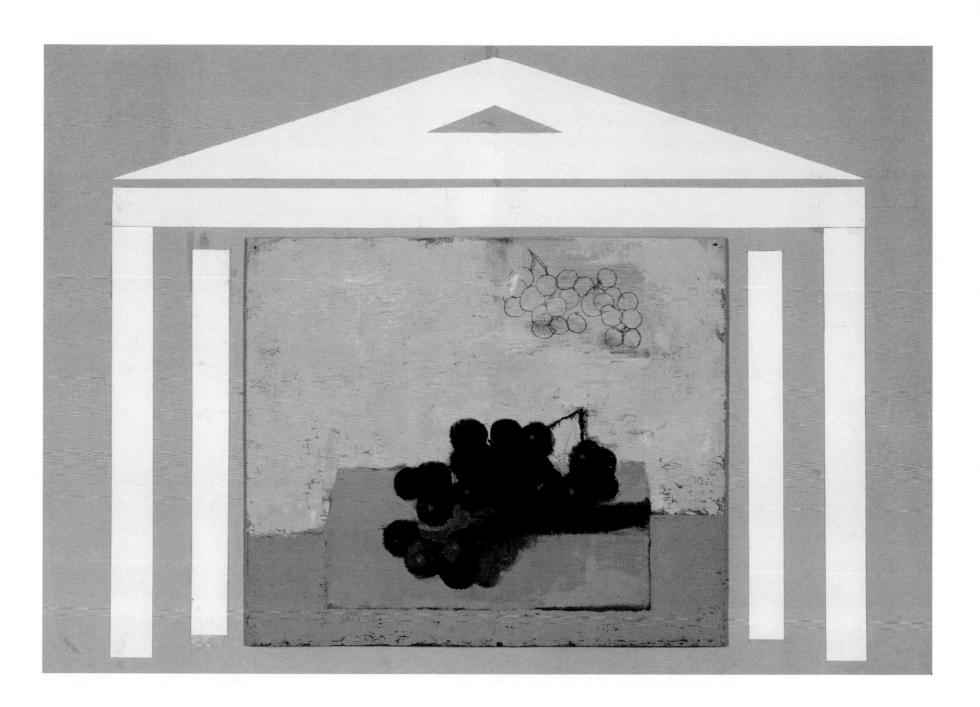

"Untitled" 2003
ACRYLIC AND COLLAGE ON PAPER
8-3/4" x 12-1/2"

255

WILLIAM T. WILEY

What makes anything a viable alternative is the integrity of your approach to it.…It doesn't have anything to do with the materials, or the style…it is a kind of energy that comes into the particular sequence of events.

—William T. Wiley
From *View*, www.crownpoint.com

Born: 1937 Bedford, Indiana
Lives and works in Woodacre, California

EDUCATION
1962 M.F.A. San Francisco Art Institute, San Francisco, CA
1961 B.F.A. San Francisco Art Institute, San Francisco, CA

GRANTS AND AWARDS (selected)
2004 Marin Arts Council, "Life Work Award," Marin, CA
1980 Traveling Grant to Australia, Australian Arts Council
1976 Bartels Prize, 72ND American Exhibition, Art Institute of Chicago, IL
1968 Purchase Prize, Whitney Museum of American Art, New York, NY
1962 Painting Prize, 65TH Annual Exhibition, Art Institute of Chicago, IL
1961 New Talent Award, *Art in America*
1960 Fletcher Award, California School of Fine Arts

ONE PERSON EXHIBITIONS (selected)
2004 "William T. Wiley: 60 Works for 60 Years," From the Collection of the Belger Arts Center, Center for Visual Art, Metropolitan State College of Denver, Denver, CO
2003 "William T. Wiley: New Watercolors—My Country, is it Thee," Marsha Mateyka Gallery, Washington, D.C.
2002 "William T. Wiley: Before and After," Boise Art Museum, Boise, ID
2001 "William T. Wiley, Unobjektive Art," Marsha Mateyka Gallery, Washington, D.C.
2000 "William T. Wiley: The String Theory…is it…sound? Yours as Ever, Marked Twine," L.A. Louver, Venice, CA

GROUP EXHIBITIONS (selected)
2005 "The Intimate Collaboration: 25 Years of Teaberry Press," San Francisco Art Institute, Walter & McBean Galleries, San Francisco, CA
2004 "100 Artists See Satan," Grand Central Art Center, Santa Ana, CA
2004 "Weaving Weft and Warp: Tapestries from Magnolia Press," San Jose Institute Contemporary Art, San Jose, CA
2004 "The True Artist Is An Amazing Luminous Fountain, from the di Rosa Preserve," Kreeger Museum, Washington, D.C.
2003 "Aftershock: The Legacy of the Readymade in Post-war and Contemporary American Art," Dickinson Roundell, Inc., New York, NY and London, England
2003 "Private Eye: Public View," The Wally Goodman, Patrick Duffy Collection of Contemporary Art, Las Vegas Art Museum, Las Vegas, NV
2003 "State of Art 2003 Biennial Watercolor Invitational," Siena Heights University, Klemm Gallery, Adrian, MI and Parkland Art Gallery, Champaigne, IL
2002-2004 "Tamarind: 40 Years, a Retrospective Exhibition of 60 Lithographs" (traveling exhibition)
2002 "Night Skies & Imaginary Coordinates: The Artist as Navigator," The Palo Alto Art Center, Palo Alto, CA
2002 "Oh, Mona!" Herbert F. Johnson Museum of Art, Cornell University, Ithaca, NY

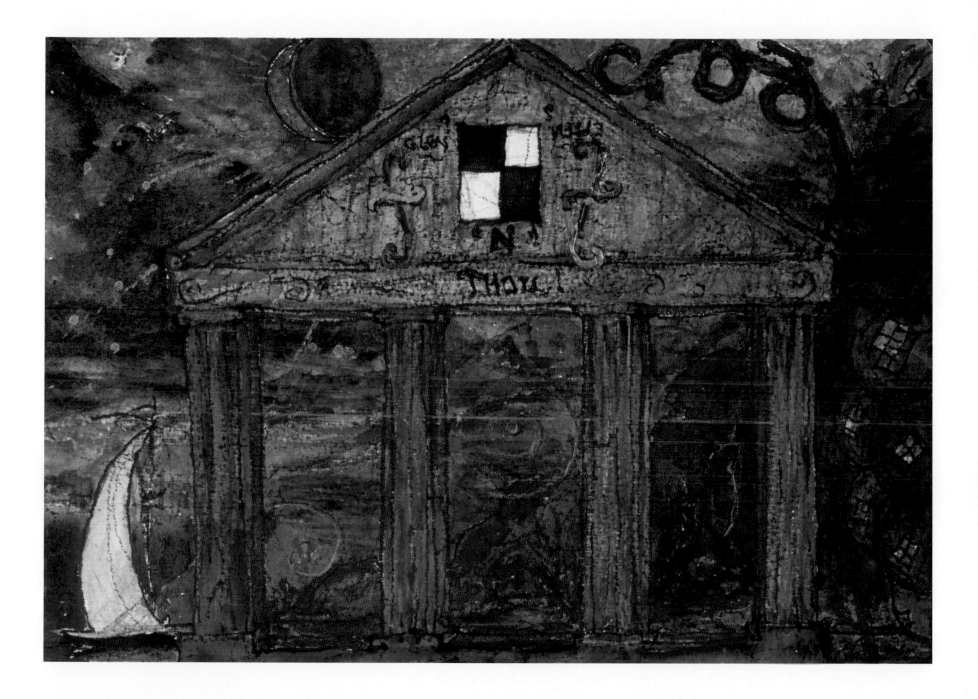

"For Glen Ellen Winery" 1990
Watercolor/mixed media on paper
7" x 10-1/4"

TERRY WINTERS

Over the years Terry Winters has worked in a variety of media including painting, drawing, prints, and set design. The work on paper he did for us in 1995 was during what I would call a "transitional period." Moving away from his more organic forms derived from nature, Winters was exploring new ideas and references while developing a series of paintings titled "Computation of Chains." At first I was surprised by the image. But after seeing his show at Matthew Marks Gallery in New York the work made total sense. As an artist he continues to grow and change, producing tremendous amounts of work that excite and enlighten.

—Bob Nugent

Born: 1949 Brooklyn, New York
Lives and works in New York, New York, and Geneva Switzerland

EDUCATION
1971 B.F.A. Pratt Institute, Brooklyn, NY

ONE PERSON EXHIBITIONS (selected)
2005 "Terry Winters/Paintings, Drawings, Prints/1994-2004," The Addison Gallery of American Art (traveling exhibition)
2005 "Terry Winters: Prints & Sequences," Colby College, ME
2004 "Terry Winters 1981-1986," Matthew Marks Gallery, New York, NY (catalog)
2004 "Terry Winters Paintings, Drawings, Prints 1994-2004," The Addison Gallery of American Art, Andover (traveling exhibition) (catalog)
2004 "Terry Winters: Local Group/New Work on Paper," Pratt Manhattan Gallery, New York, NY (catalog)
2003 "Terry Winters: Paintings and Drawings," Matthew Marks Gallery, New York, NY

GROUP EXHIBITIONS (selected)
2005 "Brice Marden, Al Taylor, Terry Winters/Works on Paper," Nolan/Eckman Gallery, New York, NY
2004 "Tear Down This Wall: Paintings from the 1980's," Museum of Contemporary Art, Los Angeles, CA
2004 "The Print Show," Exit Art, New York, NY
2004 "Fresh Works on Paper, 5ᵀᴴ Anniversary Exhibition," James Kelly Contemporary, Santa Fe, NM
2004 "New Additions: Prints for An American Museum," Whitney Museum of American Art, New York, NY
2003 "Under Pressure: Prints from Two Palms Press," Arthur A. Houghton Jr. Gallery, The Cooper Union, New York, NY
2003 "20 Years/20 Artists," Aspen Art Museum, Aspen, CO (catalog)
2003 "Terry Winters and Barry Le Va: Zeichnungen," Galerie Zell am See, Austria

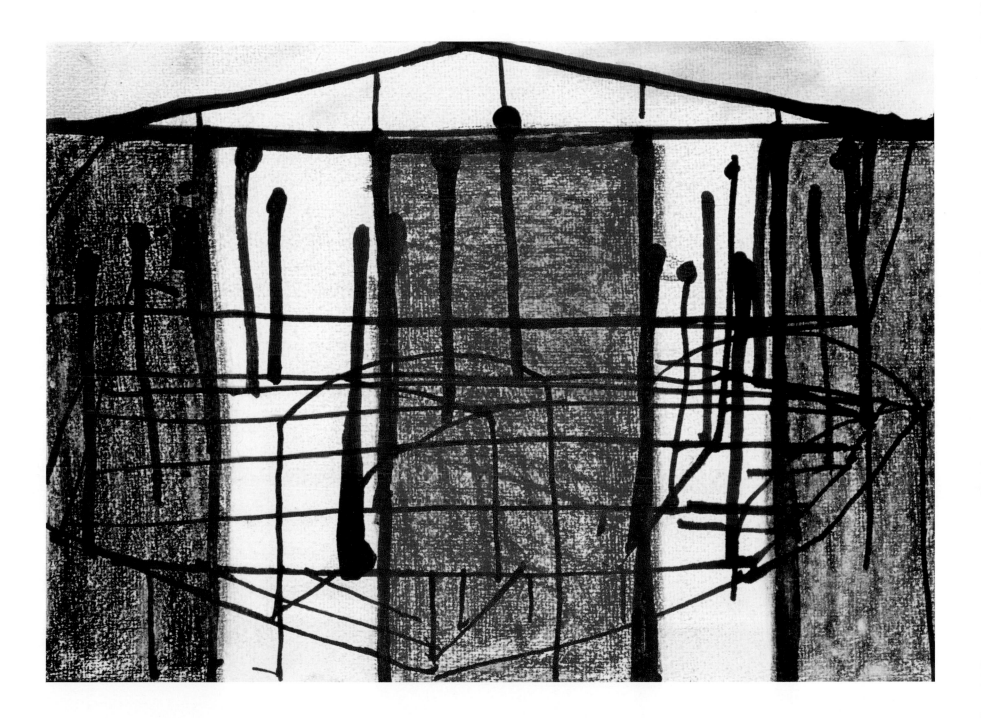

"Untitled" 1995
OIL PASTEL/INK ON PAPER
8-1/8" x 11-3/8"

259

PAUL WONNER

I met Paul Wonner in 1968 while he was a visiting artist at the College of Creative Studies, University of California at Santa Barbara, where I was a student. He was very patient with me and allowed me to ask lots of questions about the kinds of things young painters need to know. To this day, the things he told me play a role in the development of my own work. I thank him for that and for all of the wonderful work he has made throughout his career.

—Bob Nugent

Born: 1920 Tucson, Arizona
Lives and works in San Francisco, California

EDUCATION
1955 M.L.S. University of California at Berkeley, Berkeley, CA
1953 M.A. University of California at Berkeley, Berkeley, CA
1952 B.A. University of California at Berkeley, Berkeley, CA
1941 B.A. California College of Arts and Crafts, Oakland, CA

ONE PERSON EXHIBITIONS (selected)
2004 John Berggruen Gallery, San Francisco, CA
2003 DC Moore Gallery, New York, NY
2001 Michael Kohn Gallery, Los Angeles, CA
1999 DC Moore Gallery, New York, NY
1998 John Berggruen Gallery, San Francisco, CA
1998 "Paul Wonner: Still Lifes," Art Institute of Southern California, Laguna Beach, CA

GROUP EXHIBITIONS (selected)
2004 "The Not So Still Life," San Jose Museum, San Jose, CA
1995 "Works from the Anderson Collection," San Francisco Fine Arts Museum, San Francisco, CA
1989 "Bay Area Figurative Art," San Francisco Museum of Modern Art, San Francisco, CA
1982 "Realism and Realities: The Other Side of American painting, 1940-1960," Rutgers University
 Art Gallery, New Brunswick, NJ
1981-1982 "Contemporary American Realism Since 1960," Pennsylvania Academy of Fine Arts, Philadel-
 phia, PA
1976-1977 "Painting and Sculpture in California: The Modern Era," San Francisco Museum of Modern Art,
 and National Collection of Fine Arts, Smithsonian Institution, Washington, D.C.

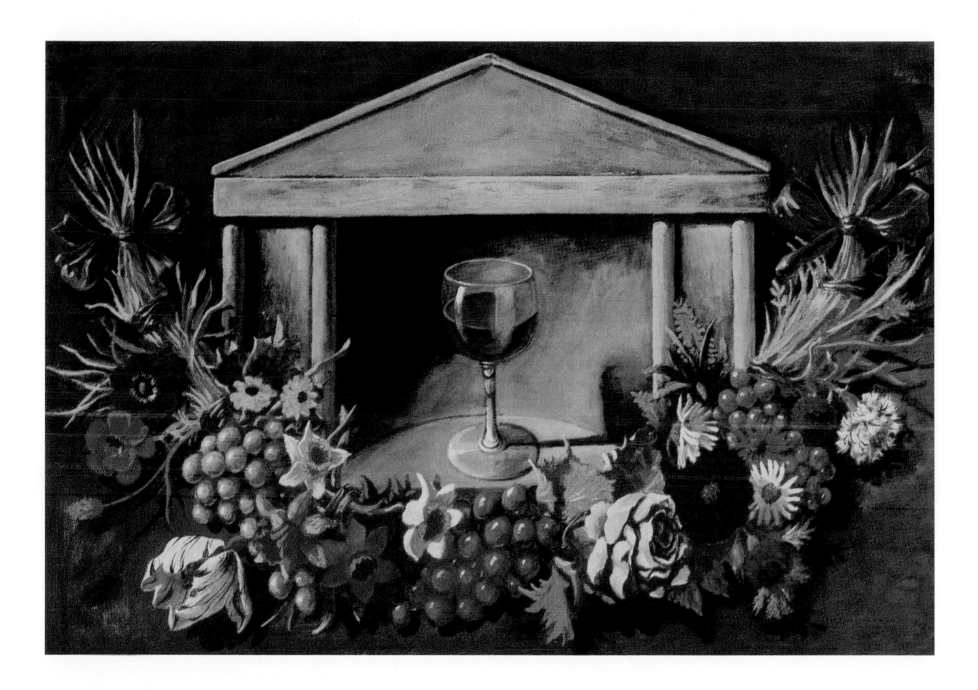

"Untitled" 1992
WATERCOLOR ON PAPER
13" x 18"

TOM WUDL

I have exhibited for 30 years and in that time my work has undergone numerous transformations. In so doing I have unintentionally challenged established doctrines of consistency and logical development that are requisites for legitimization in a career. My early works were responses to process art; however, their titles implicate them as agents of literature and poetry, thereby anchoring them to the succession of figurative interests that have preoccupied me since 1975.

Known originally for my works on paper, I turned to painting on canvas in 1975 and continued to do so for nearly 20 years. In 1995 my interest in paper was revived while preparing studies for an upcoming exhibition of paintings. Since that time I have worked on a regular basis in both media.

In 1985, influenced by Panofsky's *Early Netherlandish Painting*, I adopted illusionist strategies with antiquarian affinities to paint pictures that were highly personal if sometimes hermetic. Occasionally taking as long as 18 months to complete, these were declarations of my conviction that no matter how private the symbol it speaks a universal language. After a decade the dark inward-looking nature of this work became oppressive and working in oil a tyranny.

The use of acrylics liberated from me a suite of romances on the pleasures of love and art that later coalesced into didactic studio celebrations: paintings about painting and the life of the artist. This brought me to contemplate creativity itself. Years of working by trial and error have instilled in me a deep respect for ineptitude. It is at the heart of the creative process.

My recent paintings employ slapstick strategies to extol ineptitude and in a spirit of frivolity address the issue of sanctimonious piety and reverence for the art object.

—Tom Wudl

Born: 1948 Cochabamba, Bolivia
Lives and works in Los Angeles, California

EDUCATION
1970 B.F.A. Chouinard Art School, Los Angeles, CA

GRANTS AND AWARDS (selected)
1975 National Endowment for the Arts Fellowship
1972 "Young Talent Award," Los Angeles County Museum of Art

ONE PERSON EXHIBITIONS (selected)
2003 "Tom Wudl: You've got to Be Kidding!?" William D. Cannon Art Gallery, Carlsbad, CA
2002 Peter Blake Gallery, Laguna Beach, CA
2002 L.A. Louver, Venice, CA
2000 "Tom Wudl Paintings," Peter Blake Gallery, Laguna Beach, CA
1999 L.A. Louver, Venice, CA

GROUP EXHIBITIONS (selected)
2003 "LAPD-Los Angeles Pattern and Design," Rosamund Felson Gallery, Santa Monica, CA
2002 "August 2002," L.A. Louver, Venice, CA
2001 "Chouinard: A Living Legacy," Oceanside Museum of Art, Oceanside, CA
2001 "Tom Wudl/Peter Shelton" Peter Blake Gallery, Laguna Beach, CA
1994 "Three Visions," Riva Yares Gallery, Scottsdale, AZ
1993 "Menagerie: Animal Images by Contemporary Artists," The Hope Street Gallery, Los Angeles, CA
1991 "Individual Realities in the California Art Scene," Sezon Museum of Art, Tokyo (traveling exhibition)
1989 "Whitney Biennial," Whitney Museum of American Art, New York, NY

PHOTO CREDIT: ROXANNE JANNETTE
COURTESY OF L.A. LOUVER GALLERY
VENICE, CA

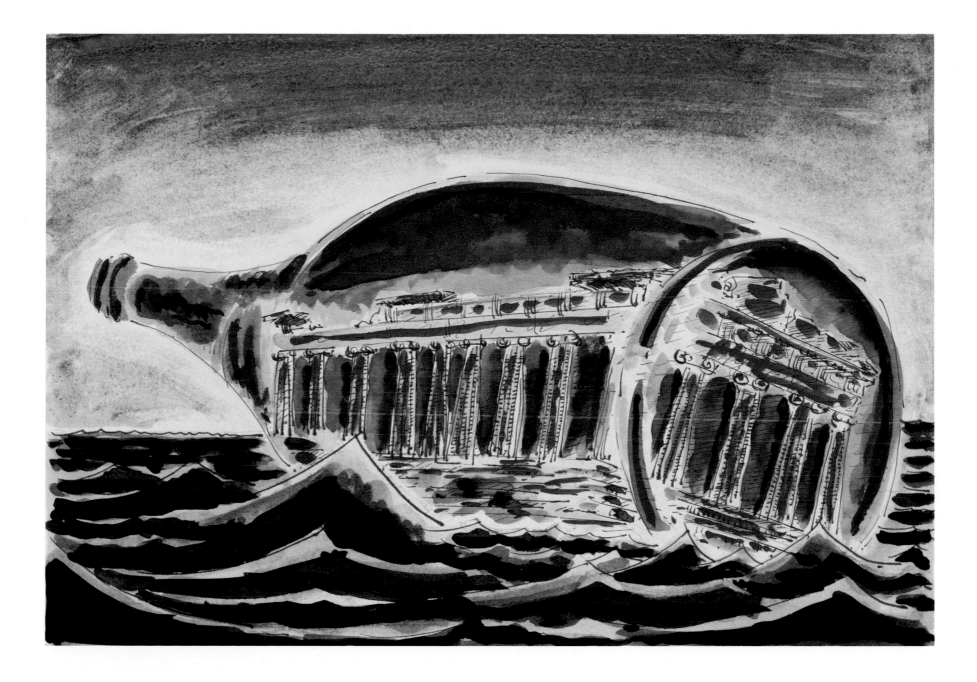

"Untitled" 1992
WATERCOLOR ON PAPER
13" x 18"

263

YURIKO YAMAGUCHI

Paradox, transformation, connection and harmony are the essence of Yamaguchi's art, in which any object in any state of existence can change and become something else.

—Howard Fox
Web & Metamorphosis exhibition catalog

Born: 1948 Osaka, Japan
Lives and works in Vienna, Virginia and Washington, D.C.

EDUCATION
1979 M.F.A. University of Maryland, College Park, MD
1975 B.A. University of California at Berkeley, Berkeley, CA

GRANTS AND AWARDS (selected)
2005 Benesse Award, Japan
2004 Franz & Virginia Bader Foundation Grant
2001 Virginia Museum Professional Fellowship
2000 Virginia Commission of Arts Individual Grant
1995 Mid Atlantic/NEA regional Visual Arts Fellowship
1994 Virginia Commission of Arts Individual Grant
1993 Salzburg Kunstlerhaus Artist-Residency Grant
1988 Virginia Museum Professional Fellowship
1986 Visual Arts Residency Grant, Mid Atlantic Arts Foundation
1985 Virginia Museum Professional Fellowship
1982 Fellowship, Virginia Center for Creative Arts

ONE PERSON EXHIBITIONS (selected)
2005 Howard Scott Gallery, NY
2005 Ise Contemporary Art Museum, Japan
2004 The Museum of Modern Art, Kamakura, Japan
2003 Numark Gallery, Washington, D.C.
2003 LoRoy Neiman Gallery, Columbia University, NY

GROUP EXHIBITIONS (selected)
2004 Schneider Museum of Art, Southern Oregon University, Ashland, OR
2003 Corcoran Gallery of Art, Washington, D.C.
2002 "American Spectrum: Smith College Museum of Art Collection," Katonah Museum of Art, Katonah, NY; Tucson Museum of Art, AZ
2002 Memorial Art Gallery, University of Rochester, NY
2002 Pennsylvania Academy of Fine Art, Philadelphia, PA
2002 The Museum of Fine Arts, Houston, TX
2002 Norton Museum of Fine Arts, West Palm Beach, FL
2002 National Academy Museum, NY

PHOTO CREDIT: CAROL HARRISON

"Untitled" 1998
MIXED MEDIA ON PANEL
16" x 20"

265

CHIHUNG YANG

My work tries to capture the primitive forms of nature, and its unending succession of growth and decay. It also attempts to unveil the subtle within the primal, the delicate within strength, the resignation to fate which provokes urgent desire, and the compelling dramatic force which resonates through ambiguity. My paintings hover on the borderline between abstraction and representation.

—Chihung Yang

Born: 1947 Taiwan, China
Lives and works in New York, New York

EDUCATION
1965-1968 National Taiwan College of Art

GRANTS AND AWARDS (selected)
1985-1986 The Institute for Art and Urban Resources, Inc., New York City Residency at the Clock Tower
1984-1985 The Institute for Art and Urban Resources, Inc., New York City Residency at the Clock Tower

ONE PERSON EXHIBITIONS (selected)
2004 National History Museum, Taipei, Taiwan
1997 O'Hara Gallery, New York, NY
1996 O'Hara Gallery, New York, NY
1993 Michael Walls Gallery, New York, NY
1991 Michael Walls Gallery, New York, NY
1989 Michael Walls Gallery, New York, NY
1988 Betsy Rosenfield Gallery, Chicago, IL

GROUP EXHIBITIONS (selected)
2002 Las Vegas Museum, Las Vegas, NV
2001 Shanghai Art Museum, China
1999 Beijing China Art Museum, China
1994 The National Gallery, Bangkok, Thailand
1988 Nina Freadenheim Gallery, Buffalo, NY
1988 Yale University Art Gallery, CT
1986 The Queens Museum, New York, NY
1985 Virginia Museum of Fine Arts, VA

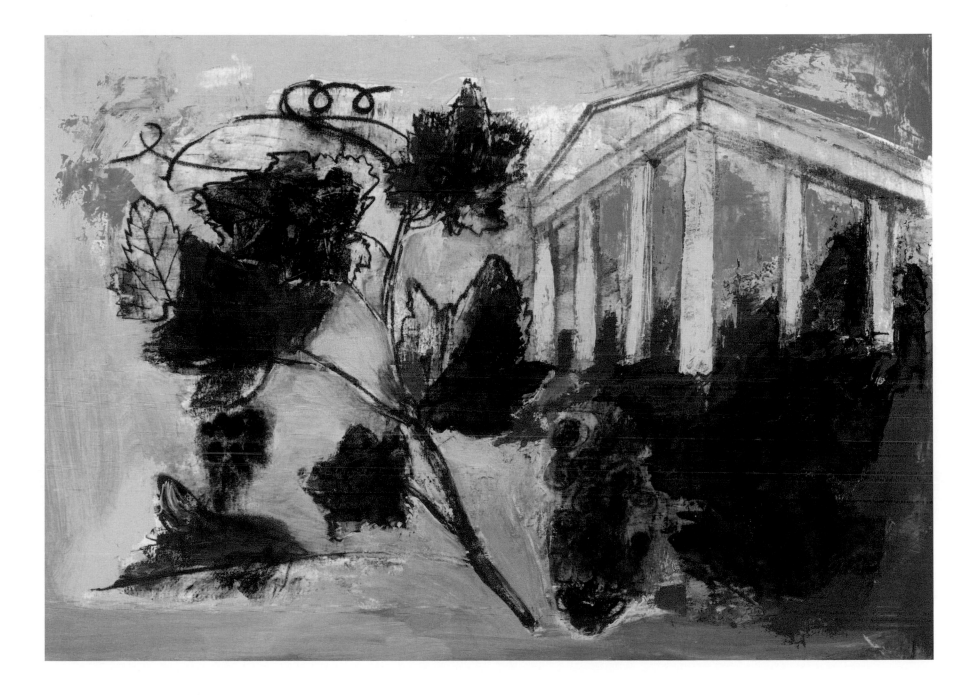

"Untitled" 1994
ACRYLIC/PASTEL ON PAPER
15" x 21-1/4"

Labels

&

Vintages

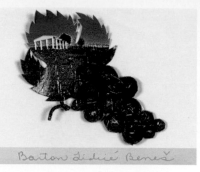

1985 Cabernet Sauvignon
(Sonoma Valley)
Barton Benes
P. 20

1985 Cabernet Sauvignon
(Sonoma Valley)
Don Farnsworth
P. 66

1986 Chardonnay
(Sonoma Valley)
Wade Hoefer
P. 96

1986 Chardonnay
(Sonoma Valley)
Dick Ibach
P. 104

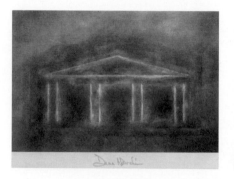

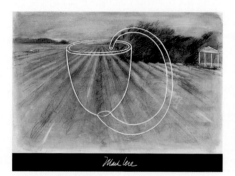

1986 Chardonnay
(Sonoma Valley)
Dann Nardi
P. 170

1987 Petite Sirah
(Paso Robles)
Sara Krepp
P. 118

1987 Trousseau
(Cienga Valley)
Mark Lere
P. 134

1988 Cabernet Franc
(Alexander Valley)
David Shapiro
P. 214

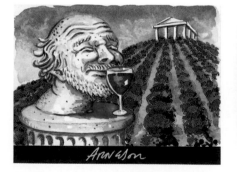

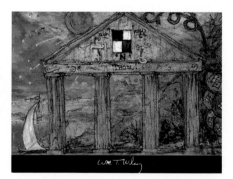

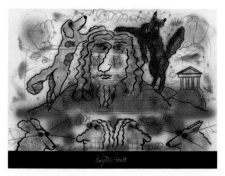

1988 Cabernet Pfeffer
(Cienga Valley)
Robert Arneson
P. 10

1988 Chardonnay
(Carneros)
Deborah Oropallo
P. 186

1988 Chardonnay
(Napa Valley)
William Wiley
P. 256

1988 Petit Verdot
(Alexander Valley)
Roy De Forest
P. 46

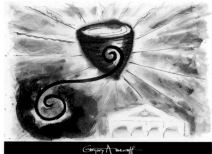

1988 PETITE SIRAH
(ARROYO SECO)
NATHAN OLIVEIRA
P. 184

1988 ZINFANDEL
(DRY CREEK VALLEY)
PAUL WONNER
P. 260

1989 ALEATICO
(LAGOMARSINO VINEYARDS)
ROBERT KUSHNER
P. 126

1989 CABERNET FRANC
(ALEXANDER VALLEY)
GREGORY AMENOFF
P. 6

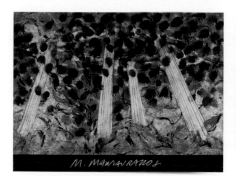

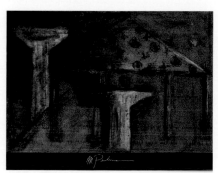

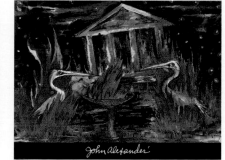

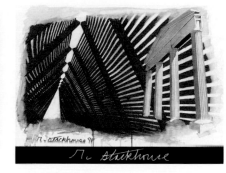

1989 CHARDONNAY
BARREL FERMENTED BRUT
(CASSIDY & BRYTON VINEYARDS)
MICHAEL MANZAVRAKOS
P. 142

1989 LATE HARVEST RIESLING
(BIEN NACIDO)
MARK PERLMAN
P. 194

1989 MALBEC
(BLUE ROCK VINEYARDS)
JOHN ALEXANDER
P. 2

1989 PETITE SIRAH
(SHELL CREEK VINEYARD)
ROBERT STACKHOUSE
P. 234

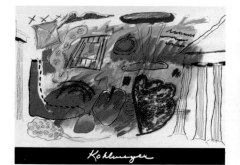

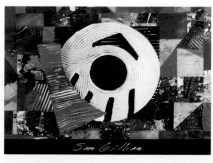

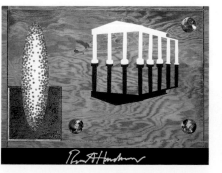

1989 PETITE VERDOT
(BLUE ROCK VINEYARDS)
IDA KOHLMEYER
P. 116

1989 SYRAH
(SANTA MARIA VALLEY)
SAM GILLIAM
P. 80

1989 ZINFANDEL PORT
(DRY CREEK VALLEY)
ROBERT HUDSON
P. 98

1990 ALEATICO
(LAGOMARSINO VINEYARDS)
TONY BERLANT
P. 26

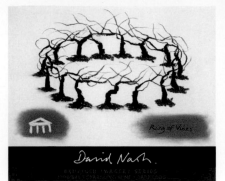

1990 Brut Sparkling Wine
(Carneros)
David Nash
p. 172

1990 Dolcetto
(Napa Valley)
April Gornik
p. 82

1990 Late Harvest Zinfandel
(Dry Creek Valley)
Judy Pfaff
p. 198

1990 Petite Verdot
(Alexander Valley)
Nancy Graves
p. 84

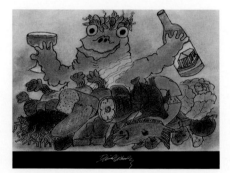

1990 Syrah
(Santa Maria Valley)
David Gilhooly
p. 78

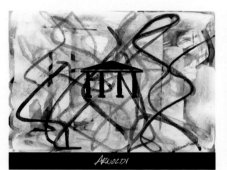

1990 Trousseau
(Eagle Crest Vineyard)
Charles Arnoldi
p. 14

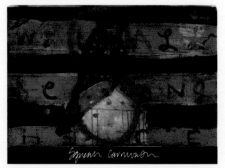

1990 Zinfandel Port
(Mayo and Carreras Vineyards)
Squeak Carnwath
p. 36

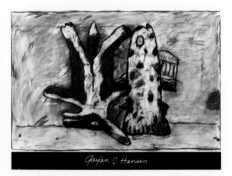

1991 Aleatico
(Lagomarsino Vineyards)
Gaylen Hansen
p. 90

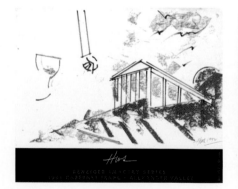

1991 Cabernet Franc
(Alexander Valley)
Hassel Smith
p. 224

1991 Petite Verdot
(Alexander Valley)
Billy Al Bengston
p. 24

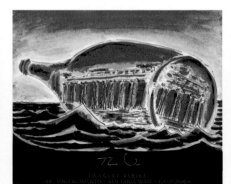

1991 Vino Momento
Red Table Wine
(California)
Tom Wudl
p. 262

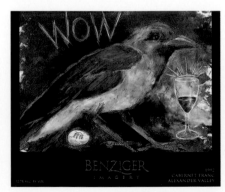

1992 Cabernet Franc
(Alexander Valley)
Terry Allen
p. 4

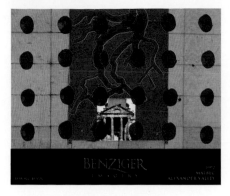
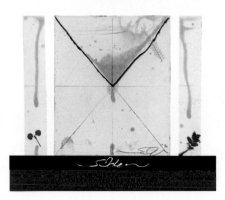
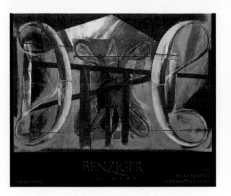
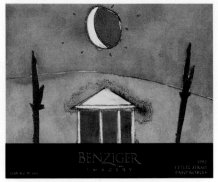

1992 MALBEC
(ALEXANDER VALLEY)
JAMES BROWN
P. 32

NV INTERNATIONAL RED TABLE WINE
(FRANCE, CHILE, AUSTRALIA, USA)
SHOICHI IDA
P. 106

1992 PETIT VERDOT
(ALEXANDER VALLEY)
STEVEN SORMAN
P. 230

1992 PETITE SIRAH
(PASO ROBLES)
GONÇALO IVO
P. 108

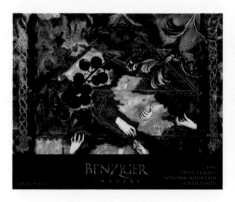
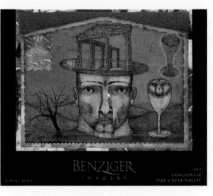
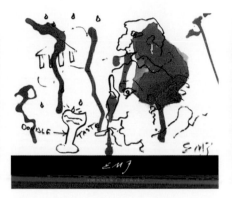
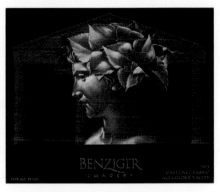

1992 PETITE VERDOT
(SONOMA MOUNTAIN)
PAM LONGOBARDI
P. 140

1992 SANGIOVESE
(DRY CREEK VALLEY)
KURT KEMP
P. 114

1992 WHITE BURGUNDY
(NAPA VALLEY)
ED MOSES
P. 166

1993 CABERNET FRANCE
(ALEXANDER VALLEY)
JOHN NAVA
P. 174

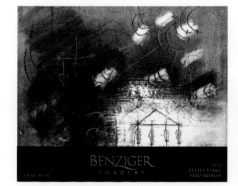
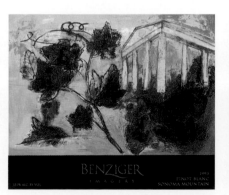
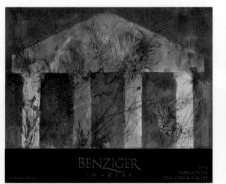
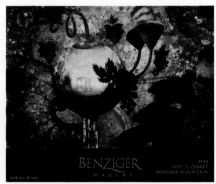

1993 PETITE SIRAH
(PASO ROBLES)
SUSAN LAUFER
P. 130

1993 PINOT BLANC
(SONOMA MOUNTAIN)
CHIHUNG YANG
P. 266

1993 SANGIOVESE
(DRY CREEK VALLEY)
LARRY THOMAS
P. 246

1993 WHITE CLARET
(SONOMA MOUNTAIN)
TIM MCDOWELL
P. 158

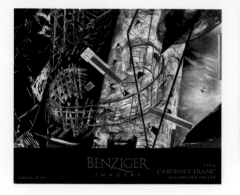

1994 Cabernet Franc
(Alexander Valley)
Hugh Merrill
p. 162

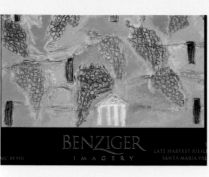

1994 Late Harvest Riesling
(Santa Maria Valley)
Joan Snyder
p. 228

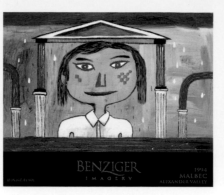

1994 Malbec
(Alexander Valley)
Michael Nakoneczny
p. 168

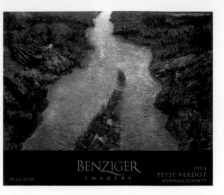

1994 Petit Verdot
(Sonoma County)
Chester Arnold
p. 12

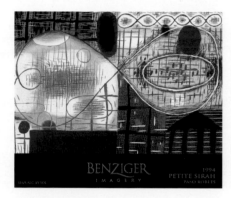

1994 Petite Sirah
(Paso Robles)
Karen Kunc
p. 124

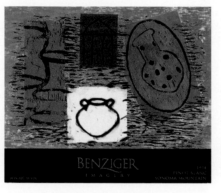

1994 Pinot Blanc
(Sonoma Mountain)
Gordon Powell
p. 206

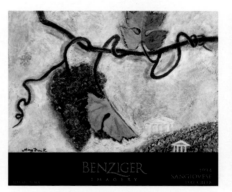

1994 Sangiovese
(Dry Creek)
Mary Frank
p. 72

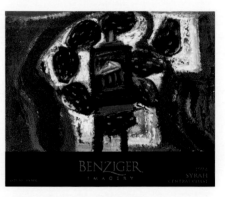

1994 Syrah
(Central Coast)
John Walker
p. 252

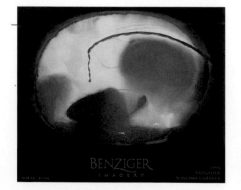

1994 Viognier
(Sonoma County)
Gary Stephan
p. 238

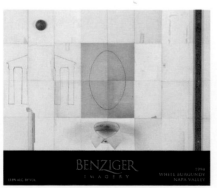

1994 White Burgundy
(Napa Valley)
John Fraser
p. 74

1994 Zinfandel Port
(Dry Creek)
Bob Nugent
p. 180

1995 Barbera
(Sonoma Valley)
Carl Palazzolo
p. 188

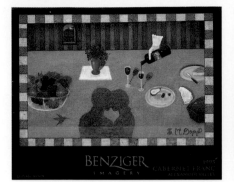

1995 CABERNET FRANC
(ALEXANDER VALLEY)
SUSAN DOPP
P. 56

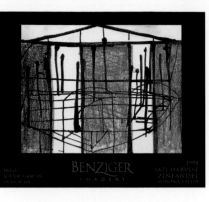

1995 LATE HARVEST ZINFANDEL
(SONOMA COUNTY)
TERRY WINTERS
P. 258

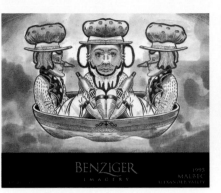

1995 MALBEC
(BLUE ROCK VINEYARDS)
BEATTIE & DAVIDSON
P. 18

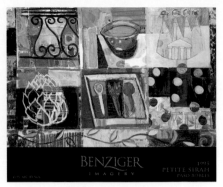

1995 PETITE SIRAH
(PASO ROBLES)
GARY NISBET
P. 178

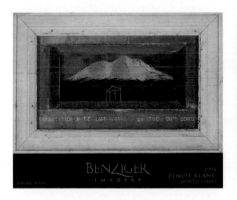

1995 PINOT BLANC
(NORTH COAST)
ROBERT MCCAULEY
P. 154

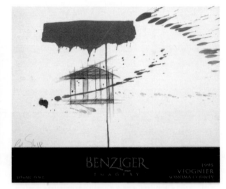

1995 SANGIOVESE
(LARGO VISTA, ALEXANDER VALLEY)
ANNE SIEMS
P. 218

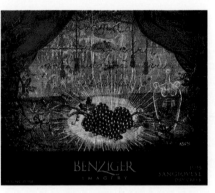

1995 VIOGNIER
(SONOMA COUNTY)
PAT STEIR
P. 236

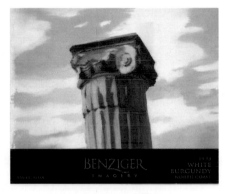

1995 WHITE BURGUNDY
(NORTH COAST)
CHRISTOPHER BROWN
P. 30

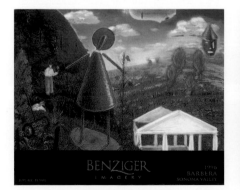

1996 BARBERA
(SONOMA VALLEY)
WILLIAM CASS
P. 38

1996 CABERNET FRANC
(SONOMA COUNTY)
SOL LEWITT
P. 136

1996 PETITE SIRAH
(PASO ROBLES)
JOHN PITTMAN
P. 202

1996 PINOT BLANC
(SANTA MARIA VALLEY)
KENNA MOSER
P. 164

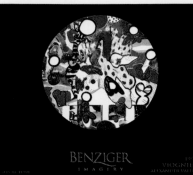

1996 Viognier
(Alexander Valley)
Holly Hughes
p. 100

1996 White Burgundy
(Napa Valley)
Tom Marioni
p. 146

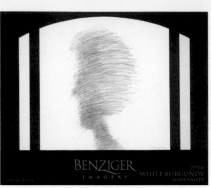

1997 Barbera
(Sonoma Valley)
Robert Helm
p. 94

1997 Cabernet Franc
(Sonoma Valley)
Robert Ecker
p. 62

1997 Petite Sirah
(Paso Robles)
Robert Kelly
p. 112

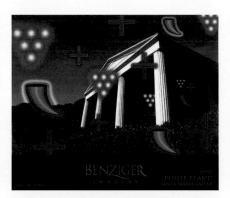

1997 Pinot Blanc
(Santa Maria Valley)
David Kiester
p. 110

1997 Sangiovese
(Sonoma Valley)
Michael Dvortcsak
p. 60

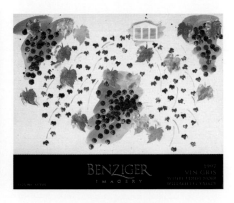

1997 Vin Gris
(Willamette Valley)
Michelle Stuart
p. 240

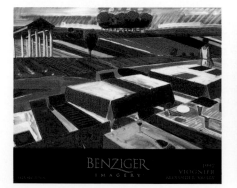

1997 Viognier
(Alexander Valley)
Roland Petersen
p. 196

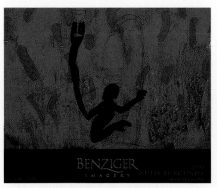

1997 White Burgundy
(North Coast)
Hans Sieverding
p. 220

1998 Cabernet Franc
(Sonoma Valley)
Frances McCormack
p. 156

1998 Malbec
(Alexander Valley)
Sergio Fingermann
p. 68

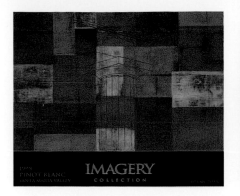

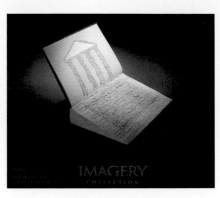

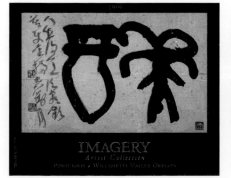

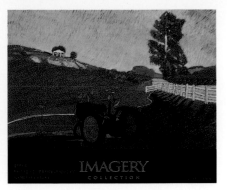

1998 PINOT BLANC
(SANTA MARIA VALLERY)
DAN DEVENING
P. 50

1998 PINOT GRIS
(WILLAMETTE VALLEY)
JACK STUPPIN
P. 242

1998 VIOGNIER
(ALEXANDER VALLEY)
BUZZ SPECTOR
P. 232

1998 WHITE BURGUNDY
(NORTH COAST)
JOE DRAEGERT
P. 58

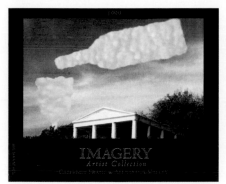

1999 CABERNET FRANC
(ALEXANDER VALLEY)
JOHN BALDESSARI
P. 16

1999 PETIT VERDOT
(SONOMA VALLEY)
PEGAN BROOKE
P. 28

1999 PETITE SIRAH
(PASO ROBLES)
JEANETTE PASIN-SLOAN
P. 190

1999 PINOT BLANC
(SANTA MARIA VALLEY)
DEBRA McKILLOP
P. 160

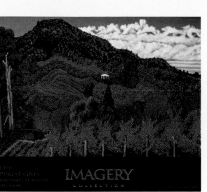

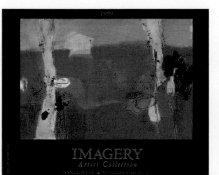

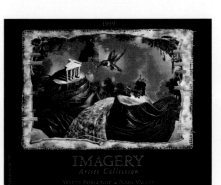

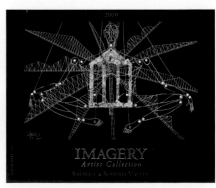

1999 PINOT GRIS
(WILLAMETTE VALLEY)
WANG DONGLING
P. 54

1999 SANGIOVESE
(SONOMA COUNTY)
JAMES KUDO
P. 122

1999 WHITE BURGUNDY
(NAPA VALLEY)
BARRY BUXKAMPER
P. 34

2000 BARBERA
(SONOMA VALLEY)
CARLOS ESTEVEZ
P. 64

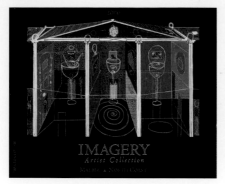

2000 MALBEC
(NORTH COAST)
RICHARD HULL
P. 102

2000 PETIT VERDOT
(SONOMA VALLEY)
TERENCE LA NOUE
P. 128

2000 PETITE SIRAH
(PASO ROBLES)
MICHAEL GREGORY
P. 86

2000 PETITE SIRAH PORT
(MENDOCINO COUNTY)
DAVID ANDERSEN
P. 8

2000 PINOT BLANC
(SANTA MARIA VALLEY)
ANN TAULBEE
P. 244

2000 REISLING
(MENDOCINO COUNTY)
YURIKO YAMAGUCHI
P. 264

2000 SANGIOVESE
(DRY CREEK VALLEY)
LIBBY WADSWORTH
P. 250

2000 VIOGNIER
(ALEXANDER VALLEY)
GLADYS NILSSON
P. 176

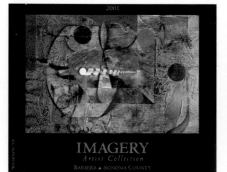
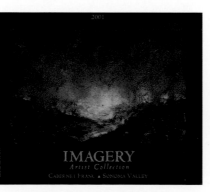
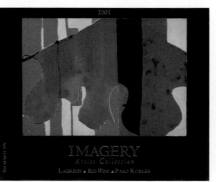
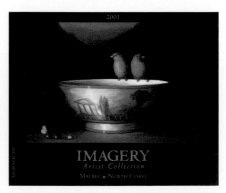

2001 BARBERA
(SONOMA COUNTY)
RAFAEL PEREA DE LA CABADA
P. 192

2001 CABERNET FRANC
(SONOMA VALLEY)
FORD CRULL
P. 44

2001 LAGREIN
(PASO ROBLES)
JOHN OCHS
P. 182

2001 MALBEC
(NORTH COAST)
DAVID KROLL
P. 120

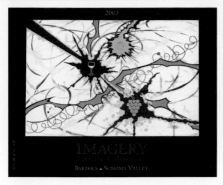

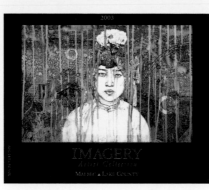

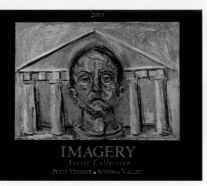

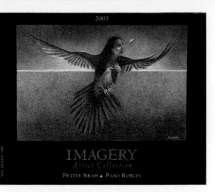

2003 BARBERA
(SONOMA VALLEY)
KARA MARIA
P. 144

2003 MALBEC
(LAKE COUNTY)
HUNG LIU
P. 138

2003 PETIT VERDOT
(SONOMA VALLEY)
JEFFERY COTE DE LUNA
P. 42

2003 PETITE SIRAH
(PASO ROBLES)
MARIANELA DE LA HOZ
P. 48

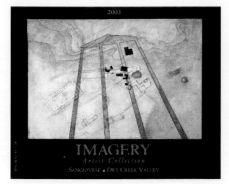

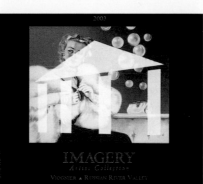

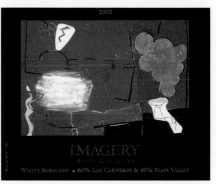

2003 SANGIOVESE
(DRY CREEK VALLEY)
FRED PLOEGER
P. 204

2003 MUSCAT CANELLI
(LAKE COUNTY)
SUSAN WALP
P. 254

2003 VIOGNIER
(RUSSIAN RIVER VALLEY)
ALEXIS SMITH
P. 222

2003 WHITE BURGUNDY
(LOS CARNEROS, NAPA VALLEY)
GUSTAVO RIVERA
P. 210

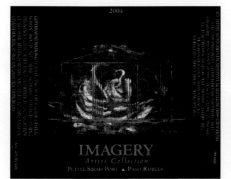

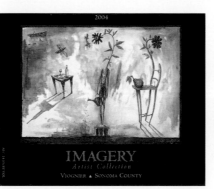

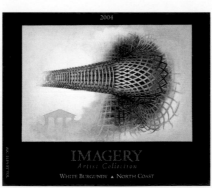

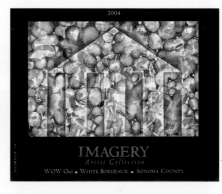

2004 PETITE SIRAH PORT
(PASO ROBLES)
AARON FINK
P. 70

2004 VIOGNIER
(SONOMA COUNTY)
ANDY SAFTEL
P. 212

2004 WHITE BURGUNDY
(NORTH COAST)
DAN GAMBLE
P. 76

2004 WOW OUI WHITE BORDEAUX
(SONOMA COUNTY)
PAMELA MARKS
P.148

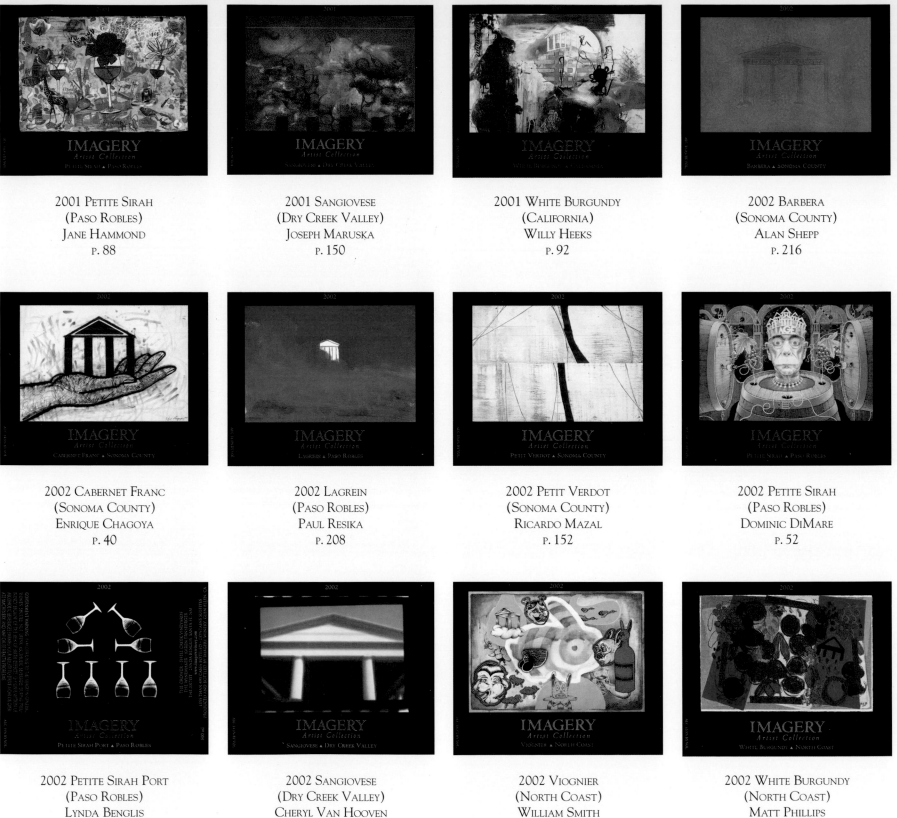

2001 Petite Sirah
(Paso Robles)
Jane Hammond
p. 88

2001 Sangiovese
(Dry Creek Valley)
Joseph Maruska
p. 150

2001 White Burgundy
(California)
Willy Heeks
p. 92

2002 Barbera
(Sonoma County)
Alan Shepp
p. 216

2002 Cabernet Franc
(Sonoma County)
Enrique Chagoya
p. 40

2002 Lagrein
(Paso Robles)
Paul Resika
p. 208

2002 Petit Verdot
(Sonoma County)
Ricardo Mazal
p. 152

2002 Petite Sirah
(Paso Robles)
Dominic DiMare
p. 52

2002 Petite Sirah Port
(Paso Robles)
Lynda Benglis
p. 22

2002 Sangiovese
(Dry Creek Valley)
Cheryl Van Hooven
p. 248

2002 Viognier
(North Coast)
William Smith
p. 226

2002 White Burgundy
(North Coast)
Matt Phillips
p. 200